GAY MEN'S STYLE

Marybeth C. Stalp, *Quilting: The Fabric of Everyday Life*
Jonathan S. Marion, *Ballroom: Culture and Costume in Competitive Dance*
Dunja Brill, *Goth Culture: Gender, Sexuality and Style*
Joanne Entwistle, *The Aesthetic Economy of Fashion: Markets and Value in Clothing and Modelling*
Juanjuan Wu, *Chinese Fashion: From Mao to Now*
Annette Lynch, *Porn Chic: Exploring the Contours of Raunch Eroticism*
Brent Luvaas, *DIY Style: Fashion, Music and Global Cultures*
Jianhua Zhao, *The Chinese Fashion Industry: An Ethnographic Approach*
Eric Silverman, *A Cultural History of Jewish Dress*
Karen Hansen and D. Soyini Madison, *African Dress: Fashion, Agency, Performance*
Maria Mellins, *Vampire Culture*
Lynne Hume, *The Religious Life of Dress*
Marie Riegels Melchior amd Birgitta Svensson, *Fashion and Museums: Theory and Practice*
Masafumi Monden, *Japanese Fashion Cultures: Dress and Gender in Contemporary Japan*
Alfonso McClendon, *Fashion and Jazz: Dress, Identity and Subcultural Improvisation*
Phyllis G. Tortora, *Dress, Fashion and Technology: From Prehistory to the Present*
Barbara Brownie and Danny Graydon, *The Superhero Costume: Identity and Disguise in Fact and Fiction*
Adam Geczy and Vicki Karaminas, *Fashion's Double: Representations of Fashion in Painting, Photography and Film*
Yuniya Kawamura, *Sneakers: Fashion, Gender, and Subculture*
Heike Jenss, *Fashion Studies: Research Methods, Sites and Practices*
Brent Luvaas, *Street Style: An Ethnography of Fashion Blogging*
Jenny Lantz, *The Trendmakers: Behind the Scenes of the Global Fashion Industry*
Barbara Brownie, *Acts of Undressing: Politics, Eroticism, and Discarded Clothing*
Louise Crewe, *The Geographies of Fashion: Consumption, Space, and Value*
Sheila Cliffe, *The Social Life of Kimono: Japanese Fashion Past and Present*

DRESS, BODY, CULTURE: CRITICAL SOURCEBOOKS
Rebecca Mitchell, *Fashioning the Victorians: A Critical Sourcebook*

GAY MEN'S STYLE

Fashion, Dress and Sexuality in the 21st Century

SHAUN COLE

BLOOMSBURY VISUAL ARTS
LONDON • NEW YORK • OXFORD • NEW DELHI • SYDNEY

BLOOMSBURY VISUAL ARTS
Bloomsbury Publishing Plc
50 Bedford Square, London, WC1B 3DP, UK
1385 Broadway, New York, NY 10018, USA
29 Earlsfort Terrace, Dublin 2, Ireland

BLOOMSBURY, BLOOMSBURY VISUAL ARTS and the Diana logo are trademarks of Bloomsbury Publishing Plc

First published in Great Britain 2023

Cover design by Holly Capper
Cover image © MStudioImages/Getty Images

A catalogue record for this book is available from the British Library.

A catalog record for this book is available from the Library of Congress.

ISBN: HB: 978-1-4742-4914-0
 PB: 978-1-4742-4915-7
 ePDF: 978-1-4742-4917-1
 eBook: 978-1-4742-4916-4

Typeset by RefineCatch Ltd, Bungay, Suffolk NR35 1EF
Printed and bound in India

To find out more about our authors and books, visit www.bloomsbury.com and sign up for our newsletters.

To the memory of **Jonathan Jackson**, forever one of the most stylish gay men

CONTENTS

ACKNOWLEDGMENTS

Firstly, I would like to thank all the men who agreed to be interviewed for this research, for sharing their time, memories, stories, and opinions—without you there would be no book. Also thank you to those men who shared and agreed that I could include photographs of them.

Thank you also to Anna Wright for suggesting this book and to my editor Georgia Kennedy for all her support.

I am indebted to Ashley Palmer, Donna Sgro, Paul Bench, Sally Gray, Nick Henderson of Australian Queer Archives (AQUA—formerly Australian Lesbian and Gay Archives (ALGA)) and various colleagues in the fashion departments at the Royal Melbourne Institute of Fashion (RMIT) and the University of Technology Sydney (UTS) for sharing contacts and putting me in touch with friends and colleagues to interview. In the same vein, thanks go to Cathy Leff and colleagues of Fashion Project at Bal Harbour Shops, Miami, for helping set up and hosting my focus groups in 2015. Related to this I am thankful to Judith Clark for making introductions to the Fashion Project.

I was grateful to receive funding from the Centre for Fashion Curation (CfFC) at University of the Arts London and Faculty of Humanities and Arts at University of Southampton to support transcriptions of my interviews. Thanks go to Katherine Spence, Kerry at Business Friend and especially Susan Nicholls for their clear and understanding transcripts of interviews and focus groups. I would also like to thank Graham and (the late Penny) Powell for the use of their flat in New York while on my research trip there. Thanks as well to CfFC for the loan of a digital tape recorder, invaluable for my interviewing process.

I would like to thank Charlotte Hodes, who in her role as Head of Research at London College of Fashion suggested I apply for a research sabbatical to RMIT, and who supported this trip. Relating to this trip, my thanks go to Robyn Healy and Jessica Bugg for hosting me at RMIT and other colleagues in the fashion department for making me so welcome. Also, to Nick Henderson and his colleagues at AQUA/ALGA for making me welcome in their research community and access to invaluable information of Australian gay life and history.

Research is a long process and it was invaluable to be able to present at conferences during this period: thank you Teleica Kirkland and Costume Institute of African Diaspora, Jay McCauley-Bowstead and Charlie Athill of London College of Fashion's Masculinities Hub and Andrew Groves and Danielle Sprecher at Westminster University for accepting my abstracts for conference papers at "Si Wi Yah: Sartorial Representations of the African Diaspora," "Globalising Men's Style," and "Invisible Men" conferences, respectively; and to Theodora Thomadaki of Roehampton University and Vicki Karaminas of Massey University for inviting me to give Keynote papers at the "New Reflections on Fashioning Identities: Lifestyle, Emotions and Celebrity Culture" symposium and "Millennial Masculinities: Queers, Pimp Daddies and Lumbersexuals" conference. Presenting at these conferences and work in progress sessions at both the London College of Fashion and Winchester School of Art, University of Southampton

and receiving constructive feedback from attendees all helped in formulating and coalescing ideas and plans for this book.

Writing can be a long process and I am indebted to those who have been there to support me. To Paul Bench, Adam Briggs, Fenella Hitchcock, Valentina Cardo and, particularly, Pamela Church Gibson for reading draft chapters and offering invaluable feedback and suggestions that made this a more cohesive text. Also, thanks go to colleagues at both London College of Fashion and Winchester School of Art (particularly Joanne Roberts and Jo Turney), friends—especially Ray Weller and John Green—and family and who have all been so supportive. Latterly, I want to thank my dad (who sadly passed away late in the writing process) and mum for always being supportive of everything I do. And finally, as ever, to my husband Andrew—Falala Lalala La La La!

PREFACE

While, historically, texts on men's fashion have noted that gay men have a particular interest in fashion and appearance, this had not been dealt with in any serious detailed manner until my 2000 book *Don We Now Our Gay Apparel: Gay Men's Dress in the Twentieth Century*. This text investigated and demonstrated the ways in which gay men used clothing and their choices of certain garments or combinations of garments to make a statement about their sexuality and negotiate their identities as gay men. Thematically it addressed class, masculinity, effeminacy, signifiers and codes, cross dressing, visibility and invisibility, subcultures and subcultural interaction, gay liberation, the body, swimwear and underwear, public presentation and nightclubs, and private spaces. Subsequently, more research has specifically addressed gay men, fashion and style, as well as styled appearance as part of a broader examination of sexual identities and behaviors.

My own research has continued to explore aspects of gay men's style and builds upon the arguments proposed in *Don We Now Our Gay Apparel*, furthering these in relation to hypermasculinity (Cole 2008), negotiations of masculinity and femininity (Cole 2015), hair (Cole 2009), representation of young gay men (Cole 2012), archetypes in pornography (Cole 2014), and the intersection of race and sexuality (Cole 2019). However, gay men's dress and style remains an area that is relatively under-researched, particularly from the perspective of intersectionality and multiple-subject positions, but there have been other significant texts including Geczy and Karaminas (2013), Steele (2013), and others included in the bibliography for this book.

While *Don We Now Our Gay Apparel* (2000) dealt with issues of the intersections between race, ethnicity, and sexual orientation, the material was mainly drawn from printed primary or secondary sources, and the majority of the men I interviewed were white and British. These men had also primarily discussed their dress choices in the earlier parts of their lives and these factors led me to want to provide a fuller intersectional approach to gay men's dress choices in the twenty-first century. *Gay Men's Style: Fashion, Dress and Sexuality in the 21st Century* offers insights into gay men's "style-fashion-dress" (Tulloch 2010) at the beginning of the new millennium. It addresses the way in which gay men in the western world/globalized north use their dressed appearance in relation to their multiple subject positions within contemporary society. The globalization of gay and queer culture(s) has been the focus of prior research (e.g., Altman 1997, 2001; Boellstroff 2005, 2007; Fortier 2002) and, while this book attempts to provide a consideration of gay men's dress within a globalized world, it focuses upon the experiences of men living in the United States, the United Kingdom, Australia, and Japan. This is neither to ignore nor negate the lives and dress practices of gay men outside of these countries but to give a realizable focus for the research. Gay lives, experiences, and identities outside these countries are addressed through the voiced experiences of gay men's various cultural backgrounds and their migration to the countries that provide the focus of this book.

INTRODUCTION

The very idea of a gay identity has been examined and problematized in the late twentieth and early twenty-first centuries. Writers such as David Halperin (2012) propose that being "gay" is a nebulous zone of a far greater spectrum of non-heteronormative inclinations. Others, such as Edmund White (2012), disagree, proposing gay identity as one of "effect" wrought by heteronormative power play. Such theoretical debates set the scene in which contemporary gay identities, fashion, and style operate. Today gay men in the globalized north and the west have a complex relationship with style, fashion, and dress, offering wider possibilities than those allowed by restrictive cultures and societies historically. *Gay Men's Style: Fashion, Dress and Sexuality in the 21st Century* takes the idea that to be gay is about both sexuality and culture. Halperin (2012: 13) notes that "homosexuality itself, even as an erotic orientation, even as a specifically sexual subjectivity, consists in a dissident way of feeling and relating to the world" and this has an impact upon the ways in which gay men consider their subjectivity and their dressed appearance.

The twenty-first century has seen much progression in terms of LGBTQ+ rights and equality in the westernized world, contrasting with social and moral repression and laws forbidding same-sex practices and LGBTQ+ identities in other, developing, countries. There are marked differences between the predominantly accepting attitudes within western democratic societies and the restrictions operating under more autocratic regimes. Social, cultural, and political factors that had both positive and negative impacts are key to understanding gay men's style choices. Positive changes include the introduction of same-sex marriage, changes to equal rights based on sexual orientation, and the consideration of intersectional identities in the light of the Black Lives Matter movement. It is also important to consider the negative impact all these changes have had on the ongoing struggles against homophobia, expressed in events such as the Orlando Pulse nightclub shooting, the rise of the right and Trump's populism, and the increase in homophobic, racial, and xenophobic violence in autocratic states and, for example, in Britain following the Brexit vote (Stonewall 2017). Amin Ghazi notes what he calls "performative progressiveness [that is] performing a liberal sensibility without the backing of action" where there was support for gay rights "in theory" relating to "formal rights, hospital visitation, inheritance rights," but there was still discomfort in supporting rights "such as the freedom to express affection in public places by sharing a kiss or holding hands" (cited in Abraham 2019: 108).

Gay Men's Style addresses the similarities and differences in gay men's style and fashion in the first decades of the new millennium. It moves away from a universal idea of gay men's sexuality operating as a primary subject position in their lives and dress choices to offer a broader intersectional approach to understanding the role of clothing in the lives of gay men since 2000. Gay men, those interviewed for and quoted in this book, as well as more broadly, do not operate in a vacuum in terms of their dress and style. Both their own and others' attitudes toward race and ethnicity, sex and gender, and the constructions of the masculine and feminine have all had an impact upon gay men's dress choice. However, even in an age

when gay men are afforded the same rights as heterosexual people in many contexts and situations, there are still instances in which sexuality impacts in specific ways on gay individuals, particularly in intersectional areas such as racism and effeminophobia or in relation to matters such as internalized shame (Halberstam 2005a, Halperin and Traub 2009, Todd 2016). Clothing and dress, if not necessarily style, is for the gay men interviewed for this book about both the individual and the collective, where a pendulum swings between these two depending upon other contextual concerns and influences. There is a "need to see individual and collective identities as mutually shaping each other" as individuals "contribute to the formation of collective identities" and gay men both reject and adopt aspects of collective identities that are present around them and of which they may be a part (Cooper 2013: 116–117).

The twenty-first century has also seen an enormous growth in men's interest in, and consumption of, fashion, style, and personal appearance. This is reflected in the value of the men's clothing market, that reached 385.55 billion GBP or 483 billion US Dollars in 2018.[1] John Clarke, Janet Newman, Nick Smith, Elizabeth Vidler, and Louise Westmarland (2007) stress that citizens were recast as consumers under neoliberalism in the late twentieth century. Thus, the rise of neoliberalism was coupled with a rise in both media and consumer cultures, where the "ideal neoliberal subject is the entrepreneurial self" (Hakim 2020: 61). In relation to both celebratory queer politics and consumption, as well as through global communications via the internet, Bev Skeggs also notes that the "global gay discourse represents Western gay men as a cipher for hyper-mobile, affluent and privileged consumers" (Skeggs 2004: 160), aligning with Brewis and Jack's suggestion that the thesis of the "pink" economy which emphasizes visual aspects of consumption, such as "dress, speech, fashion and style, bodily rituals and habits," creates what they call "hegemonic homosexuality" (Brewis and Jack 2010: 254).

In the twenty-first century, LGBTQ+ communities are partly structured by online activity and connections, mediated through blogs, social media, and dating/hook up websites or applications (apps). Popular apps include Grindr, Tindr, and Scruff. In relation to gay men, Tim Blanks noted that "the notion of community used to be absolute. The internet presents a different sense of immediacy. Your desire is now more important than your style" (cited in Flynn 2017). In the past, personal ads in mainstream and specialist publications offered opportunities for gay men to make contact alongside physical spaces of clubs and bars. The advent of the internet and chatrooms such as AOL [America Online], followed by social media sites such as Facebook and dating and hook-up apps such as Grindr, changed the ways in which people established connections (Alvear 1999, Thomas 2011). Sharif Mowlabocus highlighted a "symbiotic" relationship between the virtual world of apps and physical scene space, whereby the former could lead to meetings in the latter (Mowlabocus 2010). The rise in e-commerce in the twentieth century has also impacted upon the ways in which people engage in consumption practices. The role of the internet and online connections is important to this book in the ways in which gay men interact and situate their identities and relationships with dressed appearance.

Gay Men's Style addresses both place and space as important in gay men's dress choices. The home, workplace, and venues on the gay scene each impacted upon the ways in which gay men reflexively chose and used their clothing, in relation to their individual and collective ideas and ideals of self. For gay men, style-fashion-dress (Tulloch 2010) can operate as a "contested site where agency and structure collide" (Cooper 2013: 101) in practices of both fitting in and standing out, both amongst other gay men and in broader heteronormative society. The ideas of the well-dressed gay man and that all gay men are overly interested in shopping and their clothing could be considered stereotypical, based upon historic perceptions of gay men (Cole 2000, Geczy and Karaminas 2013). Indeed, Halperin asks: "What does male homosexuality have to do with dancing, or cooking, or the music you like, or the car you drive,

or the clothes you wear, or your attachment to period design? Are these just stereotypes about gay men?" (Halperin 2012: 14). Stereotypes often serve a purpose and "are reflexively and ironically acknowledged among gay men in order to neutralize their potentially damning social consequences" (Kates 2002: 395). Thus, the stereotype is acknowledged as an explicit role that can be assumed or discarded at will (Kates 2002: 395). While many stereotypes of gay men, such as those noted above and those that associate all gay men with effeminacy, have been challenged, they also give rise to new forms of prejudice from both within and outside LGBTQ+ communities, for example the demonization of effeminacy through femmephobia.

Identities, subject positions, and intersectionality

Although *Gay Men's Style* takes as its focus gay men, it is a central tenet of the book to understand the ways in which sexuality operates as just one of a number of subject positions, alongside race, ethnicity, age, dis/ability, class, and occupation, in the formation and position of the self and in influencing and impacting on gay men's style-fashion-dress in the twenty-first century. A key approach and contribution of this research is in addressing the intersectionality in the lives and dress choices of the men interviewed for and cited in the book. Relevant to my research approach was Susan Kaiser's observation that "Intersecting, embodied subject positions are not just about *who* we are becoming; they are also about *when* and *where* we are becoming" (Kaiser 2012: 172, emphasis in original). Intersectionality is not just a "hierarchical list of what counts" but a means of addressing "*both* sameness *and* difference" (Cooper 2013: 36). In discussing intersectionality, Patricia Hill Collins and Sirma Bilge note how "individuals can be seen as having multiple 'subjectivities' that they construct from one situation to the next" and that the "major axes of social divisions" noted above "operate not as discrete and mutually exclusive entities, but build on each other and work together" (Hill Collins and Bilge 2016: 124, 4). One of the key areas that this book explores is the ways in which gay men in the westernized world negotiate various subject positions, the intersection of these subject positions, and how they present these through dress choice, fitting with the ways in which intersectional scholarship has explored "the collective influence of various identity categories on a person's daily life" (Huang and Fang 2019: 28).

The concepts of identity, subject positions, and the "self" in relation to dress choice also underpin the discussions in this book. The coming together of a variety of subject positions and subjectivities creates not one identity for an individual but a series of co-existent identities (Kaiser 2012), that are "made up out of partial fragments" that "can be seen as either historical or constitutive" (Grossberg 1996: 91), changing within different contexts. For Halperin, gay men's identity "affirms itself not only through *identity*, an experience of sameness with other gay men like oneself, but also through *identification*, the feeling of closeness to, or affinity with, *other people*, with anything and everything that is not oneself" (Halperin 2012: 122). The self can be "reflexively understood by the person in terms of his or her biography" (Giddens 1991: 53) and thus be both embodied and gendered as well as being seen in the light of the intersection of various subject positions and through the use of clothing and dress. The idea of the self as expressed through clothing choices flows through the interviews with gay men cited throughout the chapters of *Gay Men's Style*. Joanne Finkelstein proposed that "fashioning the body becomes a practice through which the individual can fashion a self" (Finkelstein 1998: 50), a sentiment echoed by Wayne Brekhus who observes that "that different 'types' of gay men had conflicting ideas about how to organize their 'gayness' in relation to their overall 'presentation of self' and that this conflict seemed to have

important implications for a more general theory of social identity" (Brekhus 2003: 4). Brekhus's three types—gay lifestylers or *Peacocks,* gay commuters or *Chameleons*, and gay integrators or *Centaurs*— are complemented by Cooper's "fortress," coherent and "solid," identity and "sticky" identity that represents "individuals in trying to fit together different aspects of their identities" as "part of the challenging project of identity work" (Cooper 2013: 49, 10). For Kenji Yoshino, "covering"—a concept borrowed from Erving Goffman—is different from "passing"[2] in that it is not about deception or denial but relates to the acknowledgment and downplaying of "stigmatized" (Halperin 2012: 473). Marcus Hunter (2010) explored a similar idea in his three models for the ways in which gay men expressed their "self" by variously "compartmentalizing, de-emphasizing, or de-prioritizing" aspects of their identities. In the first, sexuality and race are united or "interlocking." Despite not referencing Erving Goffman's work, Hunter's models resonate with Goffman's (1959) social interaction theory that outlines differentials and negotiations undertaken by individuals between the public and private. Rather than identify different types or models, Shaun Filiault and Murray Drummond suggest the possession of "three sets of clothing: clothes for home, clothes for the straight/mainstream world, and clothes for the gay world" (Filiault and Drummond 2009: 180), aligning with ideas about the use of fashion and dress, in a less regimented manner, discussed throughout *Gay Men's Style.*

Defining style, fashion, and dress

The title of this book intentionally uses the term *style*, one often invoked in discussing men and their clothing, as opposed to *fashion* which historically has had a femininized context (Wilson 1985, Edwards 1997, Entwistle 2000, Tseëlon 2001, Reilly and Cosbey 2008, McNeil and Karaminas 2009). Alfred Gell (1998: 157) describes style as "personhood in aesthetic form," while "in the context of fashion," style "is often associated with personal identity – rather than a mainstream trend adopted by the majority" and "can also operate as collective identity" (Berry 2010: 52). Halperin identifies "the importance gay male culture places on style – its characteristic tendency to accord value to any coherent expression of a historically specific system of taste" (Halperin 2012: 315) and that "style is saturated with meaning" so that liking particular styles reveals much about personal "sexual and gendered identity" (Halperin 2012: 357), further emphasizing the use of the term in this book's title and focus.

Style subtly but significantly differs from both *fashion* and *dress*. Noting that the terms dress, fashion, clothing, and adornment have been used interchangeably, Joanne Eicher and Mary Roach-Higgins have specified that the term dress includes not just clothing but also more broadly modifications and supplements of, and to, the clothed or unclothed body (Roach-Higgins and Eicher 1992, 1995). The embodied practices of dress, which Roach-Higgins and Eicher (1992, 1995) have related not just to clothing but to supplements and modifications to the body, are central to *Gay Men's Style*. *Dress*, then, perhaps describes more fully the multitude of ways gay men use items of clothing and accessories, as well as their bodies, better than *fashion.* In turn, fashion can be understood as the place of clothing within a "system" (Barthes 1983, Vinken 2005, Kawamura 2005) closely associated with newness and rapid change (Lipovetsky 1994, Wilson 1985) but can also be a social process or a material object. In their study of everyday fashion, Cheryl Buckley and Hazel Clark have noted that clothing can "reveal an ongoing engagement with fashion on a scale from extraordinary through to ordinary" (Buckley and Clark 2017: 7). *Gay Men's Style*, then, looks at the ways in which gay men negotiate the use of clothing and dress items, influenced by both "fashion" and personal style.

Methodological approaches

For this book, I undertook seventy-seven in-depth semi-structured (predominantly one-on-one) interviews,[3] five email interviews, and five focus groups, with twenty participants, conducted with a broad cross-section of gay men in Britain, America, Australia, and Japan over a six-yea period (between 2012 and 2018).[4] I endeavored to interview men from a broad range of age groups (19–69), social classes, and ethnic and cultural backgrounds, despite living, at the time of their interviews, in the UK, USA, Australia, or Japan. My interviewees were found in a variety of ways: some through advertisements put out by voluntary organizations in Australia, some through contacts made during another research project in Miami, some were friends and acquaintances of work colleagues and ex-students who were recommended, while still others I met giving talks or lectures on the subject. Here, various social networks were tapped into with a "gatekeeper" making introductions to other gay male friends and acquaintances. In many instances, the first connection led to a series of subsequent contacts in a snowballing method (Browne 2005, Patton 2002). There is an inevitability that the men who responded and agreed to be interviewed were particularly interested in clothing and dressed appearance.[5] The initial set of interviews conducted in 2012 in London, New York, and Philadelphia were primarily for a chapter on gay men's dress for the exhibition catalog of *Queer History of Fashion* held at the Museum of Fashion Institute of Technology in New York. These interviewees were aware of my intention to write a book and agreed to their interviews being included in *Gay Men's Style*. In accordance with institutional guidelines, all interviewees were asked to sign consent forms, which also provided an outline of the research project. All interviewees were happy for their interviews to be used for this book and a small number requested that they view and approve their quotes prior to publication, a process that was followed.

All interviewees were cis-gendered male, openly gay, and happy to discuss their sexual orientation, gender, fashion, style, and dressed appearance. I consider this in the context of Sophie Woodward's statement that "clothing is the locus for multiple social and personal identities" (2007: 3). While all interviewees were comfortable using the term "gay" as a self-descriptor, in keeping with the title of this book, a number, particularly younger interviewees, preferred to use the term "queer"; fitting with Eve Kosofsky Sedgwick's definition of queer as "the open mesh of possibilities, gaps, overlaps, dissonances and resonances, lapses and excesses of meaning when the constituent elements of anyone's gender, of anyone's sexuality aren't made (or *can't be* made) to signify monolithically" (Sedgwick 1993a: 8; see also Geczy and Karaminas 2013). For some of the older men interviewed, the term "queer" had negative associations as a form of insult. There was an agreement amongst my interviewees that being gay was not purely about sexuality but had a cultural and historical connection and connotation that echoed David Halperin's (2012) extended discussion of innate knowledge, social experience, and identification. One interviewee, in their early twenties, asked to be referred to by gender neutral pronouns of they/them/their. This reflected the flexibility that younger interviewees showed around the intersections of sexuality and gender. These uses of pronouns and terminology fitted with ideas that historically gay men identified their sexual attraction and their sexual gender identities as the same thing, but that these have come to be expressed as different aspects of identity or subject position.

Although the interviews were guided by specific questions, many progressed in "a conversational manner" (Miles and Huberman 1994), focusing upon areas that were important and relevant to the individual or pair of individuals being interviewed. The interviews were what could be described as "cultural" (Rubin and Rubin 2012) as they covered a broad range of topics that situated sexuality and other intersectional subject positions and style-fashion-dress within broader cultural contexts. Focus

groups were conducted as a time efficient way of gathering information from a group of gay men during a short research trip to Miami in 2015 (Smithson 2007). While similar questioning led the five focus groups, the value was in acquiring "high-quality data in a social context where people can consider their own views in the context of the views of others" (Patton 2002: 386). During the interviews and focus groups, I posed questions around the individual's own relationship with clothing and dressed appearance in relation to their sexuality. I also asked about how subject positions such as age, race, ethnicity, and social class intersected with sexuality, as well as more broadly about gay style, gay men, fashion, and the impact of changing approaches to gay men and style-fashion-dress.

Both Sophie Woodward (2007) and Amy Tooth Murphy (2020) discuss the idea of being an "insider," when conducting interviews. Significant to my research, Tooth Murphy highlighted that "in the case of LGBTQ oral histories, the perception of this shared identity is invaluable in overcoming many other social and cultural differences, placing the emphasis on mutual understanding of the issues faced as members of marginalized and historically oppressed group[s]" (Tooth Murphy 2020: 37). The "maxim 'no intimacy without reciprocity'" (Tooth Murphy 2020: 37) and my own "insider" or "emic" (Pike 1967) status as a gay man meant that my experiences as a gay man and researcher around gay men's style-fashion-dress and its place in both gay and broader cultures offered a form of reciprocity with my interviewees. In comparison to being an insider, an interviewer/researcher's position as "outsider" (Tooth Murphy 2020, Kong 2011) or "etic" (Pike 1967) should also be considered and my own "outsider" status became apparent particularly in relation to matters of race, ethnicity, age, and, sometimes, occupation. Tooth Murphy also cautions against "assuming sameness, common ground and shared experience" (2020: 39) or as Valerie Yow has noted, of being aware of being "too much invested in the topic, too closely identifying with a person or cause" (Yow 1997: 76). Lynn Abrams (cited in Butler 2020) and Peter Robinson (2008) identify the importance of narrative and its co-construction during the interview process, something that offered challenges when combining multiple personal narratives into a cohesive book.

Although it is now more common within oral history to talk about the "narrator" rather than interviewee (see for example Gluck 2013), I have used the latter term as my interviews were informed by oral history methods but do not stick rigidly to such processes and so align with other ethnographic or qualitative methods of interviewing. Accounts of ethnographic and oral history interviewing have highlighted concerns about memory and subjectivity of related experiences and encourage interviewers to triangulate facts and memories with other sources (Thompson 1998, Personal Narratives Group 1989, Hinchman and Hinchman 2001, Perks and Thompson 2006, Hunter 2010). Daniel Miller and Sophie Woodward (2012: 15) state that "an ethnography always has to be circumspect about the further process of generalization" and as such *Gay Men's Style* does not attempt to generalize, but to draw upon my interviewees' experiences and narratives to identify common and differing practices across the variety of intersectional identities, subject positions, and experiences of these men. The way in which the chapters are structured using a large number of comparative quotes from my interviews was to allow the voices of my participants to be heard in telling their stories and recounting their experiences and feelings regarding gay men's style-fashion-dress and connected to Peter Robinson's identification of "narrative identity" that "suggest[s] our identity is narratively constituted, that is, that we are who we are because of the stories we tell about ourselves" (Robinson 2008: 2).

All focus groups and interviews (except five that were conducted by email in 2012) were digitally recorded, with the interviewees' permission, and transcribed. I personally transcribed the interviews from 2012 and those conducted between 2015 and 2018 were transcribed by professional transcription services. Transcripts were checked against the recordings for accuracy and a process of coding and thematic

analysis (Glaser and Strauss, 1967, Braun and Clarke 2006) was employed that allowed "patterns, themes, and eventually theoretical propositions" (Schofield-Tomschin and Littrell 2001: 45) to emerge. I followed Michael Drummond's lead, when coding, using "rich descriptive data from the participants . . . as a means of embodying and being representative of" themes and ideas around gay men's use of style-fashion-dress (Drummond 2005b: 276); these formed the basis of the chapters and subsections of chapters of this book.

Throughout the book the men interviewed are cited by their real first names only; a decision that perhaps goes against academic conventions for anonymizing participants but that was agreed to by all participants.[6] In approaching a subject such as gay men's identities and subject positions in relation to dress choices, I chose to use my interviewees real names in a spirit of openly addressing what had previously been considered a hidden history, to give clear voices to self-identified "out" gay men on such identity-related practices. At first mention of each interviewee, there is provision for their age (at the time of interview), ethnicity, nationality, and occupation as a means of situating their differences and commonalities. These are also included in the appendix. By listing such *characteristics*, I do not intend to "categorize" each interviewee but rather, following Sophie Woodward (2007), this contextual information was important in understanding clothing choices.

Chapter arrangement

The first chapter of *Gay Men's Style* examines the ways in which gay men might dress differently to straight men and whether it is possible to tell a gay man by his clothing choices. It investigates concepts of capital invoked by Bourdieu, and subsequently developed by others, to situate a variety of influences on gay men's appearance. This chapter provides an overview of what the men interviewed for this book felt defined "gay men's style," asks whether there is a stereotyped way of dressing for gay men in the twenty-first century, and explores a blurred boundary in the emergence of hipster and metrosexual identities, scene-setting for the following chapters.

Building on concepts of embodiment, performativity (Butler 1990, 1993), and ideas of gendered bodies, the first part of Chapter 2 investigates the binarism of gender and how this is negotiated by gay men. The chapter then considers the intersection of gender and sexuality manifested in dress practices, and addresses ways in which the gay men articulated understanding of the binaries of gender and a breaking down of such binaries through behavior and dressed appearance. Chapter 3 addresses how my interviewees discussed their own bodies and how they chose to dress or modify those bodies, in relation to somatic or body types and regimes. It also addresses the ways in which gay men present their bodies on various social media and internet sites and applications. In relation to bodies, the descriptions of tattoos that were provided by my interviewees were not just those acquired in the new millennium but in the building of a "collection" (Vail 1999) across various stages through these gay men's lives.

The relevance of "coming out" in gay men's lives and in constructing identities is examined in Chapter 4. It explores how coming to terms with sexual identity intersects with the other aspects of gay men's lives and affects how they might change their appearances and dress styles, within the context of a broader intersectional consideration of how sexual orientation perhaps takes a primary role during these life stages. Although all my interviewees discussed their personal coming out experiences, this chapter focuses on those who have been through this process since 2000. The chapter addresses the teenage adoption of punk, goth, and emo styles by a few interviewees as a strategy for self-understanding, negotiating their adolescence and coming to terms with their sexual orientation.

Chapter 5 addresses the ways in which the men I interviewed described the gay venues they frequented and the choice of clothes they wore to them or observed other gay men wearing. It pays attention to the idea of the gay scene as a "safe space" or sites for specific dress style choices. This chapter is not a comprehensive historical overview of the scenes and venues in the cities discussed but focuses on and compares gay scenes in a variety of cities and the dress choices of gay men within the places and spaces identified in the interviews. This demonstrates how these men understood the relationship between dressed appearance and the commercialized or alternative physical gay spaces in specified cities. Drawing on interviewee comments, this chapter will also highlight the decline in the number and variety of physical gay nightlife spaces and how the closure of LGBTQ+ bars and clubs, and the rise of internet-based communication and networks, has impacted upon gay men's dress choices by shifting emphasis to body display.

Chapter 6 begins by looking at the ways gay men dress to attract partners. Historically, gay men have used dress as a tool for attracting sexual and romantic partners (Chauncey 1994, Cole 2000, Geczy and Karaminas 2013, Houlbrook 2006, Norton 1992). Acknowledging this, Andrew Reilly highlighted the fact that theories of shifting erogenous zones invoked in relation to fashion "did not address same-sex relationships where presumably eroticism and dress were functions of attraction" (Reilly 2014: 213). Redressing this omission, this chapter explores the significance of sexual and erotic capital (Martin and George 2006, Hakim 2010) and how sexual attraction functions through dressed appearance and forms an important consideration in the construction of gay men's style. This chapter also considers how, once in relationships, gay men negotiate their style of dress with their partners, sharing common wardrobes and styles, shopping together, and giving clothing as gifts.

Chapter 7 considers the variety of ways in which gay men create their personal collections of clothes or wardrobe. It covers the ways in which gay men have described building their wardrobe or collection of clothes and how they might pull together particular outfits or ensembles of smart, casual, or sportswear garments based on different occasions and contexts. It finishes by considering how certain regulatory dress codes impact upon the way they dress and understand their own place in the world.

Drawing on John Clammer's assertion that "shopping is not merely the acquisition of things: it is the buying of identity" (Clammer 1992: 195), Chapter 8 explores gay men's relationship to shopping for clothes. It sets out to understand why my interviewees chose to shop in specific locations and the ways these choices impacted the relationship between their dressed appearance and identities. The chapter also draws comparisons between practices and choices across age groups and countries. It explores preferred shops and brands and how this might link to ideas of fashionability, currency, and comfort in both physical shops and online. It considers the "sites" of consumption, comparing the physical store with buying online and, in deliberately following or rejecting trends, discusses a preference, for some men, for purchasing second-hand clothing and vintage garments.

Returning to consideration of particular physical spaces, Chapter 9 addresses the ways in which gay men choose to dress for work, reflecting on different occupations and considerations that were taken into account. Many of the men interviewed worked in fashion-related careers, as well as more broadly in the arts or creative industries and within what Richard Florida (2014) terms the "Creative Class." As these sectors have traditionally been especially welcoming of gay men, and historically have offered relatively safe spaces in which gay men could be out, this was reflected in dress choices and within the discussions in this chapter. Those not working within the creative industries worked variously in education, human resources, banking and finance, information technology, retail, hospitality, and in marketing and public relations. This chapter addresses the ways in which for the men in less creative careers, sexuality was

often not an issue and how they considered their clothing choices in relation to the conventions of the sector, the decisions made by work hierarchies and whether their role was public facing or more privately located.

Chapter 10 explores how my interviewees discussed ideas of "comfort," both in the physical and emotional sense, in relation to the fit of their clothes on their bodies. Accordingly, "fitting in" is related in an emotional sense to embodied appearance and the chapter builds on the discussions in Chapter 4 about how gay men dress to fit in with the gay scene after coming out. This chapter addresses the ways in which gay men understand and feel about both the psychological aspects of the concept of comfort. It also addresses the physical, in relation to two of the three aspects of fit identified by Daniel Miller and Sophie Woodward: on the body and in fashion (Miller and Woodward 2011) and how the physical and psychological ideas of fit and fitting in relates to perceptions of comfort.

The penultimate chapter examines the way in which my interviewees viewed concepts of age and ageing in relation to their dress choices; it considers how awareness of age affects choices, particularly of "fashionable" clothing, how feeling too old and judged by others impacted upon their decision, either to "conform" to popular ideas of appropriate styles or to buck these constraints in favor of a more individual age-defying style. The concluding chapter summarizes the major ideas raised in this introduction and throughout the book and offers thoughts on further development of studies of gay men's style-fashion-dress.

Notes

1 The date was selected as it was when the interviews for this book ended. The figures for 2022 were 499.80 bn US dollars or 373.10 bn GBP (Statista, n.d).

2 This term also is employed by Martin Levine (1998) in relation to gay men's identity and dress practices—see also Levine usage in discussion in Cole 2000.

3 Seven interviews were conducted with couples.

4 2012 London and USA—ten face-to-face plus five email; 2015 Australia "four week research trip"—thirty-five men interviewed plus three in Japan; 2015 Miami—twenty participants in five focus groups; 2017–18 London—twenty-nine men interviewed.

5 Given the traditionally gendered associations with "fashion" this was a word I avoided in my calls for participants and on first contact, in order not to put off anyone who was interested in their appearance but not in "fashion."

6 One interviewee asked to be referred to by a pseudonym that was chosen by him.

1

WHAT'S THE DIFFERENCE?: SITUATING GAY MEN IN THE NEW MILLENNIUM

"Would a straight man wear a Marc Jacobs floral print shirt, white jeans and lime green SeaVees?" asked 34-year-old white American writer, Lee. "Perhaps," he continued. "But when I wear all that, it's definitely a gay look" (see Color Plate 1). One of the major questions in investigating gay men's dress choices in the new millennium is about difference. Is there a difference between the way gay and straight men dress? Is it possible to tell the difference between a gay and a straight man by his clothing, and does it matter? While this book goes on to look in detail at the ways in which a group of men interviewed over a six-year period describe their clothing choices, it is relevant here to explore what was said in relation to these questions. Tristan Bridges discusses ways in which straight men borrow elements from gay culture, in order to "discursively [frame] themselves as 'gay'" (Bridges 2018: 378). This contrasts with Connell's (2005 [1995]) proposition of "very straight gay" men that explored contradictions around subject position and the relationship between sex and gender and social and cultural understandings of gay men's presentations of "masculine" identities (see also Cole 2000, Levine 1998, Nardi 2000).

"How to spot a millennial homo"[1]: differences in gay and straight men's dress

The idea of being able to tell or spot another gay person is often referred to as "gaydar," which Chris Tan identified as "educated and trained ways of looking" and "knowing how to be looked at by effecting the correct dress and demeanor" that can "vary across such vectors of difference as space, time, class, cis status, and especially gender (as men and women are socialized differently as gendered beings)" (Tan 2016: 859). Robert, a 61-year-old white Australian stylist and make-up artist, stated that "it's really hard to pick out the gay boys from the straight boys now, because they've all got on the same clothes." Similarly, Remi, a 27-year-old white French retail assistant, noted that "there is not that much difference anymore I feel, like between straight and gay men," and 27-year-old white Scottish hairdresser Barry argued that "you can't tell the difference now at all." These same sentiments were echoed by American respondents, with Adriann, a 26-year-old Mexican American artist, believing there was a conscious blurring of the lines of demarcation. Sean, a 29-year-old white American operations manager, saw similarities as a reflection of changing social and legal conditions: "because of our equal movement, right for equal marriage . . . the younger generation's wanting to be more homogenous, whereas I feel in the

'90s there was emphasis on being different than the straight males." Guy, a 40-year-old white British hotel manager living in Miami, also felt that younger men were not so concerned about identifying as gay or straight, reflecting attitudes identified in the propositions of "inclusive" and "hybrid" masculinities and the decline of "homohysteria" (Anderson 2009, 2018; McCormack 2012), with the latter "blurring gender differences and boundaries" (Bridges 2018: 379).

Perhaps contradicting Sean, in his discussion of "Dress Codes" in the 1990s Michael Bracewell argued that "the codes have become confused, and . . . There is no longer any 'us and them,' in fashion terms; what remains are more simple notions of style which adapt to the sexuality of the individual" (Bracewell 1993: 41). Joe M, a 49-year-old Cuban interior designer, concurred with Bracewell in noting that "it's like, okay, we're like everybody else. We don't need to be different." While Bracewell is right in stating that there has been a breakdown of the gay and non-gay "us and them," fashion and dress choice are still used by many to differentiate themselves, sometimes as individuals, sometimes as members of a group, and sometimes as both (Simmel 1957). Bridges employs the concept of "sexual aesthetics," which he describes as "cultural and stylistic distinctions used to delineate boundaries between gay and straight cultures and individuals" (Bridges 2018: 378). He identifies three elements of sexual aesthetics: as "tastes," which could include clothing; as "behavioural," relating to speech and body comportment; and "ideological" (Bridges 2018: 383). Bridges also notes that "having the 'right' sexual aesthetics is often part of framing oneself as *authentically* gay" (Bridges 2018: 382).

Nick, a 28-year-old white American artist, believed "fashion is a very personal thing and a lot more gay men than straight men are conscious of what they wear . . . I think because gay men are concerned with how they look, because we already feel like we are different." Nick's statement echoes Dennis Altman's belief that whether people are "born" disposed to homosexuality, "the adoption of a homosexual identity involves a series of choices" (Altman 1982: 156), which also relate to the importance of notions of intersectionality, introduced earlier and highlighted throughout this book. Several men recalled their conscious decision about whether to have left or right ears pierced. Remi particularly chose to have his "left one . . . so [it's] easy for people to know that I'm gay" and this was enhanced "when I open my mouth, people can guess probably that I'm gay." Jun, a 26-year-old Malaysian-Singaporean fashion photography student, also had his left ear pierced but noted that this was because in Asian culture boys had their left and girls both ears pierced. Having been told by fellow students that he did not seem to be the sort of person to have his ear pierced, 19-year-old white British tailoring apprentice Taylor had his done and when he asked the piercer about the meanings related to a particular side was told "it doesn't really matter anymore."

"It is the tiny little details . . . mannerisms or grooming" that Taylor saw as the differences between gay and straight men's dress choices. For Lee, this difference was down to "a sensitivity to the look, a thoughtfulness, a just too-well-put-togetherness" and this was echoed by black gay British filmmaker Rikki: "The difference is in the details. It's a knowingness of how to put together and those little camp touches that a straight boy wouldn't think of" (cited in Cole 2019). Reiterating ideas about detail, 50-year-old white Venezuelan designer Luis questioned whether this is a "gay thing" or more related to other aspects of his subject positions: "People who always told me, well you dress like a gay man because you are so focused on the details, but the details have nothing to do with that, if you're an architect, if you're a designer . . . you focus on details . . . But not because it's a gay thing." What is identified here is that looking gay is not necessarily just about the choice of clothing, but the ways in which those clothes are styled and the contexts in which those clothes are styled and worn.

Well-dressed gay men—a stereotype

For both Lee and Taylor, the sexual orientation aspect of their individual subject position is important in identifying individual gay style. Perhaps what Lee alludes to here is the "myth" that all gay men are well dressed. Diego, a 26-year-old Peruvian operations manager living in Miami, particularly felt this pressure: "that I have to dress well . . . I feel like if I'm not dressed to the nines, everyone's judging me and being, 'Oh well, he's the gay guy here. He's not dressed up. What's wrong with him?'" Similarly reflecting on this, Matt, a 33-year-old white British accountant, recalled that "people have said to me before, 'Oh, you know, you're not that kind of gay that dresses well,' and I'm like, 'Yeah, I guess I'm not.'" Bryan, a 36-year-old Melbourne-based Malaysian architect, believed that being gay, he got to "see more things, see more fashion" and "the way you observe . . . what people are wearing through the social norms [and] places" helped him make clothing decisions.

Johnny, a 31-year-old white British designer living in Melbourne, admits that the well-dressed gay man is a stereotype, that it is popularly perceived that, "a gay look is someone who's incredibly well presented . . . wearing the Ralph Lauren polo shirt tucked into the chinos with boat shoes and they have manicured fingernails and they have perfectly coiffed hair and stuff like that." While Johnny identified a particular casual style, this reflects Taylor's and Rikki's emphasis on the detail, the specific combinations and the way in which these are styled that constitute the "gayness" of the "look." In his observation of the idea of the well-dressed gay man, Benjamin, a 26-year-old white British make-up artist, noted that, "with the well-dressed gay man . . . I think it's about an attitude. I think you can wear what you want, you just have to be able to pull it off. Be comfortable in it. And look like you're comfortable in it." The notion of comfort in both physical and emotional/psychological senses—the inner and outer self—in dress choice and personal appearance will be explored further in Chapter 10. Drawing on ideas of both "stereotypes" and "attitude," Chip, a 49-year-old white American art director, observed that even when gay and straight men wear the same clothes, gay men, are, he believed "born with a certain style . . . being born different makes you aware of what being different is all about and sensing little differences, that attunes your sensibility." Halperin identifies such feelings as a "queer *subjectivity*" that expressed itself through a "*way of relating* to cultural objects" including clothing and "cultural forms" (Halperin 2012: 12, emphasis in original). In a similar vein, Max Morris (2018: 1195) proposes that certain cultural forms and knowledge of such were "culturally coded as gay." Here, Chip also raises what could be considered controversial notions of essentialism and the relevance and importance of the nature-versus-nurture debate in relation to sexual orientation (Eagly and Wood 2013, Sullivan 1995).

What is gay style?

There was, however, little consensus among my interviewees on what constitutes a gay style or whether dressing in a particular way is indeed "gay style." Eduardo, a 49-year-old Hispanic librarian, noted a studied quality that he believed was apparent in gay male style, that unites gay men, but "not to the point that you basically look like a statue or anything." Perhaps what Eduardo alludes to is the place of stereotypes and/or archetypes of gay male style that have existed in the past and that do persist in certain circumstances, and scenes. For example, an American cartoon by Glen Hanon and Allan Neuwirth, titled "Chelsea and Other Big City Gay Boys" and reproduced in the free UK gay magazine *QX*

in April 2005, featured the Chelsea Boy, the SoBe Boy, the Wehe Boy and Castro Boy; pointing out identifying features of each American urban "type." An article entitled "The Usual Suspects" in the British gay lifestyle magazine *Attitude* in January 2001 identified The Suit, The Muscle Mary, The Scally, The Disco Dolly, and The Trendy as typical "gay types," reflecting archetypes and stereotypes raised in other places and by men interviewed for this book.

Historically, tight-fitting clothing was often associated with homosexuality and this was understood both within gay communities and by outside observers (Cole 2000). This still seems to be the case in the twenty-first century. Erich, a 27-year-old white American nurse, believed that **"**generally how you tell the gay men from straight men up here [in Hell's Kitchen in New York] is because the gay men wear more tight-fitting clothes." This is not just the case in New York, as 32-year-old Polish academic Lucasz recalled of Poland: "I remember when I saw a guy, that was really well dressed up, and having a little bit more tighter clothes, I could easily say this is a gay man." The importance of fit in gay men's clothing will be addressed in more detail in Chapter 10.

Raj, a 35-year-old Indian product manager living in Sydney, recalled how when he was living in Singapore in the early 2000s, he was "not out to the whole world" and was "dressing up as a straight guy . . . t-shirts and trousers or jeans or whatever, sneakers," partly because of his perception that gay men wore "bright orange pants or pink pants and tights." Sixty-year-old white Australian retired air crew, Mark, recalled, "I used to share with this guy . . . and they used to call him a truckie's poof . . . [he] was very conservative, would just wear very daggy clothes and that's the expression, a truckie's poof." Although Mark did not state that his friend identified as "straight-acting," his choice of clothing and Marks' terminology—"daggy" or scruffy and "truckie" as in a truck driver—to describe his style hint towards an adoption of a look that would not be read as gay. Elsewhere I have discussed the idea of the "male impersonator" in the mid-twentieth century as a way of men looking both "masculine" (in a hegemonic or orthodox manner) and "straight" (Cole 2000). British journalist Stewart Who? saw such straight-acting as "veneers of masculinity," as a form of "drag" (Who? 2005: 40), the appropriating of a costume that creates a character, that of a "straight" man. In this respect Who? is acknowledging the way in which hegemonic presentations of heterosexual masculinity impact upon gay men who, in some or all social circumstances, "play" the role of a straight man, distancing themselves from more traditional ideas of how gay men should appear (see also Cole 2008). Krysto, a 48-year-old Greek Australian yoga teacher and café owner, related this to men "not embracing being gay" and just wanting to be "normal," where normal was equated with straight, reinforcing heteronormative attitudes. Patrick, a 24-year-old white Australian performer and retail assistant, further elaborated by declaring "I'm sorry, but if you say you're straight-acting, it means that you believe that you are wrong, it means that you do not believe, you believe that heterosexuality is the normality that you must succumb to and you must become a part of."

Focusing on broader ideas of blurring and "passing," 49-year-old Fort Lauderdale-based Hispanic American librarian, Eduardo, observed the ways in which understanding certain practices or belonging to particular gay communities could lead to "pass[ing] through society more or less invisibly" so that "it's hard to tell in some contexts . . . whether someone is gay or not." The notion of "passing" for gay men was clearly identified by Martin P. Levine (1998) as intentionally dressing and behaving in such a way as to become "invisible" as a gay man, in order to negotiate the wider world under a "disguise" of heterosexuality. While Levine was specifically discussing passing in the context of contextualizing the hypermasculine style of the 1970s clone, certain circumstances in the twenty-first century, such as a homophobic work or other socio-cultural contexts, may mean gay men choose to "pass" and not be immediately identified as gay.

"... made me gay": cultural influences on gay men's dress choices

Joe P, a 56-year-old white British DJ, explained that for him clothes were "important, in the sense [that] for me they can reassert my roots, my history, my beliefs, my likes" as well as being "fun." He further elaborated that he did not come from a "place" or background where "clothes are necessarily social status" but acknowledged the ways in which his choice of garments and combinations into outfits was not necessarily about monetary cost but about different kinds of "status." The ideas Joe P invokes here relate to the forms of capital proposed by Pierre Bourdieu (1984) and the ways these might be related to ideas of "taste." Bourdieu defined capital as a "set of actually usable resources and power" (Bourdieu 1984: 114) that, "in its objectified or embodied forms, takes time to accumulate" and can be seen in "three fundamental guises" (Bourdieu 1986: 241, 242). These "guises" or forms of capital Bourdieu (1984, 1986) identified as: *economic*, the possession of financial wealth; *cultural*, that is accumulated through upbringing and education; *social*, through possessing networks of contacts that can be mobilized to benefit the holder. These can each be adapted into symbolic capital, that "suggests a state of legitimation of other forms of capital, as if other capitals obtain a special symbolic effect when they gain a symbolic recognition that masks their material and interested basis" (Swartz 1997: 92). Bourdieu's concept of capital has been developed and applied by subsequent writers and theorists in a variety of fields, including the notions of subcultural capital (Thornton 1995), sexual capital (Martin and George 2006), erotic capital (Hakim 2010), gender capital (Bridges 2009), ageing capital (Simpson 2015), and fashion capital (Rocamora 2002), that are applied in relation to gay men's dress and style in later chapters of this book. Drawing specifically on the symbolic economy of class, Morris (2018) developed the concept of "gay capital." For Morris, cultural gay capital related to "insider knowledge of gay culture," social gay capital belonged to "exclusively or predominantly" gay social groups, and symbolic gay capital to "having one's gay identity recognized and legitimized as a form of social prestige by others" (Morris 2018: 1199). This connected to the way that Travis Kong employs "'embodied capital' to refer to the possession of economic, social, cultural and symbolic capital by lesbians and gay men" (Kong 2011: 31).

Such forms of capital were embodied in the experiences of many of the men interviewed for this book. As David Halperin has suggested, a "distinctive gay *way of being*" appeared to be "imbedded in a particular *way of feeling*" that was often implanted in gay men early in their lives (Halperin 2012: 12, emphases in original). Growing up in the suburbs of Australian cities, as the children of immigrants, impacted upon the attitudes toward class and appropriate style of 37-year-old Indian Australian banker, Gareth, 36-year-old Chinese Cambodian designer and lecturer, Sang, and Gino B, a 41-year-old white Australian make-up artist. Both Mario, a 37-year-old Italian American PhD candidate, and 46-year-old white Australian designer and pattern-cutter, Glen, described the working-class backgrounds of their parents and how this impacted upon ideas of respectability in terms of dress. Several interviewees recalled how their mother's, father's, or grandparent's attention to dressed appearance and forms of elegance rubbed off on them and influenced the ways in which they later approached their own clothing choices.[2] "What have I been wearing?," reflexively questioned Michael B, a 54-year-old white British church advisor. "Am I sort of copying what I was seeing of adults when I was a child, or men when I was a child, and how much is me?" Stephen Kates identifies that gay men's "tastes" were initially formed during "family upbringing and education," as such "internaliz[ing] the class habitus" and latterly through various interactions within gay scenes and communities, "augment[ing] cultural capital" with "subcultural variant[s]" (Kates 2002: 397).

Patrick; 33-year-old British analyst Adam; 36-year-old British mixed-race teacher Alex M; 38 year-old Indian-born artist Homi; and Roy (a black British model and performer, who both cagily and jokingly described his age as "between 45 and death"), all talked about being brought up in religious households and how this had impacted upon their childhoods but was not something that they felt had a part in their adult lives. For 46-year-old white Australian radio DJ Greg, 32-year-old Romanian-Australian computer scientist Teddy, 30-year-old white Australian PhD student Sam, 37-year-old white American artist Carl G, and Simian, a 22-year-old Chinese creative direction student, all growing up within actively religious Christian families, the importance of dressing "correctly" and "respectfully" for attending church left a lasting impression that variously surfaced when these men consider what they were wearing in a variety of situations. For Carl G, for example, wearing his shirt with the top button fastened with no tie had an especial resonance with his childhood (see Figure 1.1). Describing the crucifix tattoo he had on his hand, Benjamin explained that this was "not because I'm religious by any means, because I found that being a gay man, I didn't have a place in religion." Coming from a Jewish family meant, for 23-year-old white British performer Dex, feeling both spiritually and culturally connected. To attend synagogue, they tended to wear smart suits, in contrast to their more gender-fluid daily dress choices but did "keep my nail polish on now at synagogue and that's absolutely fine." Andrew Cooper invokes Andrew Yip's work on British non-heterosexual Muslims, to suggest that family and religious matters can "play a major role in the management of identities" and for some "balancing individualism with socio-religious obligations represents significant challenges" (Cooper 2013: 21).

"I grew up in a multi-racial family," explained Roy, "with Irish aunts, black family members, Asian, Indian, Cuban, so for me, I see the bigger picture, and . . . that's probably my fashion sense and how I don't want to be pigeonholed." Roy's reflection relates to Fernando Ortiz's term "transcultural" that symbolizes the complex converging and merging of intercultural influences. Pulls from his mixed cultural heritage were also important for 31-year-old Thai-Irish university lecturer Daniel, living in London, who: "represent[ed]" his "Asian-ness" by buying garments from emerging Thai designers and young Chinese designers, as well as "bright blue, red, green, white . . . fabrics and garments" that were "cut beautifully" and "very contemporary" from a shop in Varanasi in India. These Asian designed and made garments resonated for Daniel in relation to his Asian cultural heritage. Homi recalled that "we were very westernised in our family," but he was conscious of Indian men around him wearing more traditional clothing. He noted how as he grew up and began to become aware of his sexuality, he also gained access to contemporary "fashion" and felt he could "buy one thing and then accessorise it constantly and then that could be my look." Discussing queer south Asian youth, Raisa Kabir notes many "were influenced by their parents' understanding of moral codes of religious and cultural dressing: yet they also questioned their parents' ideals of dressing" through their diasporic experiences (cited in Begum and Dasgupta 2018: 92).

In his observation that there is not one "singular Black gay man" and by extension no singular gay man of *any* ethnic or cultural background, Marcus Hunter (2010: 90) echoes Katherine Sender's (2001) conclusion, through her discussion of camp, kitsch, masculinity, dress, and grooming as gay-specific subcultural capital, that there is no one single gay habitus. Habitus was defined by Bourdieu (1984: 170) as expressions of the mental structures that unconsciously generate "meaningful practices and meaning-giving perceptions." The ways in which these unconscious processes and practices occur, or manifest, is often seen as natural but is instead culturally developed and socially conditioned, often by family or social groups (Bourdieu 1984). In this way habitus also "generates perceptions, aspirations, and practices" that can include dressed appearance (Swartz 1997: 103). Reflecting on the concept of habitus

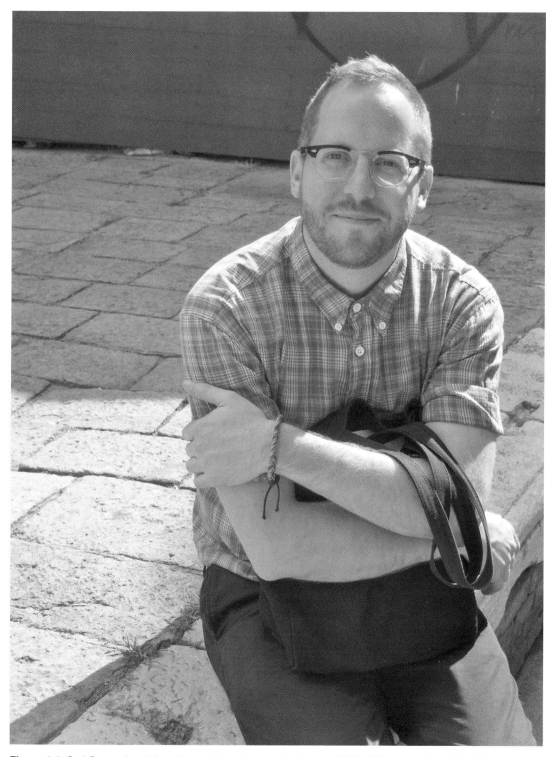

Figure 1.1 Carl G, wearing shirt with top button fastened, in Venice, 2012. With permission of Carl G.

in relation to dress, Susan Kaiser notes that it is not just "*what* is worn but also *how* bodies are dressed or styled that inform us about everyday processes of subject formation as the interplay between subjectivity and the subject positions people inhabit" (Kaiser 2012: 31). Paul Sweetman (2003) develops the idea of a "reflexive habitus" that allowed certain people to "self-fashion" in a manner where they were not necessarily aware of reflexivity but could express agency in their self-fashioning. In *How to be Gay* (2012), Halperin explores the ways in which gay men appeared to instinctively be drawn to certain cultural artefacts, practices, and behaviours, similarly to Sweetman's "reflexive habitus."

Perhaps unconsciously acknowledging the concept of habitus, Adriann, Simian, and 19-year-old white British fashion history student, Josh, explained that they had been influenced by female friends when at school. This had encouraged them to express their sexuality and to dress in particular ways that reflected both these young men's and their female friends' ideas about how gay men should dress. "I remember me and my friends were obsessed with wearing really oversized cardigans and I used to wear waist belts with cardigans," said Adriann, attributing this to the influence of actresses Mary-Kate and Ashley Olsen. He recalled how ridiculous this style was as he lived in the New Mexico desert, but that he and his friends were willing to suffer to imitate these well-known celebrities. Reflecting on how his style changed when he moved to London to study in 2011, Josh described the clothing choices of his three gay classmates: one was "very very fashion forward," wearing designs from JW Anderson and Givenchy and looking both "chic" and "gay"; another wore "flared trousers and fox furs and polo neck jumpers"; and a third (Taylor, also interviewed for this project) "dressed very properly" in brogues and chinos and blazers. Josh noted reflexively how this impacted on how these new friendships made him begin to negotiate his style differently. Barry, like Josh, recalled his move to London and how he met the person who, after a brief romantic dalliance, was to become his closest friend: "we were very similar, you know? . . . Like similar age, growing up and being into fashion . . . he's had a massive influence on me." That Barry had been in a romantic relationship with this man has resonance on the influences of sexual and romantic partners that is discussed further in Chapter 6. David M, a 25-year-old white Irish filmmaker, recalled that his early forays into gay style was "imitating other people's style," including friends he met after moving to Dublin. In moving to London, he became involved with "warehouse communities" where he met more lesbians and "gender diverse [and] trans people" who influenced him both at that time and subsequently. Josh's, Barry's, and David M's reflections resonate with Peter Nardi's proposal of gay friendship networks as "mechanisms of social reproduction in which gay masculinities, gay identities, gay cultures, and gay communities get created, transformed, maintained, and passed on" (Nardi 1999: 7). Roy and Johnny both reflected on how their various friendships, including with gay men, had influenced them in ways of being, behaving, and dressing, unconsciously evoking ideas of habitus.

"I didn't have any other gay friends or context of what a gay life was," reminisced 27-year-old white American performer and club host, Joe H, "except for seeing *Will and Grace* on television." Similarly, Alex B recalled "when I was 13, 14, I didn't know anybody that was gay besides me . . . So the only people that I knew were on TV" and invoked the reality TV series *The Real World* and the television dramatization of Armistead Maupin's book series *Tales of the City.* For Teddy, the 1990s reality series *Queer Eye for the Straight Guy* was "really inspiring for me." He also reflected on watching American black-and-white films from the Golden Age of Hollywood, a practice that 57-year-old white British vintage shop owner, Ian B, also raised, and that resonated with Halperin's (2012) discussion of the importance of Hollywood in forming gay sensibilities. Whilst Alex, Teddy and Joe H do not directly relate these viewing experiences to their dress choices the visual representation of gay men where clothing was important must surely have had an impact, giving them a context for how gay men appeared and behaved.

Barry, Daniel, Josh, Mario, Roy, Teddy, and TJ, a 26-year-old white American fashion public relations manager, all discussed buying fashion or lifestyle magazines (such as *The Face*, *i-D*, *Mademoiselle*, *Ebony*, *L'Uomo Vogue* and various national editions of *Vogue*) which provided inspiration for their own stylistic choices. Dat, a 42-year-old Vietnamese jeweler, recalled that when he was younger, he had consumed fashion magazines looking for influences, but as he got older, he stopped buying them and felt instead that "being overseas" provided influences as well as a different choice of what was available to buy, "rather than being dictated by what the season tells you." As print magazines began to decline in sales in the mid-2010s, online sources became more important (Ellonen 2008; Gomez 2008; Guenther 2011; Nossek, Adoni and Nimrod 2015). Darren, a 45-year-old white British marketing manager, emphasized how Instagram provided inspiration for choosing garments and developing his style, following particular fashion sites, a practice echoed by both Daniel and Jordan. "Viewing online media, where people are posting what they are wearing, and especially [Ari Seth Cohen's] Advanced Style blog" was, Teddy recalled, inspirational and "really stirred me to just express myself and not be afraid of that."

As well as being influenced by family and friends, several interviewees commented on the role of musicians in influencing how they dressed. Singers Grace Jones, PJ Harvey, and Lady Gaga were identified by Patrick, Sam, and David M respectively, for their unique styles. Adriann discussed how he adapted elements of the dress of musician Lana Del Rey and lead singer of Perfume Genius, Mike Hadreas, into his own style. He particularly highlighted that Hadreas was "somebody who's harnessed their queerness and has weaponised it" which was "really empowering" for Adriann and made him feel "I can fucking do it too." The predominance of female signers cited as influences by these men correlates with Halperin's (2012) discussion of a seemingly instinctive attraction and devotion to female divas by gay men.

Hipster/metrosexual/homosexual—where is the gay/straight border?

Several of my interviewees in London, New York, Miami, Melbourne, and Sydney identified the "hipster" look as one that blurred the boundaries of gay and straight style. Mark Greif identified the hipster as emerging in the late 1990s in "the neo-bohemian neighborhoods, near to the explosion of new wealth in city financial centres" such as "the Lower East Side and Williamsburg in New York" (Greif 2010). Matt Siegel felt that hipsters had emulated not *gay* style but *queer* style; as, for Siegel, "queer" implied "a resistance to assimilation which is ironically (and you know how much the hipsters love irony!) the very thing hipsters are doing: assimilating" (Siegel 2009). George, a 46-year-old Chinese fashion technician at an Australian university, felt that hipster was not "a gay orientated trend, it came from straight men and now even gay men are doing it." Nick particularly noted how it was hard to "tell the difference between gay and straight [hipsters] unless the gay was more effeminate," believing "hipster culture has blurred the lines between gay and straight." Krysto; Gino B; 56-year-old white Australian artist, designer, and university lecturer, Douglas; 51-year-old white British book merchandiser, Mikey; 42-year-old Iranian-British lecturer and illustrator, Sina; and Tim, a 60-year-old white Australian performer, all referred to the fashionability of facial hair in relation to hipsters' preferences for big beards and the cross-over between hipsters' and gay men's styles in facial hair, particularly amongst bears, in the cities in which they resided. Douglas identified a "hipster kind of culture" in Melbourne but highlighted that it was difficult to "know if someone's actually part of the bear culture or gay culture or just part of hipster culture." Also commenting on Melbourne, 35-year-old Italian-Australian designer Jon speculated, "I guess I see more straight

hipsters than I do gay hipsters, [and] I would say for gay hipster it's probably a smidge more curated." Picking up Jon's term, Lee reflected that he felt hipster style was "some of the most particularly-curated fashion in the whole of the world." Discussing the Williamsburg area of New York, Joe H noted "the guys are very hipster and the straight hipster guys look very gay and the gay hipsters look very straight." Matthew, a 30-year-old white Australian digital collections analyst, believed that both hipsters and metrosexuals were "subcultures in a way," that they each had defined styles but there was a blurred boundary between the two. He noted the boundary between these two and between gay styles.

The term metrosexual—one much debated within academic discourse (cf. Hall 2015, McCauley Bowstead 2018) and popular culture (Simpson, M. 1994b, 2002, 2013)—was invoked in many of my interviews, with mixed responses, encapsulated by Gino B: "I like it and I don't like it in the sense that it's defining . . . the metro thing seems to be a way of saying it's fine to be stylish, but you're hetero." Other responses to the idea of the metrosexual ranged from "I don't even know what that is," to a discussion of how it has impacted upon straight men's relationship to clothing and to how it has made gay men feel about how they are perceived. The idea of the stylish heterosexual, distinct from the fashion-conscious gay man, is one that is articulated by my interviewees. "I think metrosexual is a term used to make straight men feel more comfortable . . . without being labelled gay" pronounced Clarence, a 69-year-old Chinese retired fashion designer. This sentiment was echoed by Lee who believed that "the metrosexual ideal . . . is certainly borrowing from gay men in that it allows straight men to be concerned about their appearance in a way that allows them to look flirtatious and glossy, while retaining their masculinity, which is something gay fashion has tried to do for ages."

While Mark Simpson's (1994) original metrosexual was defined in terms of consumption as much as sexuality, the descriptor gave rise to a concept of a heterosexual man embracing products and processes previously seen as both feminine and effeminate (Hall 2015). Thus, the boundaries between gay and straight masculinity appeared to be blurred through the more sexually ambiguous repertoire of the perfectly coiffured, obsessively groomed and manicured late-twentieth-century male consumer. Susan Kaiser (2012: 163) notes how "the metrosexual label attempted to define a space in between gay and straight" and served, in Lynn Segal's words, as a "queering of heterosexuality" (Segal, 1994: 259–260). Anderson (2018) proposes that the "metrosexual" label offered "'queer' power," relating to ideas of queer or gay capital (Morris 2018), particularly for men who "contest orthodox masculinity" and its very fluidity as a term that destabilizes "masculine orthodoxy," as well as being used to describe increased fluidity in gender "as a euphemism for bisexuality" and "a heterosexual male who dabbles in same-sex sex" (Anderson 2018: 43). Mark McCormack (2012) links the rise of the metrosexual and inclusive masculinities that are less discriminatory about homosexuality to what he terms the declining significance of homohysteria; that is a (perceived) decline in western cultural homophobia.

Conclusion

There are elements that seemed to be consistent across the men I interviewed and their observations about how the specific aspects that constitute gay styles mirrored, echoed or was different from straight male styles. On the one hand, gay style appeared to be something quite specific and identifiable, while on the other it was something less tangible and there was a blurring with the styles of dress worn by straight men.

It is the "queering," defining, and subsequent blurring of the boundaries between the binaries of gay and straight that the metrosexual has allowed, that is echoed by many gay men and presented as a challenge in writing a book about gay men's fashion, style, and dressed appearance in the twenty-first century. Gino C, a 32-year-old Peruvian American public relations manager, stated "I look at it and I'm like it's the gayest thing and it's straight men are wearing it," while Gary, a 51-year-old white Australian air crew, felt he was often wrong in his reading of gay and/or straight and puts this down to both his age and the changes amongst younger generations: "it's just the blurring of the lines and the younger 20-somethings that are dressing really gay now . . . which is smartly dressed."

The following chapters of this book identify styles worn or observed by the gay men interviewed for this book across the first decades of the twenty-first century, arranged thematically. They do not however make claims for universal gay styles that are always significantly different from those adopted by men who do not identify as gay. Building on ideas of masculinity, femininity and boundaries between genders and sexualities, the next chapter addresses the role of gender in the ways in which gay men in the twenty-first century manage their personal appearance.

Notes

1 This subtitle is taken from the headline of an article from British newspaper the *Sunday Mirror* in 1963: "How to spot a Possible Homo"—see Cole 2000 for further discussion.

2 Gino B, Greg, Kevin, and Michael discussed their mothers; Christopher, Eduardo, Josh, and Taylor, their fathers; and Daniel and Taylor their grandparents.

2
GENDER(ED) PLAY

Questioning whether as a gay man one can "feel both masculine and feminine," Matt felt that perhaps "it's more of an attitude than anything else that makes you think somebody is especially masculine or especially feminine." Pierre Bourdieu (2001: 3) defined gender as manifestations of "sexually characterized habitus" that can characterize bodies in dualistic and contradictory ways. Genders can be considered culturally informed or enforced presentations or manifestations of feminine and/or masculine (acknowledging an emphasis on the binary) "performed" by biologically sexed bodies. These ideas and Matt's question resonate with David Halperin's proposition that certain "sophisticated" gay cultures take "delight" in "the opposition between the feminine and the masculine: between camp and beauty, culture and sex, queer subjectivity and gay male culture" (Halperin 2012: 210). Fashion Studies scholarship has long noted the close relationship between fashion/dress and gender (Barnes and Eicher 1992, Entwistle 2000, Wilson 1985). Through Judith Butler's (1990, 1993) declaration that gender is performative, that is, something that we *do*, dress becomes a visible and conscious marker of constructed or performed gender. Attitudes towards sex and gender and the constructions of the masculine and feminine have had a considerable impact upon gay dress choice, both historically and in a contemporary context (Cole 2000, Geczy and Karaminas 2013, Steele 2013).

Femininity, effeminacy, and drag

Benjamin recalled that he "was quite an effeminate gay" and "very much aware of my femininity." He recalled being mistaken for a woman in the ways in which he specifically chose to wear clothing that enhanced his perceived and culturally understood effeminacy, such as soft draped fabrics, figure-hugging jeans, and particular colors. Peter Hennen argues that the manifestation of gay femininity as *effeminacy* "intersects broadly with both class and race," relating to the ways in which certain cultures, races, ethnicities, and practices have been feminized by western cultures (Hennen 2008: 37). Clarence, Daniel, Sang, and Simian all related the ways in which they were perceived as effeminate based on their Asian ethnicity. Sang went on to recall his initial realization that he was "so much more effeminate than I realized, so much more expressive as well" and that this "clearly prompted my interest in the way I dress." The way the term *femininity* is applied to gay men, Halperin states, is not in relation to "the qualities and characteristics of women" but instead "the non-standard formation of gender and sexuality that is distinctive to gay male culture" (Helperin 2012: 320). As such it is a "cultural formation" (Halperin 2012: 337) that challenges "the normal coding of cultural objects and activities in accordance with a strict gender polarity, masculine versus feminine (Halperin 2012: 375). Historically, effeminacy was conflated with homosexuality and so for many gay men an expression of their homosexuality was through their visible trappings of effeminacy (Cole 2000, Hennen 2008).

Rather than use the term "effeminacy," both Adriann and 23-year-old Malaysian Sri Lankan fashion journalism student, Sanjeeva, used the term "feminine" in relation to the ways they dressed and the garments they chose. Jon and Homi both recalled choosing to wear pink and how this was associated with effeminacy and homosexuality (Cole 2000, Paoletti 2012). Similarly, Patrick, Sam, Simian, Sina, and Joe H recalled wearing glittery and shiny accessories and garments that they felt had associations with, and were read as, feminine. The choices and practices of each of these men echo Victoria Clarke and Megan Smith's findings that "effeminacy" or gay male femininity was "expressed" by their interviewees, "both through the way in which the body was adorned and through gesture, body posture, and gait" (Clarke and Smith 2015: 13). The ideal female body has been culturally determined as thin (Grogan 2017) and this link between thinness and femininity or effeminacy extends to the gay (male) community. Chris, a 32-year-old British Sri Lankan chef stated that "I associate men who are feminine with a lot slimmer bodies, a lot leaner." King-To Yeung, Mindy Stombler and Renée Wharton (2006: 7) described an "internal hegemony" in which "some men are marginalized and deemed feminine by dominant men."

"There is a big problem in gay culture with the effeminate man," Benjamin observed, in a sentiment echoed by Matt, Chris, Joe H, Sina, and Chris. This attitude is described by Tim Bergling (2001) as "sissyphobia" and by others as "effeminophobia," which Eve Kosofsky Sedgwick identified as "a discreditable reason for this marginal or stigmatised position to which even adult men who are effeminate have often been relegated in the [gay] movement" (Sedgwick 1993b: 72). This is not a new attitude in the twenty-first century and relates to a history of the persecution or denial of gay femininity and forms of gender deviance (Geczy and Karaminas 2013). Dwight A. McBride investigated what was considered uppermost within the "gay marketplace of desire," noting that racism affected how in the USA both gay white men and gay men of color responded to representations of gay men, and subsequently to each other (McBride 2005: 88–89). Along with requests for whiteness and youth were calls for overt masculinity and statements such as "no femmes." Performance artists, 25-year-old Portuguese Antonio, 27-year-old Italian Riccardo and Adriann each recalled instances when they had not received much attention on apps, which they interpreted as related to their feminine presentation in particular photographs, a femininity they understood as located in their pose, body type, or long hair. For Dex, such attitudes and instances of femmephobia "forced a lot of fem and queer and trans people to seek different avenues." Dex felt there was "disinterest" in or dismissal of "femme identifying people" paired with a "real fetishization of that femininity" and worried about the impact this would have on the LGBTQ+ communities that had historically often embraced such identities and provided a safe space. Elaborating on reasons for the type of relationship Dex identified, Antonio identified that online relationships are "virtual so you don't really have that attachment" and that the way apps are structured enable users to forget that "there's an actual real person . . . it's just like another image." This could also be related to heteronormative criticisms of any form of gay or queer male behavior and dress style, especially where boundaries of hegemonic masculinities are broached. Elspeth Probyn proposes that "often groups spring up around sites of experienced shame, which then coalesce into fields where those assumptions and rules are used to shame others" (cited in Halperin and Traub 2009: 33) and as such effeminate gay men are shamed for such behaviors or appearances, arising out of what Dana Rosenfeld (2009: 621) called the "homonormative gulf between gender-transgressive and gender conforming homosexuals."

Connected to ideas of effeminacy are those of flamboyance and camp. Homi, Sang, and Tim each used the term flamboyant in relation to their dress and behavior: "I'll have really flamboyant hats" stated Homi, for example. Tim Bergling suggested that "a distinction has to be observed between simple effeminate behaviour, which can often be rather subtle, and actual *flamboyant* behaviour, to which the

word subtle rarely applies" (Bergling 2001: 79). Traditionally, "camp" was used by gay men to describe an ostentatious and exaggerated effeminacy or theatrical, extravagant, and effeminate behaviors. Many of the accepted definitions arise from Susan Sontag's (1967) *Notes on Camp*, that highlights a form of self-knowing, stylization, and playfulness that revels in the idea of artifice. Moe Meyer (1994), for example, identifies camp as a resistance strategy used to ensure social visibility, while Steven Kates (2001) sees it operating as a form of cultural capital. Drawing on Esther Newton, Halperin proposes that camp "works from position of disempowerment to recode social codes whose cultural power and prestige prevent them from simply being dismantled or ignored" (Halperin 2012: 217).

Tim and 23-year-old white Australian fashion student, Jordan, both celebrated the use of camp as a gay performative strategy, while Taylor felt that it was "old fashioned" and younger gay men did not use the practice or the term. Douglas believed that many gay men were "trying to steer away from that campness, but I think it's a fairly unique aspect of being gay and I embrace it." While acknowledging that there were "some negative connotations" to camp, Adam said he had always "been comfortable with it" but questioned whether this was a performance or a natural state, asking "are you turning on the campness or are you turning on the masculinity?" Halperin identified camp, along with other gay "cultural appropriations and identifications," such as drag, as "*subcultural* practices, insofar as they are in a dependant, secondary relation to the pre-existing non-gay cultural form to which they respond and to which they owe their very existence – such as social norms of masculinity and femininity" (Halperin 2012: 422). Riccardo compared the "sense of performativity" he felt in "dressing up" in garments that challenged the gender norms for men, such as skirts and high heels—what he referred to as "camp dressing" (see Figure 2.1)—with the discomfort he felt in public when he dressed in more hegemonic casual men's styles. When he looked "very normal" wearing "joggers and a pair of trainers" and people looked at him, he said he felt "there's nothing queer about me right now, why are you staring at me?" Riccardo also noted how he wore corsets to give him "a sort of hourglass shape that I cannot have" that resembled what is popularly conceived as a "feminine body." He described his engagement in "bodywork" practices he deployed to create a body that explored ideas about gender and how these were constructed through exercise and clothing choices. His style of dressing emphasized his body shape, which he liked to be intentionally "not masculine," in opposition to particular hegemonic styles of western gay cultures (discussed below).

In her conceptualization of performativity, Butler (1990, 1993) had discussed drag practices, particularly as portrayed in Jenny Livingstone's 1990 film *Paris is Burning*. The history of drag is well covered elsewhere (Baker 1994, Chermeyeff 1995, Greene 2021, Kirk and Heath 1984, Newton 1972, Rupp and Taylor 2003) but drag practices were discussed by a small number of my interviewees. The popularity of drag manifested in the success of the television series *RuPaul's Drag Race* was mentioned by eight of my interviewees, including by those men who engaged in drag practices, in the context of gay men "dragging up," the popularity of the TV show and the exposure of queer cultures to a broader audience. Crystal Rasmussen describes drag as "a world of possibility: a world where someone can create a whole new person and, if lucky, a whole new family of their own. Drag allows you to be anything you want to be" (Rasmussen 2019: 300). These possibilities of drag were expressed by Dex, Chris, Johnny, Sang, and 32-year-old Polish academic, Lukasz, who each described their own experiences of and engagement with drag. Johnny, Lukasz, and Sang discussed their first time experimenting with this form of dressing. Attending a drag party in 2013, Sang borrowed shoes, bought a wig, and wore make-up and "an amazing black dress with these woven flowers on it" he had bought for his mother at a sample sale. He noted how he had intended to shave but once he had tried on the clothing and

Figure 2.1 Riccardo (left) and Antonio at Saatchi Gallery, London, October 2018. With permission of Riccardo and Antonio.

make-up, thought "I love this," and kept his beard. Johnny attended his first drag night the same week as his interview for this book (an event in Melbourne that both Sang and I also attended) and borrowed his blue wig and dress from friends who ran the regular drag event he attended. Like Sang, he retained his beard, as he had an event the following day to promote his fashion brand where he wanted to feel comfortable, but he covered it in blue glitter to match his accessories.

Like Johnny and Sang, Lukasz recalled attending drag parties wearing dresses in what he described as "proper drag." He compared this to the "kind of gender fuck look" he wore for Gay Pride in London in 2017, where he combined his shaved head and beard with a dress, high heels and make-up, and carried a banner reading "Gender fuck me." Here he referenced "genderfuck" and the radical drag practices of gay men in the 1970s (Cole 2000). Terry Goldie's proposition that drag allows for a "a male subject caught within a place of femaleness" (Goldie 2002: 127) to be presented, is here combined with Leila Rupp and Verta Taylor's suggestion that "symbols, identities, and cultural practices" are utilised to subvert "dominant relations of power" and challenge "dominant constructions of masculinity [and] femininity" (Rupp and Taylor 2013: 218). Sean and Dex both identified drag practices in London's club scene that also echoed these gendered practices of dressing. Sean recalled clubbers wearing "bikini bottoms, high heels, studded black leather jackets, full beard, and a trucker cap" at London's Duckie in 2005. In 2017 Dex observed what they called "jock strap drag" comprising, a jock strap with wig, make-up, and "a pair of knee-high boots." These styles blurred signifiers of male and female, masculinity and femininity and are perhaps extreme versions of the androgynous and gender-blurring styles worn by interviewees, described below.

As well as observing drag practices Dex also performed in drag, particularly as Chanukah Lewinsky, the host at queer Jewish performance night, "Homos and Houmous." For this "character" they were inspired by Jewish "orthodox conservatism" and what they described as a "slightly horrifying, ugly, frumpy style" that they observed in Orthodox Jewish areas in London, as well as "the elevated elements of the style of Jewish comedians Joan Rivers and Bette Midler, you know, a lot of sequins" (see Color Plate 2). Like Dex's drawing on his religious cultural background as a foundation for his drag performance, Chris described his drag persona, Dosa, named "after the pancake 'cause it's still Sri Lankan [laughs] she is in her 40s, she's stuck in the '80s [and] based on my mother . . . she's got this very floral '80s blouse on and then a gold skirt with humungous petticoats . . . gold shoes and a big sort of, you know, Madonna hairband or pink ribbon in her hair." For both Chris and Dex, these drag personas form a part of their paid employment and the styles are particular to this occupational activity. The ways gay men dress within various other work environments is explored in more detail in Chapter 8. Chris contrasted "Dosa" with his more sedate explorations of his subject positions through dress (see Color Plate 3), while Dex related this as an extension to their challenging of the binaries of gender through their everyday dress practices that adopted a more gender fluid and androgynous approach, addressed below.

Gay masculinities and "butch" styles of dress

Halperin (2012: 306) wrote that "masculinity represents . . . a central cultural value – associated with seriousness and worth, both within broader and gay male cultures, as opposed to feminine triviality – but also a key erotic value for gay men." However, as Peter Nardi identifies, "to automatically assume that all gay men . . . enact the same masculinity roles – does not take us beyond monolithic concepts of gender" nor does it "adequately reflect the reality that gay men are as diverse as all other groups of humans" (Nardi 2000: 7). Roy questioned what constitutes masculinity in relation to intersectionality: "all those constraints, whether you're a man, a woman, bisexual, asexual, transgender, . . . how you think and see and approach things in life . . . there shouldn't be [constraints]." Richard Dyer (2002: 68) observes how the "quoting of mainstream masculinity" destabilizes the supposed naturalness of masculinity and so some gay men have articulated interpretations of "masculinity," or what it means to be a man, through

their choice of clothing. However, Jennifer Moon observes that "white gay masculinity [makes] clearly visible the inconsistencies, contradictions, and inadequacies that are central to *all* identities, especially those marked by sexual deviance and shame" (Moon 2009: 367), allowing for the questioning of capital associated with this particular form of gay masculinity. Discussing gay-identified trans men he knew, Douglas highlighted the "balance between their masculine and feminine aspects of themselves and a lot of gay men are quite comfortable about that, that sort of camp thing exists. They're not camp. They're really hyper, hyper-masculine, because they want to a certain degree to hide the origins of themselves . . . they all grow facial hair, if they can." Their facial hair thus acts as a bodily marker of masculinity.

"I think hair means masculinity. Everyone looks scruffy, so you think masculine," Diego pondered. "If they're clean shaven, they're more feminine. I think that stigma's still there." Gino B noted that "the three-day growth seems to be what the ideal is for men, for masculine men" invoking, like Diego, ideals of gender appearance in relation to conventions of contemporary masculinities. Sam described how since moving to Melbourne in 2011 he had swung between an "impressive" full beard and just a curled moustache, inspired by actor Aaron Taylor Johnson playing Count Alexei Vronsky in Joe Wright's 2012 film *Anna Karenina* (see Figure 2.2). Also connecting to ideas of facial hair and masculinity, Riccardo explained he had a beard "because I do lots of make-up, I like to go out, I like to have my face on." He elaborated that, because a lot of his clothes were women's, his beard acted as "an involuntary statement" that "I'm a man!" (see Figure 2.1). Having a moustache balanced Adriann's long head hair, reducing the frequency that people mistook him for a woman. Short or cropped hair communicated qualities of masculinity, in opposition to long hair's associations with femininity or effeminacy and both appealed differently to gay men. In his theorizing of hair as a theory of opposites, relating to gender binaries, hair, the body, and oppositional ideologies, Anthony Synnott (1993) ignores associations of effeminacy and the attention and "control" that gay men differently exercise over the presentation of their head, facial hair and body hair. Closely cropped or shaved heads have also historically had associations with criminality and punishments as well as with subcultures such as skinheads; who were notorious for violence and, from the late 1970s, certain extreme right-wing politics, but also had gay members (see Cole 2000, 2009). Teddy recounted the dismay with which his family greeted his decision to shave his head, worrying that he was making a political statement. However, he explained that "culturally, that context has lost significance" and that he was doing this for this for practical reasons, not having to "to worry about styling my hair as much."

Raewyn Connell (2005: 78) identifies that one form of masculinity operated through "cultural dominance" preferencing men over women and subordinating the weak, feminine, or homosexual and other forms of masculinity. This *hegemonic* masculinity was the "most honored way of being a man [requiring] all other men to position themselves in relation to it" (Connell and Messerschmidt 2005: 832). Michael Kimmel (2005) further argues that the central tenet of hegemonic masculinity is the renunciation of femininity while Shaun Filiault and Murray Drummond propose hegemonic masculinity as a "flight from being seen as feminine and consequently" a demonstration of a "rejection of femininity" (Filiault and Drummond 2007: 175). It is not just hegemonic masculinity but also hegemonic gay masculinity that operates such attitudes. Articulating these ideas, Nick stated, "I think that is the huge paradox of the gay world that we're not traditionally masculine men and yet the masculinity is what we want to uphold and subscribe to in terms of clothes and appearance." Both Andrew Cooper (2013) and Perry Halkitis (2000) argue that hegemonic masculinity is a major contextual factor in the negotiation of gay masculinity and thus I would propose, in dressed appearance, as a marker of various forms of gay masculinity. In 2000 Fred Fejes identified a hegemonic gay masculinity promoted within gay media as "young, white, Caucasian, preferably with a well-muscled, smooth body, handsome face, good education, professional

Figure 2.2 Sam self-portrait in mirror, Melbourne, 2015. With permission of Sam.

job and high income" (Fejes 2000: 115); this continued to operate into the twenty-first century and relates to discussions of body types below.

One of the terms central to ideas and manifestations of gay masculinities is that of "butch." Historically, the term was applied by gay men to masculine (straight) men seen as desirable. The term "post-gay liberation" was sometimes applied in a tongue-in-cheek fashion when butch masculine behavior was seen as a "performance." Here, the term applies to an appearance or behavior that is traditionally seen as masculine. In "the self-conscious act of adopting a 'butch' masculine appearance, gay men reveal themselves to be performing a self-conscious mimicry of stereotypical heterosexual masculinity" (Duncan 2010: 44) and so masculine capital therefore comes to the fore. Although he did not use the term butch, Adriann reflected on the influence of such tendencies toward traditional masculinity or particular cultural "macho" attitudes, growing up in a border town near Mexico, where "the culture really was quite

predominantly Mexican and so the culture that I grew up in [and] the men in my life were very machismo and strong." Butch, machismo, and forms of hypermasculinity based on displays of overt masculine capital continue to be "the signifiers of gay sexuality as well as the object of gay desire" (Mercer 2003: 289); this is discussed further in relation to sexual attraction in Chapter 8. Emphasising the hegemony of masculinity within gay cultures, Alex M, Lukasz, and Sina all raised the idea of "masc for masc," (masculine looking men seeking similar men) encapsulated in Alex M's observation that there had been "a massive shift towards people having to be more masc for masc and present themselves as masculine more than ever." Jokingly referring to the imperative within certain parts of the gay community to look masculine, Barry related that he and a gay male friend: "sometimes joke [when] getting ready to go out and he'll come to my room and just be like, 'shit I look too masc, do you think? . . . I look too straight' and we just think that's so funny because it's not like we're trying to but it's just like the clothes that we may be drawn to now, you know." The striving for masculinity has been identified as leading to a form of "male impersonation" (Simpson 1994a, Cole 2000) and manifested in a practice termed "straight-acting," that aligns with Connell's (2005) observation of very straight gays and discussed in Chapter 1.

Gender ambiguities in gay men's dressed appearance

While there are those who align themselves with one side of a traditional binary division of masculine/ feminine, others have opted for a more fluid "both/and" rather than "either/or" (Kaiser 2012), blurring the lines between what was traditionally seen as gender (in)appropriate. "For me particularly, the terms masculinity and femininity are so outdated and ridiculous," stated Patrick. "But I think that's very personal to me, so I have moments of more femininity and more masculinity." Sam related this blurring and questioning more specifically to clothing, trying to "find the line between masculine and feminine of having sort of very, I don't want to say beautiful, more pretty style . . . it's more tailored and . . . very consciously put together." Here, both Patrick and Sam invoke the ideas of androgyny, gender neutrality and gender fluidity that have been relevant in fashion, particularly in the twenty-first century (Reilly and Barry 2020). In relation to dress, Fred Davis defined true androgyny as "a melding or muting of gender-specific items of apparel and appearance so thorough as to obliterate anything beyond a biological 'reading' of a person's sex" and so the clothes "would have 'nothing to say' on the matter of gender or sexual role" (Davis 1992: 36). Both Douglas and Rafal, a 29-year-old white Polish artist, commented on the influence of ideas about the fluidity of gender. Echoing ideas about gender-fuck styles of 1970s radical drag, that elsewhere I have argued influenced glam rock and thus straight male dress choice (Cole 2002), Douglas reflected that younger people "grab aspects of masculine clothing and feminine clothing and put it all together in this mish-mash of very interesting ways." Rafal acknowledged ambiguity in gender and sexuality: "there are people . . . maybe a few years ago you would have said that that person who is dressing up in this particular way is definitely gay." While he respected decisions to identify as "non-binary," Riccardo personally took "the decision not to do that but to be like, no, I'm masculine and no, I'm male, because by doing so I want to enlarge the view of what a man can be," echoing ideas of hybrid and inclusive masculinities noted above. Based on the observations and experiences described above, it is worth considering how questioning of gender and its relation to fluid sexuality is impacting on how young people consider their identity and clothing choices.

Rashad Shabazz (2015: 77) highlighted the importance of gender performance and the ways in which "rituals and acts stylize the body into ideologically constructed notions of gender," something that Alex M observed as being challenged by a friend: "he's extremely muscly, but not because he goes to the gym, he just weirdly is, and so he passes off online as this quite butch black guy, but then he's quite kind of queer femme. He has a beard as well, so sometimes he'll wear lipstick or eyeshadow and maybe a dress and go out and attempt to challenge." Watching Paris, Milan and London catwalk fashion shows, Riccardo observed "more blurring of gender on the runway." As someone who engaged in gender-blurring dressing practices, he felt this was "amazing" but simultaneously "a bit scared that there is the image but there's not the content inside, and so it's being perceived by the mainstream as something [to] laugh [at]." Sina related this gender blurring and fluidity to "the '90s when I came out [when] there was a similar emphasis on androgyny." He continued, speculating "I wonder if it's a language around gender now that has emerged . . . I've heard people using the term non-binary in ways that's just like androgyny or that's not actually too different to the way I see my own gender in a way."

Adriann stated that he liked to find garments that were "at the crossroads of masculine and feminine," buying clothes such as button-up shirts designed for women, "that were way more fitted" than "men's or boy's clothes." A lot of his clothes were "more on the more masculine side of women's design." Sang, Sanjeeva, and Alfie, a 32-year-old Italian-British creative director, each noted having women's garments in their wardrobes. For Sang this related to his small physical frame that many menswear brands did not cater for and "the opportunity to buy a whole lot of other clothes in the womenswear that didn't look like womenswear." The women's garments that Alfie owned were not, he said, "a typical womenswear shape, but fitted comfortably and just *happened* to be womenswear." "I've never been averse to whether it's male or female clothing," stated Roy; rather, he would "see what gender outfit I can actually spin, but still make it look like a men's outfit" (see Color Plate 4). Sanjeeva described owning several "flouncy shirts" that were "actually blouses" but when he wore them "you can't really tell." He also noted owning women's long faux fur coats, aligning with Gino B's ownership of three vintage women's fur coats—mink, fox, and astrakhan—that he had resized to fit him and wore with long, trailing, silk chiffon scarves. Conscious of notions of cultural appropriation, Remi and Homi talked about wearing women's Kimono, rather than men's Yukata, but with elements of men's clothing: in Homi's case for a private view of his work based on paper dolls and geisha. Raj described how wearing traditional Indian Kurta kameez, comprising trousers and a long shirt, made him "feel like I was dressing in women's clothing in some sense.'

"I've got a lot of women's clothing," stated Vlad, a 25-year-old Melbourne-based Azerbaijani fashion design student, "brocade pants and that sort of thing . . . To be honest, I actually don't care . . . Menswear's very conservative really, because the majority of men are conservative." Echoing Vlad's lack of concern about the sex his clothes had originally been designed for, Dex said that they probably owned more women's than men's clothes but did not see a "separation," just that it was "particularly womenswear that I'm attracted to," while Riccardo noted that for both he and his partner Antonio, "there's really no difference" between men's and women's garments (see Figure 2.1). However, Antonio did add to this that: "I feel much more comfortable in heels and a dress than I do with jeans and a t-shirt and sneakers, I always feel very, very uncomfortable if I'm just walking with basic clothes in the street." Remi stated that "I'm not interested in drag. I'm not interested in cross-dressing either" and that even if he "wore a skirt" he wanted to "look masculine." He went on to describe a Zara pleated women's metallic silver skirt that reminded him of a kilt and which he wore with "white trainer socks from Adidas." Although he did not frequently wear skirts and admitted that he had avoided buying skinny women's jeans for fear they would "out" him as gay, Jordan described buying "a long second-hand knitted skirt with the intention of cutting

it up and using the fabric" but instead "turned it back to front . . . made it shorter." Jokingly trying it on, he realized that it looked "really cool" and put on his Dr Martens" boots "that masc'd up in the lower half, because I was wearing bare legs." He reflected on the balance of feeling both masculine and feminine in the garment. In contrast to Jordan's pairing his skirt with Dr Martens, Remi explained that he started to wear women's high heel shoes at the time he started working at the women's shoes department in London's Harrods department store. His first pair were Isabel Marant trainers with a wedge heel, but once he became comfortable in these, he bought a pair of Alessandro Michele Gucci women's shoes: "with a massive GG logo with a heart in the middle [with] a proper heel. They were eight and a half centimetres."

Marjorie Garber notes that dressing practices that were at the border of cross dressing or gender disruption created a "category crisis" that draws "attention to cultural, social or aesthetic dissonances" (Garber 1992: 16). This is reflected in Crystal Rasmussen's observation that "with expressions of gender, we're so often punished for how we transgress out of a role" (Rasmussen 2019: 107), echoing ideas related to shame and effeminophobia or femmephobia discussed above and again below in relation to online dating apps. Drawing on Connell's (2005) conceptions of masculinities and Bourdieu's (1984) work on capital, Bridges proposes that gender capital, that is intimately connected to the body, "refers to the knowledge, resources and aspects of identity available–within a given context–that permit access to regime-specific gendered identities" and allows for discussion of how certain "things count as masculine or feminine for some, but not for others, in some situations and not in others" (Bridges 2009: 92). Considering gender, Tim Edwards (2006: 10) proposes that performativity "reveals the body beneath the performance." Based on participant responses, scholarship on gay men's body image highlights concerns, initially developed in childhood, about both other's perceived, and self-perceptions of, effeminacy, which westernized culture has linked to homosexuality (Reilly, Rudd, and Hillary 2008, Strübel and Petrie 2016, 2018, Clarke and Turner 2007). Critical of the ways in which certain body types and sizes have been prioritized in gay culture, Antonio observed: "Bigger is better, muscles are great, tall people are better than short people." Relating this to his own body image, he joked, "I hate tall people . . . because they make me feel short." He qualified this, explaining that "it's not because I actually hate it, it's because of the way I feel . . . less valuable" or perhaps the way societal ideals direct his relationship with his own stature and body.

Conclusion

Although all my interviewees identified as cis-gendered gay men the complex relationship between sex, gender and sexual orientation was important to identify and concepts of gender and performativity were considered in relation to individual's consideration of their own "masculinity" or "femininity." In considering gay aesthetics, Tristan Bridges (2018: 384) stated that the *behavioral* dimensions of signifiers of gender illustrate "the co-construction of gender and sexuality." These clothing signifiers of gender offered ways in which gay men could conform to hegemonic and culturally accepted ways to dress as men, to embrace a long queer tradition of adopting gender non-conforming styles or to challenge and blur those gendered boundaries. Considering the relationship between gender and the body, the next chapter addresses the ways in which gay men respond to their somatic type and develop, manipulate, or present their physical bodies.

3
MILLENNIAL GAY BODIES

"I do need to be aware and fit my body and my body type," stated Luis, "because, you know, that's to me more important than anything." Luis's statement emphasized the importance of the body to gay men. This was echoed by Daniel, who stated that gay men are "very aware of their bodies and how they present themselves to the world." He thought that gay men's "uber-awareness of their bodies" was because "their bodies are attracted to the same body," a subject addressed in more detail in Chapter 6. Scholarship on gay men's body self-image and body satisfaction has often compared them to straight men, addressing differences across age groups, summarized by Sarah Grogan (2017) and Chris Shilling (2012). Daniel's perspective is consonant with Murray Drummond's (2005b) proposition that the way gay men perceive their bodies often resulted from their understanding that they differed from hegemonic masculine norms, looks, and mannerisms. Considering bodies more broadly, theorists such as Grogan (2017) argue that the body is both a site of personal physical *and* external social control. For gay men in the twenty-first century, these aspects of "control" (Foucualt 1977) condition their understanding of their bodies as the site of their sexual and social self, as well as in relation to their self-presentation through dress as a "situated bodily practice" (Entwistle 2000: 4). Connecting to Entwistle's idea is that of "body image" which includes a range of relationships between the body and individual/societal perceptions and impositions, the way one feels about one's physical attributes (Grogan 2017, Wykes and Gunter 2006). This relates to the ways the gay men interviewed considered their "selves," their physical bodies and the way they developed, changed, or accepted their bodies across their lives, as well as the relationship between their bodies and dress choices, ideas that underpin the discussions about style-fashion-dress across this book.

Hannah Frith and Kate Gleeson's (2004) research highlights that men used clothing to hide or enhance parts of their bodies in relation to hegemonic body ideals, through processes of internalized regulation shaped by social pressures and self-perception. So for Luis, the relationship between body and clothes was the "perception you have on yourself and how you predict [project] that with your clothes," while for Daniel, "fashion is about the body, that's what it is first and foremost, style is more about . . . what you choose to do with that body and how you choose to present yourself, how you present that body to the world."

Mesomorphic bodies, muscularity, and the gym

Considering the (perceived) relationship between muscularity and masculinity in both broader and specifically gay male culture, several men reflected on the social pressure to attend the gym and develop muscular physiques. Alex B, a 39-year-old African American brand manager, related working out and gym attendance not to having a bulked up body that conformed to hegemonic gay styles, but to wear clothes he favored. He said he would "rather have a bigger body type than skinny. For my style I thought it worked. . . . It was about how I looked in my clothes." Jay McCauley Bowstead (2022a) details that clothing

Figure 3.1 Gareth, photographed for the "Make Me Hot" campaign for *DNA* magazine, March 2014. With permission of Christian Scott and Gareth.

worn by "gym-bros" or spornosexuals emphasizes an aesthetic, rather than athletic or sporting, muscularity. He identified brands such as Gymshark that are designed to reveal the results of such gym-based aesthetic labor. Garments by brands such as Gymshark, Reebok and Nike were also identified by Sanjeeva as being worn by muscular gay men in gyms. Gareth explained how, after he had first come out as gay as a young man, he avoided going to the gym. Latterly however, he began going to the gym and described entering a competition called "Make Me Hot," run by Australian gay magazine *DNA* (see Figure 3.1). As well as the impact upon his musculature, he noted how the whole experience was "invaluable, learning how to eat better and work out at the gym" and that "you can change things you want about yourself quite easily." Linking his move from Singapore to Sydney with a change in his body, Raj reflected: "I got more conscious about my body . . . I started working out . . . then my body got into a certain shape, and I felt like I could actually dress in a certain way." He also reflected on how a gym-worked body fitted certain hegemonic elements of Sydney's gay scene that was predominantly "white-skinned, well-toned, you know, abs." Brian Pronger (2000) contends that in the move away from effeminacy as an outward sign of homosexuality, muscularity is not merely a substitute for make-up but differs in the content of the excess.

Ectomorphic skinny and slim bodies

Even gay men who did not subscribe or aspire to the muscular hairless body were affected by this "ideal" because this was, and continues to be, the physique most frequently represented in the gay press and gay pornography (Drummond 2010, Mercer 2003, Padva 2002, Saucier and Caron 2008, Simpson 1994a). Sang noted his own slender frame, jokingly lamenting "I just missed the memo about all the Asian men being ridiculously buff," stating that what the "ideal Asian man would be had shifted . . . from kind of this skinny, twinky, hairless situation to something that was bigger, muscular and tattooed as well." Daniel, Clarence, and Simian each emphasized that they had always been "skinny," connecting with Murray Drummond's (2005a) research into young Asian gay men's attitudes towards bodies, where he found that his participants were concerned about their skinny frames in relation to predominant ideals on the Australian gay scene. Drummond acknowledged that the links between masculinity and muscularity were different in East Asian cultures from those in Australia and by association, western cultures more broadly. Similarly, other research about gay Asian migrant populations has demonstrated that such men are often deemed less physically attractive than white gay men and work on body shape to align as closely as possible to hegemonic gay standards as well as altering dress styles as a strategy of assimilation (Huang and Fang 2019, Kong 2011, Srinivasan 2018). Gay Asian men have also been eroticized as exotic "others" in western gay cultures. In their broader study of body image amongst "ethno-racialized gay and bisexual men," David Brennan and colleagues found that "the added pressures of managing racialized body stereotypes alongside the mainstream body idealization creates a complicated intersection of race and masculinity" (Brennan et al. 2013: 396).

Simian believed he would "definitely fit in the twink type 'cause I'm skinny, I'm quite pale." However, he maintained that he did not "really like labels, 'cause I feel like if you label yourself as a twink you kind of need to fit in the behavior of the label as well." Shaun Filiault and Murray Drummond describe the twink by body type as young, "slightly muscled" and smooth, with little body hair and as well as being "label-conscious" (Filiault and Drummond 2007: 179), while Crystal Rasmussen (2019: 125) defines *Twink* as "gay slang for thin, white, into no kinks." Adriann recalled that "one time a guy told me that I was not a twink because I had facial hair"; he elaborated that he did not identify as a twink but "it was just like the

closest thing" that he felt he had in terms of using a recognized term or definition. Jun said that he did consider himself a twink and related that his body and facial hair grooming practices fitted with the practices and signifiers of this archetype. Significant to Simian's and Jun's acknowledgment of the twink is Filiault and Drummond's (2007) identification of this slim adolescent corporeal ideal in an East Asian context. However, Matthew Todd sees the term in relation to "objectification" and "inbuilt disrespect" that gay men have been taught through exposure to concept of shame and a hierarchical "pecking order of fuckability" (Todd 2016: 312).

Like Clarence, Daniel, and Simian, Remi stated that he had "always been super, super skinny" and effeminate. His family always made fun of this, leading to a form of Foucauldian self-regulation that induced Remi to attend the gym to try to bulk up, like other men discussed above. Benjamin noted how, in his teens, he was "the short plumpy one" with "a lot of baby fat." He described how, "believing Kate Moss's epigram that nothing tastes as good as skinny feels," he lost weight and became "very skinny." To emphasize his changed body shape, he chose clothes that he felt flattered his new shape, such as high street store Zara's "amazing draped tops that would hug in certain areas, flow in certain areas" and close-fitting leggings. His choices were "about showing [my] body . . . I was very aware of body, very aware that I was very thin, I was attractive to older men, to muscular men, and I loved it.'

Endomorphic bigger, heavier, fatter bodies

'I obviously have never been thin," stated Glen, and "that definitely kind of informs how you dress." Reflecting on his body shape, he described how "apart from having weight on me . . . I have a really long body and really short legs" and so dressed to balance this body shape. Glen noted that he had never "flaunted" his body, but this was not about "body shame" or a "sense of insecurity" about his body. Ben Barry and Dylan Martin (2016b), along with Jason Whitesel (2014), found that men with bigger body sizes identified that only a small range of fashion clothing brands were available to them, although there were t-shirt brands that offered large sizes. Barry and Martin's respondents also identified limited "social spaces that celebrated their body type, leading to feelings of de-sexualization and exclusion" (Barry and Martin 2016a: 342). However, Whitesel's research identified specific social spaces and groups that celebrated bigger gay bodies particularly within the "mirth and girth" and "bear" communities. Homi noted that "the thing that really change[d]" the way he dressed was his weight, admitting that "when I get heavier, I do neglect to look at myself" and observed that there was a "gap in the market" to provide fashionable clothes for larger men.

Closely connected to larger bodies and embracing heavier, hairier, and often older bodies were the "bears." The development and international nature of bear culture is explored in detail elsewhere (Gualardia and Baldo 2010; Hennen 2008; Manley, Levitt, and Mosher 2007; McGlynn 2020; Mijas et al. 2020; Suresha 2009; Tan 2016, 2017; Whitesel 2014; Wright 1997, 2001) and in previous work I have discussed body type and clothing choices of bears in the new millennium (Cole 2008, 2013, 2015). Richardson (2010) highlights bears' eroticization of big bodies as masculine in relation to the way gay men have eroticized working-class masculinities. Glen and Joe P described how having heavier bodies and facial hair meant that they fitted into the bear scene and [sub]culture without necessarily having to identify as "bears." Theresa M. Winge proposes that a subcultural body is "a representation of a subculture's visual and material culture and ideology" as well as "a visual celebration of the body" (Winge 2012: 1). Within bear [sub]culture, possessing a large and hairy body functions as a form of sexual

capital. Discussing the rise of bear subculture amongst gay men, Joe P noted how the heavier, bearded, hairy man had become the new desired archetype, joking that "it's the same old thing, just in a larger sized t-shirt." Writing in relation to bears in 1997, Eric Rofes warned that a cautious approach should be taken when attempting to provide an all-encompassing description and definition of appearance and identity, as groups are spatially, geographically, and temporally contingent.

Several men who aligned themselves with bear (sub)culture discussed clothing style as opposed to just body type: "the style is very relaxed as well, lots of lumberjack style shirts, t-shirts, jeans, trainers" explained 36-year-old white British accountant and bear, Graham, echoed by Lee's listing of a typical New York bear's clothes as "boots, jeans, plaid flannel shirt" (see Figure 3.2). The similarity of the dress elements here and the clothing worn by hipsters (discussed in Chapter 1) emphasizes Douglas's questioning of the differences and boundaries between the two. David W, a 46-year-old British management trainer who identified as a bear, noted that after years of trying to fit in to commercial gay scenes, it was liberating to find the bear community, in which his larger body size was valued. Patrick McGrady (2016: 1720) notes that "bear subculture [wa]s a resource for some men who have a large body, are attracted to large bodies, and both to feel connected to a gay subculture and resist the effects of weight stigma." David W described how he "stopped worrying about the size of my body—not trying

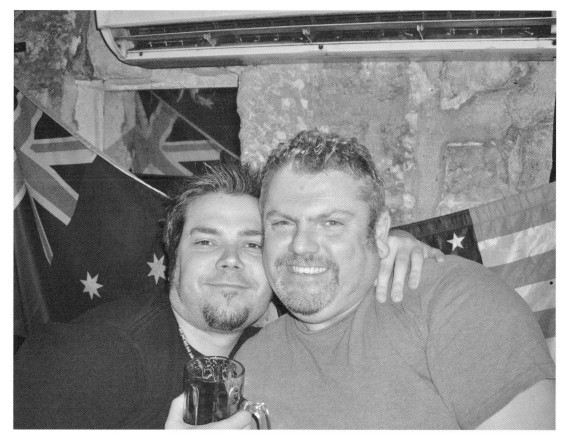

Figure 3.2 Graham (left) and David W, Bear's Den, Paris, 2007. Photograph by Shaun Cole. With permission of David W and Graham.

to wear fashionable clothes and people found me attractive." He adopted staple bear garments—plaid lumberjack style shirts, t-shirts, rugby shirts, jeans, trainers, and boots (see Figure 3.2). Although not self-identifying as a bear, 49-year-old Japanese language teacher and artist Wataru's body type fitted within Japanese boundaries of what constituted a "bear" and his chosen dress style correlated with the bear image. Frequenting some of the bear-focused bars in Tokyo, he acknowledged that: "If you call yourself a bear, you're a bear, I guess . . . I mean so the size is important, maybe." Chris Tan (2017: 570) identifies that Japanese gay culture is predominantly "segregated according to somatic 'types'" and bears are distinguished in this way from other slimmer men. Acknowledging the transnational nature and commonalities of international bear body and dress styles, Douglas discussed the relevance of bodies, including his own, within bear subculture from an Australian perspective:

> there's the whole "muscle bear," which is huge now, a whole sort of subculture . . . muscle bears tend to dress a little bit more sort of smart upmarket . . . compared to the grizzlies that kind of wear the checked little lumberjack sort of thing . . . [bear culture is] much more open to differences in age, because as you grow older you just become another type of bear and you're still attractive, even polar bears or silver bears, you're in the seventies, can be sexy and attractive.

Douglas acknowledged areas of commonality as well as variations amongst bears, which aligns with academic work on bear subculture and scenes. Such scholarship identified that individuals sought out like-minded people and communities where their bodies were deemed attractive rather than facing stigma about their weight and sexuality. As well as larger body size being significant in bear identification, the other significant bodily marker is hirsuteness, with a celebratory wearing of both facial and body hair. Like the larger body size this contrasts with the hegemonic gay images of slim or muscular hairless bodies and cleanshaven faces. Freddy Freeman, the organizer of New York's annual "Bearapolooza," explained bears in relation to hair: "Men lose the hair from the top of their head as they age. They grow hair on their bodies" (quoted in Flynn 2003: 68). The relationship between hair and ageing is considered further in Chapter 11.

Body modifications: tattoos

In her review of literature on tattooing and other forms of body art, Enid Schildkraut (2004: 338) summarizes that "bodily inscriptions are all about boundaries, a perennial theme in anthropology – between self and society, between groups, and between humans and divinity." "I've been tattooed for a long time. . . . For me it's a diary, it's autobiography," explained Joe P, going on to note that he had tattoos done to mark both his fortieth and fiftieth birthdays as well as "within a week of Bowie dying" as a mark of commemoration (see Figure 3.3). He elaborated that he liked tattoos "because I like art and I like having it with me. All of them have a reason." Benjamin, Jon, Luis, and Daniel all echoed Joe P's emphasis on tattoos having personal meaning, images or marks that had become what Vitor Sérgio Ferreira (2009: 294) calls "auto-bio-graphical" signs. Jon, Glen, Luis, Daniel, and David J each explained how, like Joe P, they had been tattooed to mark important moments in their careers or lives, such as Jon's tattoo of a skull seemingly stitched with thread he had on his leg to mark graduating from a fashion design course in 2011 (see Figure 3.4). A renewed interest in the 1980s clothing designer Sue Clowes led Mikey to have one whole leg "collaged" with the crosses, planes, and roses from her

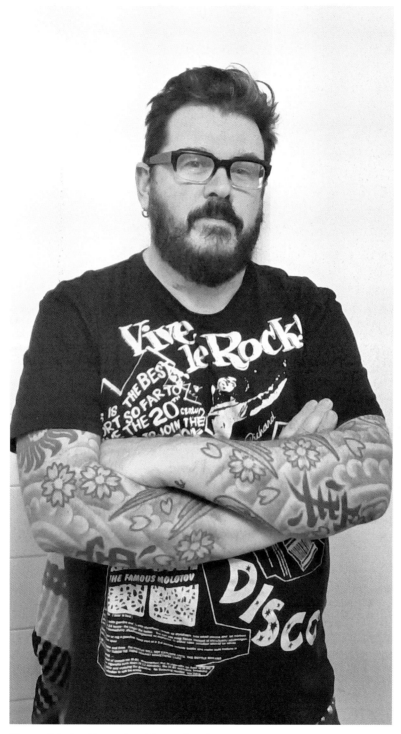

Figure 3.3 Joe P wearing "Vive le Rock" t-shirt, showing tattoos on forearms, London, September 2022. With permission of Joe P.

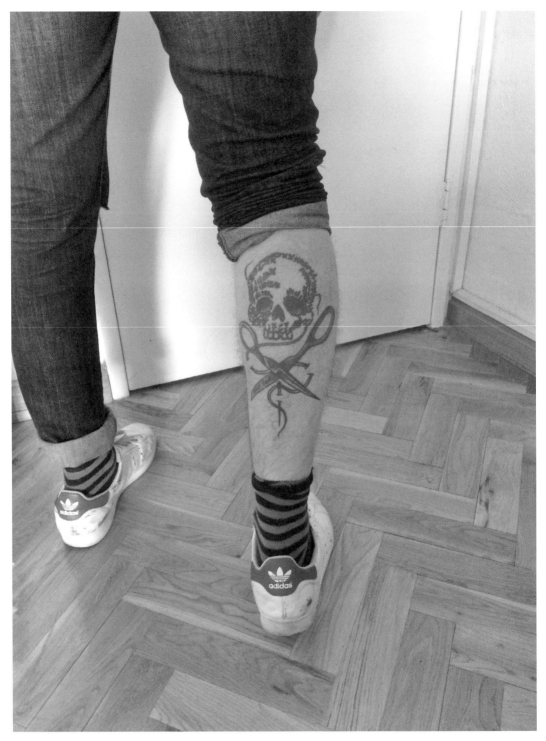

Figure 3.4 Jon's tattoo of "stitched" skull and scissors, Melbourne, August 2015. Photograph by Shaun Cole. With permission of Jon.

early 1980s print collections. Michael Atkinson and Kevin Young note a "flesh journey" where the "corporeal . . . symbolically represent[s] and physically chronicle[s] changes" (Atkinson and Young 2001: 118). In contrast, Alex B's motivation was he "liked" tattoos and Remi's tattoos did not "have any meanings at all" but were on one side of his body in contrast to the "smooth" bareness of the non-tattooed side. This might in turn be connected to Cihan Ertan's (2017) proposal that, regardless of motivation, the mere act of inking the skin can be considered a form of resistance to the hegemonic norms of a smooth undecorated body.

The number of tattoos that my interviewees had on their bodies varied from two, in the case of Milty who would not discuss one but explained the other was a piece of text reading "it's too cold outside for angels to fly," to those including Barry, Benjamin, Mikey, Joe P, Roy, and Marcus (a 57-year-old white British photographer and lecturer), who had large areas of their bodies covered. Benjamin, Roy, Barry, and Joe P had, like Milty, passages of text or words inscribed in various places on their bodies, ranging from single words across knuckles to lines of poetry or scripture across chests or backs. For Roy, Benjamin, and Marcus there was a connection with spirituality and protection in the images they chose; for Marcus "the seven chakras, seven energy center's alchemy symbols" and the five elements of nature—earth, air, water, fire, and void—undertaken by three different tattoo artists. Joe P, Glen, Jon, Roy, and George had various animals depicted across their bodies and flowers and foliage also featured in the tattooed works of several men.

In his investigation of tattooing in relation to the theory of shifting erogenous zones, Andy Reilly (2014: 216) found that "once [a] particular style of tattoo became overexposed, men sought new tattoo styles and body locations." This was particularly reflected in both Glen and Marcus recounting that at a certain point they told their tattooists that they did not want the Celtic style armbands that had become "fashionable" and popular. Alex B and Ian J, a 63-year-old white British vintage clothes dealer, both noted the "fashionability" of tattooing in the second decade of the twenty-first century, with Ian J explaining that his oldest tattoo of a snake and a rose was forty-eight years old, as he had begun getting tattooed aged fifteen, and rather than have new tattoos he was having his existing ones recolored. Reilly (2014: 216) also notes how certain tattoos and their locations on the bodies of gay men "denoted sexual behavior," linking this to hanky codes and the wearing of accessories such as earrings and keys that had been used as indicators of sexual position preference (Cole 2000: 111–114). While none of my interviewees discussed this specifically, they were aware of the sexual as well as the social and cultural contexts of their choices, as gay men, to be tattooed. Luis and James, a 34-year-old white American office manager at a media company, reflected upon their sexual attraction to tattoos and tattooed men, finding them "fascinating," "attractive," and "sexy." This was contextualized by James's admission that he would never have a tattoo and Luis's description of his own body art and the motivation for his three tattoo pieces, and connects to dressing for sexual attraction discussed in Chapter 6. Llewellyn Negrin notes that the traditional "unambiguous affirmations of masculinity" that were once associated with tattoos had changed, and now, for gay men, tattoos were "deployed as a means of subverting phallocentric masculinity" and "reclaiming the sensual self" (Negrin 2008b: 97, 105).

For each of the tattooed men I interviewed, the personal decision about style, size and location of their tattoos was what Susan Benson (2000: 245) notes as a "declaration of me-ness." David Bell and Gill Valentine (1995) and Peter Lentini (1999) discuss the ways in which personal politics were bound up in the decision to adorn the body with tattoos and the ways in which people responded to tattooed bodies; something that was reflected on by several of my interviewees. For example, George explained that people "look at me and they think, you don't have this, and they're surprised when they see" his large back piece of a ram's skull.

Bodily presentations on social media

Peter Lehman claims that the internet "enable[d] people to seize control not just of the representation of their body but the distribution of the images and the opportunity to enter into discourse with others about it" (Lehman 2007: 261). Other academics discussing social media applications observe how they allowed users to mediate the presentations of their bodies and dressed appearances (Carr and Hayes 2015, Sorokowski et al. 2015, Barry and Martin 2016a). Jamie Hakim connects the increase of particular muscular presentations of men's bodies on social media to "neoliberalism's struggle for hegemony both prior to and during [the period] 2008–2016" (Hakim 2020: xvii). He explains that "the "aesthetic labour" or beautifying body practices that women have been exhorted to perform under neoliberalism have been one of the major ways that neoliberalism has "got under the skin" of its subjects and that this impacted equally upon men (Hakim 2020: xvii). Sina identified the fact that "I do feel like when you put a picture that's sexy, of yourself with no shirt on or an unbuttoned shirt or something like that, you're more likely to get responses." He highlighted that muscular bodies were prevalent and that "if you don't have the kind of body . . . you're probably less likely to try and present that image, or if you just aren't feeling that confident in your body at the time, you're less likely to [get responses]." This relates to Jamie Hakim's (2018, 2020) proposition about the prevalence of the muscular "spornosexual" on social media sites. In 2008 Mark Simpson coined the term "Sporno" to describe a new take on what he saw as an overt homoeroticism combining images of sporting prowess and (gay) soft porn imagery in advertising. He later updated his ideas in relation to social media as well as advertising, coining the fuller term "spornosexual" to comment on the rise of young men attending gym's, building their muscularity, and posting images on social media sites, such as Instagram (Simpson, M. 2014). Connecting the rise of these "lean-muscular" bodies to a rise in particular forms of neo-liberalism post-2008, Hakim links this practice of promoting "digitally mediating sexualized versions" of one's body to needing to "*feel* valuable," but that "the 'actual' – economic, social or cultural—value that they created was very limited" (Hakim 2020: 25, emphasis in the original).

In relation to the predominant body types on gay apps, Alfie felt that "it's almost like there's kind of . . . a top tier look" that was topless, muscular, and predominantly bearded and "in some ways kind of a super easy formula" but that "personally I don't feel like I want to be in that group, it's not necessarily a thing that I find attractive." Remi identified this as "the look" predominating over "the person," leading users to "all look[ing] the same, they're all wearing the same kind of clothes." A few other interviewees linked this look with "masc for masc," an online statement commonly made by users that singled out and discriminated against those who did not fit this formula. Benjamin described such labels on apps as "tribes within a tribe," a "tribe mentality" that he felt led to "bashing at the other tribe [so] no femmes, no fags, no blacks, and . . . no Asians." Hennen (2008) notes the rise in phrases such as "no fems" and "straight-acting" in personal ads and on social media. This exclusionary and prejudicial attitude was also highlighted in an Australian context by Gary Wotherspoon, who cites an article by Benjamin Law, entitled "Kiss me, I'm Asian," that identified that Grindr users often "state what they're avoiding. 'No femmes,' some say. 'No fat, no old,' say others. 'No Asians.' That last one . . . comes up a lot." (cited in Wotherspoon 2016: 291). Tom Penney observes that in online dating, "Bodies as presented under glass surfaces become manipulable, non-visceral, gaze-oriented visual bodies, for consumption as objects by narcissists through the personal screen" (Penney 2014: 108). Simian noted how he perfected his image on Instagram by using "photoshop a lot" because he felt "Instagram is all about the image you create" and this would allow him to produce a "really subtle change" to enhance his nose and chin. Commenting

on gay men's use of this app, Riccardo stated, "I think Instagram is never a good place to understand what kind of person someone is because it's highly curated, highly edited, and specific." Daniel perceived a "huge influence from Instagram" on dating apps such as Grindr, specifically referring to the way gay men adapted their images to represent idealized selves. Interviewed in 2012, Mario identified that on apps such as "Grindr . . . clothing plays so little part . . . it's just down to the body."

Conclusion

This chapter investigated the relationship that the gay men had with their bodies and how both self-perception and hegemonic gay ideals impacted upon their individual body projects. It considered how body type impacted upon personal dress choices. It also identified different relationships with somatic types and the ways men modify their bodies with tattoos. Lastly, it addressed the ways bodies were presented and perceived on online dating apps. The next chapter looks at the role of dress in the process of coming out.

4

"COMING OUT" AND FIRST GAY STYLES

"When I was growing up and exploring coming out, the clothes were sort of how you let someone know that you were that way inclined, because you couldn't do it so obviously . . . so nowadays kids don't need to do that because it's okay to be gay, thankfully, in most places." What is interesting in this quote is how Guy, a 40-year-old white British hotel manager living in Miami, highlighted the way in which clothing moves from being an identifier to an identity or vice versa, that by wearing certain clothes you become identified through them, reflecting discussions that have been apparent throughout the history of the study of fashion and dress. "Coming out" is the term most widely used to denote an individual self-identifying as gay to themselves and to others. It assumes that each individual will be either gay or straight and "out" or "in." The coming out stage of identity formation is often linked with an epiphanic moment creating a crucial turning point and which, according to Ken Plummer (1995), forms a positive identity from negative experiences.

Several models have been put forward to explain the complicated process of an individual coming to terms with their sexual identity and taking on a gay identity. In 1979 Vivienne C. Cass identified six stages to explain the coming out process, beginning with "identity confusion" and progressing through "comparison," "tolerance," "acceptance" and "pride" to "identity synthesis." Cass's model was subsequently modified and simplified into four- and two-stage models (e.g. Brady and Busse 1994, Giertsen 1989, Marszalek et al. 2004; see also Cole 2022 for more discussion of these models). Coming out can be seen as colluding with the idea that a person's sexual identity has been intentionally hidden and this positions them as being assumed to be straight unless it is announced otherwise, as in Judith Butler's (1990) heterosexual matrix. Andrew Reilly and Kimberly Miller-Spillman (2016) compare "coming out" models to the "Public, Private and Secret Self" (PPSS) dress model, developed in 1994 by Joanne Eicher and Kimberly Miller, to investigate the ways people have expressed the self in relation to these three states.[1] This PPSS model was traditionally applied in a heterosexual context, and Reilly and Miller-Spillman tested it in relation to coming out models to understand LGBTQ+ dress practices "before, during and after coming out" to "communicate 'gayness,'" "demonstrate 'belonging'" and/or to "be accepted or blend" (Reilly and Miller-Spillman 2016: 8, 9). A connection can be made here to Ruth Holliday's (2001) examination of the "queer self" and comfort (that will be examined in Chapter 10) as a link between the inside "imagined self" and the "outside of one's body"—expressing externally what one feels internally.

Thinking about coming out

A gay sexual identity, then, may be either suppressed or just not highlighted because of gender or sexuality expectations. This may often be enacted through family, culture, race, class or economic positions, where heterosexuality is positioned as accepted and homosexuality as deviant. Both Teddy and Sam described the disapproval they felt from their families and the Christian religious communities they had grown up in when they came out. Twenty-two-year-old Chinese Simian was not out to his family as they are "all Christians so they are definitely not okay" with homosexuality. Similarly 26-year-old Malaysian-Singaporean, Jun, was not out to his family, because even though they were not religious he felt homosexuality was "quite a sensitive subject" within Asian culture. Adam described how his Ethiopian parents initially responded negatively to his coming out, although his mother later became more accepting, leading to a conscious negotiating of his black and gay identities, especially when with family. Jack Halberstam highlights the abundance of writing that "foregrounds racial processes" and how shame (addressed further below) is implicated "in producing [gay and] queer identities" (Halberstam 2005a: 219). In contrast to Sam's and Teddy's experiences, for many of my interviewees their family situation was supportive and coming out as gay was not an issue in this context. As Sina recounted, he never felt the pressure to get married, have children, or live a straight life, and that "since coming out . . . they've always been supportive of the idea of a stable, healthy, monogamous relationship" that he himself felt inclined towards.

 The emergence of internet chatrooms and apps was highlighted by several men in relation to coming out or changes in their lives. For younger men who grew up with access to the internet, online space often facilitated their first contact with other gay people. Thirty-one-year-old Gino C recalled "when I first came out I used to go on chatrooms . . . that's how I met my first serious boyfriend." Daniel recalled that "[b]efore I started to explore the scene openly [in early 2000s] I was exploring the scene privately" and "that was pretty much always through the internet, so through chat rooms." He explained that he began to understand his sexuality by talking to others, "digitally engaging with my homosexuality and other homosexual people" online. Thirty-two-year-old Teddy recalled a "lightbulb" moment when he discovered Grindr in 2012, finding it both comforting and exciting to know there were other gay people he could access where he lived in the suburbs of Melbourne. In contrast Jordan, who came out almost a decade after Daniel, in the early 2010s, noted that "I didn't have Grindr or anything then. I probably didn't even know what that was at the time. I was probably too scared to use it." He had been introduced to other gay people by mutual friends through Facebook, and seeing other "out" gay people had made him feel less like "the only gay in the village," referring to Dafydd, the gay character played by Matt Lucas in the comedy sketch show *Little Britain* (BBC Television 2003–2007). Erich discovered the opportunities of online connections while on a trip to Europe after coming out. When he asked about the location of gay bars he was told "some cities have gay bars but for the most part you just go to any bar—we don't really have the gay bars" and "you do it online."

Teenage coming out and effeminacy

Historically, for some gay men effeminacy was a way into a gay lifestyle (Cole 2000), providing, for younger men especially, a first step in the process of making sense of their apparent sexual and gender difference and reconstructing their image of themselves. Remi compared his pre-coming out style that

was "very simple, very casual, kind of sporty . . . dull, black, navy" to that after discovering the gay scene, embracing "a more feminine side . . . wearing handbags, [and] very crazy shoes." Gino C expressed a similar investigation with "gendered" clothing on coming out: "it was like wham bam, I'm gay . . . I was really, really skinny and . . . I felt like men's clothes they didn't really fit me well [so] I would wear women's jeans 'cause I felt like they fit me better . . . looking back then I guess I was a little flamboyant." Like Remi and Gino C, post-coming out styles for Benjamin centered around a visibly effeminate style and behavior:

> I came out and I exploded. . . . Being young, single, at that time ready to mingle . . . I wanted to explore the gay sexual identity. . . . No tea, no shade, no pink lemonade . . . I was very aware that I was this new sexual being, and I wanted to show off as much skin as possible. So I would buy cardigans from ASOS that had sheer panels in the front and the back.

Benjamin went on to explain how this visibly out appearance had its drawbacks when he was the victim of a violent homophobic attack, after which he "became very subdued" but remained "silently confident." Some gay men continued this effeminate identity and style while others modified or moved on as their life paths progressed. For example, Gino C said that his "style toned down."

While some of the men I interviewed revealed an affinity with effeminate expression and style of dress that offered a means of communicating a gay, or "queer," identity, not all were comfortable with this. Jordan recalled when he initially came out, he was "scared of the scene . . . the culture . . . the campness," feeling that he was "kind of outside of it so you're not sure of it yet and you're kind of scared, and you're like, oh, I don't really want to be a part of that." Adam explained that he was interested in the idea that "camp" is often seen as an "act" and questioned whether for gay men they are "turning on the camp or the masculinity?" For Adam, "camp" was expressed through his behavior rather than through his dress. It could be proposed then that on the one hand, the adoption of effeminacy post coming out is a "false" persona or the presentation of an appropriated behavior as performative, and on the other is an acceptance of self, permitting behavior and an identity that feels comfortable, rather than feeling "shame" for this. Tobin Siebers proposes that the shame gay men might feel in relation to their effeminacy or femininity likely "derives from the unequal social mobility and cultural access produced by the equation between femininity and disability" (Siebers 2009: 209) leading also to attitudes of anti-effeminacy, femmephobia and femmeshaming (discussed in relation to social media in Chapter 3). This is echoed by Jennifer Moon who avows that "shame adheres to (or is supposed to adhere to) any position of social alienation or nonconformity" where effeminacy is viewed through this particular lens (Moon 2009: 359). Echoing theorists on shame discussed above in relation to body size, Jack Halberstam invoked José Esteban Muñoz's idea of "disidentification" to explain that "shame can be transformed into something that is not pride, but not simply damage, either" (Halberstam 2005a: 229).

Punk, goth, and emo as a defining teenage gay style

Although not especially, nor necessarily, effeminate in style, the adoption of a punk, goth, or emo teenage style did allow a certain flamboyance for some of my interviewees while they negotiated their positions as teenagers who were at different stages of acceptance of their sexuality and coming out as gay.[2] Matthew was a goth from around the age of sixteen, in 2000/1. He recalled that by the time he came out at nineteen he "had been goth-loving" for some time, wearing black PVC skirts and platform boots, with

make-up and dyed black hair down to his mid back, which he wore "all tied up." He went on to emphasize gender and sexual ambiguity within the goth subculture, where it was hard to identify who in that subcultural community was gay, partly because "the dress sense is very much about skirts and corsets and that sort of thing." Dex similarly talked of their engagement with a punk-goth-emo subcultural appearance as a teenager between 2009 and 2011: "I had black sort of goth industrial trousers that had ribbons and corseting and chains on them, and dog collars." Thirty-two-year-old Chris described his first look away from his family, around 2005, as a bit "emo," where he wore black clothes, "grew the fringe" long and straightened his naturally curly hair. Despite realizing this did not really suit him, he felt "it was a necessary part of me just experimenting." Brian M. Peters identifies emo as a predominantly white "subcultural and countercultural genre" that provided young queer males with "a means to express their desires as an aesthetic that counters both gay and straight mainstream visions of masculinity" (Peters 2010: 130, 135). He found that queer emo boys "reject[ed] both heterosexual and queer models of masculine normativity" (131) through their behavior and dress practices, similarly engaged in by my participants who identified their teenage styles as punk, goth, or emo. The dress items described by Dex and Chris's fringe align with the androgynous stylistic markers of (gay) emo identified by Peters (2010).

Alex J, a 26-year-old African American retail manager, recalled that at high school in Philadelphia in the early 2000s, many of his friends were "into a punk way of dressing" and that he began to emulate this style. When he came out as gay, his style choice was "very much like punk and gothic and black and tight and little t-shirts with stripes and oversized pants . . . so I was a little weird." He emphasized that he was one of the few black pupils at a predominantly white school and the adoption of this style as a black gay teenager highlighted his coming to terms with his identity and subject position. He compared his high school punk-inspired clothing choices to the "tight fitting . . . medium wash" boot-cut jeans from the chain store Express, and "grey t-shirt that was short sleeved, kind of tight fitted" he wore the first time he went to a gay club in Philadelphia. He articulated that he chose this less "punk" combination because it seemed more appropriate to what he understood was being worn at Philadelphia gay clubs from gay friends he met at a "LGBTQA youth" group. Experimenting with subcultural styles, such as goth and grunge, was a part of exploring identity and pushing at conventional dress boundaries for 34-year-old white Australian hospital administrator, Christopher, when he was at school and college. Wearing a "full pinstripe suit" when all his classmates wore "jeans and t-shirts" was for him "about trying to push the boundaries and also maybe challenge things a little bit." Here sexuality and gender blurring became fluid and offered a comfortable personal space in which to explore subcultural, sexual, and gendered identity. Comparably, 36-year-old Alex M recalled his teenage style that mixed the influences of skateboarding and punk music. He wore make-up and wanted to look "weird and glam," echoing Alex J's choice of the word "weird." Significantly, and in contrast to Alex J and Dex, he did not dare to wear these clothes to school as "people were kind of mercilessly cruel" about these alternative dress choices.

Although each of these men adopted a punk, goth, and/or emo dress style in their teenage years, they each grew up in different socio-economic and family environments. The adoption of such styles and subcultural belonging allowed each of them an understanding of their racial, gender, and sexual orientation subject positions within and outside educational environments and to challenge class-based familial expectations and societal gender-appropriate dress as they explored their teenage identities. For each of these gay men, such styles or subcultural belonging permitted them to stand out and marked their difference as burgeoning gay men and allowed a means of negotiating who they were "becoming." This proposition, initially proposed by Simone de Beauvoir (1953 [1949]) and built upon by subsequent feminist scholars, that one is not "born" but "becomes" a woman is relevant here in relation to the idea

that one's identity is not fixed but instead is always in flux, that it is changing and developing. This may be somewhat controversial in the context of the nature or nurture debate about whether one is born gay (Eagly and Wood 2013, Sullivan 1995). However, in terms of identity, even if one is born with one's sexual orientation already in place, then accepting this and growing into oneself and accepting sexual orientation as part of one's identity is an ongoing process. Speaking in relation to gender but equally applicable to sexual orientation, Butler (1986: 40) notes the not entirely conscious choice "that we make and only later realize we have made." Giles Deleuze and Félix Guattari suggest the importance of "becoming" when they state that "what is real is the becoming itself . . . not the supposedly fixed terms through which that which becomes passes" (Deleuze and Guattari 1988: 262).

Coming out and adopting gay styles of dress

For some of my interviewees, coming out was related to moving cities or countries where they could express their sexuality through style choices, often coming out away from family and childhood friends. Relocating from Chenai, India, to Singapore in the early 2000s to attend university, 35-year-old Raj felt that he could come out as gay away from his home and family. He recalled the predominant dress choice of Singaporean gay men at that time as "really tiny shorts," a style he found "quite interesting" and wore because he "thought that was sexy." As he became more integrated into the Singapore gay scene, Raj became increasingly conscious of his Indian heritage, and began to wear garments made from the hand spun Indian fabric Khadi "that would make me stand out." The influence of ethnic and cultural heritage on teenage and post-coming out dress choice was explained in a different context by Chris. He recalled the way that his Sri Lankan heritage played "a big part in coming out" and "lots was suppressed." Moving away from family who "didn't really get" him allowed him to develop his personal style as a young gay man. He recalled wearing a black velvet jacket with a white shirt, a slim tie, tight skinny black jeans, and black shoes to a family funeral that caused a "huge argument" between him and his father over acceptable choices. His father felt this outfit was "offensive" and this was "to do with both culture and this idea he did not want me to look gay."

Twenty-three-year-old Sanjeeva recalled that when he was at school in Kuala Lumpur it was "very obvious to people that I was the gay one. I would wear bow ties . . . fancy blazers and things." This was a dress choice that he felt reflected his newly acknowledged and out gay identity. Leaving Malaysia in 2014 to attend London's Central Saint Martin's, Sanjeeva initially followed an expensive "gay fashion student" style, but stopped because he felt this did not reflect his "true" identity as a gay man: "I'd rather buy something from Topman or Top Shop that looks good and looks appealing to me . . . I'm going to stay true to myself." Also moving to London for university in 2014, Simian changed his style to wear skinny jeans. These replaced the hip-hop-inspired baggy styles popular amongst his classmates in Beijing in the early 2000s, that he had also worn at that time, not being out as gay at school. Nineteen-year-old Josh recalled that, on non-uniform days at school, wearing skinny jeans as opposed to tracksuits set him apart from the other boys and he was bullied for his appearance, an experience similar to that of Alex M at the hands of his "mercilessly cruel" classmates.

Changing his look from goth-punk-inspired to one that was much more influenced by pop culture and sportswear marked a moment of coming to terms with his sexuality for Rafal, while still living in his native Poland. He recounted how, although he had had girlfriends, he began "a search for potential [male] partners" in his late teens. He described wearing "Adidas kind of long-sleeve tops with boot-cut jeans

and then Puma trainers'; a combination that resembled Alex J's when he first attended a gay club. Both Daniel and Alfie recalled the importance of sportswear elements in their teenage clothing choices. Purchasing a pair of Converse All Star trainers, was, for Daniel, "a defining moment" choosing a garment that was *seen* as quite alternative, a bit emo," that coincided with awareness of his sexuality and "starting to find a sense of individuality." Alfie's choice of a "kind of vintagey Adidas" sportswear combined with clothes that he altered, by removing the sleeves or cut down into shorts, was important to him because it "meant something." Although in retrospect "it was absolutely ridiculous," he said that he felt that at that point he was "dressing how I thought a young gay man" dressed.

The above opinions and experiences echo Elizabeth Wilson's argument that dress serves to "stabilize identity" (Wilson 1985: 12) and relate to Dennis Altman's belief that whether people are "born" disposed to homosexuality, "the adoption of a homosexual identity involves a series of choices" (Altman 1982: 156), including how one physically appears. Just as important as identifying and stabilizing an individual identity is the need to define oneself as part of a group and this often manifests itself through dress practices, as evidenced above. María Elena Larraín notes that, through belonging to a group, "subjective identity is strongly influenced by the ideas, language, appearance, taste and music the group defines" (Larraín 2012: 146), echoing ideas of habitus and capital discussed in Chapter 1. Attempts to assimilate, conform, and fit into a particular gay scene or subculture had a particular impact on how gay men dressed when they began to come to terms with their sexual orientation or first encountered the gay scene. Jordan recalled that he had had a nose and multiple ear piercings around the time he came out as gay aged around sixteen, as a connection with the gay subcultures that he was newly discovering. Citing Jack Halberstam, Fenella Hitchcock and Jay McCauley Bowstead note how the "idealisation" of gay or queer clubs and scenes is "connected to a 'metronormative' myth of urban nightlife which maps migration to the city to the 'coming out' narrative" as evidenced in examples above and relating to discussions in the next chapter (Hitchcock and McCauley Bowstead 2020: 37).

Both Greg and Joe H recalled that the predominant style on Sydney's and Philadelphia's gay scenes when they came out was jeans and t-shirts with "white tennis sneakers, nice cropped hair, perfectly trimmed facial hair." Greg quickly realized that he did not have to fit this stereotype and that it was fine for his own subcultural affiliations and musical tastes to inform how he chose to dress both on and off the Sydney gay scene. The items of clothing and adornment identified by Joe H and Greg placed men within "collective identities" that Kath Weston (1991) argues are key to the definition of "gay community." The dilemma between conforming and not raises the potential conflicts that exist when individuals negotiate between a collective and individual identity: "the extremes of uncompromising individuality and total belonging" (Bauman 2005: 30). The idea of self-perception and understanding of how one's own "identity" and subject positioning intersects with the established commercial gay scene and its perceived conformity to types and roles was important to 24-year-old Patrick's place within the gay community/scene in Sydney. He described how, even though coming out to family was not an issue, finding his place within the gay community took a long time as he was not a "type." "I wasn't a twink really," he recalled, "I was young, but I was, I had a brain," emphasizing the stereotypical categorization of a young, pretty but not especially bright gay man, introduced in Chapter 3.

Relating to ideas of belonging, some of my interviewees discussed how they altered their appearance on coming out to fit with a particular scene or community's ideas of "attractiveness." TJ related how, after coming out, he became very conscious of his body and the role dressing sexually played in his self-acceptance: "I was able to express myself in my clothing . . . my clothes became a lot tighter and [I began] wearing less clothing . . . I stopped wearing underwear and I would make sure my jeans were

very low." The outfit Benjamin chose to wear to London gay club GAY Heaven on his eighteenth birthday echoes TJ's changes to his appearance. Having dyed his hair blond and shaved the back and sides, he wore "a white tank top, with white skinny jeans . . . because I knew I'd been seen . . . it was about showing body." Also considering sexual attractiveness as a key factor in appearance after coming out, Gareth emphasized how he began "dressing in a way to attract guys without even realizing it." Feeling "a bit more confident" with his body, his clothing choices changed: "I was aware that I was quite a skinny guy, but if you wore a tighter t-shirt you looked a bit more muscular." That this was what was considered attractive on the Sydney gay scene that he was exploring resonates with Greg's experiences above. "After I came out, I was like 'OK you need to step this up, you can't be on the gay scene and looking terrible.'" Erich explained how he swapped the relaxed comfort of sweatpants and t-shirts for better fitting jeans and button-down collar shirts. Roberta Sassatelli (2011) identifies fit to mean "something that conforms well to the particular shape of one's body" and that "has enabled one's body to come across as sexy"; reiterating the descriptions given by my interviewees. The choices gay men make over the fit of clothes on their body will be discussed further in Chapter 10 and dressing for sexual attraction in Chapter 6. The formative dress choices of young gay men and the importance placed upon the reflection of an individual or shared identity is summed up by Teddy, who reflected that "as teenagers you want to be accepted as part of the group" but later "you just want to be yourself [and] express yourself." While he admitted that he may have been making this "too black and white," his musing chimes with Sophie Woodward's observation that for her female respondents their teenage years were "characterized by experimentation and a *series* of fashions" marked through "conformist participation and subsequent rejections" (Woodward 2007: 121, emphasis added).

Coming out—an ongoing process

Wayne Brekhus observes that "traditionally, we think of gay identity in terms of the closeted-out continuum and emphasized visibility of identity as a 'single axis' that through progressive movement leads to an ultimate 'endpoint' of 'high visibility'" (Brekhus 2003: 71). Many of the younger men discussed coming out as being a gradual process where it became apparent to family and friends as well as self. Several noted how even if they had one or a series of "significant" coming out moments—to friends and to family—there was still a constant ongoing process, where every new social situation required a consideration about making an "announcement" or somehow indicating sexuality. Erich articulated James Ward and Diana Winstanley's (2005) challenge to the "momentous" occasion of coming out by describing how when he met new people he was "always careful of how much I say, I would never go back in the closet and I am never going to lie, but I am not going to throw my business out there." In the context of this ongoing coming out process, Peter Robinson noted how some theorists rejected coming out as a means of declaring one's homosexuality "on the grounds that the very concept is 'heteronormative,'" deferring to "dominant 'heterosexist' narratives. As such these theorists see coming out as 'unnecessary'" (Robinson 2008: 9). Several men talked about the various stages of their coming out and incidents or occasions that precipitated feelings of shame and guilt. Greg and Daniel, for example, emphasized their move between cities and the countryside and beginning new jobs as ongoing occasions for coming out across a life path.

Relating to the connection between coming out and becoming, discussed earlier in this chapter, Lake Dziengel (2015) developed a "Be/Coming Out" model to further explain the complexities of both coming

out as, and living as, an LGBTQ+ person in a predominantly heterosexual world. As Alan Butler emphasized, "the reality of most LGBTQ people's lives means that they are required to come out again and again after assessing each situation and particularly considering the specific space they are inhabiting" (Butler 2020: 59). This is the case for banker Matt, particularly in a work context: "people can definitely make their own minds up as to whether Matt is gay or not . . . for me the rule is, like, until I get to know someone at work I'm not going to go talking about what I do behind closed doors." This concern potentially arises from normative constructs, such as heterosexuality, not needing definition, unlike homosexuality that is positioned as non-normative, requiring explanation and accountability. This might then relate to how an individual is "read" or perceived through their dressed appearance. Taylor noted how his particular style of dress, comprising brogue shoes, corduroy trousers, and oxford cloth shirts, meant that he did not look obviously gay and "people assume I'm straight more than gay" although "gay men always seem to know . . . a gaydar thing." He related this to his feelings of awkwardness when people wrongly assumed his sexuality and having to come out "over and over again." He expanded on this point saying that he thought "if I am uncomfortable with someone not knowing, what if they feel uncomfortable for knowing and I sometimes feel guilty for having to tell them." Matthew Todd explored issues of guilt and shame associated with growing up and coming out, highlighting that LGBTQ+ people "internalize the negative feelings and believe that it is *we* that are wrong. What we feel goes from guilt over something we can correct to shame about what we fundamentally are" (Todd 2016: 73). Eve Kosofsky Sedgwick identifies the way in which western society has conventionally distinguished between guilt and shame, where the latter "attaches to and sharpens the sense of what one is" whereas the former "attaches to what one does" (Sedgwick 2009: 51). In this sense, Taylor did not feel shame over his homosexuality but guilt at having to announce this to people in a continuous coming out. The essays in Halperin and Traub's edited book explore how assertions of gay pride needed to be explored in the context of "ongoing struggle[s] with shame" and the relationship to identity formation and politics through a lens of intersectionality (Halperin and Traub 2009: 4). Although I discuss shame here in the context of coming out, academic and populist discussions acknowledge and explore its impact at all life stages.

Coming out in later life

For most older men I interviewed, there *had* been a significant coming out moment in adolescence or the early twenties, during the latter decades of the twentieth century. Marthe Giertsen and Norman Andresson (2007) question whether any of the coming out models took enough account of social and socio-historical contexts, which may have relevance for individuals who do not "come out" during adolescence or do so after being in heterosexual marriage. Andrew, a 44-year-old white Australian teacher, living in London, felt "in some ways immature" when he formally came out at the age of 30, noting perhaps it was "quite emotionally stunting . . . arriving at that position at a later age." He linked his coming out with a particular moment in London's queer nightclub culture in the early 2000s, where extravagant fashions were prevalent and "it was so exciting . . . going to The Cock and NagNagNag." This club scene is discussed further in the next chapter. Coming out in his early thirties, like Andrew, 45-year-old Darren felt that his style of dress did not change. He continued to wear the formal style that he had developed in both a social and work context and when he had been in heterosexual relationships.

Israel, a 66-year-old Cuban lawyer, also came out later in life, in 2005, after having been in a heterosexual marriage. "It was," he recalled, "hard for me to say I'm gay, but I knew I was." He went on

to note that for him he felt he was "gay because I sleep with men . . . not because of how I dress," thus tapping into debates about whether being gay is purely a matter of sexual attraction or more broadly associated with identity and culture, as discussed by David Halperin (2012). Like Israel, both Brian C (a 51-year-old white British marketing specialist and color consultant) and his partner, 54-year-old Michael B, had been married to women. Coming out for Brian C and Michael B was both a gradual and joint process. While Brian C had always been a stylish dresser interested in fashion, both he and Michael B acknowledge that their style of dress became more colorful and adventurous after splitting up from their wives and publicly coming out. For Michael B, coming out gave him the freedom to add more interesting detail to his clothes; wearing shirts with "interesting stripes" or "having a contrasting color in the cuff and the collar." "I thought I can start to express myself now, as a gay man," stated Brian C. He explained that having been identified as a *Gamin* personality archetype by the image consultancy House of Colour, he had "some professional guidance" on how he could be "authentic." He realized he had not "been living as an authentic man, authentic person" and this could be explored through the "fun elfin style" associated with Gamin, that he felt was "actually quite gay."

Conclusion

Coming out, like the idea of "becoming," can be considered not a single event but a progression where one stage leads to another in an ongoing process of development, relating to Sara Ahmed's (2006) proposition of queer as a relational process of becoming rather than an identity. Coming out as a gay man, whether as a momentous series of announcements, a subtler signification, or continuous consideration of every social occasion, is important. As this chapter identified, dress choices are particularly important in articulations of understanding one's subject positions and the ongoing processes of becoming and coming out. In this chapter, the interviewees discussed how they used their dressed appearance as they came to terms with their sexual orientation to stand out from the hegemonic and conformist styles of their families and schoolmates. It also explored how they used clothing styles both in relation to personal intersectional positionality and to find a sense of acceptance and belonging, to fit in with the gay people they met and the scenes and clubs they began to explore and attend. Gay bars and clubs attended by my interviewees and the importance of gay scenes as sites for community and identity expression through dress will be explored in the next chapter.

Notes

1 "The secret self is that which is hidden from others. . . . The private self is that which is presented to friends, family or other intimates. . . . The public self is that which is available for others to see" (Reilly and Miller-Spillman 2016: 10–11).

2 There is a plenitude of academic literature on punk and goth has been discussed in detail, particularly by Paul Hodkinson (2002) and Andrea Harriman and Marloes Bontje (2014). Emo can be defined as contemporary emotional punk, stylistically and musically emerging from punk and post-punk goth and skater styles, that was established by the late 1990s.

5

BARS, CLUBS, AND SCENES

"Twinks, bears, East Village types, Chelsea Queens, Hell's Kitchen Queens, Bushwick Gays, Williamsburg Hipster Gays." In this list of types, cliques, tribes, or subcultures, Lee begins to equate certain styles of dress with particular gay bars, clubs, and scenes in specific parts of New York. Metropolitan gay bars and clubs have historically offered sexual minority communities the opportunity to socialize and perform their identities in ways otherwise not safely open to them (Chauncey 1994; Cole 2000; Houlbrook 2006; Wotherspoon 1991, 2016). These were places in which gay men were able to dress in ways that indicated their sexuality and that may have differed from the other predominantly heterosexual spaces of their lives. In discussing Australian gay scenes and spaces, Peter Robinson draws on Erving Goffman's proposition in *Stigma* (1967) that those who shared stigmatized identities might well socialize together and therefore be seen by "outsiders" as the same (Robinson 2008: 12). Goffman argued that this constituted an illusion, as a "pattern of mutual interaction" or "capacity for collective action" may not be present (Goffman 1967: 35). According to Benedict Anderson (1991), a national or sub-national consciousness increases upon migration to a more cosmopolitan area, where one comes across people from other sub-nationalisms. Anderson was describing migration in terms of national migrations between countries to create the largely imagined idea of community, but this could equally apply to the ways in which gay men have, both historically and in a contemporary context, been attracted to big cities in search of like-minded people who shared their sexual identities.

This connects to ideas of a cohesive gay (or even LGBTQ+) community, which David Carr argues forms "when it gets articulated or formulated . . . by reference to the *we* and is accepted or subscribed to by others" (Carr 1986: 22, emphasis in original). Robinson identifies that the "gay community" was understood to be "a loose collection of organisations, the sense of public service and social awareness" (Robinson 2008: 95), echoing John D'Emilio and Estelle Freedman's 1997 definition of the gay scene as pubs, clubs, bars, and sex venues where gay men "socialise and may consume alcohol, drugs or sex" and that "all sites of gay sociability are sites of consumption" (D'Emilio and Freedman 1997: 358). While not specifically discussing gay men, John Irwin defines "scenes" as providing individuals with "a pool of shared categories, a set of values, beliefs, symbols, and terms which will allow them to deepen their interaction" (Irwin 1977: 23, 24, 62). David Hesmondhalgh (2005: 22) identifies that the term "scene" became prevalent in the study of the interplay between popular music and youth or subcultural styles, while Richard Peterson and Andy Bennett describe "widely scattered local scenes drawn into regular communication around a distinctive . . . lifestyle" that they define as "translocality" (Peterson and Bennett 2004: 6). This translocality is reflected in the descriptions, discussions, and comparisons in this chapter of the ways in which gay men dress to frequent bars and clubs. I use "scene" in the context of LGBTQ+ bars and clubs here in relation to the use of "community." In her investigation of queer club cultures, Fiona Buckland draws on Lauren Berlant's and Michael Warner's use of the concept of "lifeworlds" as an alternative to "community" as this is more inclusive and fluid, encompassing "space[s] of creative, expressive, and transformative possibilities" (Buckland 2002: 4). Buckland links the role of clothing to

these expressive and transformative possibilities through the "ritual" of dressing to attend clubs. Erika Summers-Effler (2006) suggests that rituals generate emotions among people, adding to their significance, while Hans-Georg Soeffner (2018) identifies the importance of a social order that is followed to ensure that common rituals and processes can be defined and maintained adequately. The selection of appropriate clothing/styles in advance of attending particular gay or queer bars/clubs is key to an individual's engagement and sense of belonging in specific venues.

Connecting to Lee's list of tribes, types, or subcultures is Michel Maffesoli's (1996) definition of "tribes" that has been influential in subcultural discussions. His "neo-tribalism" is characterized by fluidity rather than rigid boundaries, as well as "occasional gatherings and dispersal" and "what is important is the energy expended on constituting the group as such" (Maffesoli 1996: 76, 96). The published work that examined subcultures and subcultural styles is broad and complex (for example Gelder and Thornton 1997; Gelder 2005, 2007). Ken Gelder's inclusion and discussion of historical gay and lesbian subcultures (2005, 2007) clearly demonstrates an attempt to redress an imbalance, where gay men and lesbians were left out of studies of subcultures. Whilst it could be argued that we are post-, after, or beyond subculture (Muggleton 2000, Muggleton and Weinzierl 2003, Bennett and Kahn-Harris 2004, Huq 2006), the fact that gay culture is now perceived as hegemonic in its own right—rather than being "subcultural" as argued previously by the likes of Jeffrey Weeks (1991) and Alan Bray (1995)—has led particular groups of gay men to create new masculinized "subcultures" (see Cole 2008). Raising issues of "queer" within subculture, Jack Halberstam, notes "[q]ueer subcultures illustrate vividly the limits of subcultural theories that omit consideration of sexuality and sexual styles" and how queer subcultures are less easily located in relation to "so-called parent cultures" as they question the very definition of parent cultures and the relations to "cultural expression" within and outside any cultures that could be identified as hegemonic and/or "parent" (Halberstam 2003: 320).

Comparing categories of bars, clubs, and scenes

In considering bars and clubs in the cities in which they had lived, many of my interviewees identified the variety of styles that were worn across the various parts of the gay scenes in those cities. "I don't feel like there is a distinctive New York style but there is [sic] different little groups," Joe H observed, identifying an "athletic look" in Hell's Kitchen and a hipster look of "skinny jeans and gingham and plaid, skull hats and lots of chains and lots of bracelets" in Williamsburg. Identifying some of the same groups, Carl G elaborated: "A Brooklyn hipster art fag is very different than a Chelsea boy. Chelsea boys are more fitness based—tight tees tight jeans, Abercrombie . . . Brooklyn hipsters: skinny jeans, casual purposeful messiness." The common element Jon saw across Melbourne was an obvious, visible muscularity: on "the north side one would be the hairy, muscly guy, whereas the south side would be the tanned muscly guy." Jon described the clientele of bars and clubs on the south side as "preened and proper and pruned and plastic fantastic" in contrast to the "more alternative, grungy, a little bit more hipster. Hipster grunge" of the north side, echoing Joe H and Carl G's descriptions of New York. Agreeing with Jon, Krysto identified "your Calvin Klein . . . your Muscle Mary" of the south side, and on the north side "Fitzroy, Brunswick Street would be a little bit more grunge" and "Smith Street . . . more alternative gay." Sam explained that clubs in the St Kilda area of South Melbourne were frequented by "muscle guys who take their shirts off at sort of every given opportunity." In contrast he identified The Laird, on north side, as having a men-only entry policy which reminded him of the one gay club in Adelaide (where he was raised and first came out in the early 2000s) that was "sort of chaps and leather and big burly men." These two

styles and looks were identified frequently in interviews and are discussed in more detail across cities below. Raj, who moved from Singapore to Sydney in 2010 because "it is the gay capital of Australia," described differences in gay styles in various parts of the city. The gay men in Surry Hills were "all pretty and beautiful," taking advantage of the weather, spending "their time outside running." Whereas in "Erskineville slash Petersham," he "categorize[d]" the men as bears. He also identified a cross over between the bears and hipsters in Newtown, and that the "pretty boys of Surry Hills" were "embracing the beard now and hipster look." This differentiation with Newtown as "queer" and the more traditional center of gay male life—Oxford Street—as "gay" is highlighted by Gary Wotherspoon (2016: 268). Raj's descriptions of this segmentation echoed those made about New York and Melbourne.

Brian F, a 33-year-old white American architect, made comparisons between cities in which he had lived, equating the gay style of "sleeve tattoos and lumberjack hats" in Portland with Brooklyn's gay hipster style and the "clean cut and preppy" styles of Washington DC with New York's Hell's Kitchen, echoing Joe H. Identifying a similar style in Chicago to that which Brian F observed in Portland, Eric, a 49-year-old white American writer and editor, recalled gay men "loving plaid shirts, lumberjack things. They're very much involved in that kind of stereotype." He felt there was an element of irony, but of the kind that "kids in New York wouldn't really do." He attributed this difference in "ironic" gestures to "taste levels being much more sophisticated" in New York. Marcia Morgado (1996) identifies irony as a characteristic of post-modern fashion, in which meaning is outweighed in value by aesthetics. Eric assigned this sophistication "partially [to] a money thing as there is more money in New York" and the prevalence of "you can't come in here like that" dress codes in operation in New York. He contrasted this with Los Angeles gay bars and clubs where "there are not many places that have a dress code." Kym, a 55-year-old white New Zealand-born photographer, explained an incident where he was criticized by another customer at a leather and camouflage themed night at The Laird for not dressing in accordance with the required code. Wearing "a pair of punk black stovepipes, Doccy's up to mid-calf and an army camouflage shirt," he questioned the entry policy and was told it was "leather *or* it's camouflage." Kym's experience highlights the negatives associated with strict door policies, the exclusive men only policies, or the femmephobic masculinist emphasis of certain bars as well as the unofficial attitudes towards larger body types and self-identifying effeminate individuals. However, entry policies exclude those who would not appreciate or conform to the specified nature of a particular venue. Phil Jackson observed that clubs with dress codes or door policies "created big variations" in how people dressed, whereas no policy meant that "people tended to conformity'; both conformity and difference may be seen as benefits in the eyes of the various venues" clientele (Jackson 2002: 47). Jeremy Atherton Lin saw how "Inclusivity could be enforced by a strict door policy" where "*inclusivity* might not mean *everybody*" but "could indicate *the rest of us*" and differentiate a "questioning person from [an unwelcome] voyeur" (Atherton Lin 2021: 14, emphasis in original). Despite dress code policies, Eric, Brian F, and Kym emphasized how New York and Melbourne provided locations in which they could be with like-minded and comparably dressed gay men.

Like the variety gay scenes and styles interviewees described in New York, Melbourne, and Sydney, Adam detailed a diverse range of venues in London, noting how "there were more subcultures in London" and in different areas such as Soho in Central London, Vauxhall in the south, or the East End "you'd see specific types of style." Alfie reflected on the changes he perceived in London's gay clubs from the time he first moved to London in 2005 to when he was interviewed in 2018: "clubbing in the way that I used to do it, it kind of doesn't really happen anymore . . . there was . . . Heaven, G-A-Y Late, Ghetto, I kind of caught the end of like BoomBox . . . Ghetto doesn't exist anymore. When I was younger they felt more fun.'[1] He perceived a greater variety of venues and dress styles in London when he first began clubbing, but felt that

in 2018 "everyone dresses the same and they're all really young" wearing "slinky Hawaiiany open neck shirts." Similarly, Andrew noted differences between his clubbing experiences in London during the early 2000s, at clubs like BoomBox, that was about "hearing good music, wearing great clothes, meeting amazing people" and scenes more associated with sex and drugs. He noted that what men on this scene wore was "so pared back" and was "about their bodies, so they are just wearing not much." Conscious of sounding judgmental, Andrew concluded that this was "the antithesis of what I like." Here, Andrew also invokes the subtle differences that sometimes emerged in interviews between dressing to please oneself, for other "fashionistas," and dressing for sexual attraction (that will be examined in Chapter 6).

Echoing the variety of scenes but relating this to the predominance of one particular venue, Barry noted that in Glasgow in Scotland in the mid-2010s, there was one large nightclub that incorporated six different "venues," each playing a particular type of music and attracting particular clientele: "you've got these people, I don't know, dancing to club music upstairs and then downstairs there's kind of these pups in rubber . . . you've got a cabaret bar, you've got a lounge . . . you've got hip-hop club and then dance club. It's beautiful actually." He went on to make a comparison with Scotland's capital city Edinburgh, which he said was "not very gay at all." In contrast to Barry's opinion of Edinburgh, Christopher recalled that when he was living in the city in 2001/2 it offered a wider variety of gay venues than he had been used to in his hometown of Canberra that had only one gay club that he had been frequenting since the age of sixteen and where different styles of dress were worn. Offering a similar perspective, Daniel described clientele in the small Dublin gay scene when he was at university and first came out around 2005, as "everyone was very samey." He noted that the scene was "quite commercial," playing pop music such as Britney Spears, that "was of no interest to me so I felt I wasn't really part of that scene." He contrasted this to his summer in London, where he was introduced to The Ghetto club in Soho, which appealed to his less commercial tastes in music and fashion. When he moved to London permanently in 2010, he continued to frequent The Ghetto as well as "places like The Joiners Arms or The George [and Dragon] in East London" that he felt were different from the commercialized gay scene of Dublin or Central London and had a more inclusive and alternative vibe (discussed further below). Dex, who had performed in many gay venues across Britain in 2017–2018, described how they saw some arty styles in Leeds and in the northern quarter of Manchester. Like Christopher, they compared these to other cities, such as "Sheffield, [where] I guess people don't dress up as much" and Manchester's Canal Street "which is the gay village. I guess there's more uniformity there." These variations fit with Bev Skeggs's observations that "Differences *and* connections are drawn in the gay space" (Skeggs 2004: 162). For Barry and Christopher these connections between venues in different cities provided fond memories, while for Daniel the homogeneity of the Dublin scene led him to seek out different alternatives when he moved to London.

Comparing the "extreme dressers" and club kids in cities like London and New York to the clientele in more mainstream clubs in a variety of European cities, Rafal observed that in having "access to all the other club kids in other places . . . you see that they've actually got the same style." He also identified broader homogenization, where "people are dressing the same everywhere now." The seemingly opposite ends of clubbers" style discussed by Rafal are echoed in Antonio's recollection of his experience at Berlin club Egg, which he described as "very mixed" with "four or five rooms and then you'll have drag queens and queers and club kids, and then you'll have . . . gender heteronormative people coming for the techno music." This format of multiple rooms each playing different music with associated clientele and dress styles correlates with Barry's description of Glasgow. Like Barry's description of the club "complex" in Glasgow and Antonio's recollections of Egg in Berlin, Lukasz recalled a similar club with three "different stages, with three different kinds of music" in Krakow. He described this as being similar in some ways to

the larger clubs in many other European cities which he visited that were attended by "similar looking guys." Having lived briefly in Istanbul, he identified "mainstream gay venues" there that were like the club in Krakow and those in other European cities, in that the Turkish men would wear "tight stuff."

Barry also made comparisons between the arty, creative East London queer scene (discussed below) and some Berlin gay venues but felt that what he observed in Berlin was "this whole same kind of black sportswear kind of look." Dex similarly observed "a real adoption of working-class sportswear inflections and cockney working-class styles into queer dress" in nightclubs in London. Echoing Barry's observations, Chris felt that "the Germans, they take their clubbing seriously . . . It is so strict and you wear black," but also elaborated that he felt the Berlin gay scene was "fantastic and crazy . . . It is amazing and very sexy." Alex B noted that in many London clubs, sportswear was derived from *chavvy* working class style,[2] "but more fashion, so they're really into sneakers, so Nikes and every sport logo. And I think that's very London." He felt that gay style in East London was particularly "sporty, sneakers, hats, baseball caps, things like that, which you wouldn't see in New York. Unless you went to a black hip hop club." Picking up on the combination of sportswear and hip-hop music, Alex B's partner Florent, a 37-year-old white French journalist, recalled that the first parties he went to in Paris were intended to make hip-hop and R&B music available to gay people. "I think it played a role in me identifying and not being freaked out about drag queens and latex," which he had associated with gay club clientele, "because really I was dancing with people who were wearing the same as everybody else in the street."

Discussing Miami, James noted "the styles" of white, black, and Latin gay men in the gay scenes in the city were "just totally different," unlike other "marketplaces." His use of this term relates to Dwight A. McBride's investigation of the "gay marketplace of desire," in which he notes how race, gender, body type, age, style, and clothing choice "work to construct and constitute what we come to accept, and in some cases to celebrate, as our value" (McBride 2005: 89). Milty picked up on this racial segregation, noting that "the culture and sexuality are both separated" in Miami. He stated that at LIV nightclub at the Fontainebleau Hotel there were separate "urban events and gay nights" intended for black and Latin clientele. Milty explained that where he lived in the Brickell area of Miami there was a large community of "closeted Latin suppressed gay men" at which he expressed incredulity given the very large population of out gay men in Miami. Thomas P. Duffin (2016) highlights the complexity of black and Latin male sexual identities and same-sex sexual activity, where "gay" was associated with feminine looks and behavior as well as a passive sexual role (see also Cole 2019 for further discussion). Buckland (2002: 150) relates the "pleasure [that] was created through border crossings" in bars with an African American and Latin clientele to José Esteban Munoz's identification of resistance to the "reductive multicultural pluralism" experienced by people of color in the United States (Muñoz 1999: 147). Sara Ahmed notes how "nonwhite bodies do inhabit white spaces. Such bodies are made invisible when we see spaces as being white, at the same time that they become hypervisible when they do not pass, which means they 'stand out' and 'stand apart'" (Ahmed 2006: 135). It is possible that Milty did not consider in detail the complex intersection of race, ethnicity, gender, and sexuality. Other black and Latin men interviewed discussed the cultural attitudes towards homosexuality that impacted upon their identities and behaviors.

Muscularity on the global circuit party scene

Connecting closely with discussions around muscular bodies in Chapter 3 and McBride's "marketplace of desire," several interviewees noted the prevalence of this body type in bars and clubs in various cities. A

common connection made by interviewees about Los Angeles was between the gay scene and the particular muscular body-culture of the city, revealed through the choice of clothing. Alex J, Erich, Sang, and Diego all observed that the casual styles of tank tops, V-necked t-shirts, and shorts worn by muscular bar clientele was influenced by the warm climate of Los Angeles, summed up by Diego: "I do see a lot of tank tops and athletics, the muscle guys like to show off as much as they can, you know" and that this was "because of the weather," meaning styles were "more relaxed." James stated that Miami's gay scene was "all about the body and it's not necessarily like that in the other markets." Joe H's description of gay men in Chelsea emphasized an athletic style of "tank tops showing off their muscles," emphasizing how the body was "the prime reference point" (Buckland 2002: 10). Gino C noted the relationship between body size and being well dressed at circuit parties in Miami, "most of the people that come down are white males that have a look . . . most of them are muscular, or really skinny twinks, and they all have really nice hair, and they have really nice clothes." Joe H observed that "gay men who go to circuit parties, [are] extremely ripped and work out a lot because it's shirtlessness . . .they talk about how they judge others who aren't beefy and they are always comparing muscle size with the person next to them." Buckland connects the physicality of venues with the ways in which dressed bodies move through "queer" spaces, revealing agency of both "compatible" and "contesting forces" that form queer "lifeworlds" (Buckland 2002: 18).

The emphasis on muscular body culture was also noted by my Australian interviewees in relation to Sydney. Several noted how gay men with muscular bodies dressed in ways to reveal or show off their muscularity, especially in gay clubs. "I think if you've got a hot body, you can show it off," reflected Hayden, a 43-year-old white Australian working in information technology, recalling that the muscular gay men at Australian parties, who had "perfectly chiseled" bodies, "built like brick shithouses," had "less on than anyone else," wearing "really, really, really small shorts or practically underwear, even though it's not an underwear party." Gareth remarked that "[t]here is a big focus on physical fitness" in Sydney and like Los Angeles "there's a strong beach culture . . . but . . . gay guys transfer that clothing to the bar scene" with men "wearing singlets and people showing off their bod[ies]." Marcus identified a particular Sydney style of wearing "wresting singlets" but "pulled down so they're just bare [chested]." Fifty-year-old white Australian IT worker Shane's description of Daywash dance parties[3] echoed Gareth's: "it's a look where everyone's got their shirts off, everyone look at me type situation." The way in which Sydney's gay men's style was served by shops in and around the Oxford Street area was discussed by both Gary and Ken, a 67-year-old white Australian clothing retailer. Owning the long-standing gay-oriented shop "Aussie Boys," Ken explained how he observed fashion trends and bought from young designers to provide body-conscious clubbing outfits and the latest underwear for his clients. Both noted a change following the 2000 Olympics in terms of clientele and competition from international chain stores such as Top Man, with local gay-focused stores closing. Ken also linked this to the decimation of the Oxford Street gay scene through the lockout laws (discussed below) and the commercialization of previously gay-focused events like Mardi Gras. For Patrick, who attended university in Sydney between 2008 and 2012, Sydney's main gay scene was "not so much about the clothing I think, it's about the attitude and then the clothing extrapolates upon that." He observed, like others, the body conscious style but also that there were "strong subcultures of twink and bear" in Sydney.

Jun frequented London's circuit party scene which was full of "muscular buff bodies" where he fitted in "in terms of dress sense, although not body types." He explained how London's party circuit was predominantly a "white" scene but he liked "to be the token Asian kind of thing" as "it's kind of this exclusivity, so it's quite exciting." To attend these clubs, he favored a "fitted T", as he liked upper body garments to "hug" his body, so for "going out I'd definitely wear something that's a bit tighter" (see Figure 5.1).

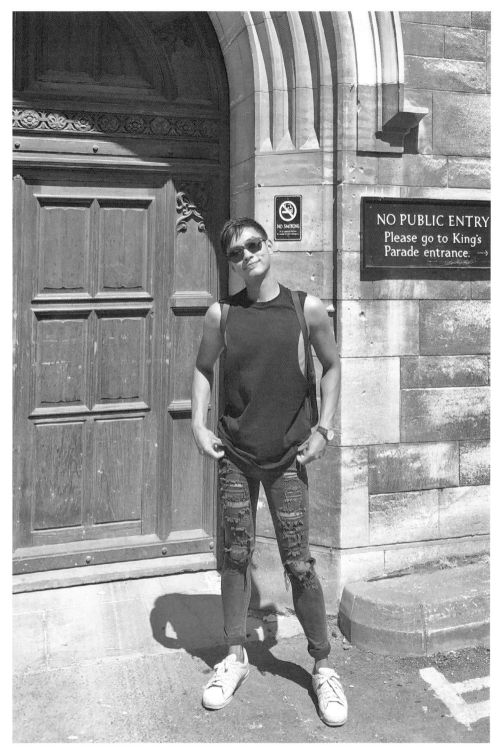

Figure 5.1 Jun wearing T-shirt and jeans he also wore to go clubbing. Cambridge, July 2018. With permission of Jun.

Jun's embodied experience relates to Phil Jackson's proposal that knowledge "becomes entrenched in the body over time and re-orientates the body's relationship to the everyday world" (Jackson 2002: 115). Simian frequently went out in London's Soho, to G-A-Y and Heaven, where he could "surround [him]self by proper muscly, straight, British guys" in what he described as "proper" gay clubs, as opposed to those offering a more alternative scene (discussed further below). In his research into young Asian gay men's attitudes towards bodies, Murray Drummond (2005a) found that his participants were concerned about their skinny frames in relation to predominant ideals on the Australian gay scene. Like Simian, Chris compared the creativity of East London clubs to the homogeneity of styles in the bars in Clapham in South London where "everyone looks the same . . . Very sort of twinky muscle." Simian's flatmate, Remi, recalled that in Barcelona in 2016, the gay men "all looked the same. They were all wearing a vest and if they are not wearing a vest then they are wearing a very tiny short[s] with Converse or a pair of Adidas. And they're all pumped."

On the international gay circuit party scene, body type operated as a form of subcultural capital (Thornton 1995), but clothing too played a role. Garments were selected to reveal the gym-fit body beneath, as Gino C described: "there's the epitome of the guy with the muscles and the tank top and the shorts, that his entire wardrobe is tank tops. And that's all he wears because he has an amazing body." The descriptions of the circuit club scene and its focus on muscular body types potentially constituted an "everyday world" (Jackson 2002: 115) for its attendees.

Bear scene (sub)culture

Clubs and bars catering to a muscular clientele are not the only ones to transcend national borders. The bear scene has developed internationally, again relating to a particular body type, discussed in Chapter 3. Several Melbourne-based interviewees discussed going to The Laird pub, that was "not as pretentious as some of the other places," according to Jon. It attracted an older, masculine-focused clientele, particularly men from the bear subculture. Elaborating on this appeal, Glen stated that while he had "always been fascinated by the idea that a lot of people assume that being gay promotes a sense of femininity, that whole idea never sat with me . . . so what I liked about The Laird was . . . it was not 'girly,'" which is how he found other clubs and bars in the city. Glen said that the reason he went to The Laird was not "because I'm a bigger guy, so therefore I must be a bear," rather he was a long-term customer: "I had a beard, before I went to The Laird. I had tattoos before I went to The Laird. I had a belly." His physical appearance resonated with bear (sub)culture, and although incidental to Glen, contributed to his feelings of belonging in that environment, making him feel "at home, visually."

Noting the way gay identities and practices were mapped onto New York, Mario explained that his friends frequented Ty's and other bars on Christopher Street in the West Village because they were "very much into daddies" and that was where the "whole daddy and bear community" was centered. Recalling his visits to New York from the United Kingdom, Barry felt that the gay men were "all quite similar" and "just looked like clones of each other . . . bearded kind of look and checked shirt and lumberjack look." Ernesto, a 36-year-old white Argentinian hotel concierge living in Tokyo, described a similar style on the bear scene in the Ni-chōme area of Tokyo, where "they're very proud of being a little bit chubby" and "they always go for something like sportswear . . . with the beard, and . . . shaved head." This is a style with which Wataru also identified. He described attending small intimate bars in Ni-chōme where he would wear, like the other clientele, checked shirts and jeans. He noted that while he had a beard many Japanese bears were less hairy than western gay men participating in this subculture, but stated "If you

call yourself a bear, you're a bear, I guess." Ernesto's and Watayu's observations of the Japanese bear scene demonstrate the existence of a transnational style noted above in New York, Melbourne, Sydney, and London.

Glen's evocation of bear style at The Laird in Melbourne, and Mario's and Barry's mention of bearish men in New York's West Village, resonated with Homi's experiences. He described downplaying his usually distinctive colorful style that drew on his Zoroastrian Indian heritage and his experience working with a Savile Row tailor, when he went out in London's Soho: "I would try and not be as flamboyant as I am. I would be more casual . . . I think that's also because of what it means to be a bear. The whole idea of the bear culture was to disassociate itself from trimming and from über . . . grooming." Sina, Homi, and Joe P identified an oppressive homogeneity and dominance of certain aspects of the bear scene and culture in relation to body type. Joe P recounted that "there has now become a right way to be a bear," which "can make other people feel not bear *enough*, but for me at that time it felt like [there were] lots of different shapes and forms."

Sanjeeva described attending London bear club XXL where he and a friend's experience contrasted with the way the bears "line the walls and they just stand there and do nothing": "one of my gay friends . . . who's a Chinese, very slim guy, he's actually 35 . . . he would wear cropped off shorts [and] he would do that thing where you tie up [his] a shirt . . . being someone who is skinny [and] yes, I am on the hairier side, but I'm not a bear. I don't think twinks frequent XXL." My interview with Sanjeeva took place just after XXL had made gay press headlines for turning away femme identified gay men (cf. Braidwood 2018, Capon 2018) and Sanjeeva described how the door staff had sometimes reacted to him and his friend if they were not aware they were friends of the DJ. In *Diary of a Drag Queen*, Crystal Rasmussen (2019: 159–60) describes attending XXL in 2016 with friends and wearing "trainer heels and a fringed dress" and the response of both disgust and acceptance they received, from staff and other patrons, for their femme dress choice and presentation in a space heavily gendered as masculine. Like Sanjeeva, Rasmussen and friends had been challenged by the door staff but allowed in and the acceptance of their large bodies (perhaps despite or because of the way it was dressed) led to sexual encounters in the club's backroom. The femmephobic attitude at XXL contrasted with the inclusive atmosphere that XXL founders promoted at its inception in 2001, with the description a "club for bears and their admirers" and the tagline "one size fits all" (Newbury 2002). Sanjeeva's experience echoes Travis Kong's invocation of Jon Binnie and Bev Skeggs's 2004 research on access to gay venues in Manchester. Kong focuses on gay clubs frequented by Asian men in Hong Kong and London, asking "who can use, consume and be consumed in such a gay space?" (Kong 2011: 39). It also resonates with discussions about effeminacy and camp in Chapter 2.

Alternative queer scenes

Describing East London's bar and club scene, Chris observed that it "appears to be very inclusive and . . . mixed." He highlighted the Sink the Pink club nights held at Bethnal Green working men's club, as "super friendly, everyone talked to each other . . . everyone dressed so well . . . strange and cool . . . it had a really nice mix of people.'[4] In 2007 the *New York Times* described the East London scene as "a grittier, fashion-forward and often outrageous hotbed of gay nightlife . . . fueled by the creative energy of the city's East End" (Chen 2007). Dex described how this club scene appealed to them particularly because "it gave me scope to try out stuff that was experimental, stuff that wasn't pretty, wasn't attractive

or even aesthetic at times." They elaborated on the kinds of dress styles they saw at the East London clubs and bars such as Dalston Superstore, Bethnal Green Working Men's Club and Vogue Fabrics in 2017–18:

> A lot of deconstructed suiting, I suppose inspired on some level by [Alexander] McQueen, but these days more people like Charles Jeffrey, Comme des Garçons . . .Bodymap coming back, Katharine Hamnett, I think because the younger generation are still meeting people in the clubs like Princess Julia, like Jeffrey Hinton, and those people are still on the scene, so I think they're having a big influence . . . I think gender-fucking in the broadest of terms, a lot of whited out faces in everyday and sort of theatrical-style make-up but in everyday

Although he went out less than in his younger days, 63-year-old Ian J noted that he sometimes went to The Glory, an independently owned club in East London focused on performance. He liked The Glory because it reminded him of the clubs he attended in his early life, which were "very mixed." His partner, Ian B, emphasized that "fashion and gay clubs in particular have sort of tended to go hand in hand" but that "for the most part I never look as if I fit in in gay clubs . . . except for the more strange ones." He particularly noted that in the mid-2000s he liked to frequent Horse Meat Disco,[5] which made him fall "back in love with clubs again," as it was more diverse than the "homogenous gay scene I never had any time for." He noted that, in comparison to his usual mixed up vintage style of dress, he was wearing "a lot of t-shirts and things like that" but that this style "wasn't doing me justice." Rafal recalled the significance of this London club scene in finding his gay identity: "I think I went through . . . six months of just wearing absolutely ridiculous things" he recalled, "because I knew I can [sic] . . . There was this kind of weird, kind of thing, fashion connected to kind of inclusivity/exclusivity." Although none of my US based interviewees discussed it, there was a comparable scene in New York, made famous by Club Kids such as Michael Alig in the 1990s and continuing in clubs such as Squeezebox, Foxy, Studio Filthy Whore, Skin, and Social Toile (Buckland 2002). Such clubs are what Phil Jackson called "dress-up clubs" that "demanded an effort from their punters" and "celebrated personal creativity and expressivity" (Jackson 2002: 47). Fenella Hitchcock and Jay McCauley Bowstead note how this legacy "highlight[s] a shared set of values that not only illuminate the experience" of such clubs "but also reveal[s] a continuity of approaches to the body and styling within this strand of queer nightlife" (Hitchcock and McCauley Bowstead 2020: 36).

Fifty-six-year-old Joe P, stated that he too had "always liked being in mixed queer spaces" and had worked as a DJ in the "gender queer" club, Bar Wotever, so named "because the quote is, 'Ladies and gentlemen and beautiful whatevers.'" He acknowledged the open and welcoming atmosphere created by the founder Ingo, equating this club night, like Ian J and Ian B, with the alternative gay bars and clubs such as The Bell that he had frequented in the 1980s (see Cole 2000). Like Joe P, Sina worked as a DJ at his monthly club night Debbie, set up as "a bit of a tangent to maybe the mainstream gay scene" and reflecting 1990s alternative London club nights such as Duckie, Popstarz, and Club Vaseline (Simpson 1996). Debbie was born out of Sina's frustration with "more traditional" or "more commercial gay places" that played a limited range of music genres, "was about camp" and "celebrating everyone's right to sort of be themselves and celebrating gay men who weren't necessarily fully trying to be masc for masc." The links Sina identified between camp, effeminacy, and hegemonic masculinity relate to debates about strategic essentialism discussed in Chapter 2. Jodie Taylor (2012) specifically addresses the idea of post-youth participants in Brisbane's queer scene, drawing on queer theory and marking out the importance

of "nonnormative" and non-heteronormative ageing and behavior that she identified in this queer scene, connecting to Sina, Joe P, and both the Ian's experiences in London.

Chris described theatrical choices for going to a club, that mixed gender signifiers: "I would probably wear things that are more masculine" he recalled, "or little something that's a little bit more flamboyant or feminine. Like, for example, I went out on Saturday, and I wore a very tight, muscle t-shirt but it was [green] velvet . . . it's very different and it's flamboyant." Similarly, Remi recalled his outfit for his first night at Trough club night at the Coronet Theatre in South London:[6]

> a vest that I bought in Zara Women, full of sequins, blue sequins everywhere with velvet underneath. And I had stitched myself some feather all around the shoulder strap on both sides, so I had those massive feathers going up [and a shirt] tied up around me with just one part on the shoulders . . . And I had a very long, long trouser, very large as well, with a pair of heels, boots, in velvet [see Figure 5.2].

Remi's and Chris's outfits resonate with Nicola Brajato's observation that "thanks to its inherent heterotopic and carnivalesque qualities, the clubbing experience can be seen as a specific cultural space in which the subversion of external rules enables bodily metamorphosis to go beyond the cultural borders that define everyday aesthetics" (Brajato 2020a: 117). Atherton Lin (2021: 185) develops this proposition, understanding the nightclub as a "site of loss—losing inhibitions, your friends, your possessions, yourself.

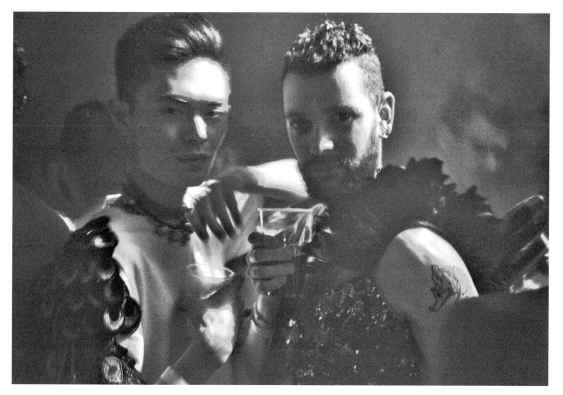

Figure 5.2 Remi (right) with his flatmate Simian at Trough, London 2017. Remi is wearing a blue velvet and sequin vest from Zara Women, customized with feathers. With permission of Remi (and Simian).

It's a place to find something through abandonment." Chris and Remi both noted that their dress choices were not their everyday clothing and for Remi they were quite particularly chosen for Trough to fit the club's inclusive policy. Venues that allowed or encouraged flamboyant dress could be categorized as what Michael Warner (1999: 35) terms *salons des refuses*—venues that were perceived by the clientele as a safe and somewhat private and accepting space. These were important to my interviewees who attended them because of their perceived distance from everyday conventionality.

Gino B described the queer scene and subculture of Sydney in 2015, where people were free to be "eccentric and express themselves" by "dress[ing] a little more individually." He noted a "little bit of a uniform" in what he described as the gender-fluid subculture, where people would "dress a little bit more fashionably, but with a bit of a spin. So, you see them with plunging singlets and the caps and, you know, skinny jeans." Gino B's description echoed those of Dex, discussing London's "alternative" queer scenes. Recalling being taken to a Sydney gay bar in his teens in the early 2000s, Matthew felt he did not fit in as the clientele mostly had "fake tan, blond hair, like just the polar opposite of the way I was dressing" with long dyed-black hair and black clothes. He mostly went to the city's goth clubs because he liked the music, felt more comfortable in relation to his appearance and because they had an inclusive atmosphere that welcomed LGBTQ+ people. Sam explained that the Mars Bar in Adelaide did not correlate with his alternative punkish style, contrasting it to Rocket and The Exeter that were "very gay friendly" and "a very big melting pot" where "sexuality really wasn't that much of a big deal." This search for a venue that welcomed or did not discriminate against gay people and played alternative music is like that of the men who frequented East London venues. It also echoes and highlights a continuity with the experiences of young gay men coming out in the latter part of the twentieth century who were disillusioned by, or not interested in, the dress styles, music or entry policies of hypermasculine clone clubs and commercial bars (Cole 2000).

Loss of gay scenes and spaces

In discussing the importance of gay bars and clubs as what Buckland (2002: 119) calls a "third space where participants come together, sometimes in the hope of building lifeworlds," several interviewees mentioned changes in the scenes with which they were familiar. Alex B argued that there was an "assault" on gay nightlife that resulted in the loss of "gay space . . . to the point where we're all homogenized and it doesn't matter . . . we can marry, we can do this, but then you're losing your community spaces, your spaces of gathering." Ben Campkin and Laura Marshall summarize similar conclusions in their commissioned report on LGBTQ+ night venues in London, stating that there was "a perception that London [wa]s losing distinctiveness, as heterogeneous minority cultures are being diminished" (Campkin and Marshall 2018: 83). Remi identified gentrification as a reason why London's gay venues were closing; a topic discussed in the gay media in 2017 which highlighted that profitable land value caused landlords to sell venues for development. In the context of the gentrification of New York's lower East Side in the 1980s following the emergence of the AIDS crisis, New York performance artist Penny Arcade notes that there can be gentrification of "ideas" as well as 'buildings and neighbourhoods" (cited in Abraham 2019: 87). Both Amelia Abraham (2019) and Atherton Lin (2021) discuss the closure of bars and clubs in London in the latter 2010s and, along with Campkin and Marshall (2018), highlighted that 58 percent of gay bars across London closed between 2006 and 2016 (cf. Greenhalgh 2015), although new venues also opened during this period. David Halperin (2012) notes that in a similar period (2005–2011) the

number of gay and lesbian bars and clubs listed by Damron (the gay-travel-guide publisher), decreased by 12.5 percent. The cost of property in cities such as Manchester, San Francisco, and New York's East and West Villages had increased in relation to urban gentrification. Many of these centrally located and recently desirable areas had been populated by gay and queer venues, but rising rents led to their widespread closure (cf. Abraham 2019, Atherton Lin 2021, Buckland 2002, Campkin and Marshall 2018, Ghaziani 2014, Greenhalgh 2015). The closure of gay venues in Sydney was associated with lockout laws introduced as part of the Liquor Amendment Bill in February 2014. These were intended to reduce alcohol-related violence and were mentioned by several Sydney-based interviewees (cf. Lee, Tomsen, and Wadds 2020; McKinnon 2018).

Adam believed that one of the reasons many gay clubs ware closing was "there's less need for that segregation" between gay and straight people. His comment highlighted the fact that the dismantling of the binary of gay and straight has made asserting a stable queer/gay identity more difficult and it was those kinds of clear-cut identities with which earlier clubs were associated and which they served. Amin Ghaziani (2014) related the decline in segregation to a reduction of stigma about, and increased levels of acceptance towards homosexuality in the majority of countries in the westernized world. This has been reflected in the changing language used to describe sexual and gender minority cultures including the expanding acronym LGBTQ+ which stresses a plurality of identities and community inclusivity. Campkin and Marshall found that LGBTQ+ communities valued LGBTQ+ venues because they offered "safe" spaces where gender and sexual identities were "affirmed, accepted and respected" and could be expressed and performed without fear of discrimination, stigma and shame (Campkin and Marshall 2017: 10). The closure of such venues also led to a loss of community and sense of belonging (Campkin and Marshall 2017, 2018). Ghaziani (2014) additionally aligns a decline in exclusively queer spaces to LGBTQ+ people less frequently citing sexual orientation as the main element of their identities, underscoring a key concern of this book. Alex B considered the closure of LGBTQ+ venues in relation to differentiation through dress styles, noting "there's no point to differentiate yourself if you're becoming all-inclusive." This shift relates to increased civil rights and equality legislation, such as same-sex marriage and parenting rights, and the movement towards equality in particular countries has reduced the necessity of gay bars by positioning sexuality as no longer a primary and defining feature of identity (cf. Abraham 2019). Adam went on to compare the closure of bars to particular themed nights that attracted clientele from specific subcultural groups or those interested in distinctly fetishized dressed codes: "we had all these sort of scally nights and 'oi' nights and things like that, and I wonder [if] that was part of trying to over-masculinize yourself."

Robinson (2008) and Paul Simpson (2014, 2016) address how gay men engage with and negotiate commercialized gay scenes in Australia and Manchester, respectively, with Robinson arguing "that age mostly determines how gay men engage with the scene. As they age, gay men have less in common with its values and activities. They feel less at ease on the scene" (Robinson 2008: 72, 75). The rise in other available means of making gay social and sexual contacts and specific age demographics within gay venues likely impacted upon venue attendance, leading to closure. Presenting an alternative perspective, London-based DJ Jeffrey Hinton observed a "generational difference," where gay bars in London's Soho were "heaving" with "older gay men," due, he believed, to the fact that "there will always be some who feel a deeper connection with people in person rather than virtually" (cited in Abraham 2019: 110). One reason suggested for why LGBTQ+ venues in many cities have closed is because of shifts in the way gay men use real and virtual spaces to meet. The closure of many physical nightlife spaces coincided with the rise in the use of social media sites and dating or hook-up apps, leading to

what Gary Wotherspoon (2016: 288) describes as a "'dematerialised' gay life away from a particular neighbourhood." Chip recalled how he had gone to gay bars and clubs almost every weekend from the time he was old enough until around 2003, when he discovered online dating. Michael N, a 64-year-old white Australian art gallery education officer, noted that there was no "scene" in the smaller city of Ballarat that he moved to from Melbourne, instead connections between gay men were "all through kind of apps." Douglas speculated that "the advent of apps . . . [rendered] bar cultures not so important." Referring to the gay app Scruff, he explained that "you can sort of be outside of it and still be part of it. It's in this virtual kind of space, it's what I call Scruff World, you know, where time doesn't exist."

Conclusion

For the men interviewed for this book, the role of the gay scene that operated as a central location for the formation and coherence of the gay community was differently important at different stages in their lives, reflecting interests in music, subcultural affiliation and a search for friendship, relationships and/or sexual encounters. Jon Binnie suggested gay people desire "certainty, structure, order and the attachment to specific localities where sexualities can be performed, celebrated, recognized and made public and legitimized" in a quest for fixity (Binnie 2004: 82). However, this is contradicted by Alex B and Adam; the latter identified that "it's probably almost embarrassing and old-fashioned, I sense, to want to . . . be together with somebody else or a group just because you're gay." As discussed in the previous chapter, for many men, coming out as gay coincided with a discovery and exploration of particular gay scenes. These could be in towns or cities these men inhabited, that were close enough to visit, or which they intended to move to because of their known gay scenes and communities. Despite the continued importance of gay bars and clubs, online platforms have become increasingly significant, some respondents believing internet-based dating apps have contributed to the loss of gay-identified social venues. The role of dress styles in confirming comfort and acceptance within physical spaces also impacted upon virtual spaces and new app-based communications. Within such apps, dress style often took on a less significant role, leading to an emphasis on body size and shape over dress style, as well as racist, sizist and femmephobic attitudes that were acknowledged and discussed by the interviewees. The place of both physical and online scenes as sites for meeting other gay men is developed in the following chapter in relation to sexual attraction and relationships.

Notes

1 BoomBox was started in June 2006 by Richard Mortimer, a hairdresser turned club impresario, and closed on New Year's Eve 2007. Following a tradition of London club nights that encouraged creative dressing, the door was presided over by "door whore James 'Jeanette' Main." (Porter 2007, Woo 2017)

2 "Chav" is a popular term used to describe a British white, urban, working-class youth culture that emerged in the early 2000s, whose dress style draws on sportswear. In his investigation of the eroticization of such (sub) cultures, Paul Johnson identified gay men who were "seduced" by the style, rather than being "imagined to actually be chavs" (Johnson 2008: 76).

3 Founded in 2004 by promoter Johan Khoury and Dean Murphy of Rogue Dance, a Sydney-based dance event company, Daywash is a daytime clubbing event that takes place three times a year, including at New Year and during Mardi Gras (https://www.daywash.com.au/about).

4 Sink the Pink was founded in 2008 in response to "too many bland and non-inclusive nights out" (https:// sinkthe pink.com/about). The motivation for this LGBTQ+ collective and club night was to create a "club where you bond on what you're into and what you're wearing, as opposed to who you fancy" (cited in Abraham 2019: 87).

5 Horse Meat Disco was begun in 2003 by James Hillard and Jim Stanton. They were inspired by New York nightlife legend Adam Goldstone "to create an alternative party that harped back to the halcyon days of parties like The Loft and The Gallery in New York whilst at the same time adapting it for a London crowd" (Discogs, n.d.).

6 Trough originated in Melbourne in 2005 "to give Melbourne a gay disco that went against the grain and glitter" (Murphy 2015).

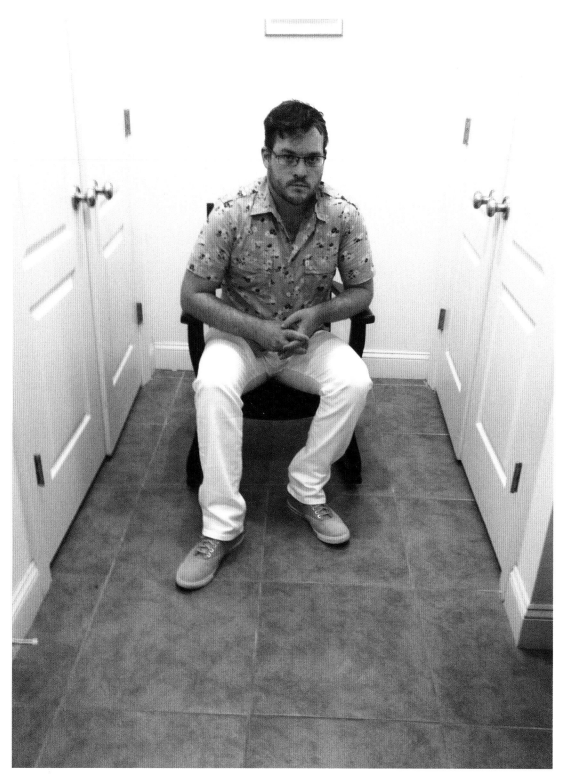

Plate 1 Lee wearing Marc Jacobs floral print shirt, white jeans, and lime green SeaVees shoes, November 2013. With permission of Lee.

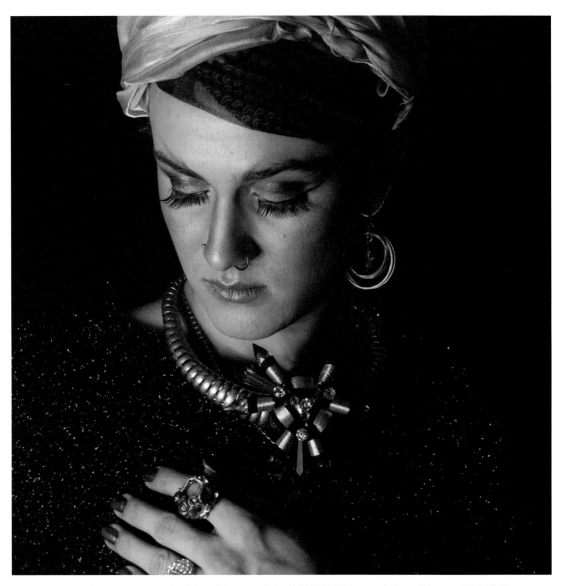

Plate 2 Dex as Chanukah Lewinsky, 2017. Photograph by Tali Wolf. With permission of Dex and Tali Wolf.

Plate 3 Chris, wearing Tom of Finland apron, outside his café, "MOTHER at the mosaic" (aka Mother canteen), London, December 2020. Photograph by Oliver Holms. With permission of Oliver Holms and Chris.

Plate 4 Roy wearing cowboy hat, lace shirt, and leather trousers, Intrepid Fox pub, London, 2001. Photograph by David Gwinnutt. With permission of Roy and David Gwinnutt.

Plate 5 Mark (left) and Gary wearing shirts from Aragaza in Barcelona, Port de Soller, Majorca, 2015. With permission of Mark and Gary.

Plate 6 Ian B (left) and Ian J at their vintage store Hunky Dory, London, September 2018. Photograph by Shaun Cole. Reproduced with permission of Ian B and Ian J.

Plate 7 Dat wearing leather jacket and cashmere sweater bought in Tokyo, Collins Street, Melbourne, 2019. With permission of Dat.

Plate 8 Mario wearing a Jack Spade cashmere sweater with Club Monaco navy trousers and Coach white sneakers, New York, 2016. With permission of Mario.

Plate 9 Mikey wearing Vivienne Westwood "squiggle" top, Southampton, May 2020. With permission of Mikey.

Plate 10 Patrick wearing second-hand red ladies' coat, Melbourne, July 2015. Photograph by Shaun Cole. With permission of Patrick.

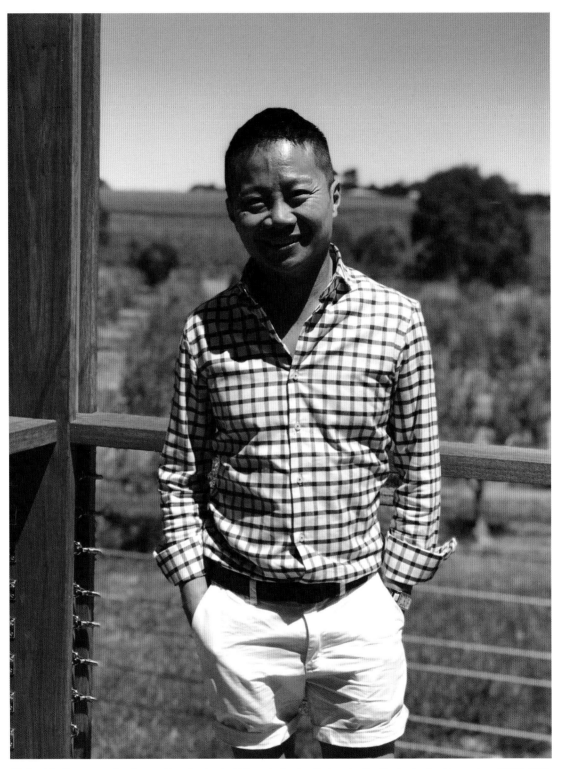

Plate 11 Alan, casually dressed in checked shirt and shorts, Torbreck, South Australia, November 2017. With permission of Alan.

Plate 12 Hayden (left) and Shane, Princes bridge, Melbourne, 2014. With permission of Hayden and Shane.

Plate 13 Alex B wearing blue checked button-down shirt and black jeans, Leake Street Arches, London, 2015. With permission of Alex B.

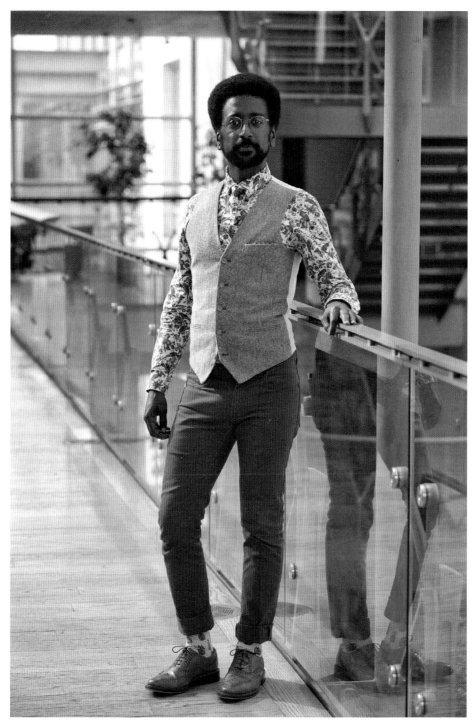

Plate 14 Adam at work at British Airways, wearing matching floral print shirt and tie, teal tweed waistcoat, brightly colored trousers, and patterned socks. December 2020. Photograph by Nick Warner. With permission of Adam and Nick Warner.

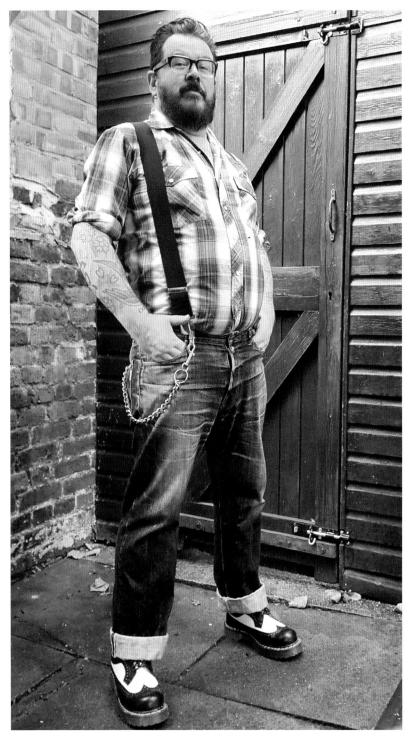

Plate 15 Joe P dressed in in his typical style, London, September 2022. With permission of Joe P.

Plate 16 Homi, wearing tweed jacket and teal fedora, in front of twelve abstract works from his "Dancing Blocks" series, London 2019. Photograph by Hannah Broughton. With permission of Homi and Hannah Broughton.

Plate 17 Florent, wearing monochrome outfit with bright blue converse trainers, Shoreditch, London, 2013. With permission of Florent.

6

DRESSING FOR AND IN RELATIONSHIPS

"Everyone dresses for some element of attraction," stated David M, "but I wouldn't go so far as to say you dress for sex." In a similar vein, editor of the menswear magazine *GQ Style*, Luke Day, explained how "the connecting tissue between all gay subcultures is that you're generally expressing your sexual preference in some sort of way. We are trying to attract. What we put out there is what we fancy" (cited in Flynn 2017). Day, however, contradicts David M in believing that for gay men "dress codes are generally about getting laid." Martin, a 45-year-old Cuban who worked in sales in Miami, and 36-year-old Malaysian, Melbourne-based architect Bryan, agreed with Day that gay men's dress choices were tied to a desire for a search for sexual liaisons. David Halperin highlights how in "fashioning a self" though "proudly affirming" and "claiming" a "collective gay identity" in the twenty-first century, gay men realize "a *healthy* gay sexuality defined by our eroticization of other gay men *as* gay, and ultimately crowned by the successful achievement of a *relationship*" (Halperin 2012: 94, emphases in original).

Dressing to pick up

Reinforcing his opinion that gay men dress for sex, Jun said that when he went out, he would "dress up more" as he liked "to be sexually objectified, in a way." Reflecting on a time when he was single, Adriann explained how when he was "on the hunt" he was very conscious of his style of dress and appearance and "was very aware" of how he was dressing "in order to attract a certain type of man that would be attracted to me." He continued that he did not feel that his usual way of dressing, that combined garments and accessories that would be deemed both masculine and feminine, would "attract tons of men" and if he wanted to attract attention he would dress "a bit more plain" or "simple." Deborah Tolman, Christin Bowman, and Breanne Fahs (2014: 760) recognize that "the social construction of sexuality provided an alternative way to map and understand sexuality, including sexual desire, sexual identities, and sexual relationships." Adam Green places this within a gay-specific context, identifying the fact that if "sexual desire must be considered in light of social structure," then items of dress were placed within a "structure of desire" in the "sexual field" of specific gay subcultures or scenes, conferring significant power and status on the possessor (Green 2008: 27). Matt linked this to what he suspected may be gay men's "greater tendency to objectify" and this manifests itself within attention to bodies. Both Johnny and Sanjeeva observed that within gay nightclubs there was a tendency for men to remove their tops, which Johnny summed up as "they undress to attract." The similarity of recollection alongside the difference in age between 31-year-old Johnny, 33-year-old Matt, and 23-year-old Sanjeeva highlights the relevance

of age within intersectional considerations of sexual attraction and dress styles within gay worlds and amongst gay men. Reflecting on how he had grown up and come out prior to the availability of the internet, social media, and apps, Guy observed that "in regards to fashion . . . most of the guys in apps are probably shirtless." This was echoed by Sanjeeva, who also speculated on "the types and brands" of underwear these men wore, was curious about "how they want to project themselves" and feeling that "someone who'd be more muscular would tend to wear, for example, a boxer short."

Jose, a 37-year-old Mexican American museum curator, stated that before dating apps he would "have to get dolled up and go to the bar and hope that something happens," but when using apps "maybe there's less pressure to put effort into fashion if you can just decide on body type." Alex M described how when he began dating using Gaydar in 2015, he varied his profile images to "flip between different looks," one day bearded, another clean shaven. "I can look quite young when I shave it off," he explained, and "so you attract a totally different type of person." He recalled how one app user thought that he might be camp because he worked in fashion, evidencing the impact of a stereotype. He explained that he attracted more responses on apps if he uploaded photographs of himself wearing "sportswear and a hoodie," surmising the appeal of this look was rooted in its apparent masculinity. "People make massive assumptions about who I was and where I'm from . . . what they assume to be black is my class, my sexual role . . . every cliché you could imagine would come out in some way." As in Alex M's description, Paul Simpson's (2014) respondents highlight that race and ethnicity became either a fetishized desire or a negative commentary on apps. Simian explained that when posting photographs of himself on dating apps such as Tindr or Grindr he did "try to make myself look bigger or slightly more muscular," recognizing the "ideals" of gay body type in relation to sexual attraction. Amia Srinivasan (2018) highlights the premiere episode of Grindr's "What the Flip" web series from 2018, in which two participants switched profiles. This episode highlighted various forms of discrimination such as racism, sizeism, and ageism. She particularly recalled a friend's observation that, "The beautiful torsos on Grindr are mostly Asian men hiding their faces," disguising racial characteristics (Srinivasan 2018).

Homi focused on the specificity of requests on dating apps and the negatives meant that men were looking for "something that looks like you, but only twenty times prettier." Consequently, he said he did not state his racial identity online "simply because it's complicated." He said that his Persian ancestry, Indian nationality, and long-term residency in England contributed to his understanding that he was "not white but I'm not South Asian in the conventional sense . . . I suppose I could put 'mixed' but I think generally people think mixed race is between black and Caucasian." In the context of using such apps around the time of his interview in 2017, he noted that his photographs clearly showed that he was "a brown, tanned, not so brown, not black, definitely not white person" but that listing "every statistic" on your profile led to "objectifying yourself" in the extreme. Raj, also born in India but living in Sydney, identified that "the idea of beauty" on the gay scene and apps was "white-skinned, well-toned, you know, abs," and this sometimes engendered a form of racism when he showed other app users his photograph: "One of them actually said . . . unfortunately . . . I am drawn to blond and blue-eyed." Sanjeeva recalled positive responses he had received based on his looks but felt that some of these were "fetishizing dark skin, fetishizing exotic looking people" and were not interested in the specificity of his racial and ethnic background. He noted how on some occasions when he said he was not interested in someone, he received racist responses that "if someone were to reject you in real life, you would never go around and say that to them." Tom Penney discusses the way in which "users are set up by the very interface to operate narcissistically and to think about themselves and what 'they want'" (Penney 2014: 108). Ben Light, Gordon Fletcher, and Alison Adam (2008: 304) elaborate on this as a "desire to

commodify," creating "monolithic caricatures that are obdurate and enroll even those who do not participate in such arrangements at all or only by proxy." It is such manifestations that many of my interviewees describe in relation to their use of gay apps, their self-presentation on these platforms, the way they are perceived by other users, and/or their decisions not to use these apps.

Invoking Jean Baudrillard's 1998 ideas around beauty as a form of capital, Jennifer Smith Maguire and Kim Stanway propose that "working on one's appearance is not about narcissism or pleasure, but about improving one's odds of success in the social market," but this could equally be the sexual market (Smith Maguire and Stanway 2008: 76). Green's emphasis on bodily activity, the body's role as a hangar for clothes, and the ways in which garments are selected to adorn the body, fits with broader theories around dress and embodiment (Entwistle 2000, Entwistle and Wilson 2001, Merleau-Ponty 1962), as well as with Chris's declaration that sexual attraction is "more about body than it is [about] clothes." Invoking similar language, Tolman, Bowman, and Fahs (2014: 759) identify that "sexuality is an intrinsic part of an embodied self." Luis had a sympathetic and understanding approach: "I love the integrity between your understanding [of yourself and your body] and what you're wearing . . . you see [a] guy who is so confident in [his] clothes and in [his] own [body], that literally feels much more sexy, you know, that is much more attractive." Luis's comment connects to Hannah Frith and Kate Gleeson's observation in relation to men's embodiment that "men are aware of and concerned about how their body will appear to others, and they strategically use clothing to alter and manipulate their appearance" (Frith and Gleeson 2004: 46).

Dressing like the object of desire

"I have this ongoing theory that gay men tend to just strive to make themselves into the type of man they're most attracted to," explained Brian F. "This simplifies things because you can usually tell what people are into by looking at them, but it has the negative effect of strengthening the ghettoizing or self-segregating of homosexuals into individual circuits," such as those discussed in Chapter 4. In identifying that dressing like an object of desire is a successful strategy, Jun, Mario, Josh, and Ian B articulated Green's propositions around the structures of desire in a sexual field: "The gay scene can be as homogenous as anything else, I think it's a club to which if you want to meet someone you have to look like them, in many ways" (Ian B). Green (2008: 32) identifies the "hegemonic currency of erotic capital in a particular urban gay sexual field" that was expressed by bodies and the ways in which those bodies are clothed, as well as the context of the space in which those bodies are located. Green's considerations of erotic capital connect to Sara Ahmed's proposition that sexuality "can be considered a spatial formation not only in the sense that bodies inhabit sexual spaces . . . but also in the sense that bodies are sexualized through how they inhabit space" (Ahmed 2006: 67).

Identifying elements that he found attractive in others, Raj explained: "If I find an attractive man . . . and if he dresses a certain way—and I find that attractive, then yeah, I would adopt it." Citing the example of his short-lived flirtation with low-slung jeans revealing underwear that he found had a certain attraction, he noted how he moved away from this when he realized it made him feel that he looked "unprofessional" and "indecent." Barry noted that there had been times since coming out as gay when his choice of dress to go out was impacted both by what he found attractive and what he felt would be attractive to other gay men. For example, he recalled "a phase of trying to look like a skinhead boy," feeling that "people would kind of be so into that" fitting with a trope of sexually attractive gay style (Cole 2000, 2008). "Because I'm attracted to really that sort of hyper-masculinity," said Douglas, who identified

with muscle bears, "I kind of dress like that . . . kind of sexy" to be "attractive to those men who like that look as well" and "to pick up." Reflecting on bear culture as a form of masculine presentation, Joe P noted "the big butch gruff man, you know, the bearded man, the hairy man, that's become the new desired thing" but questioned, "are we just replacing the old traditions" of hairless muscular gym bodies prevalent through the 1990s "with a new tradition?" Barry, Douglas, and Joe P then related these bodily ideals to certain modes of masculine presentation.

Joe H proposed a "two-sided thing," where "you want to stand out, but you also want to blend in and look your best in a tank top and ripped jeans." He emphasized both the cultural and erotic capital of these garments, stating, "you want to be the best-looking guy in tank top and ripped jeans, but you're still going to wear a tank top and ripped jeans because that's want everyone else is wearing." Green (2008: 29) defined erotic capital as "the quality and quantity of attributes that an individual possesses, which elicit an erotic response in another."[1] Joe H's observation ties in with Steven Kates's findings that within the gay scene and community "socialization into a competitive set of consumption meanings" results in a "status game" in which "men compare their bodies, appearances, and dress" and where "other men are both sexual prospects and competition" (Kates 2002: 387, 388). Picking up on this competition and the particular hegemonic gay uniformity described by Joe H, Krysto said that if he was going out to pick up, then he would wear a plain white t-shirt and jeans, as this did not really say anything about him but placed him within the frame of a desirable archetype that would get him "seen" by potential partners. Nick related this uniform to many gay men's conceptions of attractiveness when they declare that "it's just so hot that they are wearing a t-shirt and jeans" and connected this to ideas of some gay men's "straight-acting" self-identification, as discussed in Chapter 1. Mark Simpson proposes that a desire for acceptance in mainstream heterosexual/heteronormative society was so strong for straight-acting gay men that they copied behaviors and "exaggerat[ed their] masculinity" (Simpson 1992: 52) to compensate for the fact that their homosexuality created a perceived or real distance from the real or perceived straight hegemonic masculinities they encounter in daily life (Connell 1992, 2005 [1995]). These adopted "veneers of masculinity . . . based purely on image" (Who? 2005: 40) as a distancing from effeminacy, are what Anthony Freitas, Susan Kaiser, Davis Joan Chandler, Davis Carol Hall Jung-Won Kim, and Tania Hammidi (1997) identify as an "identity not" principle; in this case an "I am *not* effeminate."

Sexual attraction and masculinity and femininity

Milty expressed dislike for exaggeration, stating "I'm completely unattracted by someone that's over the top and flamboyant in their style, it's a complete turnoff." For Milty there was "sexiness in being a man" that he equated to being *not* feminine or extravagantly dressed, instead "dressing casual for me is way sexier than someone that's trying to look like they're on a runway." Milty's comments here link to the traditional association of fashion with femininity (Craik 1994, Edwards 1997, Entwistle 2000, Wilson 1985) and an historic distancing by some gay men from more visible effeminate-appearing or effeminate-behaving members of queer communities (Cole 2000). Tim Bergling questions why within gay culture "an otherwise attractive man [is] sometimes less desirable to us if he begins to exhibit certain characteristics that make him appear less manly, and more like the classical 'gay' stereotype?" (Bergling 2004: 1). In articulating his opinions about how he and other gay men may dress in relation to sexual attraction, Nick identified the kinds of dislike for flamboyance identified by Milty. Nick found that for both himself and friends who had dressed effeminately at various points in their lives, they did not get "the same attention"

as when dressing in a "more straight" manner. "Definitely I have dressed to fit in or to find a certain type of guy," recalled Jon, "sometimes [I] dressed a bit more masculine or tried to be more masculine in the style of dress. And other times just not cared and been really loud and camp," reinforcing conceptions of the role of perceived masculinity in what was deemed culturally sexually attractive. This aligns to discussions around femmephobia and adoptions of butch or hypermasculine dress styles and behaviors in Chapter 2.

Remi recalled splitting up with one of his first boyfriends in the late 2000s because his appearance became more "feminine" and his boyfriend did not like this. As a reaction to and understanding the erotic capital of a masculine look in finding partners, Remi recalled that he "went from feminine to more masculine," which he felt was "attractive and kind of normative at this time." To make this change he began to wear sporty clothes and attending a gym in order not to look like a "twink" which he felt "was not very sexually attractive." Remi's choice of the word "normative" is significant here, both in the context of gay identities being seen in relation to heteronormativity and in the increasing acknowledgment of homonormativity, where values assigned to heterosexuality are assumed and replicated by gay people, particularly as gay rights are socially integrated into western societies (Halperin 2012). The context of Remi's invoking the term relates particularly to an emphasis on performances of masculinity within western gay cultures, centered around "homonormative regimes of beauty" (Mowlabocus 2010: 13–14) and preferred masculine archetypes. Ascribing to such standards and ideals can lead to "attain[ing] more power within a [context or community] that places so much value and attention on physical appearance and normative masculinity" (Pritchard 2017: 195) and where "feminization can be disruptive" and less desirable (Whitesel 2014: 157–158).

Relating to Alex M's recalling that he was seen as more attractive when wearing sportswear, Aleks Eror (2017) cites men who were attracted to the casual sportswear style of British gay Chav or Scally because they were worn by "masculine guys" and by "wearing the same garments as desired men, a bit of [the guy] is captured in the clothing." Sanjeeva identified "full gym kit" as one of his "biggest turn ons," particularly "the tight fittingness" of such clothes. Also raising sportswear in relation to attraction, Benjamin said that "I'll wear a really baggy tracky bottom 'cause I know they hug the bum differently, so I can show that off," highlighting one of the parts of his body that he emphasized to make himself sexually attractive (see Cole 2008). For Dex this same type of garment played a part in casual sexual encounters: "I've noticed that any time I've had something casual, often I've ended up nipping out of the house in trackies."

Feeling attractive and looking sexy

"I don't think I'm dressing particularly to attract, that wouldn't be a very successful strategy in what, in how I'm doing it," reflected Ian B. "Just because you're not going out purposely to meet people, one still wants to be attractive, and you know, command a certain sort of respect or impress people in some kind of a way, you know?" According to Randall Collins: "Attractiveness is a social role as much as a state of appearance; learning to play it with self-confidence results in a self-fulfilling prophecy, while the opposite process leads to cumulative failure through awkwardness of posture, complexion, and the like" (cited in Martin and George 2006: 128). Citing Collins, John Levi Martin and Matt George also note that Pierre Bourdieu had included "attractiveness" within cultural capital as a form of "physical charm" and that Bourdieu's idea of sexual attractiveness as "natural" was "incompatible with a notion of sexual capital"

(Martin and George 2006: 125). Although Martin and George do not provide a clear definition for "sexual capital" and, as Catherine Hakim (2010) notes this is left implicit, they do state that sexual capital should be considered as a "relation" "that is equivalent to a consensus regarding desirability" (Martin and George 2006: 124). Inadvertently referencing Valerie Steele's situating of fashion as "a symbolic system linked to the expression of sexuality" (Steele 1996: 4), Luis stated, "I think fashion is completely dictated by sexuality, or sensuality . . . choices are all based on what [men] think would be better, because they want to be liked, they want to be approved, they want to be appreciated . . . it defines fashion, defines everything, design, you can look sexy because you want to be desirable."

"I do want to feel sexy but it would depend on how I feel or where I'm going," explained Chris about how he would choose to dress if he was going out "on the pull." He continued that he wore "things that are a bit more, I don't know, slutty or low cut" when "wanting a snog [kiss]." Chris noted, "strangely when I've been a bit more fem I've had more attention. . . Which I did not expect." There is some resonance here between Chris's experience and that of Nick in finding flamboyant or effeminate styles were not deemed as attractive. There is also a relation to Milty's attitudes toward flamboyance, discussed above, and the femmephobia described in Chapter 2. Describing a change between not wanting to stand out when he lived in Poland, where he wanted to be a "plain guy in a crowd," and a newfound "individuality" on moving to Antwerp in 2013, Lukasz began "thinking what's for me sexy, what should I wear to look sexy?" He settled on tattoos, piercings, and facial hair that he found sexually attractive in other men. For Lukasz, the context of the country and acceptance of gay people in Belgium in relation to Poland impacted upon his choice to stop blurring into the crowd and develop new "sexy" styles that were appropriate both to more liberal attitudes as well as styles he saw and was attracted to in Antwerp's gay scene. In opposition to Lukasz's adoption of facial hair and tattoos *because* he found them attractive, for Mikey getting heavily tattooed over time and growing a full beard led to him increasingly being attracted to men with tattoos and / or full facial hair. Although neither Lukasz nor Mikey explicitly made the point, this increased attraction links to others' experiences of dressing like the subject/object of their attraction. "I would say there are things that I think are fuckable," joked Sanjeeva. He explained that the types of fashionable garments he liked to wear, such as "perforated holed" or transparent and tight, figure-hugging shirts, and the garments that he believed were "sexually appealing," did not "always correlate." Halperin notes that to understand "the mystery of homosexual attraction, you have to focus your attention on the object of your desire in its most complete contextual realization, its full social correctness, its specific social systematicity, and to comprehend the social logic that renders that *particular* look or style so powerfully attractive to you, you are going to have to observe it very closely" (Halperin 2012: 198, 197).

Rather than use the word "sexy," like Chris and Lukasz, Diego described how he would sometimes wear something *provocative* to a bar, such as a Dolce & Gabbana shirt with the slogan "Taste me" that might start a conversation and perhaps arouse potential partners. He also explained how he might wear "tighter jeans, shorter shorts" or "really high socks from Nasty Pig" that would "send a message that I'm I guess flirty or available [laughs]." Eric also used the word "provocative" in relation to a pair of leather trousers he originally bought to go clubbing, but as he grew older wore these in a more restrained way for parties. Invoking his own age in relation to being attractive to others, Ian J stated that he believed "people do dress for desirability" but at his age, sixty-three, he was "not desirable." Also talking about age, and conscious of what was perhaps a sweeping statement, Ian J's partner Ian B noted how for many gay men "youth extends [laughs] for decades" and with this came both a self-consciousness and external pressure to "preserve outward appearances" linked to "dressing to meet, to attract." The relationships between age and dress practices will be explored further in Chapter 11.

Noting his long-term single status, Matt pondered that he had "learned the idea that what you look like is really the number one thing that's going to make a difference" in meeting someone. He believed that "there's something that you can do to change, you know, the way you look to kind of make yourself more presentable." Barry emphasized an awareness of "a certain power with being able to change your look" and that was "quite exciting." For some interviewees there was a conscious awareness that the way they dressed might not fit with received ideas of what was sexually attractive. Both Patrick and Joe H felt that the way in which they dressed, especially to go out, meant they would not attract the kind of men in which they were interested nor get picked up in a bar. David M said that he did not feel like he was consciously dressing to attract partners; instead his choices were about feeling "like myself and to feel more confident" and that this was going to be attractive to others. Comparing his desire to "look nice" in clothes that he did not wear "for the most part during the regular course of the day" at the time of his interview to his younger days of clubbing nightlife up to the early 2000s, where he conformed to acceptable nightclubbing styles, 49-year-old Eduardo felt there was no longer an intentionality to attract others, "thinking, oh, would anybody actually appreciate" the way he was dressed. However, if he received a compliment then that was a benefit, he explained. For Patrick, Joe H, and David M, feeling sexually attractive was a balance with how they felt confident in their chosen styles. In his youth, Eduardo felt the social pressure to fit in with acceptable styles in gay nightclubs, but as he aged he felt less pressure to conform and fit with styles that were deemed to be attractive, whilst also still enjoying compliments on his style. Changes in style, attitudes, and dress choice in accordance with age will be specifically addressed in Chapter 11.

In contrast to how some men described dressing in particular ways to attract partners, including dressing like those they desired, Johnny, TJ, and Alfie each expressed how they did not intentionally dress up to attract or meet men. Answering the question: "Am I dressing to be sexually attractive to myself or other people?," Sam stated, "I'm not quite sure." He quantified this by saying that hoping that someone would pick him up was not "top of my list." He emphasized that he did "put a lot of effort into my appearance" and wanted "people to think that I'm well dressed" and "I do look attractive . . . however, I always dress for me." Like Sam, 43-year-old Malaysian Chinese human resources specialist, Alan, and Teddy believed they did not dress in ways that were intentionally designed to be sexual or to attract men—for Alan, even when he was out on the gay scene. Erich acknowledged the links between sexual attraction and dressed appearance, stating "part of it is that I want to feel like someone is going to be attracted to me and if I feel good and looking attractive then it makes me more confident. When you feel confident with what you're wearing, when you feel confident it exudes attractiveness." He described a new outfit of button-down shirt and waistcoat (vest) that he wore to a friend's birthday party in early 2012 that "felt really good and confident," recalling feeling that "if I had been going to a gay bar I would have been hit on." Altering dressed appearances or pointedly not doing this in order to appear sexy or attractive links closely to hegemonic ideas relating the sexual and erotic capital explored by Green (2008), Hakim (2010), and Martin and George (2006) above.

Hair and sexual attraction

Chiming with Green's (2008) discussion of expectations within structures of desire, Alex M related this to expectations for certain appearances within gay scenes: "I need to let the beard grow, otherwise probably no one's going to want to talk to me, or they're not going to be looking at me in that specific way, if I want

to have that effect on people . . . I think there's still a fear of, do I look butch enough to attract that guy. So I think there's a bit of a problem." This emphasis on facial hair was echoed by Barry and Joe P. "If I didn't have a beard, I would probably be a bit non-existent sometimes," Barry felt, as facial hair was "quite a thing in a gay world," but that fortunately he liked having facial hair and felt that it could be "kind of like a bit of a tool" for him in terms of his sexual capital, fitting with acceptable looks that were deemed attractive. Joe P stated that for him growing a beard had been both an attempt to "butch up" and dress "like a man" and had an element of "becoming what I desired." He went on to relate this idea of "dress[ing] to become what you desired" to a desire for "some of that power, some of that sexuality, some of that glam."

Mario noted how growing a mustache in 2012 allowed him access to New York bars that he would previously not been allowed into and "certainly [got] me interest from guys I used to be interested in who wouldn't have paid me any attention." Looking quite young without facial hair meant that for Alex M, "you attract a totally different type of person." For Remi, growing a beard and not shaving his chest hair was a compromise he made in order to try and attract the bear-identified men that he "was interested in." These discussions of growing facial hair as a marker of masculinity relate to the performance of masculine hegemonic ideals and to sexual and erotic capital, whereby an individual's or group's social value increases in relation to their (deemed) sexual attractiveness (Green 2008, 2011; Hakim 2010). Also considering notions of sexual attraction in relation to facial hair, Alfie admitted "it's probably a thing that I find attractive in another person, so I don't know if that influences my choice" to have a mustache, but conceded that "I guess I kind of like the way a mustache looks and the idea of a way that a mustache looks." Eduardo considered that having had a mustache for many years might have been "because at the time I was into boys who had facial hair." He went on to ponder on the vagaries of sexual attraction in relation to facial hair, perhaps in relation to fashions, saying "it's not unattractive but it's not as attractive to me as it was. I have absolutely no explanation for that."

"I grew, I call it my crisis mo, in 2013," recalled Greg, noting how at the "painful glacial end of a seventeen-year relationship" growing a mustache was an "element of fuck you, everyone." He described the impractical nature of having a long mustache as "I used to end up with so much food in it" but that having grown a mustache he had retained facial hair from then on, having a beard that was usually "trim" but that could get "pretty scraggy" and grey if he allowed it to grow. Vlad, likewise, explained that he began to grow his goatee beard around the time of a break-up, but never developed this into a full beard because "it gets to that point where it's so itchy you just want to rip your skin off." Relating hair practices to relationship break-ups, like Greg and Vlad, Sang reflected that "the reality is coming out of the relationship and being a single man, being bald is potentially a deal breaker for quite a few people, I would suggest." So, while baldness has often culturally been deemed a disadvantage and there is a big business in products and processes to minimize or disguise baldness, for some men growing facial hair was a form of "compensation" while for others baldness was something to be celebrated in the same way as others celebrate full and luxurious locks. Issues of baldness and ageing are discussed further in Chapter 11.

Dressing for dates

"If I am going out or going on a date or something," David M said, "I am dressing in a way to feel my most confident and comfortable and to look good." He acknowledged that this might not necessarily be

something that "was considered to be very sexually attractive, as a norm." Instead, he said, it might be "something oversized and baggy, like a big woolly jumper." Chris echoed the language used by David M, feeling "confident" in his choice, but wanting, especially on a first date, to wear something that might act as a "conversation starter." Patrick emphasized his own practice of "dressing up" when he was meeting partners or going on dates because he "want[ed] to look amazing" compared to his date's more casual approach of "wearing runners and sweatpants" which he "still" found "attractive." Josh described how he would usually go to "straight places" rather than gay and to cocktail bars rather than pubs on dates in London. He would make an effort' to "dress less gay" wearing a smart shirt rather than casual t-shirt that fitted with what he observed straight men wearing in such venues. In considering who he had dated or would date, Sanjeeva considered his attention to particular designer items: "The thing is that the people that I date would never be able to understand that this is a [young British designer] Bobby Abley collection. They would just be, like, 'Oh okay, you look–, you look like how you look.'" Having noted that his dates might not recognize the designer or brand of his clothing that Sanjeeva was wearing and were important to him, he stressed that this was relatively unimportant, confirming that he was not wearing these particular garments "to impress anyone" but to feel comfortable, confident, and fashionable. This connected to comments earlier in this chapter from a number of other interviewees who discussed how what they wore was for "themselves" and to ideas of comfort explored in Chapter 10. Robert explained that he would not refuse to go on a date with someone because he did not like the way they dressed, perhaps hinting here that attraction to others was not necessarily related to dress choice for him. Robert also explained that he was aware of the impact of his own dress style on people he dated or wanted to date and that sometimes "the way I dress intimidates the shit out of them." He felt strongly that he did not want his dates to excuse his dressed appearance to their friends with comments such as, "Oh, that's just Robert." Robert's attitudes here are perhaps related to his age and experience and a certain self-assuredness that can come with age, a subject explored further in Chapter 11.

Coupledom: shared wardrobes and similar styles

Talking about women and female body experiences, Iris Marion Young discusses how sharing clothes is a means of enacting forms of intimacy, noting that "as the clothes flow among us, so do our identities; we do not keep hold of ourselves, but share" (Young 2005: 71). It is not explicitly stated by Young but there is an implication that the women here are friends rather than lovers or partners (although this is not outside the realms of possibility). Taking Young's idea of intimacy and relating it to my interviewees, there is perhaps a particular layer of intimacy when the men sharing clothes are already in committed partnerships, where their identities are intertwined as part of a couple. Partners, 60-year-old Mark and 51-year-old Gary, explained that they had a completely shared wardrobe; that all clothes that they bought and owned (including underwear but not shoes) were shared between them. They explained that this worked well because they were the same size (see Color Plate 5). Although all items were shared, they operated a "policy" that the person who bought the garment got the first chance to wear it. Elaborating on this "unwritten rule," Gary stated "if you've bought that, then you get the chance to wear it and then eventually the other one will wear it." They put this into the context of their styles of dress gradually growing together and the fact that when they had met in the early 1990s their style of dress had been very different.

Considerably younger than Mark and Gary, partners 25-year-old Antonio and 27-year-old Riccardo similarly had a wardrobe where "we share absolutely everything, even shoes" (Riccardo). Antonio added

a rider that "the only thing that I don't wear, and he wears, is hats, that's because my head is ridiculously small and his head is ridiculously big." He also noted that due to their slightly differing body sizes, some garments fit one better than the other. Again, like Mark and Gary, their style of dress was different when they began their relationship after meeting at London Contemporary Dance School in the early 2010s, but gradually grew more similar, beginning with Antonio borrowing from Riccardo who he had felt had "a much more advanced style, coming from Milan." Antonio described how their shared wardrobe grew from a performance piece they made about their relationship. Like Mark and Gary, they also had a rule that the person buying a garment has the right to wear it first; that was only problematic when they had shared the purchase. Entering into a more fluid relationship with a third partner shortly before the interview, they explained that he had broken this rule soon after moving in with the couple but that was quickly put right and the three instigated a process of claiming "dibs" on certain items, particularly for a special night out. Riccardo explained that when going out, both to formal events and for casual evenings at friends' houses, he and Antonio would consider what they were wearing carefully to be perceived as a couple (see Figure 2.1). Once Riccardo and Antonio's relationship developed into a "thruple," how each of the three appeared in relation to the others when going out together became a new consideration.

Rafal explained that his partner was "a little bit more sophisticated," wearing what Rafal described as a "classic utilitarian style" while he felt his own style was "kind of louder." Both Gino C and Nick admitted a similarity of style with their respective partners, although they also both noted that they are "more bold" and "more alternative" (respectively) than their partners. Nick explained that his boyfriend was a scientist who was "conservative," wearing "collared shirts and jeans and a blazer," while Nick was freer to be more creative as an artist, for example wearing blue suede shoes that his boyfriend would certainly not wear. For Dex, similarity between them and their partner was not so much about the nature of the clothes but in their experimentation with a range of gender experiences: "For the first time, I'm dating someone who is equally as eccentrically dressed as I am because I may be in drag or I may be in a mesh kaftan [when] he's in a bright orange Turkish wedding suit."

Partners Ian J and Ian B explained how their style of dress, incorporating a lot of vintage garments, meant that even though they each have their own wardrobes, each "resemble[s] the other's somewhat" (Ian B) and that they occasionally wore each other's clothes (see Color Plate 6). Ian B pointed out that there were "still subtle differences," but that these would only be identified by someone who "really understands that style of clothing." Ian B also noted how they were sometimes mistaken for each other, as other people "see a hat, they see glasses, they see a sort of retro style." Picking up on this similarity, Ian J described how at an event where they were both wearing suits, the British Secretary of State for Culture's assistant mistook them for the artists Gilbert and George, who notoriously dress identically in suits, because "we happened to be two older men in suits wearing glasses." Michael B noted how he and partner, Brian C, would consider the complementarity of their outfits, through a "sort of negotiation" to ensure what they wore was "reasonably similar in quality perhaps, or informality." Both Brian C and Barry raised a consideration about dressing similarly as relationships develop, where "you can end up merging into the same thing" (Barry). Brian C provided more detail: "Because we both do patterned shirts at the weekend, we can get that jeans and a patterned shirt look and we both do hats now." Brian's ten-year-old son remarked, "Oh my god, you're dressed like twins." Andrew and Jose both raised the phenomenon of couples who dress so alike that they look identical. Jose described his two best friends who were "very muscular, they have the closet full of tank tops on hangers and the same Abercrombie type shorts . . . they're Caucasian males [and] are very much like a boyfriend twin" referring to the Tumblr blog site Boyfriend Twins (https://boyfriendtwin.tumblr.com/), featuring identically dressed

couples. Jose went on to explain how he liked his partner and himself to look individual, having their own sets of clothes, and if they happened to be dressed the same to go out, "I'll tell him he needs to change."

In contrast to those with shared wardrobes, similar styles, or who borrowed from one another's wardrobes, several interviewees were emphatic about not sharing with or borrowing from their partners. Florent explained how he would like to borrow clothes from his partner Alex B, who had "made it very clear that could not happen, so I obliged." Darren emphatically stated his and partner Dat's wardrobes were "very separate." Dat elaborated that he "wouldn't dare wear his shoes, because I stretch them because I've got fat feet." Living with his Japanese partner in Tokyo, Ernesto recalled that he would often "steal an item" from his partner, but it never happened the other way around. Martin said that he would not wear his partner's clothes, not because he was not allowed but "because I wouldn't look good in it. He'd wear this huge, long shirt and he'd look good in it, I'd put it on and it'd look like a dress on me, I couldn't wear it anywhere even if I wanted to." Daniel Miller and Sophie Woodward found that, within male same-sex couples, "sartorial stances" provided a lens for negotiations around "individualism and difference" (Miller and Woodward 2012: 64). The sartorial stances of my interviewees in relation to coupledom offered both a chance for individuality but also within a shared couple-identity presentation.

The influence of partners and relationships on personal style

"I've been dating the same guy forever, and he's never really told me what to wear, what not to wear," said Gino C. "I think some people do experience that in couples, you know, like 'don't wear that, that doesn't look good.'" He also explained that in a previous relationship he had found that he sometimes discouraged his boyfriend from wearing certain items that he felt were not appropriate. Catherine Hakim expands the idea of erotic capital from being applicable to those entering the marriage market to the ways in which it is important within the performance of sexuality through dress practices and how it can be applied to "bargaining between partners in a couple" (Hakim 2010: 508). Although Hakim applies this bargaining to negotiations around sexual activity between couples, the discussions and influence of one partner on another over dress choice in order to look attractive could be applied here. The experience of being told what to wear was both reflected and countered by other interviewees who discussed both how they had influenced partners' dress styles or had altered their own dress practices to suit a partner. "He wears the t-shirts I make," Sina said of his partner, Pete: "If he sees something somewhere that he quite likes or thinks I'd look good in, I think about it and sometimes I do buy it. Underwear, I think we wear more similar underwear now than what we used to, when we first met . . . I'd say he shops on the high street as well." Picking up on Sina's noting that Pete shopped on the high street, Mikey felt his partner was "probably more interested in kind of seasonal fashion trends" than him and that this had influenced Mikey's choice of jeans, for example, encouraging Mikey to buy skinnier cut jeans than previously. Mikey also noted that he had "opened [his] eyes" to vintage garments by designers Vivienne Westwood and Sue Clowes. Barry believed that his boyfriend had not "really care[d] about fashion" until they met and was subsequently "obsessive." This introduction to fashion trends had resonance with the influence Mikey and his partner had on each other, as well as with Lukasz's recollection of his boyfriend telling him, around two or three years into their relationship, "remember when I met you, what you looked like, what you were wearing, so I really made your style."

Lukasz did admit that this boyfriend, who had spent a year away from Poland in Ireland where he bought clothes from Top Man, *had* influenced Lukasz's style, introducing him to tighter t-shirts and more pattern and color, as well as "some pink stuff, also that was quite indicative of being a gay." For Lukasz's boyfriend the social setting and context of available styles in Ireland over Poland was important, and he brought these styles back with him, influencing Lukasz in adapting his style somewhat in Poland as part of a couple. Like Lukasz, Ernesto and Jon described the influence of boyfriends on their style at particular moments in their lives. "I became more fashion orientated, once I met him," said Jon, subsequently acquiring a "substantial wardrobe." Ernesto explained that his partner, Daisuke, "reinvent[ed]" him, throwing out Ernesto's old clothes, encouraging him to "know more and more about clothing" as Daisuke was "really into" fashion. Due to Daisuke's influence, Ernesto explained he was able to see the difference between an original from Japanese brand Tomorrowland and a copy from Uniqlo, for example.

"Whether or not my partner wants to admit it, I think I greatly influence how he dresses," said Adriann, a sentiment that was echoed and explained in more detail by Matthew. When they met in 2007, his partner Josh had a fondness for blue jeans and music band t-shirts. Matthew had met all previous boyfriends on the goth scene, but not Josh who subsequently began wearing "a lot of black." Having been involved in the British goth scene in his teens and twenties during the 1980s and 1990s, Mikey reflected on the ways in which he had altered his appearance within relationships: "Although I've wanted more alternative partners I've always ended up with normal partners. They're attracted to me because I'm kind of a bit more alternative but I've always kind of changed, instead of meeting in the middle." He felt that in his relationship with his partner at the time of interview there was a mutual influence, discussed earlier. Dex recalled how their style "shifted" to a place where it was becoming quite conventional when they were in a relationship "with a cis gay man . . . for three months." Dex speculated that this was "semi-conscious, but you respond to what you feel people desire." They compared this to a newer relationship that was more a chance to "be myself being with bi or pansexual people, or gender non-conforming or queer people because that really allows me to sort of explore that spectrum." Sang and Jordan both described how, when particular relationships broke up, they changed their style of dress realizing, like Mikey and Dex, they had been toning down their choices to fit with their partner's expectations.

Shopping together and gifting clothes in relationships

Highlighting the difference in their styles, Adriann highlighted that his husband was "quite masculine looking . . . the clothes that he wears are always made for men" while Adriann's own style was more gender-ambiguous. Although they also occasionally borrowed from one another, they bought clothes for themselves and sometimes each other. Florent noted that he and Alex B would only buy accessories or shoes for one another. "When I buy [Darren] something, I always need to consider his dress sense," Dat explained, because "he's very proud about the way he dresses and his shoes." Both Dat and Darren emphasized how conscious they were of the particularities of each other's style when buying clothes for one another (see Color Plate 7). In an opposite scenario, Jose recalled how his partner "tries to buy clothes for me but I usually don't like them and he ends up usually keeping them." Reflecting on the role of clothing in his first major relationship, Greg recalled how, when his ex-partner's weight fluctuated massively, Greg would become a "sort of a surrogate . . . for the stuff he couldn't fit into." His partner

would buy Greg the clothes he himself desired, often resulting in success when Greg liked the garment, but "sometimes" with "t-shirts with these random numbers and words" he "missed the mark." Theories by anthropologists such as Maurice Godelier (1999) and Marcel Mauss (1992) situate gift giving within kinship relations creating bonds between giver and receiver and how gifted items, particularly clothing and accessories, are embedded with particular relationships.

Lukasz recalled that during his nine-year relationship with a partner living in both Poland and Antwerp, they would shop together and exchange garments, "usually not trousers, but like tops." Alex B felt that his and partner Florent's personal styles did influence each other when they shopped together, a sentiment echoed by Gary, who said that when shopping together he and Mark encouraged one another making this shared practice "dangerous." They would both try on the same garment "to makes sure we're both happy. Because we're the same size, it's alright" (Gary). Disliking shopping, Hayden explained how he relied on partner Shane to buy many of his clothes: "Often he'll be buying stuff and he'll say, you like this. And then he'll go and he'll be clicking away and he'll get me one too . . . he probably bought all of these clothes," indicating the V-necked t-shirt and jeans with elasticated ankles and ripped knees that he was wearing during our interview.

Conclusion

The idea that gay men choose their dress styles to attract partners and appear sexy and attractive underpinned much of my interviewees' discussions of various forms of relationships. Erotic and sexual capital defined within gay cultures and on particular gay scenes impacted upon the dress choices of my interviewees, particularly when seeking sexual partners. For some this constituted a practice of dressing like the object of their sexual desire, whilst for others a sense of personal style and notions of attractiveness were considered more important than fitting within a hegemonic style. In some instances, this related to concepts of masculinity or effeminacy and the ways in which particular behaviors or dress choices reflected how men were perceived in light of these gendered attributes. Ahmed's (2006) linking of sexuality to spatial formation was reflected in the ways in which gay men decided what clothes to wear to specific venues when hoping to meet partners or when on dates with potential or new partners. Being in an ongoing relationship also impacted upon gay men's dressed appearance, with some consciously (or sometimes unconsciously) dressing like one another or sharing wardrobes. The opinion of a partner and their understanding of fashionability or attractive dress influenced how gay men within relationships chose to dress. The practices of shopping with, and for, one another impacted upon the ways in which personal (and shared) wardrobes were constructed and this will be explored in more detail in the following two chapters.

Note

1 Catherine Hakim (2010) identifies six main elements of erotic capital: beauty; sexual attractiveness; social skills; liveliness; social presentation through dress and adornment and sexuality or sexual competence. She also included a possible seventh reproductive capacity, which is of course not relevant in the case of (gay) men.

7
CREATING THE GAY WARDROBE

The ways in which the men I interviewed considered the collection of clothes and accessories that they have amassed and how the choices they made in combining elements in a quotidian fashion constitute the wardrobe as a manifestation of their own personal aesthetic (Gell 1998, Woodward 2007) was important. Here, I refer predominantly to an individual's physical collection of clothes as opposed to the piece of furniture in which these are stored. Almost synonymous with *wardrobe* in one context is *closet*; but I avoid this term here, although it is a word used by some American and Australian interviewees, for its connotations not as an enclosed space containing clothing but as a state of secrecy, particularly around homosexuality, that has been extensively theorized and applied in many contexts to discussions of sexuality (see especially Sedgwick 1990). Sophie Woodward describes both the "'orders' of the wardrobe, which may be based upon social roles (such as work clothing), functionality (such as gym clothing), type of clothing (such as trousers or shirts), colors, textures" and the "act of dressing" as "the moment when social expectations and personal preferences conjoin" (Woodward 2007: 10, 2) and this is highly applicable to the ways in which my interviewees discussed their clothing choices.

Physical wardrobe and clothing arrangements

When discussing their clothing, a small number of interviewees described not just the collections of clothes that they had and the ways in which they liked to combine them to create outfits, but the physical space in which they housed their clothes. "I've got a dressing room at home" that is in "a little room that was the study," Michael N explained. "It's just easy because it's near the laundry and I've got the ironing board set up and it's all kind of there." He went on to point out that the piece of furniture that was his "actual wardrobe" did not fit into the room but was kept in his dining room with other pieces of family heirloom furniture. He conceded that this might seem odd and perhaps awkward but that it was not, "you just get the shirts out, that are color coded, the trousers that are, you know, all there, and when you're dressing, you take the items, you put them in the dressing room." What he did have room for in his dressing room was a wire mannequin on which he displayed his collection of ties, that he admitted he hardly wore but kept for both aesthetic and sentimental reasons, the majority having been bought by a former partner. Darren noted that in the rented house he and his partner, Dat, were living in at the time of their interview, they had a large "walk-in closet" that allowed them to sort their clothes. This meant they did not "really need to throw things away" but acknowledged that "when it comes to moving, we'll have to downsize." Having lived in the same house or flat for a number of years both Andrew and 67-year-old white Australian retired art director, Murray, highlighted the amount of clothes they had accumulated. Murray had a suitcase "full of stuff that I've kept over the years. Favorite shirts and things." He noted how from time to time he would return to this suitcase and retrieve a garment that he had not worn for some

time but that would fit a particular occasion. Andrew related this to the freedom from prescribed fashions and thus felt he could pick and choose clothes from previous seasons to "look exactly how [I] want to look."

Explaining that he had "a huge wardrobe at home," performer Tim noted that his stage costumes and clothes for everyday or social occasions "bleed in and out of each other" as he saw every day as "a performance, every day I'm on stage." Patrick similarly noted "a fluid boundary between performance costume and daily clothing" that was based on his "own mood . . . on who I'm seeing." Tim and Patrick here both evoke theoretical ideas based on Goffman's (1969 [1959]) ideas of the social processes through which actors execute distinct performances in front of different audiences and the ways in which the self is constantly created and recreated through interactions with other actors, as well as Judith Butler's (1990, 1993) expansion to ideas of performativity. Clothing for work, including performance-related occupations, is discussed in more detail in Chapter 8. Although they did not describe their wardrobe in detail during their interview, partners Antonio and Riccardo showed me their large, fitted wardrobes in their bedroom, one crammed with a selection of designer garments and a smaller one with more everyday "basics as well as a drawer filled with a large collection of costume jewelry." Antonio did explain the rationale for splitting out the couture from the "basics": "we open the wardrobe and it's like big piece, big piece, statement piece, statement piece, gorgeous, haute couture, haute couture, and I'm like you can't put these two together because it's too much. So then you need the basics . . . just to kind of dress around the haute couture." This shared nature of Antonio and Riccardo's wardrobe, as well as those of other couples, in terms of how they each choose, use, and wear their clothes, was explored in more detail in the previous chapter.

Fashion studies developed a particular strand in the past two decades that focused upon the materiality of individual collections of clothing and the ways in which the owners organize and select from their collections (Cwerner 2001; Fletcher and Klepp 2017; Guy, Green, and Banim 2001; Klepp and Bjerk 2014; Woodward 2007). "Wardrobe studies" can indicate how "the sorting and organization of the actual clothes reveal a great deal about how the garments function in relation to their wearer" (Warkander 2013: 62). The research for this book did not conduct detailed examinations of each individual's wardrobe, relying instead on extended interviews in what Ben Barry and Dylan Martin describe as sartorial biographies (Barry and Martin 2016b: 226). However, the principle of considering how clothes are arranged and selected in "acts of dressing" is pertinent to the understanding of both the material, symbolic, and sensual relationships between dress and identity.

Ian J highlighted how even having a lot of clothing might lead him to think, "Oh, I haven't got anything to wear" and no matter "how many clothes you've got . . . you always want something else." He contextualized this both in terms of his occupation as a vintage clothing dealer, that offered him access to a range of clothes, but also his physical body, stressing how when he lost four stone he sold his larger sized vintage items that were "quite rare really" for "good prices," replacing them with items that fit his new body shape. In contrast to Michael N's and Murray's closed storage, Daniel ensured that he did not have a physical wardrobe with doors that could be closed, in order that he could see all the clothes he owned, otherwise "I'll just get overwhelmed, and you can put it into a closet and you never know it's there and you never use it." In order to be clear about what he owned, Alfie split his clothing by category. He described how he had "two big drawers of t-shirts, another drawer of jersey sweaters. . . . A whole drawer of underwear, another whole drawer of socks . . . piles of folded clothes" and "a drawer of pants" that he categorized into jeans, silky trousers, and print trousers. Robert fantasized about arranging his collection of clothing onto open accessible rails that would "have all black at one end, and all white at the

other end, and a room full of polished shoes." This attention to the arrangement of types and styles of clothing reflected for these men a sense of self and elements of their identity across a variety of social locations and different stages of their lives

Choosing in the morning

Andrew, Adam, and Christopher each described how one of their first daily acts was to decide what to wear. Andrew said he woke up "knowing what I want to wear" while Adam noted how he would lie in bed with his wardrobe / cupboard doors open and "just sort of look and think 'oh, that's quite nice' [and] then I'll start putting things together." Both Andrew and Christopher link this selection process to how they "feel," that making particular decisions for the day sets their mood, leading to what Adriann described as being "ready to take on the world." Alex B emphasized the importance of making the right decision in his daily clothing choices as "if I'm in a bad outfit I'll be in a bad mood . . . I do care, if I know I got it wrong." Explaining his morning routine of outdoor swimming, Ian J stated that he put on grey jogging bottoms and trainers to go to the pool and while swimming would "decide what I'm going to wear for the rest of the day." He was quite clear that the jogging pants and trainers were an easy comfortable choice to get to the pool or to "lounge around at home" but not for any other purposes. Notions of comfort are further discussed in Chapter 10. This morning selection thus became a ritual for Adam, Alex B, Andrew, Christopher, and Ian J. Rituals are not thoughtless, but instead are incorporated and introduced for a specific reason (Provis 2019), acting as particular functions that define the behavior of people in given circumstances (Summers-Effler 2006). Here the process of contemplating clothing possessions and selecting appropriate combinations for the day's activities was key to the performance of these individual's identities.

What he would choose to wear depended upon "the feeling in the morning" articulated Toshi, a forty-something Japanese graphic designer, echoing those above. He also emphasized the influence of the weather, choosing lighter clothing to deal with the hot and humid Tokyo summer or reflecting a "sunny day" with "more colorful clothing." Like Toshi, Michael N and Gino C were conscious of climate and weather in their clothing selection. "I've got an interesting collection of beanies, gloves, vests, hand-knitted," Michael N noted, because of the cold weather in Ballarat, Victoria, where he lived. Gino C described negotiating the extremes of "tropical" summer heat outdoors with air-conditioned interiors in Miami: "When it's fall or winter here, I'll suffer through it, I'm obviously not going to wear a turtleneck in 85 degrees weather, but if I know I'm going to an air-conditioned event I'm going to wear the turtleneck." Also citing a turtleneck in inappropriate conditions, Sanjeeva recalled how, as a teenager in Singapore, people would think him "ridiculous" for layering his clothes: a leather jacket over a turtleneck for example. His move to London to study at university allowed him to "play with layers." Adam similarly described layering outfits—"a very pattern-full t-shirt [and] then throw a shirt on top of that, and if I need a jumper, then I'll put a jumper on top of that, and then a jacket"—if the British weather was conducive. This was not in any way random as, when constructing this layered effect, he would be "thinking very much more about the whole outfit." For Tim the "fun and the playfulness" and "effect that color has upon me, the mood, and your psyche" was relevant in his compiling outfits, particularly of one color—lilac suit, hat, tie, shoes, and lilac scented "perfume oil"—and ones that combined complimentary colors: a vivid cobalt blue suit with yellow for winter and maroon trousers with a mustard jacket and shoes, for autumn. The role of pattern and color in gay men's dress is discussed further in Cole (forthcoming 2024).

"I'll pick out one piece, whatever it is, and then the rest sort of goes from there," explained Jon, echoing Andrew's knowing which garment will form the basis of his daily outfit: "If I wake up wanting to wear a particular hat, then I kind of know what I want to put on with that." Barry made a similar point in relation to his extensive wardrobe that was "a bit of a mishmash" but within this he had his key pieces of "nice designer things" that he would make "work with something else," perhaps vintage or second-hand. Like Barry and Andrew, Gino C, Sanjeeva, and Simian each stressed interesting "statement pieces" such as a blazer or "really flashy trainers" that were key in the construction of their daily outfits and influenced the rest of the garments chosen. While he acknowledged that he liked the idea of wearing a "recognizable" "key piece," Alfie also said that when dressing he "never" wanted to feel that he "look[ed] too polished."

Assembling outfits

"I know what works together mostly," Jon explained when considering the range of clothes in his wardrobe to construct an "outfit" that would "look fashion enough." Sam recalled how after previously being focused on brands, when he began his PhD in 2013 he began to consider "entire ensembles" rather than "pulling things out of the closet because I liked them." He retrospectively connected and compared this change in approach to moving to Europe in 2009 where he was influenced by the "playfulness" he saw in London and the way "the French did that really sophisticated" style, "quite heavily detailed" with "beautiful coats." Also considering his change in approach to the clothes that comprise his wardrobe, Teddy noted how he stopped buying on impulse, thinking "this is new, this is interesting," becoming more considered, asking himself "How does this match to particular outfits?" or "Will I wear this more often?" Like those men above who considered "key pieces" or statement items, Teddy noted how in his "carefully selected wardrobe" he would have "pieces that are really good quality, that will last a long time" to which he would add basics that would work and compliment these key items, in a similar manner to Antonio and Riccardo. Adriann highlighted having "a really nice jacket" or jeans that he could wear with "multiple things" and that were "quite special so then I know I'll have it for a really long time," while Christopher related a similar thought but in relation to not shopping frequently and trying to buy garments that he felt were "going to be in your wardrobe for eternity."

The idea of acquiring clothes that would last or continuing to wear pieces over a long period of time was also highlighted by Matt. This centered around building a flexible wardrobe of good quality well-fitting pieces that could be combined in multiple ways. Alongside this was a consideration of cost and "having fewer clothes" that he could get "value" out of through both quality and fit. For Christopher, longevity was in the context of having had a "big cull" when he moved to New York in 2015 but keeping key pieces in consecutive moves to different cities before settling in Sydney. Similarly, Daniel recalled moving from London to the United States in 2012 and taking only two suitcases of garments that were important to him, throwing or giving away others. He linked this to a consciousness about his own over-consumption—"if I buy something new, I have to get rid of something"—and how being more careful and considered was a responsible and sustainable way to consume (Black 2008, 2019; Fletcher 2014; Gwilt 2019; Muthu 2019), connecting with ideas about shopping explored in the next chapter. Perhaps thinking along similar lines to Daniel in terms of quality and condition, Chris pondered on his need to clear out the cheaper purchases that had not worn well or were a spur of the moment decision, meaning that they remained sitting in his wardrobe unworn. "I've got far too many clothes," acknowledged Clarence. "I do have favorites that I can't seem to part with, though I haven't worn them for a while," similarly to Murray

and his suitcase, noting that these were not necessarily expensive items, describing a "very simple, very comfy" blue cotton jacket bought from Japanese retailer Muji, that was "very Yohji [Yamamoto]." Every time Clarence cleared out his wardrobe this garment was returned because he felt "it's one of those classics that you can dress up and down."

Eric said that depending on the location and occasion he might be more or less "dressed" up, but that he had always maintained the same style, influenced by the mid-west country clubs of his youth, that he described as "traditional" or "classic with a twist." The "twist" here for Eric was "things that some straight men wouldn't wear," such as the designer brand Pucci. For Carl G, preferred style was "Preppy with a vintage twist circa early 1960s" (see Figure 1.1). Mario, also Carl G's partner, explained how when he moved from New York to Ithaca to attend Graduate School in 2007, his style was very similar to that at the time of his interview in 2012: "Fashionable cut of jeans, nice sweaters, button down shirt," influenced by the styles he saw in the windows of the Paul Smith store in New York. He noted that moving to a more suburban location he stopped wearing "all these nice wool trousers with different patterns" because they "set me apart too much and I would get weird looks." Having referred to the outfit he was wearing for his interview to provide context for a more historic style, Mario elaborated on how his interview outfit, of a colorful patterned sweater with jeans and smart brogue shoes, was very consciously chosen to illustrate his current style while living in London and the continuity and variations in the development of his wardrobe (see Color Plate 8).

Other interviewees also noted how they had intentionally selected their interview day outfits, wanting to be able to show a particular aspect of their wardrobe and how it reflected their identity as gay men. This reflects practices in wardrobe studies where particular garments or outfits are identified and discussed in detail. "I've always got this matching kind of look" said artist Rafal, in relation to the matching khaki shorts, sweatshirt, and hat that he said made him look like "the son of a butcher" he wore the day of his interview. This was originally created as part of a performance outfit but had migrated into his daily wardrobe. The particular significance in this outfit was both the Soviet-inspired constructionist uniform look and the hand-embroidered Russian script patches that read "something in Russian language" in Russian Cyrillic (see Figure 7.1). On the day of their interview Riccardo and Antonio were both wearing patterned trousers with plain women's crop tops, they made a point of explaining that they liked the idea of wearing complimentary outfits. Remi described each item to illustrate the range of shops he bought from:

This is a Zadig & Voltaire jacket that I bought in Harrods, with an amazing discount [laughs]. It's white denim but I liked it because there is this draw[ing] at the back [of an eagle]. And then the t-shirts [sic] is The Kooples. I love The Kooples. The trouser is Zara, the shoes are Adidas, so it's coming from many different places now.

Remi's flat mate Simian also began by noting the shop his shirt came from and, later, how he and Remi influenced each other's style and sometime borrowed from the other's wardrobe: "I'm wearing a colorful [patterned] shirt. . . . That's from Zadig and Voltaire . . . a pair of trousers from Attitude, which is a French brand. Quite skinny but not like skinny, skinny . . . a pair of loafers with tassels from Jimmy Choo [and] a big hoop earring and a gold ring." Like Remi and Simian, Sanjeeva focused on particular brands and what he liked about them, emphasizing that this was selected carefully to illustrate the way in which he combined elements and how he felt his choices epitomized what for him was gay style in 2018, as in the outfit described below:

Figure 7.1 Rafal wearing matching khaki shorts, sweatshirt, and hat with hand embroidered Russian script patches, London, August 2017. Photographed by Shaun Cole. With permission of Rafal.

A hounds tooth pair of pants . . . from Top Man. I'm wearing Top Man paisley socks. I just love paisley . . . extremes of the color, like, really stands out to me . . . this shirt is a collection that Christopher Shannon did, when he was doing the London Collections Men I believe, but then I found it in a charity shop. . . . That's a River Island jacket, but, [from a] charity shop.

Sanjeeva contextualized this particular outfit by comparing it to a simpler "uniform" that he might regularly wear comprising "very skinny jeans and a cute shirt." For Teddy, describing his outfit related to the fit and how this was typical of his style at that time, August 2015:

A blazer from Jack London, [who] carry a line of clothes that fit my physique, its slim, some of the stuff is very much Mod '60s kind of look . . . I've got these Wrangler jeans, mainly because they fit me, and I was looking for the black jeans. I've got Uniqlo sweater, I love the fact that I can find a lot of high-quality stuff that's got that basic nice, beautiful look to it. Even though I am like, "Oh, it's sort of fast fashion." . . . And then my Doc Martens.

Following Teddy's explanation of fit in relation to brands, Sang described his interview outfit in terms of the textures, noting that he tended to dress in black much of the time (see Figure 7.2). As well as being "very much about textures," many of his clothes, he explained, tended to "have a slight tailored point of view" with "interesting necklines" reflecting an interest in cut and construction, arising from his career in fashion design:

So I've got on today my favorite pair of shoes, which is my boots which have got brogue detailing . . . they're navy but they're almost black. . . . But they have a white base . . . so they make them a little bit more casual than if they had a dark base, for example . . . I've got my black All Saints t-shirt on, so this is a little bit of an old one, but it's not quite a scoop neck and it's not quite a round collar, and it's got a bit of a raw edge and it's in a really fine gauge. . . . And then I've got my little knit cardigan on with rib detail that basically almost looks like a tailored jacket, so this is kind of knit casual situation.

Like Sang, Jordan concentrated on the details of one of "my favorite outfits at the moment and I thought you might ask me about it, so that's why I wore it." He "like[d] the simplicity" of the turtle necked sweater and that "because of the high neck it's kind of a little bit more futuristic and I always like kind of looking at technology for inspiration." Technology and traditions of construction were also important in his choice of jacket, which was "a take on men's tailoring, with this pinstripe but in quite a casual form of just a zip-front jacket with these little [mock] pockets." These were combined with a skirt he had made for a college assignment that was "A-line" in shape, because it needed to be practical and allow movement as he liked "to have a stride" in his walk.

Smart versus casual

"I go through phases of how I want to look" explained Andrew, noting that he had a large collection of suits but also that he wore "a lot of kind of casual clothes." Adam identified what he saw as two opposing ways of dressing, contrasting a "very tidy and buttoned-up appearance" and looking as if "you've thrown on some clothes and run out the house." Gino B identified Adam's former way as "dressing appropriate to the occasion, having a sense of a decorum and looking, not particularly formal, but just well-groomed."

Figure 7.2 Sang wearing black BLK & BLU (his own label at the time) top and black jacket from ZARA, at Marriage Equality Rally in Melbourne on 26 August 2018. With permission of Sang.

Veering more toward Adam's second option, partners Mark and Gary noted how "very caz" ("very casual") their wardrobes were and that they did not "like getting dressed up too much" (see Color Plate 5). They compared going to a party, where they would usually wear a t-shirt and shorts or jeans, with a night at the Sydney Opera House where they would "dress up to dress down" and wore suits in reaction to the casual style of jeans and t-shirts of much of the audience, so bucking their own "very caz" approach to leisure time dress. Like Gary and Mark, Gareth emphasized that "in terms of my fashion sense, it's broadly casual, in summer I do try and . . . infuse it with a bit of a beach sense about it so I'll wear board-shorts." Jose and James, who both lived in Miami, described a compromise between smart and casual, influenced by Miami's climate, of blazers and shorts, that also allowed for "that transitional period from day and night."

Pondering on his penchant for casual styles, Johnny stated that "I don't wear a suit unless I absolutely have to. I don't wear a blazer unless I have to." Consequently, he was usually under-dressed for special occasions. He did note that *if* he *did* have to wear a suit or formal jacket then he would "put a lot of effort into making sure I look like I want to look" as he was, he emphasized, very specific about the number of buttons and size of lapel, the collar (fully cutaway) and cuffs (double cuff) of his shirt and the knot of his tie. He believed this may have originated in the dress regulations of the private school he attended in England. Teddy noted that he felt "a certain confidence, like when I dress up, I feel like, I'm not going to be sloppy today, or a bit lazy. I'm getting up and I'm doing something, and I've got a purpose," linking this to his

European immigrant upbringing. He noted how his parents had moved away from a smart appearance related to their occupations in Romania to a more casual Australian attitude and so dressing smartly and taking care in his appearance made him feel "almost like I'm being a bit of a rebel." He went on to articulate that dressing outside of the casual norms of Australian suburbia "you would be seen as queer, I am using the word queer as someone who's different, but that would of course start to segue into, 'Oh, maybe you're actually gay,'" a process he said he went through in coming out in conservative suburbia and to his religious parents. Sang recalled that in the early 2000s, when he was training as an architect, he "would feel a bit overdressed for Australia" where the "cool crowd" wore jeans and t-shirts and he would always wear a shirt or red jumper and formal black dress trousers and feel that he should "go out and buy a Mooks t-shirt or something that's a little less formal." He went on to admit that "I do smart casual very well" and this suited his lifestyle, as he was conscious that each outfit had to "multi-function" across his varied day.

Recounting his first return to visit family in Singapore after moving to Melbourne in the 1960s, Clarence recalled that they expected him to "be dressed in a suit and a tie and that's how conservative" it was. He used this example to contextualize temporal differences in expectations and how one of his favorite outfits that he was still wearing in his late sixties was a "military air force jumpsuit, that I had dyed bright red" and at "the ends of the zips I put on yellow tags, you know, to personalize it even more." He emphasized that he wore it to not "feel like an old man." George also invoked jumpsuits that he occasionally wore to parties with "a big white coat that's a sheepskin" as an antidote to feeling that he was "really conservative" after having been more outrageous when he was younger. Attitudes towards dress and age will be explored further in Chapter 11.

Variety versus uniformity

Aligning in some ways to Adam's two ways of dressing, 42-year-old white American marketing specialist David J said that he was "a little bit more playful" with the clothes that he wore, continuing that he felt like he was "not really committed to one particular look." He humorously compared his work style to his "everyday style, or a gay style," the latter either a "West Hollywood prostitute look" or "military looks . . . because I grew up around the military." The way Roy dressed and put together outfits was "always interchangeable and evolving" he felt and explained that when he was modeling people used to call him "the chameleon" because he was "comfortable" wearing a range of different items and combinations "as long as it's my idea of my taste level" (see Color Plate 4). Acknowledging that people have and set their own taste levels, Roy's statement here alludes to Bourdieu's (1984) discourses on taste when he noted "whether it's deemed as the right type of taste or not to the onlooker." Taste can be perceived as a personal matter but is inevitably one that is influenced by habitus (Bourdieu 1984), discussed in Chapter 1. Although he does not use the word taste, Nick described how "fashion sense" and knowing "just what works" for individuals is not a universal gift. Again, perhaps echoing Bourdieu, he identified that having money to buy expensive designer garments did not necessarily correlate with putting together outfits that matched "your body size or your age" and for him "mixing" garments that worked for day or night reflected a personal approach. How gay men negotiate dress choices in relation to comfort and age will be explored in more detail in Chapters 10 and 11. A "mix and match philosophy" was identified by Marcus as being one of the fun elements of dressing as a gay man and he identified combining a 1950s cardigan with Paul Smith trousers or "1930s glasses with 1970s ski pants, with Doc Martens" or "whatever feels good."

"How would I describe my style?," Gino C asked, answering, "I would say maybe like eccentric to a point, I really dress to my mood most of the time" and "it can really range from, you know, a normal suit to a loud t-shirt with a loud leopard print." Rather than eccentric, Michael N described his wardrobe choices as "eclectic," moving "in and out of quite bold colors" and "fairly conservative cut" garments, combining a variety of patterns and fabrics. Alex M was clear that he did not have "allegiances" to styles and that he did not present himself in one particular way repeatedly. Instead, he "flit[ed]" between different looks, "in relation to where I'm going," stressing that he was "aware [that] I dress to suit, maybe, the event I suppose." Like Alex M, Gino C had noted location or occasion, and this was also reiterated by Eric, Josh, and James; the latter noted that the changes in his style were very much dependent on the environments in which he was in at particular times. These discussions of variety of styles links to post-modernist propositions of the ways in which adopting multiple identities or appearances facilitates control to reveal particular sides of individuals at particular moments (Lurie 1992, Negrin 2008a).

Both invoking the word "uniform," Barry and Israel described different styles. "My non-work drag is wonderful," reflected Israel, "I have the same pair of pants, I have two in green and one in grey." Emphasizing that his boyfriend hated his singularity of choice, he continued, "I have five other pairs of pants that I wear very, very rarely because I'm too lazy, and the green and the grey they always go with everything. So, I'm very uniform." Barry explained, "I say that I don't really have a uniform but I probably do. I always wear Dickies skate pants or Ben Davis, that's probably my favorite." Israel favored a smarter style that was evoked as one of the choices by the men earlier in this chapter. Taylor also described a smarter style of dress that he noted often set him apart from other British gay men of his generation:

> Church's brogues which I have quite a few pairs of which I wear all the time, cords, again I have quite a few pairs of cords. I don't really like jeans. I will generally wear cords or chinos. An Oxford shirt, purely because they are comfortable and more casual and a big jumper, cashmere jumper, cable knit and argyle socks . . . I'm sure plenty of people do see it as old fashioned [but] this is just generally my *uniform*, as I refer to it.

This repetitive selection of a particular style that becomes what is referred to by the wearer as a uniform, as opposed to a formal uniform associated with or required for particular occupations or professions, relates to a performativity, whereby the repetition of acts contributes to the becoming of the self (Butler 1990, 1993). Drawing on Foucault's models of power, knowledge, and governance, Brian McVeigh proposes that the very act of adopting a uniform "*produces and reproduces . . .* the subjective substructure" of social norms, rather than "*reflect* the wearer's commitment" to those norms (McVeigh 1997: 208, emphases in the original). This balancing of a consistent style or a variety of looks, be those smart or casual, allows individuals, Woodward (2007: 2) proposes, "to negotiate a balance between fitting in, dressing appropriately, and looking and feeling like" themselves. The relevance of occupation or profession to dress choices and how the gay men I interviewed negotiated how they dressed at and for work will be dealt with in more detail in Chapter 9.

Dress codes and regulations

Echoing familial and social influences discussed in Chapter 1, Alex M noted that his upper-class upbringing and schooling instilled in him ideas about the "correct" way to dress. While this remained with

him, he did not necessarily feel bound by these rules and varied his looks when he was visiting family, going out to clubs or bars, and at work. Johnny, who was also educated in a middle-class private school, noted how this kind of class-based educational environment had "a certain dress that comes with it . . . the check shirts and the chinos and the boat shoes and the tweed and the flat caps" but that this "wasn't really my thing at all," instead going through a "bit of a surfer phase." Hinting at the development of cultural capital being informed by education, Eduardo reminisced that he went to a Catholic high school which "had a dress code, which was very lenient . . . you could wear anything you wanted as long as you wore a shirt with a collar, a pair of shoes and trousers that were not jeans." He emphasized that this had informed his attitudes towards his fashion choices later in life. Considering the influence of family rather than education institution, Taylor acknowledged "my dad and his parents are of the mindset that there is a proper way of doing things" and "I have always identified with that. I always have clean polished shoes, always iron your clothes properly, that's the way I am, I am exactly the same." Assigning some of his thoughts about convention and appropriate public appearance to his age and the ways in which he was taught to think about how one should dress, Tim explained, "I know it's a cliché, but it's true . . . I never leave the house unless I'm happy with how I look, and the combination, the arrangement of the apparel." In her 2015 exploration of American white-collar dress codes, *Buttoned Up*, Erynn Masi de Casanova identified that fathers and other family members influenced how men dressed through socialization or by example, in similar ways to those described by Alex M and Taylor. Woodward argues that "habitual clothing" that people are comfortable wearing and "requires no extensive deliberation" as people "'know' it works" is a form of cultural capital: "the knowledge that the clothes chosen are right for the occasion," fitting related normative dress codes as well as "personal aesthetic" (Woodward 2007: 135–136). This adherence to rules and regulations reflects the descriptions above of those who deemed their adoption of certain styles as their "uniform" and the performative adoption and repetition of certain "approved" dress items and styles. This embedded knowledge and conforming to or reacting against such structures was key in the creation of the self for these men.

Roy believed that "there shouldn't be any constraints" but that for some occasions there was "obviously a dress code [and] it says on the invitation, wear a suit or wear this, or wear black or wear white, then yes" that was appropriate but, "if you want to add a little bit of some color to it or not, then it's really down to you." This resonates with the comments of Gary, Mark, and Gino C in the smart versus casual section above. Roy went on to identify that "there are certain constraints where it calls for a suit" but he would add details in his shirt or wear earrings "to give it that edge" or "go really conservative and go old school Hollywood" adding a fedora, socks with a garter, and bow tie or tie with a tie pin, to appear "full suited and booted, but with a twist, with a flash of color." Ken noted that when he was invited to formal functions he would have "to quickly think, oh, what do I put together, how do I buck the system" as he did not own a suit that was often required for such occasions. Ken noted a different way in which he liked to mix things up, describing how he "went to an opening of a gallery" that was "formal" and to flout conventions he wore "shorts and a formal jacket and boots" as he had "this thing about being noticed in a crowd."

Conclusion

The pulling together of outfits, whether smart, formal, or casual, was an important process for many of my interviewees, associated both with a sense of the occasion and with the arrangement of the physical

storage of their clothing. This related to a sense of personal well-being and confidence and the impact of external validation. The ways in which gay men assemble their wardrobes and combine garments into outfits in particular ways for a variety of activities, settings, and occasions were impacted upon by their shopping habits. Wardrobes are a fluid and flexible entity, with old garments being removed and new items introduced and combined with existing. The construction of individual men's wardrobes through the temporal aspects of purchasing new and / or second-hand, or vintage, garments that are branded or from particular named labels, is further explored in the next chapter.

WE'RE HERE, WE'RE QUEER, ARE WE GOING SHOPPING?

"I don't traditionally shop," stated Nick. He qualified this statement by noting how, when he decided that he was going shopping, he did not buy everything from one place but bought from a variety of individual brand stores, department stores, and vintage stores. He was not alone in this and many of my interviewees mentioned a variety of different stores or locations and often offered a justification that was sometimes based on price but also on the availability of styles or perception of the fashionability or connection to trends or the brand or designer label. Consumption has been recognized as being highly significant within the construction of both individual and socially focused identities (Campbell 1996, du Gay 1997, Wilson and de la Haye 1999). Fashion and clothing, especially, have been linked to the notions of choice or agency within consumption practices, particularly highlighted within cultural studies and theories influenced by post-modernism (Finkelstein 1991, Hall 1981, Polhemus 1994), to create a unique version of the self. This agency has been linked to the ways in which fashionable garments link with a personal aesthetic (Woodward 2007). It has also been proposed that choice is overstated, and people dress in a remarkably similar way (Breward 2003, Cavallaro and Warwick 1998, Davis 1992, Simmel 1957, Wilson 1985). Literature that is more focused specifically on sexual minorities pointed out that gay men are "obsessed with consumption," linked to "an effort to counteract the lack of power in other social arenas" (Kong 2011: 77; cf. Penaloza 1996). Indeed, a resounding call at gay pride marches since the late 1980s was "we're here, were queer, we're not going shopping" (referenced in the chapter title) that made light of this stereotypical perspective on gay men's habits and the increased targeting toward the pink pound/dollar. Kim, Ha, and Park (2019: 1266) point out that much of the literature on men's fashion consumption "fails to reveal statistics about where men shop frequently and why." Although their study did not demarcate by sexual orientation, this observation links to the attempt in this chapter to understand where my gay male respondents liked to shop and which brands they favored, indicating personal brand loyalty.

From high street to high-end designer

For Jose, Erich, and Daniel, high street stores such as H&M, Express, and Top Man were top of their lists of chosen retailers due to their relatively low-price points. Simian linked shopping at these stores to his middle-class upbringing which had discouraged excessive spending and the conspicuous consumption practices of buying from luxury stores. Returning to education after working as a designer in the fashion industry, Mario felt that he should be buying from these stores to fit with his newly reduced income but highlighted that, being in London, he preferred the British heritage brand Ben Sherman, as "they use

color very well, the fit is good and a particular price point for me." Mario asserted that at the time of his interview in 2012 the fit and design at Top Man was not to his liking. So for him the feeling that he should be conscious of how much he spent and be frugal by choosing high street was offset by his awareness of good design and fit that was more evident at Ben Sherman. In contrast, Daniel felt that discovering Top Man after moving from a small town to a larger city at around the same time in 2011/12, opened up more stylistic opportunities. Likewise, Sanjeeva explained that for him, Top Man offered the styles and bold print fabrics that he liked that were perhaps seen as being "girly" or "feminine," but that he felt had "a cleanness about them." He also highlighted the fact that the quality of manufacture meant that the garments were going to last and not fall apart and that because they were not manufactured in China they fitted with his ethical standpoint on manufacture.

While ethical considerations have become increasingly important for fashion consumers in the twenty-first century, Sanjeeva was the only one of my interviewees who explicitly mentioned this in relation to brands; others did however allude to the sustainable implications of buying vintage or second-hand clothing. This could have been both a reflection of Sanjeeva's age, with ethics being a concern for his generation, but also a result of discussions about ethics in the fashion industry engaged with during his then current fashion education. The Japanese high street / fast fashion brand Uniqlo was highlighted by both Taylor and Patrick, but for different reasons. For Patrick it offered a particular style, color, and fit in woolen jumpers that he felt he could not find elsewhere at an affordable price point. Like Sanjeeva's rationale for liking Top Man as clothes that did not fall apart, Taylor appreciated the "decent" quality and longevity of Uniqlo, but also that the clothes were unbranded and plain. He also noted that he bought from Ralph Lauren and British brand Albam for similar reasons.

Gareth noted his aversion to overt branding, and "visible logos," particularly identifying Polo Ralph Lauren, as he associated these with "old stereotypes of old heterosexual norms" calling them "*man* brands." Having grown up in suburban Sydney amongst an Indian immigrant culture, Gareth was aware of other minority dress choices and a certain hegemonic masculinity perpetuated within Australian culture. His awareness of his sexuality, alongside his ethnic origins, instilled in him a desire to use his dressed appearance to mark himself out from heterosexual masculinist dress choices that he saw manifested in overtly branded goods. Taylor had jokingly noted that his choice of unlabeled "classic" styles of menswear had led to people assuming him to be heterosexual and stating that he "didn't look gay," something already explored in more detail in Chapter 1. Ernesto noted that Argentinian brands Bowen and Bensimon were particularly worn by gay men who recognized the brands "by heart." He noted that compared to other international high street / fast fashion brands they were expensive. Sina recalled buying "loads of stuff from American Apparel, just basics like vests and socks and the athletic shorts" and that he had been "really influenced" by advertisements for the high-street brand specially commissioned for the specialist short-lived queer magazine *BUTT*. Ernesto, Taylor, Gareth, and Sina's comments link to Richard Elliott and Kritsadarat Wattanasuwan's observation that "brands can be used by the consumer as resources for the symbolic construction of the self" and figure in personal "socialization process[es]," in this instance into the gay "community" or in relation to other gay men (Elliott and Wattanasuwan 1998: 139, 140). Sixty-one-old Robert lamented that "fashion and sexuality has all just become so ordinary, that nobody is really identifiable" and said that this was why he liked to shop when he traveled.

At the opposite end of the fashion spectrum to high street / fast fashion brands lie high-end designer labels that several interviewees highlighted as being important in their wardrobes and part of their identity construction. The two most frequently mentioned designers were Vivienne Westwood and Comme des

Garçons, both for their innovative designs and the capital that they held amongst gay men in the know. Michael N described Vivienne Westwood ties he had been given as gifts along with other designer accessories such as scarves from the Melbourne-based designer Joseph Sabo. The cost of purchasing these Vivienne Westwood ties was not borne by Michael N, and both Patrick and Mikey discussed Vivienne Westwood garments in their wardrobes but noted how cost (for Patrick) and rarity of certain older garment styles (for Mikey) led them to buy second-hand, discussed in more detail below (see Color Plate 9). "I might wear Custo from Barcelona, or Paul Smith now, or Rare from Italy," explained Marcus. He highlighted that at the time of his interview this was rare and he had swapped buying new designer garments for "stuff on eBay that I quite like the style of and being more casual about it." Having been exposed to Comme des Garçons and other Japanese designer brands through his work at high-end Melbourne department stores in the late 1970s and 1980s, Robert noted that he continued to buy Japanese designer garments when he could find his size—a concern discussed further in Chapter 9. Performer and model Roy and hairdresser Barry both discussed Comme des Garçons in relation to particular sources that they had within the fashion industry who provided them with access to designer items. In an interview for a publication entitled *What Men Wear and Why* (Haworth and Jonkers 2019), Barry discussed at length a Comme des Garçons cycling-style t-shirt covered with Pink Panther cartoon figures that he had been obsessed with for years; a garment he discussed with me during his interview. Barry also noted that his flatmate, an artist who had collaborated with designers and who gave him this shirt, also gave him a Craig Green jacket and items from Fendi. Performers and partners Antonio and Riccardo also described having friends who were designers, which led to them having "a lot of pieces from Kokon To Zai . . . Ada Zanditon . . . House of *Malakai,* Lagerfeld, Wang," many of which were women's. Antonio continued that "for basics, this [vest top] is from H&M," echoing Christopher's noting how his wardrobe had garments by Comme des Garçons and Vivienne Westwood side by side with Zara and Top Man. Laughingly describing the outfit he wore for his interview, Vlad noted he had paired a Dries van Noten blazer and bomber jacket with a Uniqlo shirt and a pair of "cotton pants that my friend left at my house once."

While buying well-known designer brands and labels in their hometowns, some of my interviewees highlighted that they liked to discover smaller local brands when they traveled. Partners Mark and Gary highlighted that the Young Designers Emporium in Johannesburg that stocked a variety of different young local designers, was "quite reasonable and you can get some really amazing stuff there." Finding Melbourne very conservative, Dat and his partner Darren liked shopping in Tokyo where they could find "brands that are quite obscure and only known over there" such as Tomorrowland and Gentle Man (see Color Plate 7). Residing in Tokyo, Toshi explained his mixed approach of buying from smaller, less well-known design shops, second-hand stores in Harajuku, and Tokyo department stores such as Marui, Isetan, and Hankyu Men's.

While Robert expressed reservations about the styles and garments on offer at department stores, as the same garments would be available across various branches, other interviewees saw the benefits of the selection of brands and designer labels and varying price points offered by department stores. Barry and Teddy both described how they would go to the menswear sections of department stores to dream about owning the expensive designer garments on offer. To counter such expense, both Mario and Kevin, a 58-year-old white American interior designer, attended the sales at department stores allowing them to find bargains. Kevin particularly noted that he had a friend who worked at Neiman Marcus who would put aside the items he had identified as desiring, so emphasizing his social capital. Having worked at London department stores, Liberty and Harrods respectively, Alfie and Simian recalled how they made

use of their staff discounts, often on top of sale prices, meaning, as Alfie asserted, "you could have this stuff that ordinarily you wouldn't be able to have." This use of both cultural and judicious economic capital meant that during these employment periods Alfie and Simian were able to acquire many more branded and high-end designer label clothes than would otherwise have been possible.

Following fashion trends?

Having particular social, cultural, and economic capital allowed various of my interviewees to purchase the latest fashionable styles, brands, and designer labels, sometimes at full price or discounted through connections or sales. For some interviewees, following trends and being perceived to be fashionable was important. "Whenever one trend is going quite popular, I tend to get one or two items from the trend," avowed Simian. While not using exactly the same terminology as Simian, TJ explained that in his public social life he dressed "more fashion-forward" and "experiment[ed] with fashion," something that was acceptable at one of his two public relations jobs. This contrasted with his private casual style at home where fashionability was not a concern. "I want to give the impression of someone who is very fashionable and fashion conscious," said Sam, echoing TJ's public-facing approach. However, Sam tempered this by stating that he did not want this fashionability to be "dictated by those current terms or trends." Sophie Woodward noted that "with any number of things being 'in' at the same time, fashionability is defined as an individual's capacity to assemble his or her own outfit" and as such, "conformity is often seen as the easier, unimaginative relation to dressing in an individual manner" (Woodward 2007: 27). Gareth asserted that if he was attending a public event then he would "dress more fashionably" but qualified his adoption of current trends in relation to his sexuality, taking a "more muted approach" because he was fearful of being labeled with a particular stereotype of "gay guys are really into fashion." Related to stereotypes of hyper fashionable gay men and self-perceptions of fashionability, Ou Sha, May Aung, Jane Londerville, and Catherine E. Ralston's study of gay male consumers in Toronto found that the majority of their white-collar professional participants "did not demonstrate a strong tendency toward fashion interest" and perceived themselves "at the same level of fashion involvement as heterosexual men" (Sha et al. 2007: 457). This is different for many of the men interviewed for this book as they discuss their interest in "fashion" as well as dressed appearance more broadly.

Having worked in fashion in New York, 50-year-old white American design director, Shawn, noted how when he moved to Miami fashion became less important than it had been in New York "where it had to be the latest thing" and "on point fashion" garments. He described his Miami style as more casual and classic. This term "classic" was also highlighted by David M, who recounted how a friend had advised when buying clothes to be "calm with as much of a classic mentality," considering colors that accentuated his hair and eyes. However, he confessed he could "never resist a trend." When considering a phase in his life before moving to Miami, Luis explained how "in Italy if you were wearing something of last season you were out of it." He reflected on how he could not understand the amount of money some people paid to be "in season" and adopted an approach that he felt was more "timeless" but with accents that added an "edgy" fashionable twist for an element of individuality. Dat and Darren liked to buy clothes overseas because there was the option to "buy what you like, rather than being dictated by what the season tells you" (see Color Plate 7). Dat's use of the term "season" has a double meaning here in that it refers to both the fashion season where clothes are on sale following the fashion industry system of autumn/winter and spring/summer fashion shows and in relation to the weather. A connected concern

was highlighted by another Australian interviewee in relation to Australia being a "season" behind, reflecting comparative commentary from both Australian and American interviewees about the lack of season difference in Sydney, Los Angeles, and Miami compared to Melbourne, New York, or London, linking to concerns about climate addressed in Chapter 7.

"I like to choose things that I think are timeless" acknowledged Chris, identifying velvet, denim, and leather as timeless fabrics and military as a style that "will always make a comeback." For Alfie, the process of "choosing" was a long one as he liked to take time to contemplate how tied to current trends his purchases might be, how they fitted with his personal style, other garments in his wardrobe, and with his lifestyle more broadly. "I have a logical side" expressed Adam, underlining how this made him consider "exactly what is this" new purchase "going to go with and how many new outfits or iterations can this bring?" Personal style, for Greg, was about practicality overall but he recalled how every so often he would be drawn to a particular trend or garment and buy it. He qualified this by noting he would have to have felt that he was going to be wearing the garment for at least the next three or four years. Michael B also described how he continued wearing clothes "not going through saying, 'oh this is last years, I can't possibly wear it' leading to a wardrobe full of shirts!" Like Greg, who explained that "definitely politics influences my decision, so buying second-hand where possible," Michael B expressed his ethical and sustainability concerns in relation to fashion, stating "I don't see clothes as disposable, I see them as you should wear them until they're worn out."

The price is right

Paying particular attention to cost and liking to acquire branded or designer label items, both Gregory, a 51-year-old Cuban American store brand associate and peer counsellor living in Miami, and Raj noted their fondness for factory outlet stores and malls where they could, as Gregory explained, buy "very expensive stuff cheap." Teddy noted how on receiving his "first big fat paycheck" in 2007 he visited the boutique stores in Melbourne he had read about but "had never dared set foot into." At Assin, a high-end concept store, founded in 2004, he bought an in-house designer jacket, a Junya Watanabe lace shirt, and an Ann Demeulemeester hat, spending "at least $400–500." He said that at the time he got a thrill from "blowing" his paycheck but that in retrospect he could have shopped around and "probably" got a "similar look or aesthetic for much much less." These examples highlight different attitudes towards the acceptable cost of garments, whether they are from designer brands, high street store, or discount outlets. For Gregory and Raj, cost here impacted upon their purchases, wanting to own recognizable designer brand label garments but unwilling to part with high prices. For Teddy, suddenly being in possession of a new high-disposable income allowed him to indulge in a previously unavailable pleasure of buying at high-end stores. The pleasure in selecting designer goods but being conscious of available financial resources and how to allocate these reflected upon the ways in which these men considered the place of fashion in relation to their economic capital.

For some interviewees, the amount of money they would spend depended upon the type of garment and whether they had available funds. "If I had money, I would be willing to spend about $400 on jeans" stated Erich. "But I don't think I would spend $8000 on a jacket [or] $900 for a t-shirt." Benjamin and Sanjeeva similarly discussed cost in relating to a t-shirt. Benjamin said he would pay £40 for a t-shirt that would last while Sanjeeva questioned why he should pay up to £200 for a white t-shirt from Comme des Garçons when he could buy something from Top Man or Top Shop "that looks good" for a fraction of the

price. Jonathan Faiers (2016) discussed the "privileged knowledge" of the "cost, provenance, and perhaps the touch" of what he called the "stealth luxury" of unbranded designer white t-shirts. This form of luxury was "understated and undetectable" except to those with the cultural capital to recognize and understand the relation between quality, brand name, and cost (Faiers 2016: 194). For Teddy, this lay in his question of: "Look at the material. Look at how it's made. Is this really worth the money?" Eduardo echoed Teddy's sentiments, stating that he would not buy cheap goods that would fall apart after one wear, but what was key was that it did not matter how much money he was actually spending but that he wanted "to get the most value for what you're getting." For Nick and Patrick high price new designer garments were out of their budget. So, when they did find marked-down bargains or affordable second-hand items they endeavored to make them last as long as possible. Patrick related this specifically to his brief sojourn into clothes making and considerations about ethics and sustainability within the fashion industry, making the point that cost was not just about financial expenditure, but other ethical concerns associated with the production of fast fashion and what he termed "mindless consumerism."

Relating his budgetary considerations to his artistic practice, Rafal identified that he had "never really had money." Rather than feel he had to ask friends or partners for justification and validation when buying clothes to stop himself feeling "bad at buying something," he began to create costumes for his performances that he could later wear as day-to day clothing, discussed in the previous chapter (see Figure 7.1). "It's budget-driven" emphasized Greg, in relation to his clothes purchases and, like Sanjeeva and Benjamin, questioned why he should pay what he saw as a triple mark up for certain labels. This is a marked contrast to Ernesto who did not spend a lot of money on "clothes" but on "good quality" underwear that would last and "pretty expensive" Brazilian brand sneakers. Like Ernesto, Joe M stated that he would "cheap up" on jeans, shirts and t-shirts but did not mind spending "$800, $900 on a good pair of shoes and, you know, $400, $500 on a belt" as well as on expensive underwear. For these men the financial cost of the clothes that they desired related to their own self-perceptions about their identities, and in the case of Rafal, resulted in a Foucauldian self-regulation around his purchases that subsequently led to a creative solution. The consideration of economic and cultural capital in relation to clothing labels and brands can perhaps be considered against the cost, both social and economic, that these men placed upon the expressions of their identity through dress purchase choices. "I'm quite price-conscious" reflected Sang with particular reference to the cost of clothing in Australia, noting that when he had worked in New York and Paris he found the prices better value. Working overseas also allowed Gary and Andrew to be more economical. "Why would you buy it [in Ben Sherman in Australia] when you're spending so much money?," Gary asked when the same garment was much cheaper in the United States or London, places he frequently visited through work. For Andrew, moving to London in 1995 gave him access to "such exciting clothing and that was affordable." Like Roy and Barry, Andrew made friends in the fashion industry who were able to offer him a further discount.

Physical stores or online retailers?

One of the key elements that Darren focused upon was quality of service. He admitted that because he was in the service industry this might have made him more particular. Xia Liu, Alvin C. Burns, and Yingjian Hou (2103) highlighted the fact that customers attach great importance to good service attitudes and required a satisfying sensory experience, noting that this sometimes drove customers to prefer the experience of instore shopping over online retailers. Influenced by the rise in social media and e-commerce

sites such as Mr. Porter for "ideas and fashion tips," Darren noted that he shopped online "because of being time poor." Gino C, similarly, identified that while he would like to spend "every day" in up-market shopping malls such as Bal Harbour Shops in Miami, he did not have the available time. While Darren and Gino C identify online shopping as a time-saving option, other interviewees offered a variety of alternative reasons. For Michael N it was because there was not a lot of choice in the small country town where he lived. For Chris and Shane, sites such as ASOS were preferred because neither particularly liked the experience of shopping in physical stores. They also emphasized the ease of selecting a wide range of garments and being able to return those that were unsuitable. Wataru felt that for him online shopping was easier. He described how on one site there were lots of different styles of t-shirts, offering more choice than in physical stores. However, he did offer a caveat that sometimes he would go to a physical store in order to ensure he was comfortable with the size and then look for cheaper options online. Israel also noted the value of seeing garments in physical stores to be sure about sizing but described how the Italian-label Isaia suit he was wearing at the focus group was from eBay and that when buying "really, really expensive" brands "the cut is always consistent" and so he was able to buy an Isaia suit that would normally retail at $3500 for $1000. Both Lee and Diego identified the online discount e-commerce site Gilt as a primary site for their online shopping. Diego, however, questioned whether after seeing something online it would fit him: "I definitely have to try it on . . . touch it, see how it feels."

This concern was echoed by others like Barry, Dat, and Zack, a 51-year-old white American manufacturing company president, who valued experiencing the materiality and fit of clothing, aligning with Wojciech Piotrowicz and Richard Cuthbertson's (2014) findings that despite brands providing both online and physical instore services, many customers want to see, touch, and try products in physical stores. Mark, Barry, Zack, and Bryan all emphasized a particular intentionality in going to physical stores, relating to materiality, fit, the desire for a specific garment, and keeping abreast of trends. Because he was "incredibly picky," online shopping did not satisfy Joe M's "hedonic needs" (Atwal and Williams 2017). For Jose, trying on clothes was essential as he identified that the high street stores that he favored, such as H&M and Zara, "fit me differently." Shawn described how when he was younger he would not try on garments, being confident of the fit for particular sizing. As he grew older, he noted that he had lost confidence and began to ask the assistant, "Honey, does this look alright?" The impact of ageing will be further discussed in Chapter 11. Youn-Kyung Kim, Seijin Ha, and Soo-Hee Park (2019) identify differing preferences between generational cohorts of male shoppers, generation Y customers being willing to shop online and use the internet as an information resource in relation to clothing, whereas older consumer demographic groups, such as baby boomers, view instore retail experience and service as more important.[1] However, the allegiance to, and preference for, either physical or online shopping did not appear to be divided along age lines amongst my interviewees. Jordan provides a clear example of generation Y who did not often shop online, despite spending time browsing online, while baby boomer Michael N used online stores as stated above. While age did not appear to be a dividing marker around choice to shop online or in physical stores, body size and personal perceptions around their own physicality did have influence for some of my interviewees. Robert, who discussed his health issues and concern about weight and body size, recalled an incident in Japan where he was ignored by shop assistants in designer emporia such as Dover Street Market. He was later informed that this was an attempt by the Japanese shop staff to "save face" and not have to inform him that they did not stock garments in larger sizes that would fit him. While he did not explicitly mention shopping online as an alternative in relation to his size, he did express pleasure in looking at garments online but expressed

concern about availability of sizes and the use of models with particular body size and shape to promote and advertise particularly designer brands. Discussions about the ability to find the correct fit and the matching of physical body shape and size with particular styles and trends are addressed further in Chapter 10.

Although many interviewees articulated their preferences for either online or instore shopping, as above, some did use both at different times and for different purposes. Gino B explained how he made use of many different physical and online opportunities, previously using department stores and thrift shops but increasingly purchasing online from eBay and ASOS. This mixing of sources and styles aligns with Marilyn DeLong, Barbara Heinemann, and Kathryn Reilly's (2005: 39) proposal that "knowing how to create a unique look in an otherwise bland mass-produced market may be a way to regain one's individuality through revaluing and reuse."

Vintage and second-hand

Living in San Francisco prior to moving to London in 2016, Adriann "became obsessed" with vintage clothing and consignment stores, sometimes finding "really amazing kind of vintage designer pieces." He explained that this continued a practice he had begun as a teenager, buying from Salvation Army and other thrift stores to create an alternative style to the skater or surfer brands preferred by his school contemporaries. Similarly, Florent recalled buying second-hand Diesel and colorful "vintage, seventies" garments in Paris in the early 2000s, that made this period "a fun time to dress." At around the same time Barry was "definitely quite indie looking," buying vintage "Adidas tracksuit tops and kind of quite wide jeans." Dex asserted for them the importance of going to charity shops to find both ex-theatrical costumes and recent collection garments from designers such as Jeremy Scott and Jean-Charles de Castelbajac. "I love ugly style," they said, and buying garments such as a women's Bob Mackie embroidered blouse and "the kind of stuff that middle-aged women would wear" allowed them to create an individual style.

Like Adriann's trawling of thrift stores to find clothes that made him stand out from his contemporaries, Gareth explained that he liked the "attention that wearing a strange item, such as a polyester shirt from the '70s, gives me." "As soon as I got to London, I realized I loved charity shops, vintage stores," Sanjeeva said, emphasizing how a vintage aesthetic did not exist in Malaysia where he had been brought up but after moving to London he would buy, like Dex, womenswear, particularly faux fur coats and "flouncy" blouses. Aligning with Sanjeeva's choice of second-hand garments, Gino B identified that he loved vintage furs, silk scarves, jewelry, and kaftans and as such created a form of vintage "uniform with clothing." Having little financial resources to follow trends or create a "look" as a student "op shops," as second-hand shops are called in Australia, meant Vlad could "buy a women's jacket . . . chop it up . . . put a, you know, whatever [on it] and then you kind of had that look." Jon explained that when "op shopping" he rarely had an idea of what he wanted but sometimes a garment would present itself that "I just know . . . I feel like I need" and he "create[ed] holes in [his] wardrobe" to accommodate it. David M said he was much more strategic, looking for particular garments, such as "a really interesting vintage shirt with a really strong print on it, a massive, oversized jumper." Each of the above interviewees advocated the experience of what Nicky Gregson and Louise Crewe (2003: 83) called "rummagibility"—allowing them to "discover" pieces for themselves as opposed to selecting from a carefully curated selection.

Barry, Florent, and Alex B each highlighted the importance of going to vintage stores in New York and Rome and buying pieces because of their uniqueness, "because nobody else has it, you know." Clarence

and Andrew also described buying vintage clothing in European cities such as Paris, Amsterdam, and Antwerp as the stock was different from their home cities of Sydney and London, respectively. David M recalled that the vintage he was buying in New York in 2009–2010 was "very much a Williamsburg kind of look, a vintage leather jacket and an oversized plaid shirt, flannel shirts." While he had moved on from a Williamsburg aesthetic by the time of his interview, he still liked to buy vintage because of lower costs and more interesting individual finds that made it "easier to experiment" with clothing and looks. The value of designer vintage garments that allowed him to "be different," worn in a way that did not make it "look dated," was emphasized by Alex M, whose interest began when he was studying fashion design and going to charity shops and second-hand shops and markets, and customizing garments was "just a kind of normal thing to do." He went on to explain that his approach changed by the time of our interview and that he was much more "cautious" when buying from second-hand shops and the goods had to be good quality, partly because "I've got a lot of clothing that I don't wear." Considering this search for uniqueness, Rachel Lifter noted that "consuming second-hand clothes" is not "a means of engaging in global fashion trends, but rather . . . a mode of escaping them" (Lifter 2019: 146).

Andrew explained that building a relationship with the second-hand vintage dealer was useful and one particular owner "calls me now and I've bought some amazing second-hand things . . . six months ago she had about ten of Boy George's old coats in there. . . . I've got brilliant overcoats. Some Dries [van Noten]." For married white British vintage shop owners Ian J and Ian B, interest began around the time they met in the 1980s, which was, Ian B recalled, "a big dressing up box of very much retro, antique and retro clothing." This eclecticism remained an inspiration for both. Ian B described what he considered a "fairly relaxed style, [although] other people might not think so," comprising of "many, many suits, old suits, '30s, '40s, '50s and early '60s suits. I tend to like a '40s and '50s, sometimes '30s look . . . it isn't necessarily 100 percent authentic . . . I'm quite happy to mix things a little bit, but I would say by the nature of our job most of what we wear is second-hand vintage stuff" (see Color Plate 6). Ian J said he wore "a lot of traditional men's clothing, three pieces and whatever, nice hats with shoes, so I always wear nice shoes" but that as he did not want to "feel that I'm trying to make myself look young" that was "quite good really." They both highlighted the advantage of owning a vintage shop as it meant that they had "lots of [choices of] nice things that fit us" and "if it's what we want then we're very lucky" (Ian J). Like the Ians, Riccardo worked at a vintage store and had "loads of pieces that I got by managing the store, it was, like, oh, this has arrived, it is mine." Echoing Ian B's description of his eclectic period vintage wardrobe, Marcus was "not one to run with the pack," wearing 1940s suits to exhibition openings, drawn from his collection of seven 1940s suits and around 300 ties, ranging from the 1940s to the 1970s. "I call my house opshopulent," declared Tim, admitting that he loved "op shopping" because of the bargains available, such as suits from Balmain and Versace, and a pair of "wonderful" Versace crocodile skin mustard shoes with a gold buckle that he saw "online and they were $1200 . . . I like that thrill of getting a bargain, you know."

Nick also highlighted the designer bargains that could be found in thrift stores: "I bought a Gucci and Ungaro blazer each for $10 at 'housing works' in TriBeCa and by chance encounter at City Opera thrift store, an [1980s] Yves Saint Laurent blazer for $25." Patrick compared the relatively high prices of vintage designer clothes, such as a Maison Martin Margiela sweater he found in a second-hand boutique in Melbourne, with a bargain 1960s red coat he bought at the Brotherhood of St Laurence op shop (see Color Plate 10). He also advocated both Etsy and eBay as good places to find reasonably priced designer garments such as a Vivienne Westwood shirt that "was not that bad and it fits me really nicely." Also singing the praises of eBay, Mikey described finding "old Viv stuff" but also garments from other 1980s labels that he was "rediscovering," such as Sue Clowes and an "Andy Warhol" vest from Boy (see Color

Plate 10). Because a lot of the vintage Sue Clowes garments he found on eBay were in small sizes he resold them. However those he did keep, such as a rarer vest with the Star of David and yellow roses, he wore infrequently, partly because of the transience of the printed decorative design, keeping them for special occasions such as Gay Pride. That Patrick, Nick, Tim, and Mikey found reasonably priced good condition garments that fitted them well links to the rationale for clothing choices based on comfort and fit explored in Chapter 10.

For Ernesto, part of the charm of wearing second-hand clothing lay in "imagining things and just making stories up" about the possible owner based on "the shape of the clothes." Expounding an idea that second hand might be "disgusting" he recalled how, on being given clothes that had belonged to a friend's dead husband, his Japanese partner exclaimed "throw that away. It's so scary"; highlighting the cultural difference in attitude to second-hand in Argentina and Japan. Selecting second-hand clothes inscribes meaning into clothes that are not only defined by the "pre-existing biographies and narratives" of previous owners (Woodward 2007: 13) but are an active component of creating personal identity through clothing (Hansen 2004). In stark contrast to the many advocates of vintage and second-hand purchases, Jose noted that despite buying from thrift stores when he was younger, he no longer had the patience for the hunting through, and despite being aware that "there's really cool things" he did not "want to have to wash shit" before wearing them. His reticence echoed Ernesto's partner's reservations and connected to changes in shopping and dressing practices associated with ageing that will be explored in more detail in Chapter 11.

Conclusion

Through their discussions and explanations, the men cited here all enjoyed shopping for clothes, or certain aspects of this activity. However, Hayden pointedly stated, "I don't enjoy the experience of shopping." This chapter was concerned with process and practices of consumption and in particular shopping, a practice explored by Stephen Kates (2000, 2002, 2004) in relation to the identity construction and brand loyalties of gay men. Elliott and Wattanasuwan (1998: 132) highlight "the recognition that the consumer does not make consumption choices solely from products' utilities but also from their symbolic meanings." The interviewees acknowledged that certain brands and designer labels were important in a variety of ways, for quality of product, for fashionability, price, or ethical or sustainable associations. While some men expressed a preference for particular shops or online e-commerce sites for both new and second-hand, many saw the value of a mixed approach, sometimes actively seeking out particular items and other times leaving it to chance through the availability of one-off eBay purchases or chance encounters with small shops when traveling. The importance of careful consideration for dressing for work in a variety of diverse occupations and how dress choices are used in articulations of an individual's sexual identity in the workplace are considered in the following chapter.

Note

1 The secondary data from a 2017 Predictive Analytics survey used by Kim, Ha, and Park did not differentiate sexual orientation but did ask two questions relating to ethnicity.

9
DRESSING FOR WORK

I'll go in [to work] and I know it's just a normal day, so I'll just be styled, so I'll always have a really good style, whether it's jeans, t-shirt or whatever, trousers, sweater, jumper, things like that. If I know there is a meeting, then I will then dress it up, so then I will really style it.

ALEX B, brand manager

Dressing for work was a particular point of discussion in my interviews with gay men. The descriptions of their selection of clothing for work resonated with the way in which Sophie Woodward utilized sociologist Erving Goffman's idea of "framing" in relation to how work clothes impact upon the work situation, as well as how this is "an act of 'bracketing out'" (Woodward 2007: 144), defining work as different from other private and public social situations. The place of work was important for some men in the context of their chosen occupation in their intersectional identification, or what Minjeong Kang, Monica Sklar, and Kim K. P. Johnson (2011) identify as the salience of work in men's overall identity formations. In some instances, these men specifically related their work dress choices to their sexual orientation and the varying stages of being out that they operated or commanded in their work situation or environment.

Formality at work

"Putting on a suit and feeling good," was "really important," said Darren, a sales and marketing manager for a hotel chain in Melbourne. He related the smart dress code requirements of his role to feelings of comfort and professionalism, especially as he considered "what meetings I've got that day, what the audience is" and wanting to "mirror what they're wearing." He particularly expressed, "If I've got a kick-arse presentation which I'm not overly confident about, I need to make sure I've got something special that day to make me feel even more special" (see Figure 9.1). The notion of ensuring that clothing adds to a sense of self-confidence was further developed by brand manager Alex B who noted how, when meeting clients, he would "dress up" his usual more casual style and "really think about" what he was wearing in order to present to his clients "a good look" that reflected their positions in "premium, trendy fashion compan[ies]" and gave all parties confidence about their interaction and the products being discussed. Some of the women interviewed by Sophie Woodward (2007) also expressed similar approaches to dress choice and confidence in a work context, emphasizing the ways in which dressing up and the role of clients or customers impacted upon dress decisions. Alan, a 43-year-old Malaysian Chinese human resources specialist, described wearing "mainly suits, I wore a tie, that sort of thing,

Figure 9.1 Darren wearing smart jacket from Melbourne tailor, Carl Neave, Melbourne, 2018. With permission of Darren.

office-wear." He was, however, quite categorical that what he wore to work differed from his much less formal and comfortable leisure time clothes (see Color Plate 11). Comfort constituted both a physical and psychological aspect in relation to work clothing, concepts explored in more detail in Chapter 10.

"When I go see clients, I definitely dress the part, but if I'm not seeing anybody, flip flops and shorts is what I wear," Gregory said in relation to the formal restriction of dress codes in the law firms for which he had worked in both Washington, D. C. and Miami, and how this could be relaxed when not client-facing or at high-level meetings. Smart dressing was identified by both operations manager Diego and tailoring apprentice Taylor, as a means of combating either a youthful appearance or actual youth to inspire personal confidence or that of employers, colleagues, or customers. Diego would "put on a shirt, put on a jacket, anything that will make me look older" and Taylor described how wearing formal tailored clothes when he began interning at sixteen meant that his colleagues took him more seriously. This practice is what Kang, Sklar, and Johnson (2011: 414) relate to symbolic self-completion theory, "obtain[ing] the symbols associated with that identity to try to achieve a sense of completeness." Chapter 11 will deal with the implications of age and ageing capital in more detail. For Darren, Alex B, and Gregory, donning suits or smart clothing in a client-facing encounter related to a "desire to access status and power" within

their work environments and interactions, embodying what they perceived as a sense of hegemonic masculinity (Barry and Weiner 2017: 173).

Like Gregory, church advisor Michael B *could* wear casual shorts and t-shirts to work but felt he could not "concentrate quite so much" and that even on the telephone where he could not be seen this undermined his authority. He went on to describe how if he was presenting a workshop or training course, he would wear a waistcoat as it was less formal than a jacket and "the people I'm training are Quakers, are probably going to be quite quirky in different ways, but they're not going to be respecters of authority." Continuing to reflect on his mental, as opposed to physical, discomfort in wearing shorts at work in hot weather, he recalled that his father "was always going to work in a suit and tie and would probably relax in a jumper and a shirt. And I'd probably do the same." The variety of feelings expressed by these men in relation to what they wear and how they feel at work in terms of expectations from employers or customers / clients fits with what Joy V. Peluchette, Katherine Karl, and Kathleen Rust (2006: 50) call experience labor: "dissonance between what individuals believe that they are expected to wear and what they would prefer to wear." Darren stated that he was conscious of his business environment but that he did not believe that his sexual orientation "changed how I dress at work. I don't try to be more masculine, or I don't try to be more feminine in the way that I dress." Shawn recalled that working in offices early in his career, shirts and ties were compulsory, but as a gay man interested in fashion he wore "really nice suits and ties and shoes to make it interesting." He noted how even though at the time of his interview he still worked in offices within the fashion industry, he "had a look" that echoed the smartness of suits but comprised of "dress shirts, slim pants, black, navy, white, grey and red [laughter], and powder blue, good color."

As has been discussed in many texts on men's dress, the white shirt, the tie, and the clean, flattering lines of the modern suit are direct descendants of the look that George Bryan "Beau" Brummell pioneered; a look designed mainly to enhance the beauty of the male form, with the suit being "the very essence of men's fashion" and "masculinity" (Edwards 2011: 53). Drawing on writing about the suit by Christopher Breward (2016) and Anne Hollander (1994), Joshua Bluteau identifies that the suit "can act as a uniform, an invisibility cloak of sorts, allowing the wearer's existence in the space to be instantly accepted and immune from comment" (Bluteau 2021: 64). This sense of comfort that Bluteau identifies resonates with Darren's comments about "feeling good" in a suit and comfortable within his formal work environment. The connotations of masculinity that have been inscribed historically in a suit, or even a more casual version of non-matching smart trousers and jacket, have offered a sense of power both in personal and social terms to those interviewees who chose to wear such garments (cf. Barry and Weiner 2017, Brajato 2020b, Breward 2016, Hollander 1994).

Christopher, Ernesto, and Guy each discussed the dress code for working in hotels and how being in public-facing positions required a certain formality or following dress code guidelines. Christopher described the "old-style uniform [of] shirt, waistcoat, tie, blazer, brogues" that he wore working in hospitality in bars and hotels in London in the early 2000s, following the workplace norms identified by Erynn Masi de Casanova (2015) and Peluchette, Karl, and Rust (2006). He compared this to the fashionable, high street, and designer garments and a more relaxed smart look he wore as head of membership at the National Gallery of Victoria in Melbourne in the early 2010s and as a hospital administrator in 2015. Ernesto described the uniform and high "grooming standards" at the big international hotel chain where he worked at the time of his interview. Picking up on Ernesto's emphasizing his uniform and the uniformity of work attire required by Christopher's bar and hotel employers, Guy recalled that early in his career the formal hotel he worked at required that he began the day wearing "a

morning suit and change into a lounge suit and then into a tuxedo for dinner." This formal requirement of black tie was echoed by hospitality manager Milty, who described how at the exclusive Miami nightclub where he worked at the time of the interview, he wore a black "tux but very classic, white shirt . . . a very neutral palette" to which he "rarely ever add[ed] any pops of color."

Michael B's partner Brian C described the changes he was able to initiate in his work dress choices when he moved from British Telecom (that was "very male dominated [with a] very engineering mindset") to set up his own technology business. At the former he wore conventional dark suits and pale shirts and traded this for a situation where he indulged his "burning passion for clothes" in a more expressive and imaginative way. He also began to work for the color consultancy House of Colour at the same time his heterosexual marriage ended, and he publicly came out as gay, utilizing the training he received there to create a wardrobe that reflected a sense of creativity. Several other interviewees worked in technology-related fields and the style of dress that was chosen or permitted varied from company to company and role to role. "We have to dress in corporate attire" and "that's in our contract that we must dress that way," said Shane, who worked in IT for a freight-forwarding logistics company. He noted how as a gay man he would remain within the rules but "I'm always in a suit [and] wear shirts that are actually quite fashionable compared to the normal day-to-day person that works in the industry, because the industry that I work in is a very blokey type industry" (see Color Plate 12). His comments here would seem to differentiate between a straight "blokey" manliness and the masculinity that Shane presented as a gay man. These differentiations connect with ideas around straight-acting gay men's adoption of an intentionally hegemonic heterosexual appearance, discussed in Chapters 1 and 5. Teddy recalled how, when he worked for an IT company, he was reprimanded by Human Resources for wearing slim-cut velvet trousers and suit jacket combined with a black shirt and red paisley tie. "We're not an architectural firm that you can dress up like this, you have to be a bit more conservative," he was told by his Human Resources colleague who was wearing what Teddy saw as an ill-fitting creased "off the rack" suit. Teddy's comments here would imply that the self-creativity he felt in selecting well matched clothing that reflected his dress sense and sexual identity was less "appropriate" within this context. Product manager Raj recalled how his style changed from "smartly dressed" when working for a food and beverage company in Singapore, where he "had to wear a tie" to working for a technology company in Sydney where, as an engineer, he could wear "t-shirts and jeans and there was no fuss around what to wear."

Shane's partner Hayden, who worked in IT at a university, noted the more relaxed attitude toward clothing in the higher education sector: that he could potentially go to work in swimming trunks, and no-one would comment. However, his sense of responsibility for his position as manager meant that he wore trousers and a shirt, but rarely a suit. In relation to casual Fridays, he would wear "something I feel comfortable in" but as a gay man he still wanted to look different from his predominantly heterosexual IT colleagues who might wear "stubbies . . . shorts"[1] by wearing jeans that were "a bit tighter or lower cut" and similar to those he might have worn to a gay bar or club (see Color Plate 12). Melbourne-based Malaysian architect Bryan stated that "sometimes there is casual Fridays, I put on a t-shirt and . . . a pair of jeans, with the same pair of shoes" but he usually had to "appear a bit more formal in the workplace." The coincidentally named American architect, Brian F, echoed Bryan's architecture experience of casual Fridays when he noted that "my profession is casual enough and my ordinary style is simple enough that most of it can overlap quite easily." He did note that as he needed to see clients it was important to "keep myself tidier when I'm working" by trimming his beard and covering his tattoos as "it behoves an architect to have a certain image," echoing Darren and Gregory above. Fashion designer and lecturer Sang recalled that when he began his career in architecture, he felt there were not "enough gay men [and] all

the gay men aren't very gay." Being "a bit more flamboyant," he realized that he was interested in fashion and moved careers to follow a more relevant and satisfying creative outlet.

Uniformity in retail and sales?

A sense of self-labor (Kang, Sklar, and Johnson 2011) was enacted within the practices of dressing for work, in creating an impression of the persona that is required of an employee or that fits with individual creative practices. "I have to wear uniforms," stated Simian, who worked in high-end fashion retail while studying in London, invoking uniforms that fit with what Ellen Roach and Joanne Eicher (1973: 127, cited in Craik 2005) call "functionally symbolic." Simian recalled that he would temper this formality with "funky socks" and "quite quirky ties" that were "still acceptable but they might have stripes or polka dots" that would "imply" his gay sexuality. This connects with Nicola Brajato's (2021) propositions of "queer(ing) styling" of conventions of men's tailoring through accessorizing, invoked in relation to the designs of Walter Van Beirendonck. Jordan recalled that when he worked at department store David Jones in Melbourne in the mid-2010s, he was required to wear all black, remove his nose-ring, smooth back his hair, and put on a more professional persona than for outside work or at university where he studied fashion design; all of which made him feel like he was "playing a character." There is a relationship here to Goffman's (1969 [1959]) use of dramaturgy to explain the ways in which individuals become actors performing different identities and "selves" within varying contexts. Simian's flatmate, Remi, also worked in high-end retail, selling ladies shoes at Harrods Department store in London. He noted how he had never had to wear ties, suits, and "very classic shoes" before starting that role, but that "in a way, it affected the way I was dressing after this 'cause I would try to be like this" when he went out socially on the gay scene. Retail manager Alex J noted how he dressed up his standard work look of a blazer, white button-down shirt, and dress pants, all bought from Theory where he worked, for evening by "exchanging the dress pants for skinny jeans" to become, "a mix of the two" (see Figure 9.2).

TJ compared the differences between the dress etiquette in the two different public relations firms for which he worked. Working with clients from the financial sector who were primarily dressed in suits and ties, in "corporate," "professional settings" he wore "slacks and button front shirt, cardigans, and occasionally a blazer." In contrast, at a firm that represented emerging fashion designers he could "experiment with different styles and different fashions" wearing "skinny jeans, skinny pants, tighter clothing" that was more aligned with the clothes he wore in his social life. Gino C's experience was more akin to TJ's fashion related role as he was a Public Relations Manager at an Arts Center in Miami. He noted how PR was "basically an image" but the liberal nature of the performing arts sector "definitely influences my creativity and my sense of style, I don't think if I worked at a bank, I could get away with wearing what I wear." These ideas of a sense of conventionality within fashion environments contrast with Giulia Mensitieri's proposal that fashion professionals are "part of a world where conditions and status that would be considered in other contexts to be deviant are . . . considered the norm" (Mesitieri 2020: 228). Mesitieri's allusions to deviance also correlate with Jennifer Craik's (2005) positioning of uniforms as holding ambivalent positions between conformity and transgression. The connection between "official" uniforms, worn by Ernesto, Christopher, Guy (in hospitality), and Simian (in retail), and clothing which, for various reasons within a work capacity, can be described as an "unspoken" uniform, such as that worn by Alan and Jordan, is highlighted by Leah Armstrong and Felice McDowell (2018: 11). These unofficial uniforms and codes of uniformity are adopted in accordance with "informal codes of conduct

Figure 9.2 Alex J at work in Theory in Philadelphia, 2012. With permission of Alex J.

and taste" and understanding of the "professional" required in the workplace (Armstrong and McDowell 2018: 11).

Enforced smartness and "uniformity" within a retail environment was contrasted by Vlad, a fashion design student, and fashion designer Jon. Vlad recalled that the night before he began a job at the high-end designer clothes store Cose Ipanema in Melbourne around 2008, he attached some "polyester strap kind of fabric, almost grosgrain but not quite, and then some weird green buckles" to a shirt to create a "weird bondage" garment that he felt would fit with the avant-garde styles being sold at the shop. Working at Hound Dog, a street and clubwear store in Melbourne, where the clothes were "bright and

colorful," Jon recalled how this impacted both his work and leisure clothing at the time; the boundaries of which were blurred but were, he asserted, a "bit more gay . . . more brighter colors, a few layers, fitter upper body stuff . . . we'll call it gay streetwear [laughs]. Yeah, effeminate streetwear [laughs]." "It was less about looking smart and neat and formal," recalled Alfie of his first role in menswear retail, and more "about demonstrating that you understood what the product was." While he acknowledged that for some there was a required uniform, he pointed out that he "hated the idea" when people sometimes grudgingly say they "need to get some work clothes," as he felt it sounded "kind of suburban, pedestrian"; for him it was important that even when selecting what to wear for work, he was "fully behind" all his choices because he did not "want to invest in a thing that I don't absolutely love or feel really strongly [about]." Jeweler Dat was conscious of his need to dress smartly when he was working in a public-facing role in a jewelry shop but balanced this to feel comfortable, when he stated "I don't need to wear a suit at work, and I don't want to." Instead, he preferred a non-matching jacket with a pair of trousers, because he did not "want to be too formal." At the time of his interview, 46-year-old Andrew had two jobs, one at the weekend at a high-end designer brand shop in Knightsbridge, London, and the other during the week as a teacher. Echoing Darren's and Alex B's reflections on dressing for their clients, Andrew noted that the designer store did not "want personality selling the clothes" but for the assistants to reflect the brand ethos and style. He contrasted this with his role as a primary school teacher in a socially deprived part of Hackney in London, here he said he could "have more freedom" in what he wore. "I wear a hat every day to school . . . I feel much happier in a hat [and] I wear nail polish to school every day." While there were certain large earrings he would not wear to school, "pretty much on the whole, I have worn everything to school." He related these choices to self-confidence believing that "children are the biggest bullshit detectors going" and want a teacher who is "true to themselves."

Fashionability at work

For men within what Richard Florida (2014) terms the creative class, there was a flexibility to interpret dress codes in a freer way than for those working in other industries and professional sectors. "I do product development, so it's been fashion, and I've worked in companies with no dress code," said Alex B. "I wear what I want [mixing] jeans and Doc Martens with [pieces from] designers [such as] Christopher Shannon . . . Neil Barrett, Philip Limm, Korrs, [and] Raf Simmons" (see Color Plate 13). He pointed out how he might accessorize his work style with a blazer or silver jewelry if going to the theater or other social event after work. Analyst Adam made a point about how he carefully negotiated his awareness of men's fashion trends and personal taste with the requirements of his office-based job at British Airways, where there was "a general need for trousers and shirts." In line with this informal guideline, he always wore a tie with "trousers, blazers, waistcoats, leather shoes." He emphasized that he made his "own standard" to "subvert" these rules, wearing for example "beige trousers" with "a paisley white shirt and a pink tie with a dark-green waistcoat," thus creating his "own standard" (see Color Plate 14). Even on Fridays when Adam dressed down, losing his tie and increasing the color and pattern of his garments, he stressed that "putting my clothes on prepare[d] me; like one would put on a uniform and think of customers, I think about the spreadsheets," echoing feelings expressed by Darren, Alex B, and Michael B.

Gareth, who worked in finance in Melbourne, observed that for this particular work sector the impetus was on "corporate clothing" and that in the early 2000s he was unusual in wearing "quite bright colored business shirts." He felt that making a point about his individual character and sexual orientation through

a subtle form of differentiation was important. Similarly, training manager David W noted how he bought "less conservative shirts" to express "some personality" into the casual business requirements of his client-facing role. The acknowledgment of elements that related to gay identity and visibility at work here perhaps contrasts with May Aung and Ou Sha's (2016) findings in their investigations into a neo-tribe of gay professionals (in Canada), that indicated the fact that for several gay professionals, clothing choices differed little from their heterosexual counterparts. Describing how he was generally out about his sexuality at work, Gareth felt he did not want to be stereotyped as "the gay gossip guy" and that as time passed in working in the financial sector, he became less "keen at presenting a fashionable look at work," toning down the colors in his shirts to more subtle pastels. He also saw his own change in contrast to the increased "daring" of his straight male colleagues who began to "wear clashing prints on their shirt and tie" and particularly pink shirts that had previously had a queer association. Adam's and Gareth's awareness of the "rules" of work dress and their subversions through overt use of color and pattern that are permissible in their non-public-facing positions at work align with others' awareness and self-regulation when, for example, teaching, discussed below.

Gareth's and Adam's descriptions of their use of bright colors in their work wardrobes stands in contrast to others whose choices were much more monochrome. As a hairdresser, Barry observed "you've got to try and look good every day [and] try and pull a look all the time," for, as with those who worked in fashion retail discussed above, the person providing appearance related services needed to inspire confidence in their clients and in the products or services they were selling. Martin, who worked in sales, also raised ideas about fashionability and the creative sector when he observed "creative people have more agency to dress more loud[ly], I'm not creative at all, I'm more black and white." Barry's raising of the role of black as a smart and acceptable "uniform" and Martin's linking this to a personal lack of creativity was also highlighted by English make-up artist, Benjamin, who stated that "the idea of make-up artists wearing black" was "because you don't differentiate hierarchy in that situation." Individual personality was important at MAC cosmetics where he worked, because "authority and individuality" was a "pillar" of the company ethos. Benjamin emphasized that there was freedom to make individual choices that reflected personality and for him as a gay man that led to the choice of particular garments that were similar to those he wore outside of his work context. He believed that "rules have to change because fashion changes." He finished this discussion by stating that at MAC "you can show up to work in a bikini, as long as you're covering your privates, that's fine. And it's black!" Like Benjamin, Gino B worked as a make-up artist and described his work clothing as "pretty simple because it's black. You know, black shirt, black slacks, but jewelry's fine." However, unlike Benjamin he noted a greater restriction and need to look more conventionally presentable. This was not an issue or conflict for Gino B as he noted that "it's not too dissimilar from how I would dress" outside work; the difference being that he would wear jeans rather than "slacks."

Artistic and creative

In their discussion of aesthetic labor, Joanne Entwistle and Elizabeth Wissinger note how self-employed or freelance workers in artistic and performance related occupations "have to commodify themselves under fluctuating conditions" that are different from the labor required of those whose employers might enforce a "corporate image" upon work dress practices (Entwistle and Wissinger 2006: 776). For some this meant consciously going out of their way to wear certain items or styles that they would not normally have chosen to wear in their own personal non-work time. Nick summed up such an attitude when he declared:

I can only imagine if I decided not to do arts and had to work in finance and have to be in that world and so counterintuitive to who I am and how I want to express myself. It would drive me nuts and I feel the pressure of heteronormative society on me and making decisions for me that is just not how I want to choose to live my life.

"I kind of like the sort of incongruity of being an artist, textile designer, and looking like a truck driver," fashion designer and educator Douglas joked. He discussed the need for practicality and pragmatism in his choices for the studio and contrasted this with the more creative and fashion-forward elements he included when lecturing: "really beautiful shirts" with waistcoats (vests) and trousers, "mostly with jeans [and] lovely blazers." One of the points Douglas explicitly made about his lecturing style over studio clothing was the way in which colleagues would comment "oohh, you're dressing up." He articulated that these were the garments that he most enjoyed wearing for their expressive qualities, but accepted practical need when in the studio. This practical requirement was also highlighted by other artists/painters I interviewed, Carl G and Nick. To supplement his income as an artist, Nick also worked for an interior design firm, where he was required to wear a formal collared shirt, like others noted above in office or business contexts. Contrasting to his studio comfort, Nick noted that "I do agree that if you are going to be in a professional environment you should think about what you are going to wear." Being "super casual" as he would be in the studio "doesn't come across as strong" and committed to the role.

For George, a fashion technician at an Australian university, dressing for work meant a t-shirt and jeans "because it's comfortable . . . sometimes I have to kneel down and sometimes I'm under a machine, and so I can't dress up." Like Douglas, he emphasized the appropriateness of his clothing selection for occasions and added that dressing casually for work meant that "when I'm out of school, I'll get dressed up." Like Douglas and George, Alex M, Sang, and Daniel also worked in fashion education. Alex M provided an example of how he self-regulated his appearance when teaching, explaining how previously "casual" style became "more sophisticated as there's a sense of authority if you dress up a little more." He specifically cited wearing smart shoes rather than trainers as an example of how he found this balance. This compares with Shane's approach within a university IT department and Andrew's expressive creativity through his jewelry and nail polish that was enjoyed by his primary school pupils. Both Sang and Daniel emphasized responsibility to dress in a way that showed respect for their students and the subject they taught. For Daniel this manifested as having to "consume as ethically as I can," injecting this sentiment of responsibility into his teaching. For all four of these men working within fashion education, there is a connection with Foucault's (1977) ideas of self-regulation in terms of the disciplined body, regulating appearance in both conscious and subconscious ways. There is a commonality between their comments about their teaching wardrobe being influenced by the creative environment of an art school that allowed for a more expressive choice that considered the audience as much as the work activity. This links to Armstrong and McDowell's observation that "creative professionals are both products of, and productive in meanings and values that inform our understanding and knowledge of what 'work,' 'labour,' 'practice,' 'creativity' and 'identity' are and can be" (Armstrong and McDowell 2018: 14).

Also reflecting self-regulation and echoing Shane's comments about avoiding casual clothing like shorts or t-shirts for work, Jose, a museum curator in Miami, believed such clothing choices would "reflect on what I do for work." Despite this avoidance he tended not to dress overly formally and could be "creative in my style but still be formal." He described how his role often meant he had work-related social engagements in the evenings and how he would "pick something that can transition from going to work and then coming to this [referring to the focus group] and then going to dinner after this," wearing

block colors in black, blues, and greys. In this sense and because of the lack of dress code in the creative arts, his wardrobe did not "tend to change during the weekends unless it's a complete day off or a proper holiday." Working at an art gallery in Ballarat, Victoria, creativity in dress was valued, Michael N said, fitting with Kang and colleagues' (2011) findings relating the appropriateness linked with creativity. He compared the freedom in clothing choice at the gallery, which was run by the city council, to the particular code of dress enforced within other city council departments, and believed that the outfit comprising "Katharine Hamnett trousers and a Yohji Yamamoto jacket, and an Asian shirt" that he wore to his interview had an influence in getting the position. For artist and chef Chris, working in front of house in art galleries in London's Mayfair when he finished art school around 2010 meant that he "modified" his earlier experimental subcultural style to be "a bit smarter" and dress closer to the way he saw people in that field dressing in "fabulous suits." He attempted to balance smartness with looking "slightly eccentric," wearing red trousers and black velvet jacket over a t-shirt or colorful shirt, accessorized with a tartan scarf and bowler hat. Chris's clothing choices as a chef became much more practical, echoing Douglas and George above (see Color Plate 3). Matthew recalled how, when he was undertaking an internship at New South Wales State Library in 2003 before he gained a permanent position, he wore a more generally acceptable version of his gothic subcultural style, but this was not commented upon. He noted that for his interview for his job at the library at the time of our interview in 2015 he "toned down" his look and wore a suit and collared shirt as he "wanted to make an impression." As he settled into the permanent role his choices became more casual as he "realized it's uncomfortable doing my job in that attire as well, and . . . I'm more comfortable in t-shirt and jeans."

Performance as work, work as performance

"I'm a performer [and] costume is incredibly important," stated Adriann. He explained how his work was related to both his sexuality and his cultural heritage and these were reflected in his performance costumes. He also noted that these two influences were also important in the clothes he wore outside of work as well as in his costumes. Considering the "dramaturgy" framework, Goffman (1969 [1959]) uses to describe the social processes through which actors execute different performances in front of different audiences, this section explores the dress choices of those whose careers are as performers. Based in London with his work and personal partner Antonio, performance artist Riccardo explained that performances were sometimes dictated by their very particular clothing choices that challenged gender dress conventions (see Figure 2.1). Their work, like Adriann's, explored sexuality and Antonio pointed out in some performances they either dressed very simply or were "naked most of the time." The importance of how Riccardo and Antonio dressed at events on the London arts scene, that they linked to informal performances, was highlighted when Antonio revealed that they had got work based on the way they dress from "people who had never seen our work and they've commissioned it having no idea what we do." That costume was both an important part of his performance shows and his everyday life was highlighted by 66-year-old performer Tim, when he declared, "I think I'm always on stage from the moment I get out of bed. In fact, I'm on stage in bed." He attributed this to his time on television as a child where each week he was required to wear a different themed outfit and that "I've never stopped dressing up, you know, since a child."

Roy, who worked as a model and singer, related how his performance-focused occupations impacted on his ability to "play" with his appearance as he wished and that his outfits were "always interchangeable

and evolving" (see Color Plate 4). His connections with designers, stylists, and other models, as well as those in the music industry, meant Roy was able to leverage his cultural capital to access fashion garments that he then put together in his own way. He contrasted an outfit comprising a variety of designer labels he wore to an LGBTQ+ event in 2017 with a black leather outfit he chose to wear to model for publicity for London's 2018 Fetish Week (see also Cole 2019). The situational differences highlighted by Roy were echoed by Patrick when he compared the black outfit he was required to wear at David Jones department store with the clothes he wore to perform music. Formally trained as a singer and self-trained on piano, Patrick recounted the transparent blue shirt covered in gold paint made by a friend and enhanced by his mother's addition of "shoulder pads," created from an old bra, to create presence when he sat at the piano in 2011–2012. Roy's, Adriann's, Antonio's, Riccardo's, and Patrick's dress practices could be aligned to the concept of aesthetic labor that Entwistle and Wissinger, citing Chris Warhurst and Dennis Nickson (2001), define as "embodied capacities and attributes" enabling people to "look good and sound right" at work (Entwistle and Wissinger 2006: 775). Aesthetic labor is seen as a preferred term to "emotional labor" by many scholars as "it foregrounds embodiment" (Entwistle and Wissinger 2006: 775). Dress as an embodied practice in relation to the physicality of these men's performance work is key in understanding the labor invested in their dressing for their performances. Entwistle and Wissinger's emphasis on how workers need to work on their bodies and appearance not just within but also outside working hours to produce an "appropriate" body "*for* work" (Entwistle and Wissinger 2007: 777, emphasis in original) relates to discussion of the "construction" and maintenance of millennial gay bodies in Chapter 3.

The relationship between clothing, music, and public performances that played a role for Roy, Adriann, Antonio, and Riccardo was also important for the two men interviewed who worked as DJs. Joe P recounted that when he began deejaying he included a lot of leopard and tiger skin prints in his graphic imagery and clothing, that reflected his rock and roll and punk musical tastes. He recalled that as animal prints became more fashionable and mainstream, different garments became available, but he had to be careful not to overdo the pattern and "look like [1980s childrens' television presenter, known for his loud clashing style] Timmy Mallett on safari." He also elaborated on how his "working" looks for deejaying were almost indistinguishable from his choices for other moments of his life: "it's just a slightly amplified version of who I am all the time" (see Color Plate 15). Sina described the informal, casual nature of the clothes he wore to deejay, as "one of my own t-shirts with a pop star on it" or the logo of his club night Debbie. Occasionally he would dress this up and wear a "blond wig [and] a dress once or twice." While not a DJ, Joe H co-hosted a party club night at the Standard hotel in New York. As with Joe P, Antonio, and Riccardo, his dressed appearance was important to the tone of the event that "everyone knows I'm gay." He felt that if he was getting "crazy dressed up" then others would start "dressing up to get our attention," creating the kind of atmosphere that Joe P and Sina strove for in their DJ roles.

Conclusion

The concept of "making an effort" that was important to how Joe H reviewed the success of his party club night emerged as a theme for many of the men interviewed in describing their work dress choices. Whether this was to fit an employer's dress code, to attract a particular audience, or to create empathy with clients or students, this form of self "labor" as well as work labor (Kang, Sklar, and Johnson 2011) was key. Several men described the differences between their work and leisure wear. "I have my weekend

clothes, and my work clothes," emphasized Alan, relating to the way the "corporate self" that is mandatory in some occupations can be put on and off when required (Entwistle and Wissinger 2006: 786) (see Color Plate 11). This distinction led to the development of a varied and categorized wardrobe for a number of men that was discussed in more detail in Chapter 7. Unlike some interviewees who saw wearing smart clothes for work as perhaps a chore and were keen to change into their more casual or personal choices for outside work, Darren underscored that "I probably spend a lot more time thinking about my clothing from a business perspective than I do from a social perspective." A comfort zone lay within the smart requirements of particular work environments, and this began to influence choices outside of work. Alex J, Alex B, and Jose described how they would change one element or accessory to segue from work to social events. The addition of fashionable elements or adaptations to professional or occupational dress conventions meant a subversion of the codes of hegemonic masculinity often associated with smart dress, such as suits, linking to Barry and Weiner's (2017) findings for their heterosexual and queer trans interviewees, but here within the context of male homosexuality. Particularly for those interviewees who worked in the cultural industries and creative arts, there was a blurring between work and social or leisure wardrobes and their dress choices were often freer and more expressive, summed up by vintage shop owner Ian B: "I always dress the way I dress; I don't have a going to work style, and a going out style, you know? . . . The nature of what I do means that I can wear whatever I want to wear anyway" (see Color Plate 6). The blurring between dressed *performance* of personal style and performance art was emphasized by Antonio's conviction that "clothes for us as performance artists become also a catalyst [for] where we're going," leading to a form of cultural capital that allowed for their entry into more employment through commissions or to particular spaces and social groups, not unlike Joe H's encouraging dressing up and Joe P's and Sina's creating an environment when deejaying by dressing in a particular manner. The "comfort" that many of my interviewees noted in relation to work dress codes, practicality of certain clothing choices, the freedom of expression in creative fields or presenting to clients, is developed in the next chapter.

Note

1 Fashion Historian Vicki Karaminas (2010) notes that stubbie shorts were "extremely short, sometimes with frayed leg ends . . . popularized by young men often as a sign of overt masculinity."

10
COMFORT AND FIT

"I do definitely dress for comfort." Glen's statement here emphasizes that for gay men the notions of sexual orientation, gender, and the hegemonic ideas of body shape and dress conventions for men impact upon the relationship between comfort and the fit of clothes on the body. The term comfort is complex and has different meanings and contexts. It relates to how garments fit on the body and this physical aspect can be related to a more psychological concern; that is, how people "feel" about themselves and the self in relation to their social and cultural surroundings. Bev Skeggs (2004) proposes that comfort is related not just to the way the clothing fits on the body and how the wearer feels but in having the appropriate embodied cultural competences to wear those garments in particular circumstances. Kate Schofield and Ruth Schmidt (2005: 318) similarly note that "clothes allow an individual to fit in or belong to situations, thus supporting the concept of the situational self." Consequently, the selection of clothing items that fit and add to a sense of comfort are important in terms of gay men's sense of self and their intersectional identities. Georg Simmel (1971) identifies tensions between individuality and conformity, and this connects with concepts of both fitting in and feeling comfortable. Daniel Miller and Sophie Woodward identify three interrelated areas of fit: "to the body, to fashion and the need to look *fit* in the eyes of the opposite [but here same] sex" (Miller and Woodward 2011: 13, emphasis in original). This relates to Erving Goffman's (1963) ideas about the body as a "conventionalized discourse" as well as to Hannah Frith and Kate Gleeson's observations about men wanting "to both display and conceal different aspects" of their bodies that were linked to their confidence about their bodies (Frith and Gleeson 2004: 44).

Baggy, loose, and comfortable

The idea of comfort and fit in terms of the cut of clothing was raised specifically by several of my interviewees and for some this related to the loose-fitting or "baggy" nature of the clothes on their bodies. Adriann preferred oversized garments, that were "boxy" because he liked the "way that it kind of falls" on his slender frame. Both Benjamin and Matthew expressed preferences for "drapey" clothes that both simultaneously concealed and revealed the body, as well as allowing for ease of movement. Jay McCauley Bowstead (2018: 104) links "soft, draping, fluid fabrics" for menswear to a "more sensing, sensual, embodied form of masculinity" that appealed to younger sensitive gay men like Benjamin, Matthew, and Adriann. Benjamin elaborated on the loose drapey qualities of his preferred upper body garments discussing how he balanced them with tight close-fitting trousers or "skinny" tracksuit bottoms that "hug me in the right places" and "made my bum look good"; emphasizing the parts of his body he liked and how they could play into his feeling desirable and attractive to potential partners. This is in line with Miller and Woodward's third aspect of fit noted above and is considered in more detail in Chapter 5. Ernesto also compared the fit of garments between upper and lower body, but in an opposite combination to

Benjamin. He described how in his early twenties (at the turn of the millennium) he preferred tighter tops with "super-baggy low waist pants." Although George expressed a clear preference for "baggier stuff," and Lukasz recalled his fondness for wearing shorts that were so baggy they "looked more like a skirt almost" when he was living in Antwerp in 2012, neither elaborated on their reasons in the same manner as Adriann, Benjamin, and Matthew. "When I put on a really huge [Dries Van Noten] coat and I'm kind of like wafting around . . . that feels good," said Alfie. "I think there's something nice about . . . knowing that you're wearing like this big, stupid shape but kind of really enjoying it."

Close-fitting and tailored

In contrast to the "comfort" of loose-fitting clothes are the feelings of those who expressed a dislike of baggy clothing. "I don't like buying clothes that are too baggy because I feel like I get lost in them," said Matt, highlighting an awareness of his body shape and how, when buying clothes, he ensured they were "easily put together because I'm, you know, not very fashion forward and just don't draw attention to me or to my body really." Sam explained that his close-fitting high-waisted trousers "make me look very fat" but he still loved the cut, emphasizing that "I don't do baggy." For Christopher, being as he described, "very tall and quite slim," a narrow silhouette had "always" been his preferred choice. Recounting that he would struggle to find "the right fit" in clothes that would work for his body, he emphasized that he always felt "most comfortable in narrow silhouettes." For Sam, Matt, and Christopher the choice of close fitting over baggy styles related to the way in which their clothes felt on their body and the relationship to their sense of self. Their sense of comfort came from a closer fit that they felt worked with their own particular physique. It was important to Matt that he felt "confident in what I'm wearing, . . . it shouldn't draw attention to itself—That I don't have to think about what I'm wearing when I'm talking to somebody or they're talking to me." These men's self-perceptions fit with Woodward's observations that "there is an aesthetic fit" through which the individual "hope[s] to project or enact through clothing [that which] matches the image they see before them in the mirror." When this clothing is worn in public the wearer "receives the appropriate admiring comments and glances of others" (Woodward 2007: 83). This in turn relates back to those gay men who described their dressing to "fit" into a particular gay scene or community.

Skinny jeans were highlighted as a particular choice by a few of the men who described being more comfortable in close-fitting clothing. Twenty-six-year-old Jun replaced "baggy . . . unfitted jeans" with those that were "tighter" and "hugged" his body, after beginning sexual relations with men, from the age of sixteen (see Figure 5.1). This echoed the experience of Simian, who altered his style on moving to London, replacing baggy t-shirts and joggers with skinny jeans. For both Jun and Simian their move to a skinny fit was related to getting older and changing geographic location, as much as coming out as gay. Also implied in Jun's and Simian's descriptions was a style that had developed from the use of overtly baggy and "sagging" jeans within hip-hop (sub)cultures. Chris recalled that his first purchase of black skinny jeans was related both to their perceived fashionability and how they "help[ed] with proportion . . . especially if you had chunky thighs." In this respect his approach differs from Milty, who disliked the way skinny-fit clothes fitted his thighs, who in turn preferred to wear what he felt were more flattering looser "jogger khakis [with] a little [elastic] tag around the ankle." There is a sense here in Milty's and Chris's discussions that their self-perception of their body shape mattered, in the sense that it coincided with their self-image.

For both Benjamin and Jon, the wider adoption of skinny jeans by straight men demonstrated a fashionable movement from a very gay style to one less tied to a particular gay style. Benjamin exclaimed: "Skinny jeans were a gay thing. What the hell . . . I was like, I don't think straight men have the right to dress like this." While Jon acknowledged that this had become a "norm" for straight men that made it "harder to tell [and] Now I can't tell who's gay and who's straight," echoing the comments of many men outlined in Chapter 1. Several men described how, before skinny jeans became widely available for men, they would buy women's jeans that offered them a closer tighter fit than the men's styles available to them. There is a resonance with this selection of close-fitting women's jeans by predominantly heterosexual members of heavy metal bands in the late 1970s and early 1980s, selected for their crotch-hugging qualities in a form of erotic narcissism (Simpson 1994a). Inherent here is the intersection between sexuality and gender in dress choice practices by gay, straight, and bisexual, as well as sexually ambiguous men (if we move away from simple oppositional binarism). These choices echo the reflections and choices of gay men who did not feel bounded by gendered clothing, such as Antonio, quoted in Chapter 2 (see Figure 2.1), and Andrew, who sometimes "bought womenswear" because of his awareness of "fit and function" which he related to an understanding from his upbringing about a "correct" way garments should fit and the way in which they "interact" with the body beneath.

Comfort and confidence

Ernesto and Milty both linked the looser fit of their clothes to their perceived larger body size. "I can't wear fitted clothes," Milty declared. "I have short fat legs, I have big thighs, I can't wear like super skinny jeans and be comfortable, joggers are perfect for me 'cause they're like a little bit like looser." Ernesto described a favorite shirt that "makes me like a little bit broad in the shoulders and hides the belly." Joe P similarly discussed his weight and size: "I have no problems looking big . . . but I like clothes to fit me well . . . I feel very confident body-wise . . . when I say I like clothes to be flattering on me . . . it's got nothing to do with how thin or fat I look, but I like it to be, is the term proportion?" For Joe P, then, it is not so much that the clothes are baggy or tight but more a case of how he feels they fit his body proportions, and if they fit well they reflect his confidence about his body and his appearance as a gay man (see Color Plate 15). This ties to Skeggs' (2004) propositions around having appropriate embodied cultural competences to wear certain garments in particular circumstances, here the gay scene and culture.

In their study of men's appearance, anxiety, and dress decision, Ben Barry and Dylan Martin articulated how "perceived body imperfections were apparent when men tried on contemporary apparel that did not fit them, while body confidence was achieved when the popular styles effortlessly complemented their physiques" (Barry and Martin 2016a: 332). Echoing Barry and Martin's findings, Luis also related how his partner always had clothes altered by a tailor, in order that he had "a perfect fit on his back." The price point and quality of clothes that is implied by Luis is elaborated upon by Joe M, who believed that "good" clothing fit better than inexpensive, but as with Luis's partner, inexpensive clothing could be improved by being tailored. However, he concluded that what was *most* important was "how they fit on your body." The question of both economic and cultural capital is important in these reflections. Understanding what constitutes good choices in relation to fit and being able to afford the clothing that best fits one's body and makes one feel most at ease has an impact on all aspects of sense of comfort. This relates to the discussions of considerations of price explored in Chapter 8.

That being comfortable and confident are related was also echoed by Johnny and Roy. "If you've got confidence and you own what you're wearing . . . you can pull it off," specified Johnny, but if "you're going to be worried about it and you're going to be fidgety" then that is apparent. Echoing Johnny, Roy affirmed, "If you have that conviction and you are very comfortable in your own skin and what you're wearing and how you're wearing it" then "that shows." Andrew picked up on this notion of confidence, explaining that he was "not a terribly confident person" but *was* "very confident about what I like and what I like to wear" and in this sense felt comfortable in his choices.

Based on their empirical research on denim, Miller and Woodward (2012; 56) observed that "for every person who sees comfort as a precise fit to the body, there is another who sees comfort in the opposite idea." Similar ideas were evoked by Dat, who insisted it was important "just to be comfortable enough in your own skin and know what you like and know what you think looks good, rather than allow society to say this is what you should be wearing." London-based Homi described how he could "walk out in the most outrageous outfit" contrasting this with an incident when he removed a bespoke pink beret he loved because someone shouted "poofter" at him. This was the moment, he said, the outfit "falls apart . . . the minute you have doubt in your mind": it is the moment for Homi where discomfort sets in and he doubts his confidence in his appearance and dress choices (see Color Plate 16).

As well as noting how he appeared to others in his close-fitting and tailored garments, Sam explained that he enjoyed "that feeling of that sort of binding" and this related to the way he would hold himself in those clothes and that his pleasure was partly in the physical "discomfort" that was created by the "restriction" of the cut of his clothes and the fabric next to his skin. Sarah Ahmed observed that comfort is not necessarily something that we are always conscious of and therefore "we might only notice comfort as an affect when we lose it—when we become uncomfortable" (Ahmed 2006: 134). In this sense Sam is conscious of his comfort in relation to the discomfort of particular garments and accessories that restrict or bind his body or leave a feeling of comfort once they are removed. Miller and Woodward have explained discomfort as "something that through the sensation of touch reminds people of the presence of their body" and in this way the restriction that Sam enjoyed was also for him a private "comfort" (Miller and Woodward 2012: 64). Also emphasizing the relationship between the skin and the fabric of clothing worn next to it, Bryan described comfortable as "something light and soft to the skin" almost in contrast to Sam's pleasure in "discomfort." Chris contrasted comfort and discomfort in relation to fabric choices. Noting that he tended to sweat when wearing formal clothing, he explained that breathable materials like mesh worked well for him in keeping him cool, stopping him sweating and so stopping him from feeling self-conscious and doubly uncomfortable (see Color Plate 3). Sarah Ahmed describes the "ordinary feelings of discomfort" in the context of how a particular body may or may not fit into a chair that has been shaped by specific bodies and that pleasure (such as that described by Sam in the context of the restriction of his clothes or for Chris in sweating or not sweating depending on the fabric of his garments) begins with "feelings of discomfort" (Ahmed 2006: 155).

Fashionability, integrity, and authenticity

The notion of fashionability and fit was a "pet peeve" for Eduardo. He expressed concern that in many shops the range of cuts for trousers for men was more limited than for women, providing a "variation on a theme" rather than any "real" choice. Elaborating further, he said that shorts were "a perfect example," getting "longer and longer and baggier and baggier" when he was looking for "proper shorts" that were

also "not hotpants" because "I'm not going to be running round with my butt cheeks hanging out," but that sat at a short distance above the knee. Ernesto's focus on how much leg was covered or exposed by the fabric of a pair of shorts, like the looseness or close-fitting nature of longer trousers or jackets or tops described by other men cited here, relates closely to Woodward's observation about the "pivotal" relationship between clothes and the body, the "embodied relationship of how clothing feels on the skin and allows the body to move" and how "clothing affects the appearance of the body" (Woodward 2007: 3) For Teddy, fashionability and trends were not a frustration as they were for Ernesto, but he did consider how he felt "lucky" that his personal aesthetic had been in tune with recent trends in men's fashion, and that this was appropriate to his physical frame. He described the appeal of close-fitting tailored clothing that he had found readily available in fashionable shops in Melbourne, but also how he liked some hyper-fashionable "baggy and drape-y . . . oversized, but it's probably the stuff that will be straight off the catwalk as opposed to the stuff that's diluted down" for the high street. "I said no, you won't see me in a pair of those ever, because they are hideous," said 51-year-old Gary about loose-fitting jeans with elasticated ankles when he first saw them appear in shops. He noted how he had to eventually swallow his words, because "now we [Mark his partner and he] have them. They are the most comfortable thing." The importance of following, or reacting against, fashion trends was explored in more detail in Chapter 8.

In his essay on the importance of brands to gay consumers, Steven M. Kates cites Douglas Holt's description of authenticity as "a high cultural capital consumer process" and that authenticity is therefore found in objects or garments that are "distanced from, the capitalist ethos as exemplified by mass marketed brands" (Kates 2004: 463). This is also explored in Chapter 8. In relation to buying and wearing vintage, second-hand clothing, 57-year-old Ian B recalled that, once he passed the age of fifty, "the best thing I could do was to make myself individual . . . and pursue my style quite . . . what's the word? not relentlessly, but [with] an integrity." For Ian B dressing with "integrity" added to his sense of "comfort" in his appearance (see Color Plate 6). The importance of notion of authenticity, that could be related closely to Ian B's "integrity" was articulated by Joe P (a friend of Ian B):

> It's a need for authenticity and history and roots and I think that I carry my own autobiography with me of who I am . . . I'm more interested in the quality than the name . . . specially Dr Martens, if I had the choice between a pair of Dr Martens or a pair of Dr Marten-alike-ees that were cheaper, I'd probably still go for the Dr Martens

The style and choice of garments described by Joe P (like many of the outfits and selections described by my interviewees) are not exclusively gay. Joe P's choices reflect an affiliation with a shared subcultural dress history of people of his generation, emerging from punk and post-punk styles, demonstrating a collectively shared sensibility, and allowing for an age-appropriate style that nodded to more youthful interests (see Figure 3.3 and Color Plate 15). Joe P's observation of brands and details and Ian B's striving for integrity along with other interviewee's focus on particularities of the way in which garments fit could be related to what has been described as a Dandy sensibility: a keen attention to detail even in choices that are not especially ostentatious (cf. Breward 2000, 2016; Cole and Lambert 2021, Hebdige 1979). Paul Simpson (2016; 33) emphasizes that "authenticity is integral to an age-inflected form of cultural capital," what he defines as "ageing capital." This relates to both Joe P's and Ian B's discussions of their choices of clothing and will be explored further in the next chapter. A similar attitude to authenticity is raised by Sassatelli (2011) in relation to fitness when she noted "a perception of 'fitness' that articulates

comfort with compliance as well as authenticity with adaptability." While it was only Joe P who explicitly mentioned authenticity in relation to comfort in dress, others did allude to this idea, as Ian B does in his mention of integrity. They were conscious of how their changing bodies and their place within the gay scene or community, as well as the broader (heterosexual) society, encouraged them to consider who they were, how they wanted to be perceived and how the fit of their clothing, whether close, tight fitting, or baggier more forgiving styles, was a means of expressing who they believed themselves to be.

Well-fitting garments and age-appropriate comfort

Although of varying physical builds, from short and slender to tall or larger framed, many of my interviewees emphasized the importance of the way clothing "fit." For 49-year-old Eduardo, 50-year-old Luis, 45-year-old Martin, and 69-year-old Clarence, a balance between fashionability and good fit was key, relating to Miller and Woodward's (2011) second area of fit—relation to fashion. Forty-three-year-old Alan discussed fit of clothing both in relation to his physical body and his age. He noted how, as he grew older, "fit is more important" than the label or brand, but also that it was important to find which styles worked for him and made him feel "comfortable." Being short and slender was for Alan both a disadvantage, in that oftentimes it was hard to find adult sized clothes that fit in the way he would like, but an advantage in that he could buy children's clothing (from brands such as Burberry) that were "more sympathetic given my build" and cheaper than equivalent styles in adult sizes (see Color Plate 11). Like Alan, both Martin and Clarence focused on their slim frames. For both, the fit was important not just because it made them feel comfortable but also because being fashionable and wearing quality designer garments or accessories was key. Carl H described wearing clothes given to him by his father (as hand-me-downs) and his sister (as gifts) "because it's sentimental even if maybe it doesn't fit right" and the intention was good. However, when he purchased for himself, the fit was important to make him feel at ease and comfortable and this could override cost concerns. Fifty-one-year-old Zach described how he moved away from a looser cut to narrower, tighter, shorter cut sports jackets "because I don't want to look like somebody's Uncle Murray who's in town from Brooklyn"; evoking a style-less middle-aged archetype. Although much younger than Zach, 27-year-old Erich considered the importance of fit over fashionability: "As long as the things look good for you and your face shape and your body shape or whatever, it seems like, you know, you can keep doing those things without having to follow that." This sentiment was reiterated by Luis who proposed that "once you find something that works for you, you know, you should stick to it."

Glen explained his enjoyment in buying and wearing Issey Miyake's Homme Plissé trousers, because they are "elastic-waisted, even though they're tailored" and "so exceptionally interesting in their cut." He alluded to his bigger body size and hairiness as fitting within the bear subculture. Based on his ethnographic investigations, Peter Hennen (2008) observes that bears dress for personal bodily comfort more than fashion: relating this to the discussions of particular body size and hirsuteness favored by my interviewees (some of whom who identified as bears). Here, Glen disrupts this binary between comfort and fashion by wearing fashionable Japanese clothing that was comfortable on his body shape. Like Glen, 61-year-old Robert described the pleasure and physical comfort of wearing unstructured Japanese style clothing in relation to his larger body size. He also stressed the emotional discomfort of not being served in Japanese stores because of his size (discussed in Chapter 8). Similarly, Ernesto discussed size differentials in Japan, where he was living at the time of his interview. He noted how he was "considered a big guy, broad guy" and was told in shops "no, we don't have XL" which was the size he required in

the smaller proportions of the Japanese sizing system. Lauren Downing Peters has argued that fashion marginalizes and even excludes people with "plus-size" fatter bodies (Downing Peters 2014). Glen and Robert chose Japanese designer garments because they accommodated larger bodies so went some way to negating such negativity and marginalization.

Reflecting specifically on gay men, Jason Whitesel notes how some men "distinguish[ed] themselves from the image of big men as undifferentiated 'slovenly fat slobs'" and "redefine[d] their size as something special, something with sexual currency" (Whitesel 2014: 82). "I used to be—I mean I still am—slightly overweight," stated 24-year-old Patrick, who went on to describe how feeling uncomfortable with his body had led him to wear loose shapeless clothing in "shades of brown" that helped him fade into the background. Although not explicitly using the term, Patrick's discomfort could be related to experiences of shame. Eve Kosofsky Sedgwick notes that for certain people, "shame is simply the first, and remains a permanent, structuring fact of identity," which has "powerfully productive and powerfully social metamorphic possibilities" (Sedgwick 2003: 64–65). In relation to bigger body sizes, Lory Britt and David Heise point out that while "shame may lead to hiding . . . pride may lead to expansive behaviors in public space" (Britt and Heise 2000: 254). A sense of pride thus evolves from a sense of comfort and overcoming discomfort associated with various forms of shame. Celebrating a larger body size through dress acts as a demonstration of pride for some gay men, particularly those identifying with a bear (sub)culture.

The notion and importance of age-related comfort was highlighted by 45-year-old Darren, particularly as he realized that his body was changing and "it might not always do what you ideally want it to do." What Darren did accede was that he was quite *comfortable* with his body and himself, drawing together the different aspects of comfort. He described how he continued to wear smart suits as he felt "more comfortable in suits than I am in casual gear" and that his choice was determined by his awareness of his stature as "a small man"—and so his clothing choices were defined by his height rather than his sexuality. He linked his preference for good quality, expensive clothes with his age and the process of ageing, drawing on the relevance of the intersection of his gender with his other subject positions important in fashioning personal style. Darren's sense of comfort in wearing a suit was echoed by Homi:

> If I'm walking on the street in a Savile Row suit, I'll have a builder saying, good morning, Sir . . . Confidence? . . . you really do feel like it's an armor. You've just buttoned yourself into this suit that carries not only being so elegant, but it also carries a lot of history with it because the suit just didn't arrive, it's taken 250 years to get to you . . . I think it is a psychological way of feeling, feeling much more confident [see Color Plate 16].

Homi's experience is especially related to his sexuality and could be aligned with the rationale put forward by other men for the selection of bespoke tailoring (Bluteau 2021, Breward 2016, Hollander 1994). Darren's and Homi's comfort in wearing a smart suit is contrasted quite explicitly by Christopher. "I don't feel comfortable wearing a suit every day . . . it's not me . . . I love putting one on and getting dressed up, but being forced into that kind of idea of wearing that, that almost uniform . . . I need to feel comfortable with what I'm wearing." For these men, choosing clothing that makes them feel "comfortable" could be perceived as a form of "coping mechanism" (Goffman 1967), that allowed them to deal with their anxieties, as raised by Barry and Martin (2016a), and even feelings of stigmatization, about how their bodies appear and feel in their clothes and how they present their clothed bodies to the wider world. Schofield and Schmidt (2005: 310) describe this in relation to clothing being situational, that it "facilitates acceptance and integration."

Thirty-four-year-old Lee described how he "would like to dress more 'stylishly' but the older I get the less I am concerned with this, and the more I just want to be comfortable." Sixty-four-year-old Michael N explained various approaches to his wardrobe, including wearing sarongs at home (one of which was actually a woman's Akira Isogawa skirt) because they were comfortable, but he had only once worn such a garment in public to an art opening. He contrasted this with the need to keep warm in the cold winters in Ballarat where he lived. Michael N's friend, 67-year-old retired Murray, also emphasized that he liked to "dress for the occasion." For public events he tried to "tailor what I'm wearing and my comfort levels of how I'm going to feel when I'm at that venue," specifically recalling the fawn colored "fabulous pure wool jumper" with a collar with a black trim that he paired with "black pants and the tan shoes and sort of a grey-black padded" jacket he wore to "an arts happening." "I love dressing up," Roy proclaimed, and this was very much tied to his work as a performer and model, but like Michael N and Murray, he varied his choices in accordance with what he was doing (see Color Plate 4). He described his typical outfit when he was not working, his "off duty" look, as "jeans or khakis, t-shirt, baseball cap, or flat cap or whatever," emphasizing "*that* is comfortable wear." Considering both his age and ethnicity, Roy believed that everyone must "try and be comfortable with who you are as a human being" and establish your "own taste level, whether it's deemed as the right type of taste or not to the onlooker." This personal taste and concern with other's opinions is echoed by the much younger 19-year-old Taylor: "I'm not interested in trends or anything, it's just what I am comfortable with, what I like. I just wear what I like at the end of the day, I don't really care if it's considered dowdy or whatever." The relation between a personal psychological sense of comfort in relation to the self, balanced against confidence in personal taste, was important and as evidenced by Roy and Taylor, not necessarily determined by age. In his various studies on middle-aged gay men in Manchester, Paul Simpson (2013, 2014, 2015) notes how his interviewees used ageing capital in their negotiation of their ageing bodies and discussed attitudes to older gay men on Manchester's gay scene. Simpson particularly emphasizes how a number of men criticized others for looking like "mutton dressed as lamb" and how men shopped at particular shops aimed at older men that provide clothes designed for comfort, which "symbolized social withdrawal and lack of sexual citizenship" (Simpson 2013: 159).

Conclusion

The contrasting of physical comfort, through the fit on the body, whether that be close and tight or loose, with hyper-fashionability or following trends in order to obtain or demonstrate economic or cultural capital, perhaps reflects Bourdieu's (1984) discussions around the constitution of practical and functional choices of his working classes as the antithesis of bourgeois comfort of displays of "style" and "taste." The concept of "fit" in terms of the ways chosen clothing related to individual physique was key to ideas of confidence and comfort amongst my interviewees. For many of the men cited in this chapter, the notion of comfort arose from both the ways in which their clothing fitted their body and sometimes reflected changes in their physicality across different life stages. The approaches to the need for comfort identified by older men and closer, tighter fitting clothes articulated by many younger men interviewed, along with expressions by all age demographics about instances of the (dis)comfort of (not) fitting into particular social conditions, mirror and anticipate reflections on the role of dress and fashion in relation to age in the following chapter.

11

AMBIGUITIES OF AGE
AND AGEING

"People say random passing comments about, you know, gay death happens when you're 40," Sang laughingly reflected. Although only 36, and not necessarily what would be considered old or even mid(dle)-aged in many contexts, Sang was concerned about the implication of such an opinion, reflecting that, "I think you just don't realize how easy, or not so much easy, but the type of options you have because you're younger, but this is what happens when you get older." Formalizing Sang's opinion, it has been observed that the gay community, and especially the commercial gay scene, placed an emphasis upon youth and a youthful appearance (Cole 2000; Simpson, P. 2014). It has been proposed more widely that concepts such as "youth" and "age" are products of culture and not entirely determined by biology; as such, societal values placed upon them vary (Achenbaum 2005; Allen 2005; Featherstone and Hepworth 1991; Featherstone and Wernick 1995; Simpson, P. 2014; Twigg 2013). This can be particularly notable in the way that gay communities and cultures approach youthfulness and ageing (Berger 1982, Robinson 2008). Jack Halberstam, while acknowledging the role of intergenerational queer relationships, notes that "now, gay youth very much want to supplant an older generation's model of identity, community, and activism" (Halberstam 2005a: 223). Halberstam's (2005) theorizing of "queer time" proposes that queer experience does not always match heteronormative social milestones, such as childrearing and marriage, so that age and ageing related to time might be conceived of in particular ways by gay/queer men. However, changes to social and legal conditions have sanctioned same-sex marriage to some extent and some men interviewed for this book had been married both in a heterosexual and same-sex context and had fathered children. This ties in with Julie Jones and Steve Pugh's (2005) cautioning about overgeneralizing gay men's circumstances and life choices in relation to family commitments.

Awareness of age and ageing

In his investigation into gay men's bodies, Murray Drummond found that "age plays a role in the internal marginalization and stigmatization within gay cultures, particularly where bodies are concerned" (Drummond 2010: 31). The significance of age for gay men has been the subject of several studies (Berger 1982; Bergling 2004; Jones and Pugh 2005; Simpson, P., 2013, 2014, 2015), some specifically in relation to the body and appropriate dress and behavior, as well as to various subcultures (such as Bears discussed in Chapters 3 and 5). Both Paul Simpson (2013, 2014, 2015) and Drummond (2010) highlight mid-age as an important "milestone" and a point at which changes to the body and acceptance

within gay communities alter, as well as this impacting upon sexual attraction (discussed in relation to clothing in Chapter 7). Paul Simpson (2013) stresses how mid-life has been compressed with "later life" but was relevant as a particular point between the "loss of youth" in the late thirties and the statutory retirement age.[1] In relation to fashion and dress, the subject of age and ageing has frequently been ignored but there have been moves to redress this imbalance, predominately and initially in relation to women (Church Gibson 2000, 2018; Twigg 2013) but more recently also to men (Almila and Zeilig 2021, Sadkowska et al. 2017). Significant to the intersectional approach taken in this book and to this chapter are Julia Twigg's statements that "age allows us to think about clothing and dress as everyday practices engaged in by everyone" and the experiences of "ageing through the body . . . intersect with norms about dress" (Twigg 2013: 2, 15).

Brian Heaphy, Andrew Yip and Debbie Thompson (2003) and Peter Robinson (2008) suggest that gay men's sexuality made them particularly aware of their age and significant numbers felt excluded from areas of the gay scene and community because of their advancing age in relation to an overall focus on youth and youthfulness. Fifty-seven-year-old Marcus said that "unfortunately it's a youth-based culture" and "anything over 40 . . . you're invisible. You're totally invisible. And, you know, you have to come to terms with that." Marcus's and Sang's apprehensions and realizations were contrasted by 50-year-old Shawn recalling "I actually felt my best at 40 and did tons of shopping [going] crazy." He could not remember the name of a particular brand that he felt was "definitely more for people in their twenties" but he had bought it nonetheless, feeling, "I was sliding in there, but I wasn't going down without a fight."

Changing with age

Several of the younger men I interviewed reflected on how their style had changed or "matured," in 26-year-old Alex J's words, as they got older. The same age as Alex J, Diego said that he did like to "dress older" and even though at his age he felt he *could* "get away with a lot," he did not "really take that many risks when it comes to fashion." As he got older, he explained, he was "slowly incorporating things" into his wardrobe that he would not have "thought" to wear when he was younger. Also twenty-six, white British make-up artist Benjamin linked getting older to his changing body: "I'm having to learn that my body isn't what it used to be and that I might have to go up in a jean size. . . . When I used to be a size six in women's, that's how tiny I was back in the day."

Echoing Paul Simpson's (2014) observations on the scrutiny felt by older, middle-aged men in relation to their bodies and their dress choices, Benjamin said he felt conscious that "you're watched, you're studied." Like Benjamin but somewhat older, Roy, who evasively and jokingly described his age as "between 45 and death", related ageing to how his body changed: "my shoulders have never changed, my waistline has [grown] . . . I had a 28-inch waist. . . . Those days have long gone [laughs] never to be seen again. Gone with the youth." However, as a model and with access to fashionable clothing, Roy remained highly interested in dressing in a wide variety of outfits and styles, as discussed in Chapter 8.

Thirty-three-year-old white British banker, Matt, explained that he "definitely took more risks" when he was younger, buying "clothes that seemed a bit more individual, that made more of a statement." Connecting this to his body image he felt that he might have had "a better body image" at that time or that this might have been because he was more "aware" of himself, his body, and his age at the time of

his interview in 2017. Echoing Matt, 37-year-old Florent recalled that the clothes he wore in his "younger days" when he frequently went clubbing and worked as a freelance journalist were "more loud" and expressed his "individuality through clothes." However, now in a more stable profession and getting older, he favored "simpler monochrome looks" that were focused on details (see Color Plate 17). "I remember when I was young it was very much about dressing young, I could wear anything," Sang said, considering his own changing attitude to his dressing as he grew older. "Now, I've just had to make some more conscious decisions about what I can't wear" citing the example of tight "really short shorts" that he replaced with versions that were "short but they're still loose."

"I do think that as you get older, I don't want to look daggy," affirmed 61-year-old Robert. He pondered on how the fashion industry was focused on attracting younger customers, "because I've got more money than a nineteen-year-old, if you want to sell me a pair of glasses for a thousand dollars if I like them, I'll buy them." Endorsing Robert's willingness to spend money on glasses, both 69-year-old Clarence and 57-year-old Ian B discussed wearing glasses, initially as their eyesight began to change with age, but then relishing the challenge of finding "glasses that you like" and felt "confident" wearing. Reflecting further on how certain accessories might move from a pleasurable luxury to a necessity (Berry 1994), Ian B explained that he wore a hat "because my hair's grey so I don't like having grey hair, so it just covers that up quite well" but also because a hat "really finishes off" an outfit (see Color Plate 6).

Sixty-four-year-old Michael N stated that he strongly believed that older men could "still kind of wear interesting kind of clothing and jewelry and glasses" as a means of "expressing yourself through your clothing." He contextualized by comparing the clothes his grandparents wore at his age to his own dress choices. "In the last ten, fifteen years, I look more demure and more covered up" joked 67-year-old Ken, recalling that previously he had worn what he was stocking in his Sydney Oxford Street shop, Aussie Boy: "the shorts and the big boots, so I was always in that because I fancied myself as a bit of a looker, you know." He continued that he did not want to lose all sense of style and wanted "people to still look at me, you know, and I want to go out with a presence." He recalled attending a formal gallery opening in 2015 wearing "shorts and a formal jacket and boots, just to buck it a little bit." He concluded that he did not want to wear "a daggy old suit or anything like that" and that in fact he did not own a suit. Ken's and Michael N's insistence on wearing stylish clothing was like Clarence's, Robert's, and Ian B's fuller descriptions of their clothing that accompanied accessories such as glasses and hats and resonates with the findings of Anna-Mari Almila and Hannah Zeilig (2021) and Ania Sadkowska, Katherine Townsend, Tom Fisher and David Wilde (2017) where the older men they interviewed emphasized their desire to retain a certain stylishness and not fade into the beige of old age.

Age-appropriate choices

Fifty-one-year-old Zack, 51-year-old Gregory, 45-year-old Martin, 41-year-old Gino B, and 49-year-old Eduardo all compared the changes in their style choices between their twenties and middle-age. Forty-nine-year-old Chip, 37-year-old Barry, 34-year-old James, and 31-year-old Gino C also all mentioned how in a similar manner they had "toned down" their style as they got older—although Barry admitted that he did sometimes "still wear something loud, meaning 'I'm gay.'" For each this was related to ideas of propriety as well as comfort and fit (explored in more detail in the previous chapter) and for James a more "traditional" style that worked for his "body," his "style," and his "industry." All in their thirties, Jose, Christopher, and Teddy acknowledged that changing their style to become more restrained was also

linked to being established within their professions as they grew older. Jose particularly identified how his style was influenced by professional peers, comparing the bell bottoms and polyester shirts he wore with colored hair and piercings at college to a more sedate style based on advice from his boss and other curators, particularly noting that he avoided wearing t-shirts and shorts. "I hate this concept of dress your age," stated 42-year-old David J, who felt strongly that "the older you get, the more wisdom you have about fashion" and so men should "dress how [they are] inspired to dress [as] you only have this life to live once."

Jeff Hearn (1995, in Sadkowska et al. 2017) identifies that the forms of disengagement that dominated men's ageing experiences included changing working roles following retirement and were connected to income as well as to changes in physical appearance. Michael N, Murray, and Clarence all described changes to their appearances as they retired or moved from full time to part-time employment. However, Michael N added that he continued to "play with colors" and he looked forward to "opportunities in the future too to be a bit more, even more creative." In contrast to those men who felt they had to *tone down* their style as they aged, 51-year-old Brian C reflected that as he got older, he became "much more comfortable about dressing more flamboyantly." He related this partly to moving from employment in a conservative corporation to working freelance and elaborated by describing "dressing younger and younger . . . So, my waistcoats are getting funkier, my coats are getting funkier." He did acknowledge some change, admitting, "I used to do this t-shirt look a lot, and as I've put on more weight [gaining] much more of a dad bod" that ceased (see Allan 2023 for discussion of "dad bod").

Several of my older interviewees expressed a sense of being "in tune" with current fashion rather than blindly following fashionable trends (Sadkowska et al. 2017). "We're not fashion victims, to be honest with you, but we do like nice clothes" explained 60-year-old Mark (see Color Plate 5). His partner, 51-year-old Gary, compared their interest in remaining fashionable with their gay neighbors in their eighties who he felt dressed, not like gay men, but more how "an old man would dress," how his father might have dressed had he been alive. "We are not the middle-aged men that our fathers were," said 46-year-old Glen. "We are not even the middle-aged man that a gay man was when your father [was middle-aged]" (cf. Sadkowska et al. 2017: 195–196). Sixty-three-year-old Israel noted that his 57-year-old boyfriend "still" had a "really, really great body and so he's all about fashion," wearing luxury brands such as Givenchy and Gucci that had become an integral part of "who he is." This ties with the importance and relevance of both luxury and lower-level brands to gay men of all ages addressed in Chapter 8. "I have always believed, for the whole of my life, that I could wear anything, and I have to keep wearing elements of youth, but I have to make them suitable for me," explained Robert. He kept on top of fashionable trends by reading fashion publications, and would adapt clothes to fit both within trends and his older larger sized body: "I can find someone to knock up a pair of elasticized pull-on leg black pants or make them wider or whatever width they have to be to fit the current trend . . . I've got some fabulous Ralph Lauren pajamas that I will wear as pants . . . cropped just up to my ankle." Likewise, 67-year-old Murray wanted to remain "fashionable without being, you know, being a victim of fashion"; not wanting to be "some fuddy-duddy old guy" like the elderly neighbors described by Gary, nor "be trying to look like I'm twenty-five either." He described how living in Torquay, a seaside town around sixty-five miles from Melbourne, he had a circle of "arty and artist friends" with whom he could wear "Melbourne fashion stuff [and] something wacky to a party." Of a similar age to Murray, Clarence explained that although he loved the idea of growing old disgracefully, he tempered a desire to follow fashion with feeling "comfortable," echoing discussions in the previous chapter. Although his style of dress was more restrained than when he was young, Clarence still endeavored to add fashionable touches to his new clothes, such as grosgrain

ribbon detail added to a Kmart shirt inspired by designer Alexander Wang, and he wore much-loved clothes in his wardrobe that he felt fitted with current trends.

In contrast to those keeping up with fashion was 54-year-old Michael B, who described having been shopping in Japanese high street brand store Uniqlo, where he admired the "wonderful colors of jeans" and, wanting to buy three different colors, tried them on: "They were like skinny fit and I looked down and I thought, no way . . . I'm the wrong age." Eduardo considered that "as you get older you do learn certain things, like you do learn what works for you and what doesn't work for you, and I think, also get to play a little bit more." Inspired by others he knew wearing clothes from the 1940s and 1950s, Ian B recalled that reaching the age of fifty (in 2010) he and his partner "went very much back into a sort of '40s, '50s look again," as it was a "little bit more serious, grown up if you like," not necessarily "ageing gracefully" but a style that they could wear that gave "certain status perhaps" (see Color Plate 6). He compared this to feeling "risible" in baseball caps, t-shirts and trainers, that he had "outgrown" and that had "outgrown me" and so "we needed to part ways." Editorial assistant for fashion at *Esquire* magazine, Wayne Northcross stated that "clothes that are imbued with such emotional significance – sex and politics – are harder to discard as one ages" (cited in Bergling 2004: 62) and for a number of men holding onto older garments, even if they are no longer worn, was an important element of their own and their wardrobe history (see Chapter 7). "I'm like almost fifty-two, when am I going to ever wear these?" asked 51-year-old Gregory, about certain items that had been "a favorite outfit or that get lucky shirt." Like Eduardo he was aware that he would no longer wear these items but kept them in "a plastic bag, a trash bag hidden in the closet" because they made him feel "like you're still undercover gay." These actions were paralleled by older straight men in studies by Almila and Zeilig (2021) and Sadkowska et al. (2017) as well as by women in studies such as those by Alison Guy, Eileen Green, and Maura Banim (2001), Sophie Woodward (2007) and Julia Twigg (2013).

In discussing age-appropriate clothing, Twigg (2013) stated that the expression "mutton dressed as lamb" applies only to women and there is no equivalent for men. However, several older interviewees expressed this concern in their choice of clothing. The concept is also raised by Simpson (2013, 2014, 2015) in relation to his respondents and his application of the processes of ageing capital, especially how that can operate in reverse in terms of detriment to younger gay men, or those who want to appear younger through their dress choices. Michael N particularly evoked this idea of "mutton dressed as lamb," noting that "you have to be a little bit careful with that sometimes" but "you can still have a bit of fun," using almost the same language as Eduardo, above. Similar in age to Michael N, Clarence stated that he "certainly" did not "want to dress like an old man" and while he felt he could get away with dressing younger than his years, he did not want to appear as "mutton dressed like . . ." In relation to the phrase, 49-year-old Eric observed that "there are just things you can't wear," citing Diesel jeans as an example for a man of his age. Although only in his late thirties, Gareth felt that because he was "past the age" where he could fully adopt youthful styles he needed to do so in a "more muted sense," so that people did not think he had "this lost youth that I am trying to relive" and he was not seen as "mutton dressed as lamb or trying too hard." That men between thirty-seven and sixty-nine evoked this phrase demonstrated that the concern with age and not being perceived as dressing too young for one's age reflected both wider societies' attitudes toward ageing and the emphasis on youthfulness within gay scenes and communities. Considering the stereotype that gay men dress younger than straight, 56-year-old Joe P felt this could be attributed to having had to deal with homophobia, that coming to terms with oneself and identity "takes longer." He also stressed, alluding to Halberstam's (2005) concept of queer time, that gay men "don't have those social constraints, so we can still spend time and our alleged disposable income on fashion and dressing up and going out and things."

In their small-scale study of older British men, Sadkowska et al. (2017) note that participants who had grown up engaging in, or inspired by, youth subcultural practices were subsequently influenced by these experiences later in life. Robert, Joe P, Marcus, Ian B, his 62-year-old partner Ian J, and 51-year-old Mikey, each discussed the ways their subcultural pasts informed how they considered their clothing choices as older gay men. Having been a goth and cyberpunk when living in London throughout his late teens and early twenties, Mikey noted how in his forties he rethought his appearance when he realized he was never going to have a "proper" job. He started getting more tattoos and rather than recreating his earlier subcultural style, returned "to it but on my own terms," dressing in what he described as "almost like a hipster look I suppose, but I don't consider myself to be a hipster, I'm more an ex-goth with a beard [laughs]" (see Color Plate 9). Joe P noted that he and many of his generation who had "their roots in punk rock" did not "dress like we did as kids, where we were a bit jumble saley and things were ripped," but instead referenced their subcultural history, as "an acceptable way to still dress". For Joe P this was a "fusion of fifties rock 'n' roll with a little bit of punk sensibility" wearing a reproduction "Let It Rock" Vivienne Westwood t- shirt, a "classy" English brand biker belt, jeans, Dr. Marten boots, and a leather, denim, or Harrington jacket: "It's borderline smart, but people who know will know that that's where your roots are" (see Color Plate 15 and Figure 3.3). More inspired by, and participating in, gay leather subculture, 56-year-old Douglas explained how as an older man he "mixed and matched" and wore "a lot of t-shirts that are kind of subversive and sort of like make sure that people know that you're, you know, the basically fuck you, kind of attitude." The pride that Douglas felt in this look and his retaining aspects of this subcultural style is contrasted by Glen's account of his 57-year-old friend who "cringes" when looking at photographs of the cowboy and leatherman looks that he wore in his thirties and early forties. However, Glen acknowledges how this had been important for his friend in "accommodating a sense of identity" through these particular dress choices.

Ageing and hair

Discussing both facial hair and baldness in relation to evolutionary significance and social perception, Frank Muscarella and Michael R. Cunningham (1996) noted a general agreement that male baldness, facial hair, and cranial hair loss was associated with male sexual maturity. They also identified male baldness as being a sign of both "senescence and social maturity" as well as "associated with decreased perceptions of physical attractiveness" (Muscarella and Cunningham 1996: 103, 105). Thirty-four-year-old James, 31-year-old Johnny, 36-year-old Sang, and 32-year-old Lukasz each discussed their facial hair preferences in relation to their lack of head hair and the process of balding. "I'm going bald," stated Johnny bluntly, "so normally the hair on my face is the longest hair I have on my body" and it was a means of him "being able to bring some sort of change or look, you know." James recalled that he lost his head hair "at a very young age and I tried to hold it on for as long as I could but was not losing it in the right places so eventually, I just had to go and fully shave, now I love it. So facial hair for me is a big part of what that looks like . . . the beard is everything." Also relating facial hair to signs of ageing, 42-year-old David J exclaimed, "I did have a beard until someone told me I looked old!" Milty acknowledged that having facial hair made him look older than his actual age—"so I'm 30, I look 40, i get that"—but had become very used to having a beard and if he shaved it off, he felt he "look[ed] weird."

Like James, Lucasz began to go bald at an early age, in his late twenties. He recounted how when "starting Googling stuff like how the bald men should dress up, or what's the good look for the bald man" he discovered a considerable amount of advice was to grow a beard. Lucasz reflected that "now I really don't think any more about being bald as in disadvantaged . . . I don't think now that it makes me kind of less desirable, and I see that some guys are actually very much into that look." Although eventually accepting and relishing his baldness, Lucasz did not initially enjoy the process of balding in his early twenties. Feeling it "lowered" his "self-confidence," he, like Johnny and 58-year-old Kevin, wore hats, but felt it was perhaps "ridiculous to wear a hat all the time everywhere." Sang also had a negative attitude to initially going bald, recalling a "huge transition period going from skinny . . . younger, prettier kind of, you know, Asian boy" to having to "deal with losing your hair, looking a lot older very, very quickly."

For Mark and Gary being "a bit thinner up here" meant keeping a tight control on their grooming regime, keeping their hair short and neat for both practicality and to fit with acceptable styles for their careers as airline cabin crew (see Color Plate 5). James reminisced that he was "fortunate" at the time he began to lose his hair because "it was really becoming acceptable to shave" your head, thus minimizing the stigma that had previously been associated with balding. Thirty-seven-year-old Barry discussed the practicality of having had his hair shaved short since he was around twenty-eight years old, after experimenting with a series of "quite indie haircuts." He also explained that as his hair receded "it's like you've got to just kind of have a shaved head basically." Robert also contextualized his shaved head in relation to his age and when he first shaved his head to remove the hair extensions he had put in during a trip to London, in the late 1990s. "You know that at a certain time in life it's time to stop wearing certain things," he reflected. "You are pushing the envelope a bit there, you know, have a rethink about it." Despite this some men, such as Chris, were concerned about losing their head hair as they aged. "If I keep my hair and I keep my weight a certain way and I'm healthy then I think I'm fine," Chris predicted, raising concerns connected to the body, outlined in Chapter 3. Greg explained that if he grew his hair longer then his bald patch became more pronounced and so keeping it short minimized the contrast between hairy and bald scalp. He also conceded, like others cited above, that he would "compensate" his bald patch "with the facial hair."

Relating to the signs of age and ageing, several men noted their consciousness about the color of their facial hair, especially its graying with age—some were comfortable with this, while others removed their graying facial hair to minimize these signs of ageing. Barry felt that over the two years that his beard had begun to gray, that it had "become more acceptable to be a bit more gray" and there was less stigma attached to this sign of ageing. Noting that he was only forty-two and his beard was gray, Sina related this to ethnicity, stating that his father went gray quite young. He admitted to having mixed feelings about gray facial hair: sometimes he felt it made him "look really old" and at others, particularly "when it's trimmed it doesn't look quite as gray, so I quite like it, really."

"I do color, about twice a year," to "maintain my youthful blondeness" joked 49-year-old Eric. Picking up on Eric's reference to age, James discussed men dying their hair in relation to ageing, noting that historically gay men had tried to hide signs of ageing by dyeing their graying hair, but that in the middle of the second decade of the twenty-first century, leaving hair gray was not only "acceptable" but was often considered "sexy, it's super-hot." Barry recalled that when he worked in Soho in London, he used to dye many gay men's hair, "masking it to get rid of the gray but I don't really do that so much now so maybe people are a bit more relaxed about being gray." Tim Bergling confirmed from his own study of ageing amongst gay men that, "alongside fashion choices, a little hair manipulation is probably the most common strategy that some men use to try and hold back the advancing years" (Bergling 2004: 64).

Noting a white spot that had emerged in his hair, Ernesto admitted that he had dyed his hair for the first time, shortly before his interview in 2015. This was met with mixed reactions, some agreeing that he should dye the spot to match the rest of his hair and other thinking it "cool." "It's not dyed, this is all natural," claimed Joe P about his dark hair. "And luckily it is actually coming through with a grey streak, so I'm saying, 'do I look like the singer in The Damned?,' and I look more like [British Television sports presenter] Dickie Davies," well known for the gray streak in his hair.

Age and health concerns

In considering how he retained elements of his youthful gay subcultural style, Douglas also explained how his having early-onset Parkinson's disease impacted on his dressed appearance. Having been diagnosed with the dyskinesia form of this degenerative condition, he had to consider how his "muscles start to twist" and how the pain of having what he described as "something like chronic arthritis," made him consider what he would wear to feel as comfortable as possible when he was in pain. He conceded that his condition was mild compared to others but that living with this condition and knowing that it would grow more acute with time meant he "couldn't give a shit" whether other people, including gay men, thought he was "fashionable or unfashionable or tragic or trashy"—instead, it was important to have an attitude of "just go with it and wear whatever you want to and don't be afraid to wear things," echoing other older men quoted above. He also noted how the degenerative nature of his condition meant that ideas of decay and the decaying of human anatomy was prevalent in the work he was producing in 2015 (at the time of his interview), providing a form of agency both within his own dress choices and through the clothing-based artwork he was producing.

Both Robert and Clarence reflected on having put on weight due to the medication they took to manage specific health conditions. Clarence said he had grown to loathe the weight he had put on as a side effect of his medication because he could not "wear half the clothes" in his wardrobe, while Robert compared his weight gain to "starving himself" when he was younger to fit into fashionable clothes and now found ways to adapt fashion trends as discussed above. Both men explained how accessories such as jewelry, spectacles, and shoes had become particularly important as ways of feeling fashionable and well dressed, providing them with a sense of agency in managing their appearance in relation to their changed body size. Also conceding that his body shape had changed as he aged, 46-year-old George explained that his back problems meant that he could not exercise to maintain the muscular frame he developed as a younger man. This meant that he had to "adjust" his "aesthetic" for his body shape. Rather than "walk around with my tummy sucked in because I want to wear that [tight fashionable] t-shirt" he would look for versions that were "baggy," a choice that was described by other men in the previous chapter. Marcus related his decision to get tattooed to "low self-esteem" about his body image, a motivation that was identified in other research on tattooing (Strübel and Jones 2017). Discussing his battles with his mental health, Marcus noted his scars resulting from past self-harm, and described how he had "saved" a place on his body for professionally undertaken branding that reflected a personal journey of self-realization and a coming to terms with his body and identity. Jessica Strübel and Domenique Jones (2017) invoked Laurence Claes and colleagues's (2005) research that demonstrated that tattoos could serve as a form of body care, protecting against self-harm. The ways in which ill health had impacted upon the dress choices of Douglas, Robert, Clarence, George, and Marcus is consistent with the stories told by Twigg's (2018) older heterosexual female respondents.

Ageing capital

Clinical social worker Paul Smith reflected that in the past gay men had viewed ageing in terms of loss of "sex appeal," "libido," "social appeal," and "physicality" as well as hair. He believed that ageing should instead be seen as "just another stage in life" which, like all other life stages, "offer[s] something useful and fulfilling" (cited in Bergling 2004: 162). This connects to the way that Simpson proposed that older men could use *ageing capital*, that he defined as a "set of multivalent, context-dependant (often transferable) emotional, cognitive and political resources" (Simpson 2015: 26), to reclaim the "body-self as attractive, valuable and not reducible to the visual (appearance) or the sexual" (163). This reclamation was discussed by my interviewees in relation to their clothing choices in both feeling comfortable and confident (see also previous chapter) and not necessarily feeling the need to conform to socio-cultural norms as to how older gay men should dress. "When you're younger you're more impressionable and therefore you probably want to conform," 45-year-old Darren reflected, adding that as you age, "you are no longer out to have to conform and impress other people, you just want to know you feel good yourself." In terms of clothing, he related this to being more interested in "bespoke, boutique, tailored" clothing rather than the ultra-fashionable. Ian J expressed a similar perspective, describing a "tried and tested look for older men" comprising "traditional men's clothing, three pieces and whatever, nice hats [and] nice shoes." He explained that this was about "style" rather than fashion, aligning with Simpson's observation of "ageing capital in the form of care in co-ordinating what to wear and how to present a dressed, groomed and shaped middle-aged gay male self" (Simpson 2015: 67–68). These sentiments were also expressed by the older heterosexual men interviewed by Almila and Zeilig (2021) and Sadkowska and co-workers (2017).

Both Robert and 66-year-old Tim emphasized how being in their sixties meant they had both an appreciation of the experience that came with age—a form of ageing capital—and a desire to not conform to looking as they might be expected to. "I've never worn clothes for other people," explained Robert. "It's me. I'm wearing them and I feel good in them." Tim expressed similar opinions, describing the outfit he had worn to the opening of the Jean-Paul Gaultier exhibition at the National Gallery of Victoria: "a sharkskin suit with black satin lapels, and this fabulous sort of black and white sort of abstract hat. And these black and white sunglasses, two-colored frames, and black and white shoes." Tim's pride in his outfit for this special occasion was echoed in 50-year-old Luis's explanation that he wore his clothes with the "dignity of someone who is fifty, who's okay with it, and celebrates it, without trying to hide or pretend to be younger . . . there is a very thin line between trying too hard" and "being comfortable and reflecting, not trying to deny that you are fifty." In his reflection on gay society and culture's move from emphasizing being "girly to get a man" to "everyone" having to be "pumped and trying to be butch," Clarence summed up attitudes expressed above, stating, "Just be yourself . . . Don't try to be something you're not." Clarence's emphasis on "being yourself" was further emphasized by 40-year-old Guy, 32-year-old Chris, and 36-year-old Bryan, who each observed an increased confidence level in themselves or in other older gay men in relation to clothing choices. This confidence is connected to the discussions of the relation between confidence and comfort—a term often applied in relation to older men's dress choices (Almila and Zeilig 2021, Sadkowska et al. 2017, Simpson 2015, Twigg 2018)—explored in the previous chapter.

As a well-dressed older man, Ian B recounted that he received "a fair share" of compliments from others, which pleased him as "it's very easy to disappear as an older person" as others think "you're just an old person" aligning with findings by Mike Featherstone and Andrew Wernick (1995), Pamela Church

Gibson (2000, 2018) and Twigg (2013, 2018) that older people are invisible, particularly with regard to fashion. "I think that sort of fifties is the new black . . . like seriously in the gay community it certainly is," asserted Douglas. Linking this to the changing culture within the fashion industry that celebrated older models both on the catwalk and in print advertising, he suggested that gay men "are much more comfortable [and] dressing in a fashionable sort of style that's trendy at the time." Continuing his train of thought and relating to ideas of attraction and sexual and erotic capital, explored in Chapter 6, Milty stated "there's nothing sexier than an old man that dresses well." Douglas and Milty's opinions resonate with Simpson's observation that ageing capital was "central to an authentically presented" older self through a "creative appropriation of what the fashion industry makes available whilst withstanding pressure to conform to what gay men are supposed to wear" (Simpson 2015: 51).

Emphasizing the particular value and influence of ageing capital on his own style, 27-year-old Joe H recalled that when he began working retail in stores, such as the Gap and Express in the early 2000s, he met "some guys who were a little bit older and gay who had a more polished look" and he started wearing dress shirts instead of tank tops because "they looked older and cooler in a different way." Both James and 46-year-old Andrew described having gay friends who were both younger and older than themselves. Andrew believed that on the one hand his personal style was admired by his younger friends and, on the other, that by spending time with men in their "seventies and eighties" he had come to admire their attitudes and dress style. Simpson found that some of his respondents judged younger men's adherence to fashionable styles as "shallow" or "cultural dupes" (Simpson 2013: 166) and that ageing capital was "implicated in forms of distinction relating to the body, emotions, style, class and moral claims in relation to others" (Simpson 2015: 33). Like Andrew, James reflected on the influence of those with whom you surround yourself, as a "sort of network or influencers" and asserted that, like Andrew, he was highly influenced by having a lot of older gay friends. Building on forms of subcultural capital (Thornton 1995) developed through subcultural dress styles throughout his life, Joe P related that his style of dress had retained similar elements since his mid-twenties, but he had "refined" the look over the years. In the context of ageing capital he reflected, "It's like you think how am I going to be when I get older, and then I think, I *am* older. And I was looking at myself in the mirror and thinking, well, what am I going to look like in twenty years' time when I'm 75? And I was thinking, I will probably be wearing the same clothes."

Conclusion

For the older men cited and discussed in this chapter, growing older had particular effects upon how they viewed their subject position as gay men, partly influenced by gay culture's emphasis on particular body cultures and youth and youthfulness, as well as broader societal and cultural attitudes to age and ageing; the "norms" that "reflect ideas about the body and its presentation" (Twigg 2013: 6). In keeping with studies by Robinson (2008), Bergling (2004), and Simpson (2013, 2014, 2015), middle age was a point for some of these men to reflect on how their age intersected with their other subject positions and the ways in which they negotiated the relationship between their age and their dressed appearance. Reflecting on how their clothing choices and relations with fashion developed as they aged provided insights into the ways they considered themselves as gay men of a particular age, and whether age in and of itself was a determining factor or related to influences discussed in other thematic chapters of this book. Even for younger men, the concept of ageing was a consideration, whether reflecting on how their

style had changed between their teenage years and twenties or considering how they related to older men and their own anticipation of their later lives. Reflecting on both the subjects of his photographic practice and his own age, 55-year-old photographer Kym stated "ever since I can remember, I didn't get that division. I didn't get the age division. I don't get the gender division. I don't get divisions," emphasizing a point about binarism within subject positions. Returning to age he concluded that when people asked his age "I always say I'm 982 because they want me to bite."

Note

1 The statutory age of retirement for men in Australia was 65 until 2017, when it was raised to 66. In the United Kingdom it was 65 until 2018 after which it changed to 66 or 67 depending on the year of birth. In the United States of America people born between 1943 and 1954 can retire at 66, and for those born after 1960 retirement age will be 67.

CONCLUSION

In 1993, Richard Dyer observed that for gay people there are "no equivalents to the biological markers of sex and race" that declare them as gay; "instead, 'gayness' can be identified through a repertoire of gestures, expressions, stances, *clothing* and even environments" (Dyer 1993: 19, emphasis added). It is the importance of clothing in relation to these other elements Dyer identified that are a major concern of *Gay Men's Style*. Race, ethnicity, sex, gender, and the constructions of the masculine and feminine are reflected in the experiences of the men cited in this book in their discussions around the ways in which they choose to dress within specific and varying contexts. While there are some gay men who align themselves with one or other side of a traditional binary division of masculine/feminine, others have opted for a more fluid "both/and" rather than "either/or" (Kaiser 2012), blurring the lines between what has traditionally been seen as gender appropriate or inappropriate. Michel Foucault speculated: "To be 'gay,' I think, is not to identify with the psychological traits and the visible masks of the homosexual but to try to define and develop a way of life" (Foucault 2000: 138). In proposing that sexuality should not be seen as a true identity category, Foucault also pointed toward the changing nature of sexualities that are called into being. This is important when understood not just in terms of stylistic choice but as a fundamental part of gay subjectivities, and, following Judith Butler, performative expression. In the context of Butler's (1990) theories of gender as a series of performed actions and behaviors, "Gayness" is constantly produced and reproduced through numerous images and practices, including dressed appearance. The discussions throughout *Gay Men's Style* situate my interviewees' "gayness" in relation to their other subject positions and to the situations and contexts of their lives. Gender is particularly addressed in Chapter 2 and age in Chapter 11.

The role of clothing and dress in the "becoming" (Ahmed 2006, Deleuze and Guattari 1988, Dziengel 2015) of an individual and the understanding of the self from an intersectional perspective was an important element that came through in many of the interviews conducted for the research for this book. It was particularly relevant in the negotiations undertaken by gay men in the processes of coming out, discussed in Chapter 3, and the ways in which discovering and attending gay bars, clubs, and scenes influenced dress choices through individual or collective choices, discussed in Chapter 4. The ideas of becoming can also be connected to the body and the ways in which gay men adapt and manipulate their bodies throughout their lives. Chapter 3 specifically addresses the ways in which my interviewees discussed their body types and the relationship between their bodies and dress choices. The prevalence and perceived preference within western gay communities and in the gay media for a mesomorphic or muscular body type was contrasted with ectomorphic or thin and endomorphic soma types and the ways these impacted gay men's style-fashion-dress. For those gay men who did not fit within the white muscular ideal (McBride 2005; Whitesel 2010, 2014) the sexual racism that has been widespread on social media and dating apps impacted upon self-perception as of those of my interviewees who did not fit this archetype. There was a clear relation between racial and ethnic identity and body type that had

bearing on my interviewees identifying as men of color. The emergence and celebration of thinner and more diverse bodies within the fashion industry (Barry 2019, McCauley Bowstead 2018, Rees-Roberts 2013) has however impacted upon the positive self-image of gay men, including those interviewed in this book.

The concept of collective identities and the idea of being a "typical" gay man, raised towards the end of Chapter 8, highlights ideas about the ways in which gay men have historically been stereotyped, particularly in their relationship with disposable income, occupational choices, and style-fashion-dress. This book acknowledges stereotypes, such as the hyper-fashionable gay man, and questions these in relation to the experiences of my interviewees. One of the purposes of interviewing a large number of gay men from a variety of backgrounds and subject positions was to explore the multifaceted lives of gay men in the twenty-first century. It was not my intention in this book to draw universal conclusions about the role of style-fashion-dress in gay men's lives and identities or subject formation. Instead, *Gay Men's Style* uses examples of specific individual gay men's experiences and discourses around their dress practices and makes comparisons through a series of thematic lenses. This offers an insight into the ways in which a number of gay men, from a variety of backgrounds and locations, of different ages and occupations, consider the place of style-fashion-dress in the twenty-first century, and hopefully provides a building block for more research and discussion in this area. The role of social class, while not necessarily explicitly raised in the interviews that underpin this book, was implicit in the ways in which these gay men understood their intersectional identity positions and their dress choices. It may appear from this research that gay men have high levels of fashion knowledge that may be greater than the majority of straight men. However, it is worth considering that many of the men interviewed were engaged in creative occupations (some in fashion) and through responding to the calls to take part in this research revealed a keen active interest in the details of their style-fashion-dress practices. An avenue for future research could be to consider the ways in which gay men who express little interest in fashion and dress negotiate their dressed appearances.

The locations and situations in which gay men chose to wear specific garments or outfits formed a key part of discussions about twenty-first century gay men's dress styles. The place of gay and broader LGBTQ+ venues offered a variety of locations, and the international circuit party and bear scenes provided transnational contexts for particular dress practices. The ideas of labor both in terms of occupational commitment (Kang et al. 2011) and in terms of aesthetic and self (Entwistle and Wissinger 2006) were implicit in the discussions of work-place dress choice amongst my interviewees. Both the site and physical and cultural conditions of various local, national, and international gay scenes exerted an influence upon the understanding of bodies and clothing in relation to sexual attractiveness, of what Catherine Hakim (2010) and Adam Green (2008) have described as erotic capital. This, along with sexual capital (Martin and George 2006), has impacted on the ways in which the gay men interviewed in this book have discussed style-fashion-dress in relation to their relationship status; the negotiating of considerations of attractiveness in seeking out new relationships and in ongoing sexual and romantic relationships. There is also a connection here with ideas of comfort and fit, specifically discussed in Chapter 10; the ways in which gay men have constructed their wardrobes, explored in Chapter 7; and the ways in which dress choices reflected gendered attributes of masculinity and femininity.

The focus on men living in the United States, the United Kingdom, Australia, and Japan admittedly has its limitations, but this made the research and the material produced through the interviews realizable and manageable. Future research could redress this focus by addressing gay men in other countries and further develop the ideas of a globalized, glocalized and/or transnational world to further understand the

differences and similarities of gay men's or broader LGTBQ+ dress practices. Stephen Vertovec defines transnational as the "multiple ties and interactions linking people or institutions across the borders of nation-states" (cited in Jackson, Crang, and Dwyer 2004: 4), while Travis Kong (2011: 8) points out how the term "transnational" could "address more accurately the asymmetries of the globalization process"; something that could be considered in the role of style-fashion-dress in LGBTQ+ lives in, and across, different locations. What Richard Peterson and Andy Bennett (2004; 6) have described as "translocality" has relevance in the ways in which there were commonalities between the clothing choices made by the men interviewed for this book who were living in different cities and countries. This translocality is also aided and manifested in the rise in the importance of the internet within the lives of gay men in the twenty-first century. For the gay men interviewed for this book, the internet was important from two perspectives. The first is in relation to the use of dating apps, blogs, and other social media as a means of connecting globally as well as locally and as a means of presenting choices in body type and clothing. Here, discussions about body type, race, ethnicity, and gendered behaviors became relevant and important in the communal and individual understandings of twenty-first century gay men's experiences, discussed in Chapter 2. Late twentieth century revisions of thinking about homosexuality led many gay men to articulate expressions of their sexuality through visible manifestations of masculinity that drew upon the preconceived ideas of hegemonic masculinity. Striving for a hypermasculinity could be read as leading to a new form of constriction on gay dress choice, with a seeming demonization of effeminacy within the western gay world. Again, it is worth reiterating the impact of the dominance and idolization of certain white muscular masculine ideals and the sexual racism, ageism, and femmephobia that was rife on dating apps and brought to a greater attention by Black Lives Matter. The second use of the internet is through the growth of e-retail and gay men's engagement with online shopping, discussed in Chapter 8. For my interviewees, this related both to the purchase of new and second-hand or vintage clothing, with motivations varying through price, availability, and convenience. Although broader research on online shopping (Kim, Ha, and Park 2019) seems to indicate that younger generations are more likely to shop online, this was not necessarily the case with my interviewees, with older men discussing their preference for and the benefits of online shopping. For gay men, discussions about the seeming advancement of post-millennial online developments could also be seen as a leap backwards in terms of acceptance both within and outside gay communities.

The problems of racism and ageism, as well as antagonism towards gay men who present themselves in feminised manners, are all concerns that, while addressed in this book, could be further developed in future research. The issues of ageism, age, and ageing more generally are key within the intersectional approach of *Gay Men's Style*'s investigation of gay men's relationship with style-fashion-dress. Emphasis placed upon particular body cultures and youth and youthfulness by gay culture has impacted upon gay men's perspective of their intersectional subject positions. The men interviewed for this book related both their comfort with their ageing capital (Simpson, P. 2016), as well as the particular worries that they have about ageing. These concerns were raised by Featherstone and Hepworth (1991, 1995) in comparison to those of straight men, but also resonate with more recent research into (heterosexual) older men and their relationship with style-fashion-dress (Almila and Zeilig 2021; Sadkowska et al. 2017). The interrelationship between age, sexuality, and gender is ripe for further investigation, building on the discussions in the final chapter of *Gay Men's Style*.

There is an element of creativity involved within the construction of the wardrobe (Almila and Zellig 2021) reflected in how gay men respond creatively through their style-fashion-dress choices to a variety of situations, occasions, and locations. A broader investigation of men's wardrobes and dress choices

may indicate similarities (as well as differences) based around sexuality identification, as well as in combination with other subject positions. The interviews cited in *Gay Men's Style* have reinforced the high premium these gay men (as well as many others cited in other research on gay men and dressed appearance) put on their own dressed appearance. This could be compared to that of many straight men, although as recent research has shown the ways in which straight men negotiate their dressed appearance in relation to *their* intersectional subject positions is important (Almila and Zeilig 2021, Sadkowska et al. 2017).

The dividing line that *may* have existed historically between the way gay and straight men dressed has been blurred in the twenty-first century, particularly amongst younger generations where sexual orientation is just one of many elements that make up an individual's subject positioning and is itself a blurred area. Historically, gay men used style-fashion-dress in their processes of recognition, both of each other, perhaps in secret or private contexts, and to be recognized by and within a broader heterosexual or heteronormative society (see Cole 2000, Geczy and Karaminas 2013). *Gay Men's Style* opens with an examination of the ways in which gay and straight men dressed both differently and similarly to one another in the first decades of the twenty-first century, focusing on the observations and opinions of the men interviewed for this book. This acted as an underpinning for the exploration of the ways in which the interviewed men discussed their dress choices in the thematic chapters that follow. Reflecting on the history of gay men's relationship with style-fashion-dress, both broadly and within certain subjective constraints or communities, Alex Bspeculated, "What is gay style, gay fashion? I don't know." Taking up Alex B's uncertainty about what constitutes gay style, Adam identified "what I'm wearing now, with all its crazy patterns, might have been seen as a gay man's dress-sense. . . . For me it's an identity. Is it a gay identity? I'm not fully sure [but] I think a lot of people would perceive it as gay." As evidenced in these quotes that act as a form of summary of such concerns, and in the quotations employed throughout this book, for gay men the selection and combination of items of clothing were negotiated in terms of time, place, and space, where occasion or company might impact how they wished to present themselves in specific temporal moments. While this book has offered a wide intersectional discussion of gay men's style-fashion-dress in the twenty-first century it is intended to operate as a springboard for further future research into the relationships between sexuality and style-fashion-dress in local, global, and transnational contexts. In concluding this book (and this research for now) I return to the opening words of *Don We Now Our Gay Apparel* (Cole 2000), citing Andrew Holleran's 1978 novel, *Dancer from the Dance* that explored the lives and loves of gay men in New York, to reiterate the book's central focus: "The Clothes!" (Holleran 1980: 20).

APPENDIX: INTERVIEWEES

Age (at time of interview). Race/ ethnicity/nationality. Country of residence (at time of Interview). Occupation.

Adam – 33. Black British. Living in UK. Analyst. Interviewed on 28 October 2017.

Adriann – 29. Mexican American. Living in UK. Performance artist. Interviewed on 10 October 2018.

Alan – 43. Malaysian Chinese. Living in Australia. Human resources specialist. Interviewed on 30 July 2015.

Alex B – 39. African American. Living in UK. Brand manager. Interviewed on 24 July 2017.

Alex J – 26. African American. Living in USA. Retail manager. Interviewed on 16 October 2012.

Alex M – 36. British mixed-race. Living in UK. Teacher. Interviewed on 1 August 2017.

Alfie – 32. Italian-British. Living in UK. Creative director. Interviewed on 18 October 2018.

Andrew – 46. White Australian. Living in UK. Teacher and retail assistant. Interviewed on 15 July 2017.

Antonio – 25. Portuguese. Living in UK. Performance artist. Interviewed on 28 September 2018.

Barry – 37. White Scottish. Living in UK. Hairdresser. Interviewed on 8 October 2018.

Benjamin – 26. White British. Living in UK. Make-up artist. Interviewed on 29 March 2018.

Brian C – 51. White British. Living in UK. Marketing specialist and color consultant. Interviewed on 22 August 2017.

Brian F – 33. White American. Living in USA. Architect. Interviewed by email 26 November 2012.

Bryan – 28. Malaysian. Living in Australia. Architect. Interviewed on 1 August 2015.

Carl G – 37. White American. Living in USA. Artist. Interviewed by email 12 December 2012.

Carl H – 37. Norwegian American. Living in USA. Public program manager. Focus Group on 2 November 2015.

Chip – 49. White American. Living in USA. Art director. Focus Group on 2 November 2015.

Chris – 32. Sri Lankan British. Living in UK. Chef and performer. Interviewed on 8 October 2018.

Christopher – 34. White Australian. Living in Australia. Hospital administrator. Interviewed on 24 August 2015.

Clarence – 69. Chinese. Living in Australia. Retired designer. Interviewed on 4 August 2015.

Daniel – 31. Thai Irish. Living in UK. University Lecturer. Interviewed on 24 July 2018.

Darren – 45. White British. Living in Australia. Hotel sales and marketing executive. Interviewed on 9 August 2015.

Dat – 44. Vietnamese. Living in Australia. Jeweler. Interviewed on 9 August 2015.

David J – 42. White American. Living in USA. Marketing specialist. Focus Group on 29 October 2015.

David M – 25. White Irish. Living in UK. Filmmaker. Interviewed on 20 November 2012.

David W – 45. White British. Living in UK. Training manager. Interviewed by email on 21 January 2013.

Dex – 23. White British. Living in UK. Performer. Interviewed on 21 September 2018.

Diego – 26. Peruvian. Living in USA. Operations manager. Focus Group on 1 November 2015.

Douglas – 56. White Australian. Living in Australia. Designer and lecturer. Interviewed on 11 August 2015.

Eduardo – 49. Hispanic American. Living in USA. Librarian. Focus Group on 1 November 2015.

Eric – 49. White American. Living in USA. Writer and editor. Focus Group on 1 November 2015.

Erich – 27. White American. Living in USA. Nurse. Interviewed on 14 October 2012.

Ernesto – 36. Argentinian. Living in Japan. Hotel concierge. Interviewed on 3 September 2015.

Florent – 37. White French. Living in UK. Journalist. Interviewed on 24 July 2017.

Gareth – 37. Indian Australian. Living in Australia. Finance worker. Interviewed on 2 August 2015.

Gary – 51. White Australian. Living in Australia. Air crew. Interviewed on 7 August 2015.

George – 46. Hong Kong Chinese. Living in Australia. Designer and fashion technician. Interviewed on 13 August 2015.

Gino B – 41. White Australian. Living in Australia. Make-up artist. Interviewed on 7 August 2015.

Gino C – 31. Peruvian American. Living in USA. Public relations manager. Focus Group on 30 October 2015.

Glen – 46. White Australian. Living in Australia. Designer and pattern cutter. Interviewed on 11 August 2015.

Greg – 46. White Australian. Living in Australia. Radio DJ. Interviewed on 12 August 2015.

Gregory – 51. Cuban American. Living in USA. Store brand associate and peer advocate/counsellor. Focus Group on 2 November 2015.

Guy – 40. White British. Living in USA. Hotel manager. Focus Group on 30 October 2015.

Hayden – 43. White Australian. Living in Australia. Information technology worker. Interviewed on 6 August 2015.

Homi – 38. Indian. Living in UK. Artist. Interviewed on 28 August 2017.

Ian B – 57. White British. Living in UK. Vintage shop owner. Interviewed on 21 September 2018.

Ian J – 63. White British. Living in UK. Vintage shop owner. Interviewed on 21 September 2018.

Israel – 63. Cuban. Living in USA. Lawyer. Focus Group on 2 November 2015.

James – 34. White American. Living in USA. Office manager. Focus Group on 31 October 2015.

Joe H – 27. White American. Living in USA. Performer and club host. Interviewed on 14 October 2012.

Joe M – 49. Cuban. Living in USA. Interior designer. Focus Group on 29 October 2015.

Joe P – 56. White British. Living in UK. DJ. Interviewed on 30 July 2018.

Johnny – 31. White British. Living in Australia. Designer. Interviewed on 27 July 2015.

Jon – 35. Italian-Australian. Living in Australia. Designer. Interviewed on 27 July 2015.

Jordan – 23. White Australian. Living in Australia. Fashion design student. Interviewed on 11 August 2015.

Jose – 37. Mexican American. Living in USA. Curator. Focus Group on 30 October 2015.

Josh – 19. White British. Living in UK. Fashion history student. Interviewed on 20 September 2012.

Jun – 26. Malaysian-Singaporean. Living in UK. Fashion photography student. Interviewed on 29 June 2018.

Ken – 67. White Australian. Living in Australia. Clothing retailer. Interviewed on 5 August 2015.

Kevin – 58. White American. Living in USA. Interior designer. Focus Group on 2 November 2015.

Krysto – 48. Greek Australian. Living in Australia. Yoga teacher and café owner. Interviewed on 11 August 2015.

Kym – 55. White New Zealander. Living in Australia. Photographer. Interviewed on 10 August 2015.

Lee – 34. White American. Living in USA. Writer. Interviewed by email 26 November 2012.

Lukasz – 32. Polish. Academic. Living in UK. Interviewed on 1 August 2017.

Luis – 50. Venezuelan. Living in USA. Designer. Focus Group on 31 October 2015.

Marcus – 57. White British. Living in Australia. Photographer and lecturer. Interviewed on 24 July 2015.

Mark – 60. White Australian. Living in Australia. Air crew. Interviewed on 7 August 2015.

Mario – 37. Italian-American. Living in UK. PhD candidate. Interviewed on 29 November 2012.

Martin – 45. Cuban. Living in USA. Sales. Focus Group on 2 November 2015.

Matt – 33. White British. Living in UK. Accountant. Interviewed on 9 October 2017.

Matthew – 30. White Australian. Living in Australia. Digital collections analyst. Interviewed on 5 August 2015.

Michael B – 54. White British. Living in UK. Church advisor. Interviewed on 22 August 2017.

Michael N – 64. White Australian. Living in Australia. Part-time art gallery education officer. Interviewed on 12 August 2015.

Mikey – 51. White British. Living in UK. Book merchandiser. Interviewed on 28 June 2018.

Milty – 40. Greek American. Living in USA. Hospitality manager. Focus Group on 31 October 2015.

Murray – 67. White Australian. Living in Australia. Retired art director. Interviewed on 29 July 2015.

Nick – 28. White American. Living in USA. Artist. Interviewed on 13 October 2012.

Patrick – 24. White Australian. Living in Australia. Performer and retail assistant. Interviewed on 22 July 2015.

Rafal – 29. Polish. Living in UK. Artist. Interviewed on 8 August 2017.

Raj – 35. Indian. Living in Australia. Product manager. Interviewed on 24 August 2015.

Remi – 27. White French. Living in UK. Retail assistant. Interviewed on 22 August 2017.

Riccardo – 27. Italian. Living in UK. Performance artist. Interviewed on 28 October 2018.

Robert – 61. White Australian. Living in Australia. Make-up artist. Interviewed on 27 July 2015.

Roy – Preferred not to disclose age. Black British. Living in UK. Model and performer. Interviewed on 1 August 2017.

Sam – 30. White Australian. Living in Australia. PhD student. Interviewed on 9 August 2015.

Sang – 36. Chinese Cambodian. Living in Australia. Fashion designer and lecturer. Interviewed on 13 August 2015.

Sanjeeva – 23. Malaysian Sri Lankan. Living in UK. Fashion journalism student. Interviewed on 29 June 2018.

Sean – 29. White American. Living in USA. Writer. Focus Group on 29 October 2015.

Shane – 50. White Australian. Living in Australia. Information technology worker. Interviewed on 6 August 2015.

Shawn – 50. White American. Living in USA. Design director. Focus Group on 29 October 2015.

Simian – 22. Chinese. Living in UK. Creative direction student. Interviewed on 1 August 2017.

Sina – 42. Iranian British. Living in UK. Artist, DJ, and academic. Interviewed on 3 November 2018.

Taylor – 19. White British. Living in UK. Apprentice tailor. Interviewed on 13 November 2012.

Teddy – 32. Romanian Australian. Living in Australia. Computer scientist. Interviewed on 28 July 2015.

Tim – 60. White Australian. Living in Australia. Performer. Interviewed on 12 August 2015.

TJ – 26. White American. Living in USA. Fashion public relations manager. Interviewed on 13 October 2012.

Toshi – "forty-something." Japanese. Living in Japan. Graphic designer. Interviewed on 1 September 2015.

Vlad – 25. Azerbaijani. Living in Australia. Fashion design student. Interviewed on 12 August 2015.

Wataru – 49. Japanese. Living in Japan. Language teacher and artist. Interviewed on 1 September 2015.

Zack – 51. White American. Living in USA. Manufacturing company president. Worked in fashion. Focus Group on 29 October 2015.

ILLUSTRATIONS

Figures

Color plates

BIBLIOGRAPHY

Abraham, A. (2019), *Queer Intentions: A (Personal) Journey through LGBTQ+ Culture*, London: Picador.

Achenbaum, W. A. (2005), "Ageing and Changing: International Historical Perspectives on Ageing," in M. L. Johnson (ed.), *The Cambridge Handbook of Age and Ageing*, 21–29, Cambridge: Cambridge University Press.

Ahmed, S. (2006), *Queer Phenomenology*: *Orientations, Objects, Others*, Durham and London: Duke University Press.

Allan, J. (2023), "One Sexy Daddy: Desirsable Dad Bods and Popular Romance Novels," in V. Karaminas, A. Geczy, and P. Church Gibson (eds), *Fashionable Masculinities: Queers, Pimp Daddies and Lumbersexuals,* 83–95, Chicago: Rutgers University Press.

Allen, K. R. (2005), "Gay and Lesbian Elders," in M. L. Johnson (ed.), *The Cambridge Handbook of Age and Ageing*, 482–494, Cambridge: Cambridge University Press.

Almila, A.-M. and Zeilig, H. (2021), "In Older Men's Wardrobes: Creative Tales of Affect, Style and Constraint," *Fashion Theory*, DOI: 10.1080/1362704X.2021.1936402.

Altman, D. (1982), *The Homosexualization of America: The Americanization of the Homosexual*, New York: St Martin's Press.

Altman, D. (1997), "Global Gaze/ Global Gays," *GLQ,* 3(4): 417–436.

Altman, D. (2001), *Global Sex*, Chicago: University of Chicago Press.

Alvear, M. (1999), "You've Got Male**:** How did America Online become the Bathhouse of the Internet? Size Matters,**"** *Salon*, 12 October. Available online: https://www.salon.com/1999/10/12/gay_aol/ (accessed 21 August 2020).

Anderson, B. (1991), *Imagined Communities: Reflections on the Origins and Spread of Nationalism*, London and New York: Verso.

Anderson, E. (2009), *Inclusive Masculinity: The Changing Nature of Masculinities*, New York: Taylor & Francis.

Anderson, E. (2018), "Inclusive Masculinity Theory," in E. Morris and F. Blume Ouer (eds), *Unmasking Masculinities: Men and Society*, 38–44, Los Angeles and London: Sage.

Armstrong, L. and McDowell, F. (2018), "Introduction: Fashioning Professionals: History, Theory and Method," in L. Armstrong and F. McDowell, *Fashioning Professionals: Identity and Representation at Work in the Creative Industries*, 1–25, London: Bloomsbury Visual Arts.

Atherton Lin, J. (2021), *Gay Bar: Why We Went Out*, London: Granta Books.

Atkinson, M. and Young, K. (2001), "Flesh Journeys: Neo Primitives and the Contemporary Rediscovery of Radical Body Modification," *Deviant Behavior*, 22(2): 117–146.

Atwal, G. and Williams, A. (2017), "Luxury Brand Marketing—the Experience is Everything!," in J.-N. Kapferer, J. Kernstock, T. O. Brexendorf, and S. M. Powell (eds), *Advances in Luxury Brand Management*, 43–57, Basingstoke: Palgrave Macmillan.

Aung, M. and Sha, O. (2016), "Clothing Consumption Culture of a Neo-Tribe: Gay Professionals within the Subculture of Gay Consumers," *Journal of Fashion Marketing and Management*, 20(1): 34–53.

Baker, R. (1994), *Drag: A History of Female Impersonation in the Performing Arts*, London: Cassell.

Barnes, R. and Eicher, J. B., eds (1992), *Dress and Gender: Making and Meaning*, Oxford: Berg.

Barry, B. (2019), "Fabulous Masculinities: Refashioning the Fat and Disabled Male Body," *Fashion Theory*, 23(2), 275–307.

Barry, B. and Martin, D. (2016a), "Fashionably Fit: Young Men's Dress Decisions and Appearance Anxieties," *Textile*, 14(3), 326–347.

Barry, B. and Martin, D. (2016b), "Gender Rebels: Inside the Wardrobes of Young Gay Men with Subversive Style," *Fashion, Style and Popular Culture,* 3(2), 225–250.

Barry, B. and Weiner, N. (2017), "Suited for Success? Suits, Status, and Hybrid Masculinity," *Men and Masculinities*, 22(2): 151–176.

Barthes, R. (1983), *The Fashion System*, New York: Hill and Wang.

Baudrillard, J. (1998), *Consumer Society: Myths and Structures*, London: Sage.

Bauman, Z. (2005), *Liquid Life*, Cambridge: Polity.

Begum, L. and Dasgupta, R. K. (2018), "In/Visible Space: Reflections on the Realm of Dimensional Affect, Space and the Queer Racialised Self," in L. Begum, R. K. Dasgupta, and R. Lewis (eds), *Styling South Asian Youth Cultures: Fashion, Media and Society*, 86–95, London and New York: I.B. Tauris.

Bell, D. and Valentine, G. (1995), "The Sexed Self: Strategies of Performance, Sites of Resistance," in S. Pile and N. Thrift (eds), *Mapping the Subject: Geographies of Cultural Transformation,* London and New York: Routledge.

Bennett, A. and Hodkinson, P., eds (2012), *Ageing and Youth Culture*, London: Routledge.

Bennett, A. and Kahn-Harris, K., eds (2004), *After Subculture: Critical Studies in Contemporary Youth Culture*, Basingstoke: Palgrave Macmillan.

Benson, S. (2000), "Inscriptions on the Self: Reflections in Tattooing and Piercing in Contemporary Euro-America," in J. Caplan (ed.), *Written on the Body,* 234–254, London: Reaktion.

Berger, R. M. (1982), *Gay and Gray: The Older Homosexual Man*, Urbana and Chicago: University of Illinois Press.

Bergling, T. (2001), *Sissyphobia: Gay Men and Effeminate Behaviour,* New York: Harrington Park Press.

Bergling, T. (2004), *Reeling in the Years: Gay Men's Perspectives on Age and Ageism*, New York: Southern Tier Editions, Harrington Park Press.

Berry, C. J. (1994), *The Idea of Luxury: A Conceptual and Historical Investigation*, Cambridge: Cambridge University Press.

Berry, J. (2010), "Relational Style: Craft as Social Identity in Australian Fashion," *Journal of Modern Craft*, 3(1): 49–68.

Binnie, J. (2004), *The Globalization of Sexuality*, London: Sage.

Binnie, J. and Skeggs, B (2004), "Cosmopolitan Knowledge and the Production and Consumption of Sexualized Space: Manchester's Gay Village," *Sociological Review*, 52(1): 39–61.

Black, S. (2008), *Eco-Chic: The Fashion Paradox,* London: Black Dog.

Black, S. (2019), *Fashion and Sustainability,* London: Bloomsbury Publishing.

Bluteau, Joshua (2021), "The Devil is in The Detail: Why Men Still Wear Suits," in S. Cole and M. Lambert (eds), *Dandy Style: 250 years of British Men's Fashion*, 63–73, London and New Haven, CT: Yale University Press.

Boellstroff, T. (2005), *The Gay Archipelago: Sexuality and Nation in Indonesia*, Princeton: Princeton University Press.

Boellstroff, T. (2007), *A Coincidence of Desires: Anthropology, Queer Studies, Indonesia*, Durham: Duke University Press.

Bourdieu, P. (1984), *Distinction: Asocial Critique of the Judgement of Taste*, Cambridge, MA: Harvard University Press.

Bourdieu, P. (1986), "The forms of capital," in J. Richardson (ed.), *Handbook of Theory and Research for the Sociology of Education*, 241–258 New York: Greenwood.

Bourdieu, P. (2001), *Masculine Domination*, Stanford, CA: Stanford University Press.

Bracewell, M. (1993), "Dress Codes," *Guardian*, 25 September: 40–42.

Brady, S. and Busse, W. (1994), "The Gay Identity Questionnaire: A Brief Measure of Homosexual Identity Formation," *Journal of Homosexuality*, 26(4): 1–22.

Braidwood, E. (2018), "London Gay Club XXL's Controversial Door Policy Banning Femme Clothing Sparks Protest," *Pinknews*, 12 September. Available online: https://www.pinknews.co.uk/2018/09/12/xxl-london-gay-club-femme-clothing-protest/ (accessed 18 June 2021).

Brajato, N. (2020a), "Dancing in the Dark: Bodily Borders and Clothing Limits in the Experience of Clubbing," *Dune: Writings on Fashion, Design and Visual Culture*, 1(1): 110–119.

Brajato, N. (2020b), "Queer(ing) Tailoring: Walter Van Beirendonck and the Glorious Bastardization of the Suit," *Critical Studies in Fashion and Beauty*, 11(1): 45–72.

Braun, V. and Clarke, V. (2006), "Using Thematic Analysis in Psychology," *Qualitative Research in Psychology*, 3(2): 77–101.

Bray, A. (1995), *Homosexuality in Renaissance England*, New York: Columbia University Press.

Brekhus, W. H. (2003), *Peacocks, Chameleons, Centaurs: Gay Suburbia and the Grammar of Social Identity*, Chicago and London: Chicago University Press.

Brennan, D., Asakuraa, A., George, C., Newman, P. A., Giwa, S., Hart, T. A, Souleymanov, R., and Betancourt, G. (2013), "'Never Reflected Anywhere': Body Image Among Ethnoracialized Gay and Bisexual Men," *Body Image*, 10: 389–398.

Breward, C. (2000), "The Dandy Laid Bare: Embodying Practices of Fashion for Men," in P. Church Gibson and S. Bruzzi (eds), *Fashion Cultures: Theories, Explorations, and Analyses*, 221–238, London and New York: Routledge.

Breward, C. (2003), *Fashion*, Oxford: Oxford University Press.

Breward, C. (2016), *The Suit: Form, Function and Style,* London: Reaktion Books.

Brewis, J. and Jack, G. (2010), "Consuming Chavs: The Ambiguous Politics of Gay Chavinism," *Sociology,* 44(2): 251–268.

Bridges, T. (2009), "Gender Capital and Male Bodybuilders," *Body and Society*, 15(1): 83–107.

Bridges, T. (2018), "A Very 'gay' Straight? Hybrid Masculinities, Sexual Aesthetics, and the Changing Relationship between Masculinity and Homophobia," in E. W. Morris and F. Blume Oeur (eds), *Unmasking Masculinities: Men and Society*, 378–389, Los Angeles and London: Sage.

Britt, L. and Heise, D. (2000), "From Shame to Pride in Identity Politics," in S. Stryker, T. Owens, and R. White (eds), *Self, Identity, and Social Movements*, 252–268, Minneapolis: University of Minnesota Press.

Browne, K. (2005), "Snowball Sampling: Using Social Networks to Research Non-Heterosexual Women," *International Journal of Social Research Methodology,* 8(1): 47–60.

Buckland, F. (2002), *Impossible Dance: Club Culture and Queer World-Making*, Middletown, CT: Wesleyan University Press.

Buckley, C. and Clark, H. (2017), *Fashion and Everyday Life*, London: Bloomsbury Academic.

Butler, A. (2020), "Creating Space in the Community Archive for Queer Life Stories to be (re)Performed and Captured," *Oral History*, 48(1): 57–65.

Butler, J. (1986), "Sex and Gender in Simone de Beauvoir's Second Sex," *Yale French Studies*, 72: 35–49.

Butler, J. (1990), *Gender Trouble: Feminism and the Subversion of Identity*, London: Routledge.

Butler, J. (1993), *Bodies That Matter*, London: Routledge.

Campbell, C. (1996), "Shopping, Pleasure and the Sex War," in P. Falk and C. Campbell (eds), *The Shopping Experience,* 159–168, London: Sage.

Campkin, B. and Marshall, L. (2017), "LGBTQ+ Cultural Infrastructure in London Night Venues: 2008–Present," London: University College London. Available online: https://www.ucl.ac.uk/urban-lab/sites/urban-lab/files/LGBTQ_culturalinfrastructure_in_London_nightlife_venues_2006_to_the_present.pdf (accessed 10 January 2021).

Campkin, B. and Marshall, L. (2018), "London's Nocturnal Queer Geographies," *Soundings*, 70: 82–96.

Capon, T. (2018), "London Club XXL Owner's Shocking Femme-phobic Rant Provokes 'Queer' Protest," *Gay Star News* 11 September. Available online: https://www.gaystarnews.com/article/london-xxl-femme-phobic-rant-protest/. Accessed 18 June 2021.

Carr, C. T. and Hayes, R. A. (2015), "Social Media: Defining, Developing, and Divining," *Atlantic Journal of Communication*, 23(1): 45–65.

Carr, D. (1986), "Narrative and the Real World: An Argument for Continuity," *History and Theory*, 25(2): 117–131.

Cass, V. C. (1979), "Homosexual Identity Formation: A Theoretical Approach," *Journal of Homosexuality*, 4(3): 219–235.

Cavallaro, D. and Warwick, A. (1998), *Fashioning the Frame: Boundaries, Dress and the Body*, Oxford: Berg.

Chauncey, G. (1994), *Gay New York: Gender, Urban Culture and the Making of the Gay Male World, 1890–1940*, New York: Basic Books.

Chen, A. (2007), "Where the Club Boys Are," *New York Times*, 20 May. Available online: https://www.nytimes.com/2007/05/20/travel/20surfacing.html (accessed 7 April 2021).

Chermeyeff, C. (1995), *Drag Diaries,* San Francisco: Chronicle Books.

Church Gibson, P. (2000), "'No-one Expects Me Anywhere': Invisible Women, Ageing and the Fashion Industry," in Bruzzi, S. and Church Gibson, C. (eds), *Fashion Cultures: Theories, Explorations and Analysis*, 79–89, London: Routledge.

Church Gibson, P. (2018), "Cindy Sherman in a New Millennium: Fashion, Feminism, Art and Ageing," *Australian Feminist Studies*, 33(98): 481–497.

Claes, L., Vandereycken, W., and Vertommen, H. (2005), "Self-Care Versus Self-Harm: Piercing, Tattooing, and Self-Injuring in Eating Disorders," *European Eating Disorders Review*, 13(1): 11–18.

Clammer, J. (1992), "Aesthetics of the Self: Shopping and Social Being in Contemporary Urban Japan," in Rob Shields (ed.), *Lifestyle Shopping: The Subject of Consumption*, 195–215, London: Routledge.

Clarke, J., Newman, J., Smith, N., Vidler, E., and Westmarland, L. (2007), *Creating Citizen-Consumers: Changing Publics and Changing Public Services*, Thousand Oaks, CA and London: Sage.

Clarke, V. and Smith, M. (2015), "'Not Hiding, Not Shouting, Just Me': Gay Men Negotiate Their Visual Identities," *Journal of Homosexuality*, 62: 4–32.

Clarke, V. and Turner, K. (2007), "V. Clothes Maketh the Queer? Dress, Appearance and the Construction of Lesbian, Gay and Bisexual Identities," *Feminism and Psychology*, 17(2): 267–276.

Cole, S. (2000), *Don We Now Our Gay Apparel: Gay Men's Dress in the Twentieth Century*, Oxford: Berg.

Cole, S. (2002), "Not Sure if You're a Boy or a Girl," *SHOWstudio*, 19 September. Available online: https://www.showstudio.com/projects/transformer/not_sure_if_you_re_a_boy_or_a_girl (accessed 15 November 2021).

Cole, S. (2008), "Butch Queens in Macho Drag: Gay Men, Dress and Subcultural Identity," in A. Reilly and S. Cosbey (eds), *Men's Fashion Reader*, 279–293, New York: Fairchild Books.

Cole, S. (2009), "Hair and Male (Homo) Sexuality: 'Up-Top and Down Below,'" in Geraldine Biddle-Perry and Sarah Cheang (eds), *Hair: Styling Culture and Fashion*, 81–89, Oxford: Berg.

Cole, S. (2012), "Television's Fashion Gay Teens: Justin Suarez and Kurt Hummel," *Film, Fashion and Consumption*, 1(2): 159–164.

Cole, S. (2013), "Queerly Visible: Gay Men's Dress and Style 1960–2012," in V. Steele (ed.), *A Queer History of Fashion: From the Closet to the Catwalk*, 135–165, New Haven, CN and New York: Yale University Press with Fashion Institute of Technology New York.

Cole, S. (2014), "Costume or Dress? The Use of Clothing in the Gay Pornography of Jim French's Colt Studio," *Fashion Theory*, 18(2): 123–148.

Cole, S. (2015), "Looking Queer? Gay Men's Negotiations between Masculinity and Femininity in Style and Dress in the Twenty-First Century." *Clothing Cultures*, 2(2): 193–208.

Cole, S. (2019), "The Difference is in the Detail: Negotiating Black Gay Male Style in the Twentieth-First Century," *Dress: The Journal of the Costume Society of America*, 45(1): 39–54.

Cole, S. (2022), "'Coming Out' and Fitting In: The Role of Dress and Style in Fashioning Gay Men's Identity in the New Millennium," in V. Karaminas, A. Geczy, and P. Church Gibson (eds), *Fashionable Masculinities: Queers, Pimp Daddies and Lumbersexuals*, New Brunswick, NJ: Rutgers University Press.

Cole, S. (forthcoming 2024), "Styling Gay Men in The West," in B. Barry, A Reilly, and J. Blanco (eds), *The Handbook of Men's Fashion,* Bristol and Chicago, IL: Intellect.

Cole, S. and Lambert M. (2021), "Introduction," in S. Cole and M. Lambert (eds), *Dandy Style: 250 years of British Men's Fashion*, 13–29, London and New Haven, CT: Yale University Press.

Connell, R. (1992), "A Very Straight Gay; Masculinity, Homosexual Experience and the Dynamics of Gender," *American Sociological Review*, 57(6): 735–751.

Connell, R. (2005 [1995]), *Masculinities*, 2nd edition, Berkeley: University of California Press.

Connell, R.W. and Messerschmidt, J.W. (2005), "Hegemonic Masculinity: Rethinking the Concept," *Gender and Society* 19(6): 829–859.

Cooper, A. (2013), *Changing Gay Male Identities*, Abingdon: Routledge.

Craik, J. (1994), *The Face of Fashion*, London: Routledge.

Craik, J. (2005), *Uniforms Exposed: From Conformity to Transgression*, Oxford: Berg.

Cwerner, S. B. (2001), "Clothes at Rest: Elements for a Sociology of the Wardrobe," *Fashion Theory*, 5(1): 79–92.

Davis, F. (1992), *Fashion, Culture and Identity*, Chicago: University of Chicago Press.

Daywash (n.d.), "Bred in Sydney, Bound Worldwide." Available online: https://www.daywash.com.au/about (accessed 19 August 2020).

de Beauvoir, S. (1953 [1949]), *The Second Sex* (ed. and trans. H. M. Parshley), Harmondsworth: Penguin Books.

de Casanova, E. M. (2015), *Buttoned Up: Clothing, Conformity, and White-collar Masculinity*, Ithaca, NY: ILR Press.

D' Emilio, J. and Freedman, E. B. (1997), *Intimate Matters: A History of Sexuality in America*, Chicago: University of Chicago Press.

Deleuze, G., and Guattari, F. (1988), *A Thousand Plateaus: Capitalism and Schizophrenia* (trans. B. Massumi), London: Athlone Press.

DeLong, M., Heinemann, B., and Reilly, K. (2005), "Hooked on Vintage!," *Fashion Theory*, 9(1): 23–42.

Discogs (n.d.), "Horse Meat Disco." Available online: https://www.discogs.com/artist/1349939-Horse-Meat-Disco (accessed 19 August 2020).

Downing Peters, L. (2014), "You Are What You Wear: How Plus-Size Fashion Figures in Fat Identity Formation," *Fashion Theory: The Journal of Dress, Body and Culture*, 18(1): 45–72.

Drummond, M. J. N. (2005a), "Asian Gay Men's Bodies," *Journal of Men's Studies*, 13(3): 291–300.

Drummond, M. J. N. (2005b), "Men's Bodies: Listening to the Voices of Young Gay Men," *Men and Masculinities*, 7(3): 270–290.

Drummond, M. (2010), "Younger and Older Gay Men's Bodies," *Gay and Lesbian Issues and Psychology Review*, 6(1): 31–41.

du Gay, P. (1997), *Production of Culture, Cultures of Production*, London: Sage.

Duncan, D. (2010), "Embodying the Gay Self: Body Image, Reflexivity and Embodied Identity," *Health Sociology Review*, 19(4): 437–450.

Dyer, R. (1993), *The Matter of Images: Essays on Representatios*, London: Routledge.

Dyer, R. (2002), *The Culture of Queers*, London: Routledge.

Dziengel, L. (2015), "A Be/Coming-Out Model: Assessing Factors of Resilience and Ambiguity," *Journal of Gay and Lesbian Social Services*, 27(3): 302–325.

Eagly, A. H., and Wood, W. (2013), "The Nature—Nurture Debates: 25 Years of Challenges in Understanding the Psychology of Gender," *Perspectives on Psychological Science*, 8(3): 340–357.

Edwards, T. (1997), *Men in the Mirror: Men's Fashion, Masculinity and Consumer Society*, London: Routledge.

Edwards, T. (2006), *Cultures of Masculinity*, London and New York: Routledge.

Edwards, T. (2011), *Fashion in Focus: Concepts, Practices and Politics*, London: Routledge.

Eicher, J. B. and Miller, K. A. (1994), "Dress and the Public, Private, and Secret Self: Revisiting a Model," *Proceedings of the International Textiles and Apparel Association*. Paper presented at International Textiles and Apparel Association annual meeting, Minneapolis MN, 10/1/94, pp. 145.

Elliott, R. and Wattanasuwan, K. (1998), "Brands as Symbolic Resources for the Construction of Identity," *International Journal of Advertising*, 17(2): 131–44.

Ellonen, H. K. (2008), *The Effect of Internet on the Magazine Publishing Industry*, Tampere, Finland: Tampere University of Technology.

Entwistle, J. (2000), *The Fashioned Body: Fashion, Dress and Modern Social Theory*, Cambridge: Polity Press.

Entwistle, J. and Wilson, E., eds (2001), *Body Dressing*, Oxford: Berg.

Entwistle, J. and Wissinger, E. (2006), "Keeping up Appearances: Aesthetic Labour in the Fashion Modelling Industries of London and New York," *Sociological Review*, 54(4): 774–794.

Eror, A. (2017) "Scally Lads," *Vice*. Available online: https://www.vice.com/en_uk/article/wd4jyw/scally-lads-v21n2 (accessed 16 September 2019).

Ertan, C. (2017), "Resistance Patterns of a Tattooed Body," in P. Guerra and T. Morteira (eds), *Keep it Simple, Make it Fast! An approach to Underground Music Scenes,* volume 3, 155–160, Porto: University of Porto.

Faiers, J. (2016), "Sartorial Connoisseurship, the T-shirt and the Interrogation of Luxury," in J. Armitage and J. Roberts (eds), *Critical Luxury Studies: Art, Design, Media*, 177–189, Edinburgh: Edinburgh University Press.

Featherstone, M. and Hepworth, M. (1991), "The Mask of Ageing and the Postmodern Life Course," in M. Featherstone, M. Hepworth, and B. S. Turner (eds), *The Body: Social Process and Cultural Theory*, 371–389, London: Sage.

Featherstone, M. and Hepworth, M. (1995), "Images of Positive Ageing: A Case Study of 'Retirement Choice' Magazine," in M. Featherstone and A. Wernick (eds), *Images of Ageing: Cultural Representations of Later Life,* 354–362, London and New York: Routledge.

Featherstone, M. and Wernick, A. (1995), *Images of Ageing: Cultural Representations of Later Life*, London and New York: Routledge.

Fejes, F. (2000), "Making a Gay Masculinity," *Critical Studies in Mass Communication*, 17(1): 113–117.

Ferreira, V. S. (2009), "Youth Scenes, Body Marks and Bio-sociabilities," *Young*, 17(3): 285–306.

Filiault, S. M. and Drummond, M. J. N. (2007), "The Hegemonic Aesthetic," *Gay and Lesbian Issues and Psychology Review,* 3(3): 175–184.

Filiault, S. M. and Drummond, M. J. N. (2009), "All the Right Labels: Gat Male athletes and the Perceptions of their Clothing," *Culture, Society and Masculinities*, 1(2): 177–196.

Finkelstein, J. (1998), *Fashion: An Introduction,* New York: New York University Press.

Finkelstein, J. (1991), *The Fashioned Self*, Oxford: Polity.

Fletcher, K. (2014), *Sustainable Fashion and Textiles: Design Journeys*, 2nd edition, Abingdon: Routledge.

Fletcher, K. and Klepp, I. G. (2017), *Opening Up the Wardrobe: A Methods Book*, Oslo: Novus.

Florida, R. (2014), *The Rise of the Creative Class—Revisited*, New York: Basic Books.

Flynn, P. (2003), "Bear up," *Attitude*, September, 66–70.

Flynn, P. (2017), "30 Years of Gay Style: From Disco Chic to Hipster Bears," *Guardian.* Available online: https://www.theguardian.com/fashion/2017/apr/25/30-years-of-gay-style-from-disco-chic-to-hipster-bears (accessed 22 January 2018).

Fortier, A. M. (2002), "Queer Diaspora," in D. Richardson and S. Seidman (eds), *Handbook of Lesbian and Gay Studies*, 183–198, London: Sage.

Foucault, M. (1977), *Discipline and Punish: The Birth of the Prison,* London: Allen Lane.

Foucault, M. (2000), *Ethics: Subjectivity and Truth*, London: Penguin Books.

Freitas, A., Kaiser, S., Chandler, D. J., Hall, D. C., Kim, J.-W., and Hammidi, T. (1997), "Appearance Management as Border Construction: Least Favorite Clothing, Group Distancing, and Identity Not!," *Sociological Inquiry*, 67(3): 323–335.

Frith, H. and Gleeson, K. (2004), "Clothing and Embodiment: Men Managing Body Image and Appearance," *Psychology of Men and Masculinity,* 5(1): 40–48.

Garber, M. (1992), *Vested Interests: Cross-Dressing and Cultural Anxiety*, New York: Routledge.

Geczy, A. and Karaminas, V. (2013), *Queer Style*, London and New York: Bloomsbury Academic.

Gelder, K., ed. (2005), *The Subcultures Reader*, 2nd edition, London: Routledge.

Gelder, K. (2007), *Subcultures Cultural Histories and Social Practice*, London: Routledge.

Gelder, K. and Thornton, S., eds (1997), *The Subcultures Reader*, London: Routledge.

Gell, A. (1998), *Art and Agency: Towards an Anthropological Theory*, Oxford: Clarendon Press.

Ghaziani, A. (2014), *There Goes the Gayborhood*, Princeton, NJ: Princeton University Press.

Giddens, A. (1991), *Modernity and Self-Identity: Self and Society in the Late Modern Age*, Cambridge: Polity.

Giertsen, M. (1989), *Lesbians Coming Out and Disclosure: A Life-course Analysis*, MA diss., University of Bergen.

Giertsen, M. and Andresson, N. (2007), "Time Period and lesbian identity events: A comparison of Norwegian Lesbians Across 1986 and 2005," *Journal of Sex Research*, 44(4): 328–339.

Glaser, B. G. and Strauss, A. (1967). *The Discovery of Grounded Theory*, New York: Alpine.

Gluck, S. B. (2013), "From California to Kufr Nami and Back: Reflections on 40 Years of Feminist Oral History," in A. Sheftel and S. Zembrzyck (eds), *Oral History off the Record: Toward an Ethnography of Practice*, 25–42, New York: Palgrave Macmillan.

Godelier, M. (1999), *The Enigma of the Gift*, Chicago: University of Chicago Press.

Goffman, E. (1963), *Behavior in Public Places. Notes on the Social Organization of Gathering*s, New York: The Free Press, Simon and Schuster.

Goffman, E. (1967), *Stigma: Notes on the Management of Spoiled Identity*, Englewood Cliffs, NJ: Prentice-Hall.

Goffman, E. (1969 [1959]), *The Presentation of Self in Everyday Life,* London: Allen Lane The Penguin Press.

Goldie, T. (2002), "Dragging Out the Queen," in N. Tuana et al. (eds), *Revealing Male Bodies*, Bloomington: Indiana University Press.

Gomez, J. (2008), *Print is Dead: Books in Our Digital Age*, Basingstoke: Palgrave Macmillan.

Green, A. I. (2008), "The Social Organization of Desire: The Sexual Fields Approach," *Sociological Theory*, 26(1): 25–50.

Green, A. I. (2011), "Playing the (Sexual) Field: The Interactional Basis of Systems of Sexual Stratification," *Social Psychology Quarterly,* 74(3): 244–266.

Greene, L. A. (2021), *Drag Queens and Beauty Queens: Contesting Femininity in the World's Playground*, New Brunswick, NJ: Rutgers University Press.

Greenhalgh, H. (2015), "Gay Bars Fall Victim to Soaring Property Prices," *Financial Times,* 28 September. Available online: https://www.ft.com/content/01d5a06c-6363-11e5-a28b-50226830d644 (accessed 3 September 2020).

Gregson, N. and Crewe, L. (2003), *Second-hand Cultures*, Oxford and New York: Berg.

Greif, M. (2010), "What Was the Hipster?," *New York Magazine*, 24 October. Available online: http://nymag.com/print/?/news/features/69129 (accessed 3 September 2020).

Grogan, S. (2017), *Body Image: Understanding Body Dissatisfaction in Men, Women and Children*, 3rd edition, Abingdon: Routledge.

Grossberg, L. (1996), "Identity and Cultural Studies: Is That All There Is?," in S. Hall and P. Du Gay (eds), *Questions of Cultural Identity*, 87–107, Los Angeles: Sage Publications.

Gualardia, A. and Baldo, M. (2010), "Bear or 'orso'? Translating gay bear culture into Italian," *In Other Words*, 36(2): 23–39.

Guenther, M. (2011), "Magazine Publishing in Transition: Unique Challenges for MultiMedia Platforms," *Publishing Research Quarterly*, 27(4): 327–331.

Guy, A., Green, E., and Banim, M. (2001), *Through the Wardrobe: Women's Relationships with their Clothes,* Oxford: Berg.

Gwilt, A., ed. (2019), *Global Perspectives on Sustainable Fashion*, London: Bloomsbury Visual Arts.

Hakim, C. (2010), "Erotic Capital," *European Sociological Review*, 26(5): 499–518.

Hakim, J. (2018) "'The Spornosexual': The Affective Contradictions of Male Body-work in Neoliberal Digital Culture," *Journal of Gender Studies*, 27(2): 231–241.

Hakim, J. (2020), *Work That Body: Male Bodies in Digital Culture*, London and New York: Rowman and Littlefield.

Halberstam, J. (2003), "What's that Smell?," *International Journal of Cultural Studies*, 6(3): 313–333.

Halberstam, J. (2005), *In a Queer Time and Place: Transgender Bodies, Subcultural Lives*, New York: New York University Press.

Halberstam, J. (2005a), "Shame and White Gay Masculinity," *Social Text*, 23 (3–4 (84–85)): 219–233.

Halkitis, P. M. (2000), "Masculinity in the Age of AIDS: HIV-Seropositive Gay Men and the 'Buff Agenda,'" in P. Nardi (ed.), *Gay Masculinities*, 130–151, London: Sage Publications.

Hall, M. (2015), *Metrosexual Masculinities*, Basingstoke: Palgrave Macmillan.

Hall, S. (1981), "Notes on Deconstructing 'The Popular,'" in R. Samuel (ed), *People's History and Socialist Thought*, 227–240, London: Routledge.

Halperin, D. M. (2012), *How to be Gay*, Boston: Harvard University Press.

Halperin, D. M. and Traub, V. (2009), "Beyond Gay Pride," in D. M. Halperin and V. Traub (eds), *Gay Shame*, 1–40, Chicago and London: University of Chicago Press.

Hansen, K. T. (2004), "The World in Dress: Anthropological Perspectives on Clothing, Fashion and Culture," *Annual Review of Anthropology*, 3: 369–392.

Harriman, A. and Bontje, M. (2014), *Some Wear Leather, Some Wear Lace: A Worldwide Compendium of Postpunk and Goth in the 1980s*, Bristol and Chicago: Intellect.

Haworth, E. and Jonkers, G., eds (2019), *What Men Wear and Why,* Amsterdam: Top Publishers BV.

Heaphy, B, Yip, A., and Thompson, D. (2003), *Lesbian, Gay and Bisexual Lives Over 50: A Report on the Project "The Social and Policy Implications of Non-Heterosexual Ageing*," Nottingham: York House Publications.

Hebdige, D. (1979), *Subculture: The Meaning of Style*, London, Routledge.

Hennen, P. (2008), *Faeries, Bears and Leathermen Men in Community Queering the Masculine*, Chicago and London: University of Chicago Press.

Hesmondhalgh, D. (2005), "Subcultures, Scenes or Tribes? None of the Above," *Journal of Youth Studies*, 8(1): 21–40.

Hill Collins, P. and Bilge, S. (2016), *Intersectionality*, Cambridge: Polity Press.

Hinchman, L. P. and Hinchman, S. K. (2001), *Memory, Identity, Community: The Idea Narrative in the Human Sciences,* New York: State University of New York Press.

Hitchcock, F. and McCauley Bowstead, J. (2020), "Queer Fashion Practice and the Camp Tactics of Charles Jeffrey LOVERBOY," *Critical Studies in Men's Fashion*, 7(1&2): 7–49.

Hodkinson, P. (2002), *Goth: Identity, Style and Subculture*, Berg, Oxford.

Hollander, A. (1994), *Sex and Suits: The Evolution of Modern Dress,* New York: Knopf.

Holleran, A. (1978), *Dancer from the Dance*, London: Corgi.

Holliday, R. (2001), "Fashioning the Queer Self," in J. Entwistle and E. Wilson (eds), *Body Dressing,* 215–232, Oxford: Berg.

Houlbrook, M. (2006), *Queer London: Perils and Pleasures in the Sexual Metropolis, 1918–1957*, Chicago: University of Chicago Press.

Huang, Y.-T. and Fang, L. (2019) "'Fewer but Not Weaker': Understanding the Intersectional Identities Among Chinese Immigrant Young Gay Men in Toronto," *American Journal of Orthopsychiatry*, 89(1): 27–39.

Hunter, M. (2010), "All the Gays Are White and All the Blacks Are Straight: Black Gay Males, Identity and Community," *Sexuality Research and Social Policy*, 7(2): 81–92.

Huq, R. (2006), *Beyond Subculture: Pop, Youth and Identity in a Postcolonial World*, Abingdon and New York: Routledge.

Irwin, J. (1977), *Scenes*, Beverly Hills: Sage Publications.

Jackson, P. (2002), *Inside Clubbing: Sensual Experiments in the Art of Being Human*, Oxford: Berg.

Jackson, P., Crang, P., and Dwyer, C. (2004), "Introduction: The spaces of transnationality," in P. Crang, C. Dwyer, and P. Jackson (eds), *Transnational Spaces*, 1–23, London: Routledge.

Johnson, P. (2008), "'Rude Boys': The Homosexual Eroticization of Class," *Sociology*, 42(1): 65–85.

Jones, J. and Pugh, S. (2005), "Ageing Gay Men: Lessons From Sociological Embodiment," *Men and Masculinities*, 7(3): 248–260.

Jones, O. (2011), *Chavs: The Demonization of the Working Class,* London: Verso.

Kaiser, S. (2012), *Fashion and Cultural Studies*, Oxford: Berg.

Kang, M., Sklar, M. and Johnson, K. K. P. (2011), "Men at work: using dress to communicate identities," *Journal of Fashion Marketing and Management*, 15(4): 412–427.

Karaminas, V. (2010), "Urban Menswear in Australia," in M. Maynard (ed.), *Berg Encyclopedia of World Dress and Fashion: Australia, New Zealand, and the Pacific Islands*, Oxford: Berg. Available online: https://www-bloomsburyfashioncentral-com.arts.idm.oclc.org/products/berg-fashion-library/encyclopedia/berg-encyclopedia-of-world-dress-and-fashion-australia-new-zealand-and-the-pacific-islands/urban-menswear-in-australia (accessed 18 June 2021).

Kates, S. M. (2000), "Out of the Closet and Out on the Street!: Gay Men and Their Brand Relationships," *Psychology and Marketing*, 17(6): 493–513.

Kates, S. M. (2001), "Camp as Cultural Capital: Further Elaboration of a Consumption Taste," *Advances in Consumer Research*, 28: 334–339.

Kates, S. M. (2002), "The Protean Quality of Subcultural Consumption: An Ethnographic Account of Gay Consumers," *Journal of Consumer Research*, 29: 383–399.

Kates, S. M. (2004), "The Dynamics of Brand Legitimacy: An Interpretive Study in the Gay Men's Community," *Journal of Consumer Research*, 31: 455–464.

Kawamura, Y. (2005), *Fashion-Ology: An Introduction to Fashion Studies*, Oxford: Berg.

Kim, Y.-K., Ha, S., and Park, S.-H. (2019), "Competitive Analyses for Men's Clothing Retailers: Segmentation and Positioning," *International Journal of Retail and Distribution Management*, 47(12): 1266–1282.

Kimmel, M. S. (2005), *The Gender of Desire: Essays on Male Sexuality*, Albany, NY: State University of New York Press.

Kirk, K. and Heath, E. (1984), *Men in Frocks*, London: GMP.

Klepp, I. G. and Bjerck, M. (2014), "A Methodological Approach to the Materiality of Clothing: Wardrobe Studies," *International Journal of Social Research Methodology*, 17(4): 373–386.

Kong, T. S. K. (2011), *Chinese Male Homosexualities: Memba, tongzhi and golden boy*, Abingdon and New York: Routledge.

Larraín, M. E. (2012), "Adolescence: Identity, Fashion and Narcissism," in A. M. Gonzalez and L. Bovone (eds), *Identities through Fashion: A Multidisciplinary Approach*, 138–155, London and New York: Berg.

Lee, M., Tomsen, S., and Wadds, P. (2020), "Locking-Out Uncertainty: Conflict and Risk in Sydney's Night-Time Economy," in J. Pratt and J. Anderson (eds), *Criminal Justice, Risk and the Revolt against Uncertainty*, 191–215, Basingstoke and New York Palgrave.

Lehman, P. (2007), *Running Scared: Masculinity and the Representation of the Male Body*, new edition, Detroit: Wayne State University Press.

Lentini, P. (1999), "The Cultural Politics of Tattooing," *Arena Journal*, 13: 31–55. Available online: https://www.thefreelibrary.com/The+cultural+politics+of+tattooing+(1).-a0128599427 (accessed 16 September 2020).

Levine, M. P. (1998), *Gay Macho: The Life and Death of the Homosexual Clone*, New York and London: New York University Press.

Lifter, R. (2019), *Fashioning Indie: Popular Fashion, Music and Gender*, London: Bloomsbury Visual Arts.

Light, B., Fletcher, G., and Adam, A. (2008), "Gay Men, Gaydar and the Commodification of Difference," *Information Technology and People*, 21(3): 300–314.

Lipovetsky, G. (1994), *The Empire of Fashion: Dressing Modern Democracy*, Princeton: Princeton University Press.

Liu, X., Burns, A., and Hou, Y. (2013), "Comparing Online and In-store Shopping Behavior Towards Luxury Goods," *International Journal of Retail and Distribution Management*, 41(11/12): 885–900.

Lurie, A. (1992), *The Language of Clothes*, London: Bloomsbury Publishing.

Maffesoli, M. (1996), *The Time of the Tribes: The Decline of Individualism in Mass Society* (trans. D. Smith), Thousand Oaks, CA: Sage.

Manley, E., Levitt, H., and Mosher, C. (2007), "Understanding the Bear Movement in Gay Male Culture," *Journal of Homosexuality*, 54(4): 89–112.

Marszalek, J. F., Cashwell, C. S., Dunn, M. S., and Heard, K. (2004), "Comparing Gay Identity Development Theory to Cognitive Development: An Empirical Study," *Journal of Homosexuality*, 48: 103–123.

Martin, J. L. and George, M. (2006), "Theories of Sexual Stratification: Toward an Analytics of the Sexual Field and a Theory of Sexual Capital," *Sociological Theory* 24(2): 107–132.

Mauss, M. (1992), *The Gift*, London: Routledge.

McBride, D. A. (2005), *Why I Hate Abercrombie and Fitch: Essays on Race and Sexuality*, New York: New York University Press.

McCauley Bowstead, J. (2018), *Menswear Revolution: The Transformation of Contemporary Men's Fashion*, London: Bloomsbury Academic.

McCauley Bowstead, J. (2022a), "Spectacularising the Male Body: Fashionable Physiques in the Age of Instagram," in V. Karaminas, A. Geczy, and P. Church Gibson (eds), *Fashionable Masculinities: Queers, Pimp Daddies and Lumbersexuals*, New Brunswick: Rutgers University Press.

McCauley Bowstead, J. (2022b), "Refashioning the Male Body: Contemporary Media Representations of the Spornosexual and the Waif," in S. Girlsbeck and C. Dexl (eds), *Representations of the Male Body*, London: Palgrave.

McCormack, M. (2012), *The Declining Significance of Homophobia: How Teenage Boys Are Redefining Masculinity and Heterosexuality*, New York: Oxford University Press.

McCracken, G. (1995), *Big Hair: A Journey into the Transformation of Self*, London: Indigo.

McGlynn, N. (2020), "Bears in Space: Geographies of a Global Community of Big and Hairy Gay/Bi/Queer Men," *Geography Compass*, 15(2). Available online: https://doi-org.soton.idm.oclc.org/10.1111/gec3.12553 (accessed 29 September 2021).

McGrady, P. B. (2016), "'Grow the Beard, Wear the Costume': Resisting Weight and Sexual Orientation Stigmas in the Bear Subculture," *Journal of Homosexuality*, 63(12): 1698–1725.

McKinnon, S. (2018), "Big City Gaybourhoods: Where They Come From and Why They Still Matter," *The Conversation*, 3 May: 1–6.

McNeil, P. and Karaminas, V. (2009), *The Men's Fashion Reader*, Oxford: Berg.

McVeigh, B. (1997), "Wearing Ideology: How Uniforms Discipline Minds and Bodies in Japan," *Fashion Theory*, 1(2): 189–214.

Mercer, J. (2003), "Homosexual Prototypes: Repetition and the Construction of the Generic in the Iconography of Gay Pornography," *PARAGRAPH*, 26(1–2): 280–290.

Merleau-Ponty, M. (1962), *The Phenomenology of Perception* (trans. Colin Smith), New York: Humanities Press.

Mesitieri, G. (2020), *The Most Beautiful Job in the World: Lifting the Veil on the Fashion Industry*, London: Bloomsbury.

Meyer, M. (1994), *The Politics and Poetics of Camp*, London: Routledge.

Mijas, M., Koziara, K., Galbarczyk, A., and Jasienska, G. (2020), "Chubby, Hairy and Fearless. Subcultural Identities and Predictors of Self-Esteem in a Sample of Polish Members of Bear Community," *International Journal of Environmental Research and Public Health*, 17(12): 4439.

Miles, M. B. and Huberman, M. A. (1994), *Qualitative Data Analysis*, 2nd edition, Thousand Oaks, CA: Sage.

Miller, D. and Woodward, S. (2011), "Introduction" in D. Miller, and S. Woodward, (eds), *Global Denim*, 1–21, Oxford and New York: Berg.

Miller, D. and Woodward, S. (2012), *Blue Jeans: The Art of the Ordinary*, Berkeley: University of California Press.

Monaghan, L. (2005), "Big Handsome Men, Bears and Others: Virtual Constructions of 'Fat Male Embodiment,'" *Body and Society*, 11: 81–111.

Moon, J. (2009), "Gay Shame and the Politics of Identity," in D. M. Halperin and V. Traub (eds), *Gay Shame*, 357–368, Chicago and London: University of Chicago Press.

Morgado, M. A. (1996), "Coming to Terms with Postmodern: Theories and Concepts of Contemporary Culture and their Implications for Apparel Scholars," *Clothing and Textiles Research Journal*, 14(1): 41–53.

Morris, M. (2018), "'Gay Capital' in Gay Student Friendship Networks: An Intersectional Analysis of Class, Masculinity, and Decreased Homophobia," *Journal of Social and Personal Relationships*, 35(9): 1183–1204.

Mowlabocus, S. (2010), *Gaydar Cultures: Gay Men, Technology and Embodiment in the Digital Age*, Farnham: Ashgate.

Muggleton, D. (2000), *Inside Subculture: The Postmodern Meaning of Style*, Oxford: Berg.

Muggleton, D. and Weinzierl, R., eds (2003), *The Post-Subcultures Reader*, Oxford: Berg.

Muñoz, J. E. (1999), *Disidentifications: Queers of Color and the Performance of Politics*, Minneapolis: University of Minnesota Press.

Murphy, T. (2015), "What's On: Melbourne's Famous Trough X on its Way to Sydney," *Star Observer*, 11 May. Available online: https://www.starobserver.com.au/artsentertainment/whats-on/sydney-city-guides/whats-on-melbournes-famour-trough-x-on-its-way-to-sydney/136164 (accessed 19 August 2020).

Muscarella, F. and Cunningham, M. R. (1996), "The Evolutionary Significance and Social Perception of Male Pattern Baldness and Facial Hair," *Ethology and Sociobiology*, 17: 99–117.

Muthu, S. S., ed. (2019), *Consumer Behaviour and Sustainable Fashion Consumption*, Singapore: Springer Singapore.

Nardi, P. (1999), *Gay Men's Friendships: Invincible Communities*, Chicago: Chicago University Press.

Nardi, P. (2000), *Gay Masculinities*, Thousand Oaks, CA: Sage Publications.

National Lesbian and Gay Survey (1993), *Proust, Cole Porter, Michelangelo, Marc Almond and Me: Writings by Gay Men on their Lives and Lifestyles*, London: Routledge.

Negrin, L. (2008a), *Appearance and Identity: Fashioning the Body in Postmodernity*, New York: Palgrave Macmillan.

Negrin, L. (2008b), "Body Art and Men's Fashion," in A. Reilly and S. Cosbey (eds), *Men's Fashion Reader*, 323–336, New York: Fairchild Books.

Newbury, M. (2002), "Huggy Bears," *Boyz*, 10 August: 60.

Newton, E. (1972), *Mother Camp: Female Impersonators in America*, Englewood Cliffs, NJ: Prentice Hall.

Norton, R. (1992), *Mother Clap's Molly House: The Gay Subculture in England 1700–1830*, London: Gay Men's Press.

Nossek, H., Adoni, H., and Nimrod, G. (2015), "Is Print Really Dying? The State of Print Media Use in Europe," *International Journal of Communication*, 9: 365–385.

Padva, G. (2002), "Heavenly Monsters: The Politics of the Male Body in the Naked Issue of Attitude Magazine," *International Journal of Sexuality and Gender Studies*, 7(4): 281–292.

Paoletti, J. (2012), *Pink and Blue: Telling the Boys From the Girls in America*, Bloomington: Indiana University Press.

Patton, M. Q. (2002), *Qualitative Research and Evaluation Methods: Integrating Theory and Practice*, 3rd edition, Thousand Oaks, CA: Sage.

Peluchette, J.V., Karl, K. and Rust, K., (2006), "Dressing to Impress: Beliefs and Attitudes Regarding Workplace Attire," *Journal of Business and Psychology*, 21(1): 45–63.

Penaloza, L. (1996), "We're Here, We're Queer, and We're Going Shopping! A Critical Perspective on the Accommodation of Gays and Lesbians into the U.S. Marketplace," *Journal of Homosexuality*, 31(1&2): 9–41.

Penney, T. (2014), "Bodies Under Glass: Gay Dating Apps and the Affect-Image," *Media International Australia*, 153: 107–117.

Perks, R. and Thomson, A. (eds) (2006), *The Oral History Reader*, 2nd edition, London: Routledge.

Personal Narratives Group (1989), "Truths in Personal Narratives," in Personal Narratives Group (eds), *Interpreting Women's Lives: Feminist Theory and Personal Narratives*, 261–264, Indiana: Indiana University Press.

Peters, B. M. (2010), "Emo Gay Boys and Subculture: Postpunk Queer Youth and (Re)thinking Images of Masculinity," *Journal of LGBT Youth*, 7(2): 129–146.

Peterson, R. A. and Bennett A. (2004), "Introducing Music Scenes," in A. Bennett and R. A. Peterson (eds), *Music Scenes: Local, Translocal, and Virtual*, 1–15, Nashville, TN: Vanderbilt University Press.

Pike, K. L. (1967), *Language in Relation to a Unified Theory of the Structure of Human Behaviour*, The Hague: Mouton.

Piotrowicz, W. and Cuthbertson, R. (2014), "Introduction to the Special Issue Information Technology in Retail: Toward Omnichannel Retailing," *International Journal of Electronic Commerce*, 18(4): 5–16.

Plummer, K. (1995), *Telling Sexual Stories*, London: Routledge.

Polhemus, T. (1994), *Streetstyle*, London: Thames & Hudson.

Porter, C. (2007), "BoomBox: The London Club that Inspired a Fashion Phenomenon," *Independent*, 16 September. Available online: https://www.independent.co.uk/news/uk/this-britain/boombox-the-london-club-that-inspired-a-fashion-phenomenon-402352.html (accessed 29 September 2020).

Pritchard, E. D. (2017), *Fashioning Lives: Black Queers and the Politics of Literacy*, Carbondale: Southern Illinois University Press.

Pronger, B. (2000), "Physical Culture," in G. E. Haggerty (ed.), *Gay Histories and Cultures: An Encyclopedia*, 688–690. New York: Garland Publishing.

Provis, C. (2019), "Business Ethics, Confucianism and the Different Faces of Ritual," *Journal of Business Ethics*, 165: 1–14.

Queer Identity in Fashion: Challenging Stereotypes. Available online: https://www.subprod.co.uk/beproud (accessed 17 October 2017).

Rasmussen, C. (2019), *Diary of a Drag Queen*, London: Penguin.

Rees-Roberts, N. (2013), "Boys Keep Swinging: The Fashion Iconography of Hedi Slimane," *Fashion Theory*, 17(1): 7–26.

Reilly, A. (2014), "Extending the Theory of Shifting Erogenous Zones to Men's Tattoos," *Critical Studies in Men's Fashion*, 1(3): 211–221.

Reilly, A. and Barry, B. (2020), *Crossing Gender Boundaries: Fashion to Create, Disrupt and Transcend*, Bristol and Chicago: Intellect.

Reilly, A. and Cosbey, S., (eds), (2008), *Men's Fashion Reader*, New York: Fairchild.

Reilly, A. and Miller-Spillman, K. A. (2016), "Linking Dress and the Public, Private and Secret Self Model to Coming Out," *Critical Studies in Men's Fashion*, 3(1): 7–15.

Reilly, A., Rudd, H., and Hillery, J. (2008), "Shopping Behavior Among Gay Men: Issues of Body Image," *Clothing and Textiles Research Journal*, 26(4): 313–326.

Richardson, N. (2010), *Transgressive Bodies: Representations in Film and Popular Culture*, Farnham: Ashgate.

Roach-Higgins, M. E. and Eicher, J. B. (1992), "Dress and Identity," *Clothing and Textile Research Journal*, 10(4): 1–10.

Roach-Higgins, M. E. and Eicher, J. B., (eds), (1995), *Dress and Identity*, New York: Fairchild.

Robinson, P. (2008), *The Changing World of Gay Men*, Basingstoke: Palgrave MacMillan.

Rocamora, A. (2002), "Fields of Fashion: Critical Insights into Bourdieu's Sociology of Culture," *Journal of Consumer Culture*, 2(3): 341–362.

Rofes, E. (1997), "Academics as Bears: Thoughts on Middle-Class Eroticization of Workingmen's Bodies," in L. Wright (ed.), *The Bear Book: Readings in the History and Evolution of a Gay Male Subculture*, 89–102, New York: Harrington Park Press.

Rosenfeld, D. (2009), "Heteronormativity and Homonormativity as Practical and Moral Resources: The Case of Lesbian and Gay Elders," *Gender and Society*, 23(5): 617–638.

Rubin, H. J. and Rubin, I. S. (2012), *Qualitative Interviewing: The Art of Hearing Data*, 3rd edition, Thousand Oaks: Sage Publications.

Rupp, L. J. and Taylor, V. A. (2003), *Drag Queens at the 801 Cabaret*, Chicago: University of Chicago Press.

Sadkowska, A., Townsend, K., Fisher, T., and Wilde, D. (2017), "(Dis-)engaged Older Men? Hegemonic Masculinity, Fashion and Ageing," *Clothing Cultures*, 4(3): 185–201.

Sassatelli, R. (2011), "Indigo Bodies: Fashion, Mirror Work and Sexual Identity in Milan," in D. Miller and S. Woodward (eds), *Global Denim*, 127–144, Oxford and New York: Berg.

Saucier, J. A. and Caron, S. L. (2008), "An Investigation of Content and Media Images in Gay Men's Magazines," *Journal of Homosexuality*, 55(3): 504–523.

Schildkrout, E. (2004), "Inscribing the Body," *Annual Review of Anthropology*, 33: 319–344.

Schofield, K. and Schmidt, R. A. (2005), "Fashion and Clothing: The Construction and Communication of Gay Identities, *International Journal of Retail and Distribution*, 33(4): 310–323.

Schofield-Tomschin, S. and Littrell, M. A. (2001), "Textile Handcraft Guild Participation: A Conduit to Successful Aging," *Clothing and Textiles Research Journal*, 19(2): 41–51.

Sedgwick, E. K. (1990), *Epistemology of the Closet*, Berkeley, CA: University of California Press.

Sedgwick, E. K. (1993a), *Tendencies*, Durham: Duke University Press.

Sedgwick, E. K. (1993b), "How to Bring Your Kids Up Gay," in M. Warner (ed.), *Fear of a Queer Planet: Queer Politics and Social Theory*, Minnesota: University of Minnesota Press.

Sedgwick, E. K. (2003), *Touching Feeling: Affect, Pedagogy, Performativity*, Durham and London: Duke University Press.

Sedgwick, E. K. (2009), "Shame, Theatricality and Queer Performativity: Henry James's *The Art of the Novel*," in D. M. Halperin and V. Traub (eds), *Gay Shame*, 49–62, Chicago and London: University of Chicago Press.

Segal, L. (1994), *Straight Sex: Rethinking the Politics of Pleasure*, London: Virago Press.

Sender, K. (2001), "Gay Readers, Consumers, and a Dominant Gay Habitus: 25 Years of the Advocate Magazine," *Journal of Communication*, 51(1): 73–99.

Sha, O., Aung, M., Londerville, J., and Ralston, C. E. (2007), "Understanding Gay Consumers" Clothing Involvement and Fashion Consciousness," *International Journal of Consumer Studies*, 31: 453–459.

Shabazz, R. (2015), *Spatializing Blackness: Architectures of Confinement and Black Masculinity in Chicago*, Urbana: University of Illinois Press.

Shilling, C. (2012), *The Body and Social Theory*, 3rd edition, London: Sage.

Siebers, T. (2009), "Sex, Shame, and Disability Identity: With Reference to Mark O'Brien," in D. M. Halperin and V. Traub (eds), *Gay Shame*, 201–216, Chicago and London: University of Chicago Press.

Siegel, M. (2009), "Are Hipsters Stealing Gay Style? Or Something Else?," *Queerty**, 4 May. Available online: https://www.queerty.com/are-hipsters-stealing-gay-style-or-something-else-20090504 (accessed 19 November 2018).

Simmel, G. (1957), "Fashion," *American Journal of Sociology*, 62(6): 541–558.

Simmel, G. (1971), *On Individuality and Social Forms*, Chicago: University of Chicago Press.

Simpson, M. (1992), "Male Impersonators," *Gay Times*, August, 51–54.

Simpson, M. (1994a), *Male Impersonators: Men Performing Masculinity*, London: Cassell.

Simpson, M. (1994b), "Here Come the Mirror Men," *Independent*, 23 May. Available online: https://www.independent.co.uk/life-style/hello-boys-soho-turns-pink-soho-has-changed-complexion-this-week-there-will-be-scenes-of-celebration-1438027.html (accessed 10 February 2019).

Simpson, M. (1996), *Anti-gay*, London: Freedom Editions.

Simpson, M. (2002), "Meet the Metrosexual," *Salon*. Available online: http://www.salon.com/2002/07/22/metrosexual/ (accessed 10 February 2019).

Simpson, M. (2008), "Sporno," in L. Salazar (ed.), *Fashion v Sport*, 106–113, London: V&A Publishing.

Simpson, M. (2013), *Metrosexy: A 21st Century Self-Love Story*, CreateSpace Independent Publishing Platform.

Simpson, M. (2014), "The Metrosexual is Dead. Long Live the 'Spornosexual,'" *Telegraph*, 10 June. Available online: http://www.telegraph.co.uk/men/fashion-and-style/10881682/The-metrosexual-is-dead.-Long-live-the-spornosexual.html (accessed 14 September 2021).

Simpson, P. (2013), "Work that Body: Distinguishing an Authentic Middle-Aged Gay Self," *Critical Studies in Fashion and Beauty*, 4(1&2): 147–171.

Simpson, P. (2014), "Differentiating Selves: Middle-Aged Gay Men in Manchester's Less Visible 'Homospaces,'" *British Journal of Sociology*, 65(1): 150–169.

Simpson, P. (2015), *Middle-Aged Gay Men, Ageing and Ageism: Over the Rainbow?*, London: Palgrave Macmillan.

Skeggs, B. (2004), *Class, Self, Culture*, London and New York: Routledge.

Smith Maguire, J. and Stanway, K. (2008), "Looking Good: Consumption and the Problems of Self-production," *European Journal of Cultural Studies*, 11(1): 63–81.

Smithson, J. (2007), "Focus Groups," in P. Alasuutari, L. Bickman, and J. Brannen (eds), *The Sage Handbook of Social Research Methods*, 257–270, Thousand Oaks, CA: Sage.

Soeffner, H.-G. (2018), *Order of Rituals: The Interpretation of Everyday Life*, Abingdon and New York: Routledge.

Sontag, S. (1967), *Against Interpretation and Other Essays*, London: Eyre and Spottiswoode.

Sorokowski, P., Sorokowska, A., Oleszkiewicz, A., Frackowiak, T., Huk, A., and Pisanski, K. (2015), "Selfie Posting Behaviors Are Associated with Narcissism among Men," *Personality and Individual Differences*, 85(1): 123–127.

Srinivasan, A. (2018), "Does Anyone Have the Right to Sex?," *London Review of Books*, 40(6), 22 March. Available online: https://www.lrb.co.uk/the-paper/v40/n06/amia-srinivasan/does-anyone-have-the-right-to-sex (accessed 10 September 2021).

Statista (n.d.), "Men's Apparel – Worldwide." Available online: https://www.statista.com/outlook/cmo/apparel/men-s-apparel/worldwide?currency=USD and https://www.statista.com/outlook/cmo/apparel/men-s-apparel/worldwide?currency=GBP (accessed 1 August 2022).

Steele, V. (1996), *Fetish: Fashion, Sex and Power*, Oxford: Oxford University Press.

Steele, V., ed. (2013), *A Queer History of Fashion: From Closet to Catwalk*, New Haven, CT: Yale University Press.

Stonewall, (2017) "LGBT in Britain: Hate crime report'. Available online: https://www.stonewall.org.uk/lgbt-britain-hate-crime-and-discrimination (accessed 23 June 2021).

Strübel, J. and Jones, D. (2017), "Painted Bodies: Representing the Self and Reclaiming the Body through Tattoos," *Journal of Popular Culture*, 50(6): 1230–1253.

Strübel, J. and Petrie, T. A. (2016), "The Clothes Make the Man: The Relation of Sociocultural Factors and Sexual Orientation to Appearance and Product Involvement," *Journal of Retailing and Consumer Services*, 33: 1–7.

Strübel, J. and Petrie, T. A. (2018), "Perfect Bodies: The Relation of Gay Men's Body Image to their Consumer Behaviors," *Journal of Fashion Marketing and Management*, 22(1): 114–128.

Sullivan, A. (1995), *Virtually Normal: An Argument About Homosexuality*, London: Picador.

Summers-Effler, E. (2006), "Ritual theory," in J. Stets and J. H. Turner (eds), *Handbook of the Sociology of Emotions*, 135–154, Boston, MA: Springer.

Suresha, R. J. (2009), *Bears on Bears: Interviews and Discussions*, Maple Shade, NJ: Bear Bones Books.

Swartz, D. (1997), *Culture & Power: The Sociology of Pierre Bourdieu*, Chicago: University of Chicago Press.

Sweetman, P. (2003), "Twenty-First Century Dis-ease? Habitual Reflexivity or the Reflexive Habitus," *Sociological Review*, 51(4): 528–549.

Synnott, A. (1993), *The Body Social: Symbolism, Self and Society*, London: Routledge.

Tan, C. K. K. (2016), "Gaydar: Using Skilled Vision to Spot Gay 'Bears' in Taipei," *Anthropological Quarterly*, 89(3): 841–864.

Tan, C. K. K. (2017), "Taipei Gay 'Bear' Culture as a Sexual Field, or, Why Did Nanbu Bear Fail?," *Journal of Contemporary Ethnography*, 48(4): 563–585.

Taylor, J. (2012), "Performances of Post-Youth Sexual Identities in Queer Scenes," in A. Bennett and P. Hodkinson (eds), *Ageing and Youth Culture*, 24–36, London: Routledge.

Thomas, J. (2011), "The Gay Bar: It's New Competition," Slate.com, 30 June. Available online: www.slate.com/id/2297608 (accessed 19 November 2018).

Thompson, A. (1998), "Anzac Memories: Putting Popular Memory Theory into Practice in Australia," in R. Perks and A. Thompson (eds), *The Oral History Reader*, 300–310, London: Routledge.

Thornton, S. (1995), *Club Cultures: Music, Media and Subcultural Capital*, Cambridge: Polity Press.

Todd, M. (2016), *Straight Jacket: How to be Gay and Happy*, London: Bantam Press.

Tolman, Deborah L., Bowman, Christin P., and Fahs, Breanne (2014), "Sexuality and Embodiment," in D. L. Tolman, L. M. Diamond, J. A. Bauermeister, W. H. George, J. G. Pfaus, and L. M. Ward (eds), *APA Handbook of Sexuality and Psychology, Vol. 1. Person-Based Approaches*, 759–804, Washington D.C.: American Psychological Association.

Tooth Murphy, A. (2020), "Listening In, Listening Out: Intersubjectivity and the Impact of the Insider Outsider Status in Oral History Interviews," *Oral History*, 48(1): 35–44.

Tseëlon, E. (2001), "Fashion Research and its Discontents," *Fashion Theory*, 5(4): 435–451.

Tulloch, C. (2010), "Style—Fashion—Dress: From Black to Post-Black," *Fashion Theory*, 14(3): 273–303.

Twigg, J. (2013), *Fashion and Age: Dress, the Body and Later Life*, London: Bloomsbury Academic.

Twigg, J. (2018), "Dress, Gender and the Embodiment of Age: Men and Masculinities," *Ageing and Society*, 40: 105–125.

Vail, D. A. (1999), "Tattoos are like potato chips . . . you can't have just one: the process of becoming and being a collector," *Deviant Behavior*, 20(3): 253–273.

Vinken, B. (2005), *Fashion Zeitgeist: Trends and Cycles in the Fashion System*, Oxford: Berg.

Ward, J. and Winstanley, D. (2005), "Coming Out at Work: Performativity and the Recognition and Renegotiation of Identity," *The Sociological Review*, 53(3): 447–475.

Warhurst, C. and Nickson, D. (2001), *Looking Good, Sounding Right: Style Counselling in the New Economy*, London: The Industrial Society.

Warkander, P. (2013), "Queer Materiality: An Empirical Study of Gender Subversive Styles in Contemporary Stockholm," in J. Turney (ed.), *Fashion Crimes: Dressing for Deviance*, 105–114, London: Bloomsbury Visual Arts.

Warner, M. (1999), *The Trouble with Normal: Sex, Politics and the Ethics of Queer Life*, Cambridge, MA: Harvard University Press.

Weeks, J. (1991), "Inverts, Perverts, and Mary-Annes: Male Prostitution and the Regulation of Homosexuality in England in the Ninetenth and Early Twentieth Centuries," in M. B. Duberman, M. Vicinus, and G. Chauncey (eds), *Hidden from History: Reclaiming the Gay and Lesbian Past*, 195–211, London: Penguin.

Weston, K. (1991), *Families We Choose: Lesbians, Gays, Kinship*, New York: Columbia University Press.

White, E. (2012), "Is There a Good Way to Be Gay?," *New York Review of Books*, 25 October. Available online: https://www.nybooks.com/articles/2012/10/25/is-there-good-way-be-gay/ (accessed 6 November 2020).

Whitesel, J. (2010) "Gay Men's Use of Online Pictures in Fat-Affirming Groups," in C. Pullen and M. Cooper eds), *LGBT Identity and Online New Media*, 215–229, New York: Routledge.

Whitesel, J. (2014), *Fat Gay Men: Girth, Mirth and the Politics of Stigma*, New York and London: New York University Press.

Who?, S. (2005), "So You Think You're a Man," *Gay Times*, March: 38, 40.

Wilson, E. (1985), *Adorned in Dreams: Fashion and Modernity*, London: Virago.

Wilson, E. and de la Haye, A., eds (1999), *Defining Dress. Dress as Object, Meaning and Identity*, Manchester: Manchester University Press.

Winge, T. M. (2012), *Body Style*, London and New York: Berg.

Wright, L., ed. (1997), *The Bear Book*, New York: Harrington Park Press.

Wright, L., ed. (2001), *The Bear Book II. Further Readings in the History and Evolution of a Gay Male Subculture*, New York: Harrington Park Press.

Woo, K. (2017), "Remembering Boombox, London's seminal clubnight," Dazes. Available online: https://www.dazeddigital.com/fashion/article/34610/1/remembering-boombox-londons-seminal-clubnight-2007-richard-mortimer (accessed 29 September 2020).

Woodward, S. (2007), *Why Women Wear What They Wear*, Oxford: Berg.

Wotherspoon, G. (1991), *City of the Plain: History of a Gay Sub-Culture*, Marrickville, NSW: Hale and Ironmonger.

Wotherspoon, G. (2016), *Gay Sydney: A History*, Sydney: University of New South Wales Press.

Wykes, M. and Gunter, B. (2006), *Media and Body Image: If Looks Could Kill*, London: Sage.

Yeung, K.-T., Stombler, M., and Wharton, R. (2006), "Making Men in Gay Fraternities: Resisting and Reproducing Multiple Dimensions of Hegemonic Masculinity," *Gender and Society*, 20(1): 5–31.

Young, I. M. (2005), *On Female Body Experience: 'Throwing Like a Girl' and Other Essays*, Oxford: Oxford University Press.

Yow, V. (1997), "'Do I Like Them Too Much?': Effects of the Oral History Interview and Vice Versa," *Oral History Review*, 24(1): 55–79.

INDEX